Acting Together

..

Performance and the Creative Transformation of Conflict

Acting Together

Performance and the Creative Transformation of Conflict

VOLUME II: *Building Just and Inclusive Communities*

Edited by Cynthia E. Cohen, Roberto Gutiérrez Varea, and Polly O. Walker

New Village Press • Oakland, CA

Published in the United States by
New Village Press
P.O. Box 3049
Oakland, CA 94609
(510) 420-1361
bookorders@newvillagepress.net
www.newvillagepress.net

New Village Press is a public-benefit, not-for-profit publishing venture of
Architects/Designers/Planners for Social Responsibility. www.adpsr.org.

Grateful acknowledgment is made to The Nathan Cummings Foundation,
a funder of this publication.

In support of the Greenpress Initiative, New Village Press is committed to the
preservation of endangered forests globally and advancing best practices within
the book and paper industries. The printing paper used in the text of this book
is 100% post-consumer recycled, Process Chlorine Free (PCF), and has been
certified with both the Forest Stewardship Council (FSC) and the Sustainable
Forestry Initiative (SFI). Printed by Malloy Incorporated of Ann Arbor.

ISBN-13 978-1-61332-000-6

Publication Date: December 2011

Library of Congress Cataloging-in-Publication Data

Acting together : performance and the creative transformation of conflict /
edited by Cynthia Cohen, Roberto Gutiérrez Varea, and Polly Walker.
 p. cm.
 Summary: "Describes peacebuilding performances in different regions of the
world fractured by war and violence."—Provided by publisher.
 Includes bibliographical references and index.
 ISBN 978-1-61332-000-6 (alk. paper)
 1. Peace-building and theater. 2. Theater—Political aspects. 3. Theater—
Social aspects. 4. War and theater. 5. Theater and society. I. Cohen, Cynthia.
II. Gutierrez Varea, Roberto. III. Walker, Polly, 1950–
 PN2051.A28 2011
 792.09—dc22 2011014215

Cover design by Lynne Elizabeth
Front cover photo by Amrita Performing Arts
Back cover photo by Cathyann Keaveney
Interior design and composition by Leigh McLellan Design

Contents

......................

Changing the World as We Know It

To our ancestors and elders who have sustained the fragile flames of peace and justice in the midst of war, colonization, dislocation, marginalization, and oppression; to the millions of courageous souls around the world who in quiet anonymity act every day with understanding, inclusiveness, and imagination; and to the young people whose passion for life burns brightly

In Peru, the Truth and Reconciliation Commission, headed by Dr. Salomón Lerner Febres, invited Grupo Cultural Yuyachkani to accompany it throughout the country, to serve as a bridge between the Commission and Indigenous communities, and to help those who had suffered in the brutal civil war prepare to testify. This set the stage for numerous rituals and performances in plazas and marketplaces in rural communities. Yuyachkani's Ana Correa performed as *Rosa Cuchillo*, a mother searching in the underworld for her disappeared son. Photo by Mike Lovett

Foreword

........................

The Rebellion of the Masks[1]

A common image used to understand the human experience consists of observing the world as if it were a theatre, and the people in it as actors in a drama. The idea that life is a stage, and that all individuals in the world acquire a mask to be in it, has been utilized even by the social sciences as a way to understand the integration of a subject with his or her community. "We come to the world," asserted the sociologist Erving Goffman, "as individuals, achieve characters and become persons." *Persona*, let's remember, is a Latin word that refers to the mask or the character that appears in a theatrical staging. This interpretation of the human being as a subject that constructs herself or himself as a character inside a social drama is valid if we understand the mask not as an object that covers us up, but, on the contrary, as a device that reveals our identity.[2]

Hence, *Acting Together*, the title of this book, signals to us one of the first aspects that, in a most intimate manner, define the condition of our species. I refer to the symbolic nature of human action, that which properly constitutes us into persons.[3]

In effect, we human beings act together because the meaning of our lives springs from our relationships with others. This is why the question "Who am I?" finds its final answer in the role that I can play within a larger community. This proof does not negate my autonomy. On the contrary, it demands of others the recognition of my own existence and of my own projects. Thus, on the one hand, every person is an end unto herself or himself, and on the other, he or she reaches a level of fulfillment by playing a role in the community. *Acting Together* allows us to understand that peace constitutes itself in the value and recognition of the roles that each one of us carries out in the daily drama of our existences.

Violence, however, has a thousand faces and all of them relate to the breaking of the bonds that give us both humanity and meaning. In effect, be it under the guise of poverty, serfdom, or carnage, the violent act involves robbing the individual of the possibility of occupying a dignified space in the world of our lives, that is, of depriving her or him of their condition of *person*. This is why those who suffer any form of violence, experience an attack on their identity. Conversely, the peoples or social groups who have suffered deaths, genocide, slavery, or other forms of oppression carry with them the stigma of having been erased from history.

Thus, we understand that violence is the destruction of meaning, a disorder that contaminates the very symbols with which we build our lives in communion with others. And because it corrupts meaning and reduces our humanity, violence often appears as an inexplicable act, almost impossible to understand at the very time when it occurs. Violent acts that reveal the capacity possessed by human beings to commit abominations against each other and, ultimately, against their own selves, can shake up our conscience and make us lose our sense of reality. It should not be strange then to notice that those who have suffered the most brutal impact of this type of acts feel as if they have lived through something outside of meaning, and although they have felt this experience in their own flesh, they nevertheless find it extremely difficult to define it or make it comprehensible.

Violence appears to be an ineffable experience, but then, how can a conscience crushed by the subtraction of identity be reconstructed? How can the lost meaning be found again?

We can answer these questions in the second meaning that we find in *Acting Together*, that is, acting as representation, to be understood as the opportunity to be able to *present once again* the traumatic act on the theatrical stage. The great power of representation lays precisely in its symbolic force, in its ability to restore, through *reenactment,* the meaning inherent in the traumatic act.

Fiction allows us to reconstitute reality and, therefore, also the individual back into a person. It is because of this that representation can be perceived to be "more real" than the represented act itself, as it is through representation that a vision of the world is recuperated and the fragmented pieces can be composed to create a coherent and meaningful picture.

This restoration or revelation of meaning is in no way an appropriation of the victim's voice. As we can understand in reading this volume, the actors on stage constitute themselves as mediators in an operation of great symbolic power that allows those who suffered the violent acts to reconnect with the facts and attain a form of catharsis. Acting together, and not separately, mending the torn fabric through community rituals, making understandable the incomprehensible, invoking the very demons that run through history: it is in these acts that the healing qualities of representation shared in this book reside.

We are dealing then with a ritual of exorcism and understanding, of revelation and knowledge. The histrionic fiction is, therefore, a sort of therapy that returns to us, mended and sensible, a broken and stunned reality.

In his *Theater and Its Double*, Antonin Artaud noted that "The theater restores [to] us all our dormant conflicts and all their powers, and gives these powers names we hail as symbols…" and later asserted that "In the true theater a play disturbs the senses' repose, frees the repressed unconscious, incites a kind of virtual revolt (which moreover can have its full effect only if it remains virtual), and imposes on the assembled collectivity an attitude that is both difficult and heroic."[4] The many diverse experiences from different parts of the world that are discussed in this anthology are comprehended by these images about the theatre offered to us by the great French dramatist. There are two aspects that stand out in them and recur again and again in the chapters of this volume: that theatre operates in a manner that awakens conscience-restoring conflicts, and that the act of representing results in a symbolic rebellion. Conflicts, of course, are not restored to fan the flames of violence, but to integrate them back into our memory. Rebellion is a vindication of that which unsettles us and keeps us awake. As a result, theatre becomes a powerful enemy of the injustice of forgetting.

This anthology narrates many diverse and particular cases in which theatre is an effective medium to understand the experience of violence. As important as probing each circumstance to understand the ways and effects of theatre on the reconstruction of dignity, peace, and justice is to notice the universal principles present in a wide diversity of expressions. Humanity, in its diverse manifestations, is, in the end, one in its essence, in its capacity to create symbols and through them its own existence is understood. Unfortunately, it is also one in its capacity to inflict great suffering and unfathomable misfortune.

Yet art and, as we see in this work, theatre in particular, can show us that there is a greater force in creativity and a greater power in solidarity. It is in instances like these that art is not just contemplation and transcendence, but also a form of justice that cleanses and vindicates our species in a universal way.

Salomón Lerner Febres

Walking The Walk, a production directed by Hope Azeda and produced by The Playhouse International Culture Arts Network ICAN. Photo by Cathyann Keaveney

Preface

........................

Speak to the Past and It Will Heal Thee

I remember one of my first experiences with the power of the arts to cross divides. When I was growing up, my mother shared her memories of being a little girl, remembering men in black berets coming to her house for secret meetings, men of the Old IRA Brigade of the 1920s and 1930s. She told me that many a night she and her sisters slept on a mattress of rifles with a box of gelignite under the bed. But she also witnessed the power of music to bring neighbors from both cultural traditions together: her father, the bandleader of their community's Catholic flute band, crossed the cultural divide to teach the neighboring Protestant flute band.

In a time of peace we can discuss war and the legacy of suffering it leaves in its wake, but in the late 1980s in Northern Ireland there were few places to safely explore the violent conflict which was showing no signs of letting up or coming to an end. It was within this period, when a culture of hate, death, bombs, violence, and self-destruction prevailed, that I decided, as a recently graduated mature student of theatre, to establish a community arts center. I envisioned the center serving the two cultural traditions of my historic city of Derry. I had a vision of the center being a place apart, a neutral space where people of all ages could come and participate in the wonder of the arts and theatre, where they could be lifted up out of the segregation of their daily life. It was to be a safe place, a creative refuge where imaginations could be restored and replenished, a place to dare to dream of a day when "the troubles" or "the war" would be over.

When eventually I found the building that would become the Derry Playhouse it was situated within and beside the Historic Walls of Derry on Artillery Street. It used to house armaments, but now was home to theatre and the arts, "weapons"

used to fight against bigotry, prejudice, and apathy. Theatre and the arts cannot stop war, but they can expose it, laying violence bare to be examined, explored, debated, and discussed—offering new insights into the experiences of the oppressed and the motivations of the oppressors.

In 1992 our city was celebrating IMPACT '92 (International Meeting Place for the Appreciation of Cultural Traditions). This was a year-long festival of theatre, music, and art, during which The Playhouse hosted workshops for local artists and community workers that were facilitated by the world's leading masters in their fields: Augusto Boal, world theorist and founder of Theatre of the Oppressed, Brazil; Barney Simon, founder and director of The Market Theatre of Johannesburg, South Africa; and Peter Schumann, founder and director of the Bread and Puppet Theatre Company, Vermont. One night, having left the theatre late, Augusto turned to me after silently watching the heavily armed military presence surrounding us and said, "I feel at home here." From then until now we hope that all artists visiting with us to work in our Arts and Peacebuilding projects will feel at home in this space dedicated to the creative transformation of conflict.

We know that we have much work to do. Paradoxically, during this precious time of peace when the army is no longer occupying our streets and our new police force is striving to have an equal ratio of both Protestant and Catholic officers, we are concerned that Northern Ireland may plummet back to the dark days of the conflict. Recently *The Guardian* newspaper carried a report from MI5 intelligence that there were fears dissident Republicans had perfected weapons with which to launch a fresh terrorist offensive, hoping to recruit a new generation of volunteers from the many unemployed in the current recession. At the time of this writing, April 2011, dissident Republicans murdered Constable Ronan Kerr at his home in Omagh, a town that in 1998 experienced the most horrific car bomb attack of the troubles. When the bomb under his car exploded outside his home, Ronan was twenty-five years old and only just qualified as a serving police officer. There was an outcry of condemnation from all sides, except from those who had perpetrated this act of terror. At Ronan's momentous funeral, Gaelic Athletic Association members stood shoulder to shoulder with Police Service of Northern Ireland police officers. Never in our history had this happened before.

In April 2011, I attended a funeral in Cambridge, Massachusetts, at St. John's Parish. It was the Funeral Mass of Timothy "Frank" McCusker, an Irish policeman who lived to be ninety-two years old and had served his Cambridge community without the threat of death for being Catholic and a policeman. The normality of the family funeral of Frank McCusker was in sharp contrast to the hurt, pain, and deep sense of injustice at young Ronan Kerr's funeral. It made me more resolved than ever to work harder in the field of community art to try and bring normality back to the communities of Northern Ireland, especially those working-class

communities who suffered and lost the most during thirty years of conflict and intercommunity tension, violence, and fear.

Although the peace process in Northern Ireland is fragile, it also demonstrates strength. In street performances across the land, people demonstrated solidarity for peace, issuing a powerful statement to the dissidents, and to the world, that such violence will no longer be tolerated. After Ronan's murder, a young man from Omagh orchestrated the "Not in My Name" campaign on the social network site, Facebook. Based on Facebook posts, thousands of men, women, and children took to the streets carrying banners stating "Not in My Name."

As artists in a time of peace we believe strongly that we must use this time to discuss the atrocities perpetrated by both sides, seeking out opportunities to share narratives of our lives during the conflict, painful as they may be. We must also celebrate the joy and humor that at times acted as the anesthetic against pain, loss, and despair. Given the threats of renewed violence, we have to ensure that as many young men and women as possible get involved in arts and peacebuilding, especially if they are jobless and have little hope for their own and their communities' futures. Arts can foster in them a sense of their own identity and through the use of theatre we can help them to understand prejudice, sectarianism, and discrimination, enhancing their capacities in positive and constructive ways. Through engagement in creativity, new relationships across difference can be created—new interests and energies can be nurtured. Such communication challenges perceptions of the other through sharing and listening to each other's stories, which can open up closed minds and

The creative spirit within all human beings can transcend the forces of conflict. The most recent manifestation of this transcendence was The Playhouse's *Theatre of Witness* program. Across Northern Ireland in town halls and theatres, I watched as audience members remained in their seats after the performances because they wanted to talk with the performers and thank them for their bravery in sharing their stories of "the troubles." For the first time ever, audience members spoke of their own stories during those conflicts. It was as if the performance had prepared the ground, a safe, sacred place for public discussion of very private stories of grief and pain. Every performance of *Theatre of Witness* was filled to capacity and audience members' reflections echoed a range of emotions, including gratitude for the bravery of the performers, and that of the male and female police officers who, despite death threats, took part in the productions. These performances, and the dialogues afterwards, engendered hope in many for a more peaceful society. As Nelson Mandela stated, "Artists work in a range that crosses the scale of human emotions from anger to zeal to love to sorrow. Such work demands the viewers' attention. They challenge our beliefs and values. They remind us of past errors, but they also speak of hope for the future."

hearts. Through creative endeavors, these young people can then see with new eyes, finding life in others' versions of the truth.

By involving today's youth (and their parents' generation) in the arts and developing their empathetic imaginations, we hope to expand their understanding of each other's truths, cultures, and traditions. Artists can create a safe place of common ground where young people can slowly get to know each other and to appreciate their commonalities and view their differences differently, giving them another perspective, another way of listening and seeing, a willingness to embrace and respect diversity.

It is well accepted that the first casualty in any conflict or war is the truth. In his acceptance speech on receiving the Nobel Prize for Literature, playwright Harold Pinter stated that "the search for the truth must never stop." In the pages that follow in this anthology, truth-seeking is paramount and central to the artists' work. The evidence provided in these substantial case studies highlights how multiple truths are excavated and portrayed in theatrical form.

This, and the first volume of *Acting Together: Performance and the Creative Transformation of Conflict*, demand and deserve readers' attention as they remind us of past errors, across the globe, in our time. They also speak of hope for the future and the God-given power of humanity's creativity to transcend the forces of violence inherent in our communities, countries, cultures, and lives. In these chapters, many of life's lessons are shared with us, especially the most fundamental lesson, the power and strength of sharing itself. May this anthology be shared far and wide and may the universal artistic wisdom embedded within it be practiced in good faith. May the practice and participation of the moral imagination lead to greater understanding and peace between and within our world's diverse and culturally rich communities.

I drafted this preface while participating in an Arts in the One World conference hosted by playwright Erik Ehn in Providence, Rhode Island. Carved into one of Brown University's buildings are the words, 'Speak to the Past and it will Heal Thee.' Dealing with our troubled past in Northern Ireland is one of our biggest challenges as we struggle to move forward one step at a time. In reading the pages of this anthology we take comfort in knowing that we are not alone on this journey—there are many more cultures emerging out of conflict, genocide, and war. Now thanks to the vision of these authors, their six years of hard work, and the courageous creativity of these theatre artists across the world who have been willing to share their work and practice, we have new tools to help us excavate our truths and our troubled pasts, to speak to them and to dare envision a future where our broken world will be healed.

Pauline Ross
Artistic Director, Derry Playhouse

Acknowledgments

Neither peacebuilding nor performance could be possible without the joint support, dedication, and expertise of large numbers of people, and the creation of this anthology certainly attests to that reality. While working on this project at many times has been thrilling and deeply satisfying, the challenges that this undertaking presented have been many, and the difficulties along this journey often tested our stamina, if not our resolve. We want to acknowledge and express our gratitude to the large community of scholars, artists, activists, friends, and family, who nurtured our spirit, advised us throughout the process, corrected our mistakes, and inspired us to move this work forward so that it could see the light of day.

We begin by thanking Roberta Levitow from Theater Without Borders and Jessica Berns from Coexistence International at Brandeis University for planting the seeds for this project and nurturing its process from the very beginning. To the chapter curators, Daniel Banks, Eugene van Erven, Catherine Filloux, Kate Gardner, Mary Ann Hunter, Ruth Margraff, Dijana Milošević, Charles Mulekwa, Abeer Musleh, Aida Nasrallah, John O'Neal, Madhawa Palihapitiya, Lee Perlman, and Jo Salas, our deepest gratitude for putting into writing what usually had been implicit aspects of their rich practices. Their contributions form the heart of this anthology. We are also deeply appreciative of the reflections on this work by John Paul Lederach, Roberta Levitow, Devanand Ramiah, Dr. Salomón Lerner Febres, Pauline Ross, and Tatsushi Arai. Our gratefulness is also extended to the numerous artists, activists, and scholars, too many to list here, who worked with each curator to contribute to their case studies (they are acknowledged individually at the first endnote of each chapter). We thank as well the members of our editorial advisory board: Daniel

Banks, Jessica Berns, Kevin Clements, Erik Ehn, Roberta Levitow, and Eugene van Erven. They held the compass steady for us when we most needed them.

In most instances, the case studies were developed through lengthy processes of discussion, drafting, exchange, comments, and revisions. Throughout this process, we were aided beyond measure by our editorial assistant, Lesley Yalen, who worked directly with several of the curators to revise the structure of their chapters and work through difficult sections. Catherine Michna worked with us on revisions of the framing chapters. Liz Canter, Barbara Epstein, Alice Frankel, Naoe Suzuki, and Shoshana Zeldner have brought patience, thoroughness, and thoughtfulness to their work formatting the document. We have also have benefitted from the expertise of our editor, Katie Bacon. We express our gratitude to these women for their commitment to the project and the careful attention with which they completed their tasks. Fred Stanton and Fred Courtright assisted with the formatting and organization of credits and permissions with precision and efficiency.

Several colleagues read earlier drafts of the case studies. For their insightful readings and helpful comments we thank Mohammad Abu-Nimer, Elizabeth Ayot, Eileen Babbitt, Jonathan Fox, Lindsay French, Ian McIntosh, Lucy Nusseibeh, Leigh Swigart, Dan Terris, James Thompson, and Karmit Zysman.

We would like to acknowledge the support this project has received from the institutions where we work, and our colleagues and students there. Brandeis University became a hub of support for many aspects of this project. The International Center for Ethics, Justice, and Public Life, and its director, Daniel Terris, created space and time and allocated resources allowing this work to evolve. The Acting Together project received initial support from Coexistence International at Brandeis. In addition, many offices and departments supported the October 2007 gathering "Acting Together on the World Stage: Setting the Scene for Peace/Actuando juntos: trabajando por la paz en el escenario mundial." Brandeis students contributed hours of work, scheduling events, reading drafts, transcribing tapes, and asking questions. Our appreciation also to the Australian Centre for Peace and Conflict Studies (ACPACS, 2004-2010) and the University of Queensland, as well as to Provost Jennifer Turpin and Vice Provost Peter Novak at the University of San Francisco. To our colleagues and students at Brandeis, University of Queensland, Partners in Peacebuilding, and University of San Francisco, our gratitude for sharing with us their unique feedback and fresh perspectives.

The filmmaker Allison Lund, who co-created and edited the documentary that accompanies this anthology, is a central member of our community of inquiry. Many ideas generated in conversation with her have found their way into this work.

We also thank Lynne Elizabeth, Stefania De Petris, and Laura Leone at New Village Press for the enthusiasm and respect with which they embraced this project for publication.

John Paul Lederach has been an inspiration to us for years. We appreciate his framework for the moral imagination, upon which the theoretical work of this anthology has been constructed. We are immensely grateful for his support.

We would like to thank our partners and families—Ann, Violeta, Kit, and Christopher—without whose patience, love, and support this project would have been impossible.

Finally, we appreciate each other and the deep trust and respect—and, above all, patience—that characterize our relationship. As co-editors, we have found this collaboration transformational: at times challenging, but always facing toward the light.

Cynthia E. Cohen, Roberto Gutiérrez Varea, and Polly O. Walker

Contributors

Tatsushi (Tats) Arai is associate professor of conflict transformation at SIT Graduate Institute. Previously, Tats taught at George Mason University and the National University of Rwanda. As a trainer, mediator, and dialogue facilitator, Tats has led a number of peacebuilding workshops for government personnel, members of international organizations, and civil society leaders from around the world. He also serves as a dialogue facilitator of Strait Talk, a series of semiannual conflict resolution dialogues aimed at fostering a new generation of peacebuilders from Taiwan, Mainland China, and the United States. Tats is a research fellow of the Toda Institute for Global Peace and Policy Research in Hawaii, an advisor to Global Majority, and a member of TRANSCEND, a global network for peace and development practitioners.

Daniel Banks is a theatre director, choreographer, educator, and dialogue facilitator. Banks has served on the faculties of the Department of Drama, Tisch School of the Arts, New York University, and the MFA in Contemporary Performance at Naropa University. He is the founder and director of the Hip Hop Theatre Initiative that uses Hip Hop Theatre as a catalyst for youth self-expression and leadership training. Banks is also co-director of DNAWORKS, an arts and service organization dedicated to using the arts as the catalyst for community dialogue and healing, and currently on the faculty in the Master of Arts in Applied Theatre at CUNY. Banks is a recipient of the National Endowment for the Arts/Theatre Communications Group Career Development Program for Directors. He has lectured throughout the US and has directed productions at prestigious international theatres. He holds a PhD in Performance Studies from NYU.

Cynthia E. Cohen is director of the Program in Peacebuilding and the Arts at the International Center for Ethics, Justice, and Public Life at Brandeis University. In addition, Cohen is an undergraduate and graduate professor and the co-editor of this anthology, as well as the co-creator of a documentary by the same name. She writes on the ethical and aesthetic dimensions of reconciliation and has been published in books and periodicals focused on conflict resolution, women's studies, and education, including *Working with Integrity: A Guidebook for Peacebuilders Asking Ethical Questions*. Cohen holds a PhD in education from the University of New Hampshire and a master's in city planning from the Massachusetts Institute of Technology. Cohen is the co-convenor of the Arts and Peace Commission of the International Peace Research Association.

Eugene van Erven has been researching theatre and social change since 1980. He is a senior lecturer/researcher at Utrecht University and author of *Radical People's Theatre; The Playful Revolution: Theatre and Liberation in Asia;* and *Community Theatre: Global Perspectives*. He is currently the research coordinator and website editor of the Utrecht Community Art Lab (CAL), a facility that aims to develop and investigate the rapidly growing community art practice in Utrecht and beyond. For Performance and Peacebuilding in Global Perspective, Dr. van Erven is conducting original research into community theatre productions designed to address relations between the Muslim immigrant communities and their non-Muslim neighbors in cities in the Netherlands.

Kate Gardner is an artist and founder/director of Community Theatre Internationale and WorldEnsemble, "creating community across borders local and global." She conceived, produced, and directed *A Happening* and *BrooKenya!*, an intercontinental grassroots soap opera involving 150 residents in Brooklyn, NY; Kisumu, Kenya; and Lima, Peru. She has presented and taught at Brandeis University, International Center for Tolerance Education; First Latin American Conference on Education-Entertainment for Social Change; International Peace Researchers Association; International Community-Based Theatre Festival; and Youth Channel. She is also a writer and designer.

Mary Ann Hunter is a senior lecturer in drama education at the University of Tasmania and former research associate with the Australian Centre for Peace and Conflict Studies. She has been a theatre worker, broadcaster, and community-based consultant in Australia and Singapore, and has published widely on youth-specific arts and policy. Dr Hunter was formerly coordinator of meenah mienne, an arts mentoring program for young people in the youth justice system, and is an honorary research advisor with the Faculty of Arts, University of Queensland.

Salomón Lerner Febres received his PhD in philosophy from the Université Catholique de Louvain. Dr. Lerner Febres was president of the Pontificia Universidad Católica del Perú (PUCP) from 1994 until 2004, when he became rector emeritus. He is the executive president of the Institute for Democracy and Human Rights at PUCP. He was the chairman of the Truth and Reconciliation Commission of Peru from 2001 to 2003. From 1999-2004, Dr. Lerner Febres was president of the Union of Latin American Universities. He has received several awards for his long and impressive academic background and his work with human rights, from the governments of Peru, Poland, Germany, France, and Chile among others.

John O'Neal is an internationally acclaimed writer, performer, and director. He is founder and artistic director of Junebug Productions, the organizational successor to the Free Southern Theater, of which O'Neal was also a cofounder and director. He

was a field secretary of the Student Non-Violent Coordinating Committee (SNCC) and worked as National Field Program Director with the Committee for Racial Justice. O'Neal has written eighteen plays, a musical comedy, and a substantial body of poetry and essays. He has numerous credits as an actor and has toured widely in the character of Junebug Jabbo Jones, a mythic figure who symbolizes the wisdom of common people. O'Neal has been a leader in the field of artists working in community and for social justice. He has received many awards including the prestigious Ford Foundation's Leadership for a Changing World Award, the Award of Merit from the Association of Performing Arts Presenters, and the United States Artists Award.

Pauline Ross is the founder and director of the Playhouse Theatre in Derry/Londonderry, Northern Ireland, where she was born and raised. One of the most influential arts activists in Northern Ireland, Pauline founded the Playhouse Theatre in 1992 and oversaw its award-winning renovation in 2009. It is now the largest, and one of the most artistically diverse, community arts centers in Ireland, home to many theatrical productions and arts initiatives that address the legacy of the conflict. Pauline was awarded an MBE (Member of the British Empire) during 2001 for her outstanding services to the Arts and Communities in Northern Ireland.

Jo Salas is the cofounder of Playback Theatre and the artistic director of Hudson River Playback Theatre in New York State. She has taught Playback Theatre in twenty countries and is a core faculty member of the Centre for Playback Theatre. She was a keynote speaker at academic symposiums on Playback Theatre held at the University of Kassel, Germany, and Arizona State University. Salas's publications about Playback Theatre include numerous articles and two books: *Improvising Real Life: Personal Story in Playback Theatre* and *Do My Story, Sing My Song: Music Therapy and Playback Theatre with Troubled Children*. She also coedited the bilingual publication *Half of My Heart/La Mitad de Mi Corazón: True Stories Told by Immigrants*.

Roberto Gutiérrez Varea began his career in theatre in his native city of Córdoba, Argentina. His research and creative work focuses on live performance, resistance, and peacebuilding in the context of social conflict and state violence. Varea is the founding artistic director of Soapstone Theatre Company, a collective of male ex-offenders and women survivors of violent crime, and of El Teatro Jornalero!, a performance company that brings the voice of Latin American immigrant workers to the stage; he is also a founding member of the San Francisco-based performance collective *Secos & Mojados*. He is an associate editor of *Peace Review*, an international journal on peace and justice studies, an associate professor in the University of San Francisco's Performing Arts and Social Justice Program, and director of USF's Center for Latino Studies in the Americas (CELASA). He is a coeditor of this anthology.

Polly O. Walker, assistant professor of peace and conflict studies at Juniata College in Huntingdon, Pennsylvania, is coeditor of this anthology. She serves as the director of Partners in Peacebuilding, a private consulting organization based in Brisbane, Australia, and lectures widely on intercultural conflict resolution. Previously awarded the University of Queensland Postdoctoral Research Fellowship for Women, she conducted research on the role of memorial ceremonies in transforming conflict involving Indigenous and Settler peoples in the United States and Australia. She has published articles in a broad range of international journals, and contributed chapters to several texts on conflict transformation. She is vice-chair of the Indigenous Education Institute, a research and practice institute created for the preservation and contemporary application of Indigenous traditional knowledge. Walker is of Cherokee and Settler descent and grew up in the traditional country of the Mescalero Apache.

Editorial Advisory Board

Daniel Banks, PhD. *See above.*

Jessica Berns is the former program director of Coexistence International at Brandeis University, which was an initiating sponsor of Acting Together on the World Stage. She is now a consultant focusing on questions of governance, peacebuilding, and civil society development.

Kevin Clements, PhD, is the director of the Aoteraoa New Zealand Peace and Conflict Studies Centre, a former secretary general of the International Peace Research Association, and a former director of International Alert.

Cynthia E. Cohen, PhD. *See above.*

Erik Ehn is a playwright and the director of playwriting at Brown University, the former dean of the School of Theatre at the California Institute for the Arts, initiator of Arts in the One World theatre and peacebuilding project, and a founding member of Theatre Without Borders.

Roberta Levitow is a founding member of Theatre Without Borders, the artistic associate with the Sundance Theatre Program's Sundance Institute East Africa initiative, and a codesigner of Acting Together on the World Stage.

Roberto Gutiérrez Varea *See above.*

Polly O. Walker, PhD. *See above.*

Changing the World as We Know It

Performance in Contexts of Structural Violence, Social Exclusion, and Dislocation

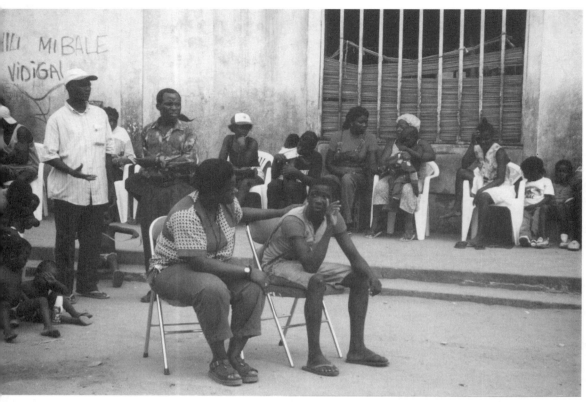

Angolan conductor Graca Francisco listens to a teller's story in an IDP (Internally Displaced Persons) camp outside Luanda, Angola. Photo by Bev Hosking

Introduction to Section I

Cynthia E. Cohen, Roberto Gutiérrez Varea, and Polly O. Walker

In situations characterized by structural violence, exclusion, and social injustice, building peace involves more than ending violent conflict; it requires creating settings and frameworks where differences can be productively engaged and negotiated, justice can be pursued, and more equitable relationships can be cultivated. Transforming conflict in these settings usually involves working for greater social and economic justice by addressing oppressive dynamics, amplifying the voices of those in less powerful groups, and building coalitions for change. It includes nurturing relationships of respect, understanding, and trust across differences in culture, ethnicity, gender, age, economic class, sexuality, and national identity. In addition to transforming relationships, laws and policies must be changed so that a society's institutions and cultural symbols are inclusive and supportive of the development of all groups.

Those who do this work confront many challenges. Unaddressed legacies—of slavery, oppression, misogyny, and geographic dislocation—create not only structural inequities but also socio-psychological barriers of shame, guilt, resentment, and mistrust. In addition, contemporary imbalances of power can insinuate themselves into even the best-intentioned efforts at change, undermining their effectiveness.

While each performance in this volume must be understood in its distinct cultural and political milieu, taken as a group the case studies in this section highlight the extent to which the global order, with its economic inequities and its movement toward cultural homogenization, as well as its opportunities for exchange and connectivity, create a shared context at another level. For instance, in a world in

which wars and geopolitical and economic forces generate massive migrations of people, conflicts about resources and culture often emerge between refugees and immigrants, on the one hand, and longstanding members of their new communities on the other.

The case studies in this section address these questions and dilemmas, as they are played out in performances and in societies grappling with issues of structural violence, including economic and social inequalities, poverty, gender-based violence, homophobia, and age discrimination. The curators of these case studies are performers and directors, researchers and evaluators, poets, coexistence practitioners, facilitators, social activists, and university educators. Some are members of the communities where they work; others are outsiders to those communities. In the chapters that follow, you will hear voices of young people, refugees, women, and men struggling with poverty, dislocation, and exclusion, and seeking to build stronger communities within Ghana and South Africa, the Netherlands, Afghanistan, Australia, Angola, New Zealand, and the United States, as well as across the divides of geography, nation, and socio-economic conditions.

The range of performance techniques and forms in these chapters is the widest of all the sections of this anthology, with artists relying on aesthetic forms from community-based performances to traditional theatre to new aesthetic movements such as hip-hop, all meaningfully addressing conflict related to entrenched structural violence and exclusion.

Eugene van Erven and Kate Gardner are champions of community theatre, based respectively in the Netherlands and New York. Their chapter, "Performing Cross-Cultural Conversations: Creating New Kinships through Community Theatre," explores transformative bridges built of stories and creative performance, spanning cultural and global divides. Van Erven describes a project in The Hague culminating in a performance called *In the Name of the Fathers,* which respectfully and sensitively addresses taboo topics, while building relationships across differences in class, sexuality, gender, ethnicity, religion, language, and generation. Drawing on their own stories, immigrant men from Muslim countries and native Dutch working-class men created a performance exploring the roles that fathers have played, and could play, in dealing with physical and structural violence in their lives and in their families and communities. Later in the chapter, Gardner discusses the innovative *BrooKenya!* project, a multicultural soap opera combining new technologies, soap opera forms, and intercontinental collaborative script development within and between multiethnic communities in Brooklyn, New York, and Kisumu, Kenya. While creating new kinds of relationships through new technologies, participants in *BrooKenya!* explored issues relevant to their communities, such as gender dynamics, HIV/AIDS, and questions of tolerance in the face of diversity.

In "Youth Leading Youth: Hip Hop and Hiplife Theatre in Ghana and South Africa," Daniel Banks explores Hip Hop Theatre's potential as a resource for young people trying to resist oppression and marginalization, in part through the creation of shared identities. The peaceful roots of grassroots Hip Hop culture, often obscured by the violent and misogynist lyrics of commercial Rap music, are evidenced by a range of forms and conventions of performance that facilitate more equitable interactions. Hip Hop ciphers, an impromptu circle of performers, also cultivate capacities for paradoxical curiosity—generating greater acceptance for diverse perspectives. These performances also serve to reduce epistemic violence, by incorporating aspects of traditional dance, music, and ritual that had been marginalized through colonization and globalization. "Youth Leading Youth" sheds light on the possibilities of projects that support artists to engage with communities for only short periods of time.

"Change the World as We Know It: Peace, Youth, and Performance in Australia," written by Mary Ann Hunter, discusses arts-based youth initiatives which draw on the experiences of Australian young people to create performances designed to transform conflict and build relationships across cultural, gender, and generational differences. Some of these performances are characterized by the creation of intercultural harmony, but others provoke social friction, making visible the latent conflicts experienced by many marginalized youth. In Contact Inc.'s *Peace Initiative*, young Australians from many different cultural backgrounds created a widely acclaimed performance articulating their own views of peace, culture, conflict, and honor. In another public performance in Brisbane, young women in the *Sk8 Grrl Space* project created a multimedia skateboarding performance to bring to light the sexism that had constrained their access to a local park and undermined the agency of young women in the community. Their performance simultaneously reclaimed the space and made the intensity of their opposition apparent to all.

Addressing structural violence in the United States and Afghanistan, Jo Salas, cofounder of Playback Theatre, explores the ways in which participant performance projects transform marginalized people and narratives. Playback Theatre is designed to create respectful spaces in which audience members share their own stories and witness them enacted on the spot. In the United States, the No More Bullying! program uses Playback Theatre to transmit information and build empathy and empowerment, seeking to engage students' fullest selves in dealing with the complexities and challenges they meet in relating with their peers. Salas illuminates the principles of Playback Theatre with examples drawn from projects in several places including Angola, New Zealand, and Sri Lankan diaspora communities in the United States. She focuses in depth on the work of Hjalmar-Jorge Joffre-Eichhorn, a theatre director and transitional justice worker in Afghanistan. Joffre-Eichhorn's work seeks to

create ways for victims of violence to restore connectivity and identify more fully as participants in the wider community. Joffre-Eichhorn and other Playback Theatre practitioners grapple with a range of dilemmas, including balancing the need to address the pain suffered by participants against the ethical principle of avoiding re-traumatization.

John O'Neal analyzes the role of theatre in addressing racism in the United States in "Do You Smell Something Stinky?" One of the founders of the civil-rights era Free Southern Theater (FST), O'Neal is also the founder of Junebug Productions, a contemporary theatre company based on the philosophy that the conditions and circumstances hindering Black people in the United States are the same as those that limit oppressed people the world over. O'Neal describes his pioneering work with story circles, both in gathering material for performances and as a rich and empathetic way of exploring the human condition. His extensive work consistently explores the connections between art and social change; he argues that artistic integrity and critical engagement with social issues are both necessary factors in creating art that makes a difference. O'Neal also addresses the delicate challenge of transforming conflict within and among performers themselves as they deal with many forms of racism and other oppressive dynamics.

These chapters address many dilemmas in creating theatre performances with and for people from different backgrounds, people who have experienced marginalization and oppression. They grapple with a number of complexities. How can safe space be created in ways that respect differences and engage commonalities? How can collective identities be formed that also respect each person's uniqueness within his or her group? How can works be effected without further traumatizing participants? How can we confront unsettling questions/issues and yet maintain hope? In conflicts with contested histories, how can these narratives be voiced without inducing violence among the participants or audience members? In marginalized communities, how can the sustainability of performance projects be maintained or enhanced? How do performances avoid strengthening an "us against them" binary that exacerbates existing tensions? How do cooperative endeavors challenge, rather than preserve, inequities in power? How can restorative and economic justice be addressed while improving relationships between conflicting groups?

These case studies also demonstrate the strengths of the many common threads related to building bridges of shared understanding and bonds of unity to reaching across regional, national, ethnic, or cultural boundaries. Artists and performances make connections between art, communities, and the issues they are facing, engaging emotions, rationality, and paradox. Through creating avenues of self-expression, performance restores agency to people who have been stripped of their full participation in the larger community, empowering them to engage more fully with the complexities of structural violence.

These aesthetic performances go beyond the limitations of language, drawing on physicality, spirituality, and emotionality, creating spaces for developing trust among people who might not otherwise trust each other. Well-crafted performances are capable of containing strong emotions, opinions, and statements as public history is reconstructed in the creative time/space of performance, allowing both shared and divergent narratives to be expressed.

As evidenced in these case studies, performance can be both purposeful in addressing violence and reflective of refined aesthetic qualities. Indeed, conflict transformation requires both qualities of artfulness and socio-political effectiveness. Changes created in the transformative space of representation also extend beyond performances, building capacities for addressing other conflicts people face; facilitating new types of relationships across the boundaries of social conflict, inequality, and cultural difference; and enhancing capacities for addressing injustice, inequity, and exclusion.

Culmination of a Brandeis class in The Arts of Building Peace, where Kate Gardner led under-graduate and graduate students in exploring the practical and theoretical principles underlying the *BrooKenya!* Project. Photo by Fernanda Senatori, Courtesy of Community Theatre Internationale

1 Performing Cross-Cultural Conversations

Creating New Kinships through Community Theatre

Eugene van Erven[1] and Kate Gardner[2]

Let us first introduce ourselves: Eugene van Erven, research director of the Community Art Lab, and Kate Gardner, principal of WorldEnsemble. Eugene lives in Utrecht, Netherlands, where he grew up and now teaches in the theatre department of the local university. He is the author of *Community Theatre: Global Perspectives* and two other books that deal with political theatre in the West and in Asia. Kate lives in New York and is a communications consultant. In 2001, she founded the Community Theatre Internationale and began searching for like-minded colleagues. She discovered Eugene's book on community theatre, tracked him down, and accepted his invitation to meet in Rotterdam at the International Community Theatre Festival, for which he works. Both share a passion for community theatre and both had formative experiences revolving around this particular medium at early ages.

EUGENE: I was born in February 1955 in a small village in the Netherlands right on the Belgian border. A locally produced and created form of drama was popular in those days, pretty much all over the Dutch south. My uncle Harry was its driving force in my native village. My dad, being the only one who knew how to type, produced the scripts. My parents had met at one such performance, "Youth Resists," in 1949; it was about young people growing up under German occupation. My mother came to see her sister, Fran, who had a major role. My father sold the tickets at the door. I am sure that stories told by my relatives about this village theatre have somehow stuck with me on my worldwide search for people's theatre and the community-based theatre that emerged from it. People's theatre—also known as popular theatre—is essentially a theatre of progressive political messages created and performed by professionals (e.g., San Francisco Mime Troupe, Dario Fo)

for non-theatre audiences outside the mainstream, usually in working-class areas. Community-based theatre emerged when some of these same professional theatre makers discovered that the people they were performing for could perform much more powerfully themselves. When I discovered these two types of theatre, I put my research hooks into it and have never let go.[3]

KATE: I came of age in the Harrisburg Community Theatre (in Pennsylvania) during a time of violent American polarization over racism and the Vietnam War. As opposed to how it works in community-based theatre—which entails people developing content based on the stuff of their lives—our scripts were imported from Broadway. Nevertheless, I was struck by how—in the course of putting on a show—people from different backgrounds so easily built relationships across ethnic, political, and religious divides. Performing together seemed to give them the freedom to be other than what they were defined to be, allowing them to create an immediate sense of community that transcended social segregation. My decades as a community organizer and international activist have taught me that effective social change requires that people see themselves and each other in new ways. It involves transforming "what is" into "what is possible" and employs the same creative capacities we use when making art. Community-based theatre deeply manifests that creative capacity, which is innate to every human being, not just artists. It is a powerful tool for teaching people from all walks of life that they can transform their lives—painful and traumatic as they may be—into something moving, beautiful, comical, and spectacular.

Now, let us introduce you to two very different community-based theatre projects: *The Fathers' Project* and *BrooKenya!*

Part 1: *In the Name of the Fathers*

Eugene discusses a locally rooted theatre project in The Hague, the Netherlands. He was not directly involved as an artist, but was explicitly invited by the facilitating artist, Marlies Hautvast, to critically observe and document the project.[4]

Over the years, I have established many long-term national and international associations with artists in the field of participatory community art. Two of them are featured prominently in the text below: theatre director Marlies Hautvast and her husband, playwright Jos Bours. Back in 1977, in my hometown of Utrecht, they founded Stut Theatre, the oldest community-based company in the Netherlands. In 1997 I documented the year-long process of their cross-cultural production *Tears in the Rain*; afterwards, Bours and Hautvast asked me to join their board.[5] Following a politically motivated cut in the municipal arts budget, Hautvast quit the company in the fall of 2005 in order to ease financial pressure and make room for a younger

colleague, Donna Risa. Suddenly Hautvast found herself with enough time on her hands to accept theatre projects elsewhere in the country. Below, you will find my perspective on her first freelance undertaking, commissioned by the Father Centre, a grassroots facility in The Hague that aims to improve parenting skills of working-class and immigrant men.

The Fathers' Project started just before the summer of 2006, but did not gather full steam until the end of August of that same year. Essentially a play-development initiative based on personal narratives of fathers or father figures from many different ethnic backgrounds, the process entered an intensive rehearsal phase after November 2006, which lasted until the play officially premiered under the title *In the Name of the Fathers* on June 1, 2007. During this one-year period, a sophisticated inter- and intra-cultural dialogue formed the foundation for a unique collaboration between professional artists and artistically untrained participants, which I observed and documented on digital video. None of the latter group had ever acted in public before; in fact, most had never seen live theatre. Although I'd been corresponding with Hautvast about the project since its inception, I did not meet the participants until an early draft of the script was read to them in November 2006. I frequently attended rehearsals after that, up to and including the first try-out on May 11, 2007. I continued to monitor the project until its final performance on May 23, 2008.

The Context: Father Centre "Adam"

The immediate context of the play is the Laakkwartier neighborhood of The Hague, a problematic immigrant working-class community.[6] In 2004, the neighborhood's already tarnished image worsened when police raided a house there in which members of the "Hofstad" terrorist group were supposedly hiding. But the area also contains positive developments, such as Father Centre "Adam," which opened its doors in 2000.

"Adam" was the initiative of social worker Anita Schwab, who had facilitated the establishment of many so-called "mother centres" all over the country in the 1980s and 1990s and had written a manual about it.[7] When she launched this publication at the City Hall of The Hague in 1999, people asked her why no such facilities existed for fathers.[8] Intrigued by that question and funded by an interdenominational church organization, Schwab carried out a feasibility study and discovered, through street interviews, that there was indeed a great need for a place where men could meet and develop themselves. Schwab began by offering free courses in practical construction skills in an abandoned space donated by the city, which resulted essentially in the remodeling of that same building. This became the home of Father Centre Adam. Many of the men who were attracted to this initial construction work stayed on as volunteers. As Hautvast told Jos Bours in 2007:

> Unlike women, men do not explicitly seek help when they are in trouble. Our original idea was to cater to 50 men; now we have 2,500 men who regularly use the facility. One hundred and eight men are on the waiting list for swimming lessons. The average age of our visitors is 38, the youngest being 18 and the oldest 82. Eighty-one percent are of non-Dutch background, 21 percent are Turkish, 25 percent Moroccan, 19 percent from non-industrialized countries, 16 percent from Surinam. Half of them only have had primary school. Half of them have jobs. The men who come here have all had difficult lives. Many of them have been divorced or lost their jobs. These are breaking points for men. They can go downhill very quickly then: house gone, alcohol, sleeping in the car, job gone. It's really unbelievable what happens to men when their wives leave them.[9]

Faris, one of the men who uses Father Centre Adam, used to own a tailor workshop in Istanbul, but when it burned down in 1983, uninsured as he was, he left Turkey to try his luck in the Netherlands. There, he managed to earn an illegal living picking fruit and vegetables in greenhouses. His life has had many ups and downs since then, including a fifty-day hunger strike in 2002 to protest his undocumented status (about which Jos Bours wrote a play, *White Aliens*). In the Father Centre, Faris is given the chance to practice his craft, teach others, and thereby redeem some of his earlier professional pride. His odyssey has been incorporated into the play.

Father Centre Adam offers a variety of practical ten-week courses, including computing, languages, sewing (offered by Faris), fitness, cooking, cutting hair, anger management, child rearing, first aid, and carpentry (offered by Kris, a Hindustani-Surinamese who sang in the play and built its set). Schwab thinks that the theatre project took consciousness among the participants to a level that none of the other activities at the Centre could ever have achieved:

> The play has enabled participants to explicitly reflect on who their father is and what kind of father, or man, they themselves would like to be. That has been the common denominator across the different cultures and generations: what kind of man or father would I like to be? The play process has resulted in deeper reflection, also within the family settings of these men. There has been a lot of discussion in their homes, including about the consequences of saying all these delicate things on stage. It has resulted in greater openness in their families. Also the relationships between the men have changed.[10]

Process

In May 2006, Schwab announced the theatre project to those who frequent the Father Centre, and twenty men volunteered to be interviewed. Thirteen of them then agreed to act. They included three Dutch working-class men (Arjen, a retired tram conductor; George, a butcher on disability; and Willem, a truck driver); Nasr, a

Sudanese lawyer who has applied for asylum in the Netherlands; and men from Iraq (Taky, a medical doctor), Morocco (Sahir and Mr. Hilali, who was later replaced by Mr. Laziz), Turkey (Bilal, who is a paid staff member of the Father Centre, and Faris, the tailor), Turkish Kurdistan (Allatin and Osman), the Dutch Antilles (Hainly, from Curaçao), and Surinam (Hendrik and Kris). Sahir, the young Moroccan, and Allatin and Osman, the two Kurds, are not biological fathers, but, as eldest sons, they have fatherly responsibilities towards their siblings.

Before the summer of 2006, Hautvast made individual appointments with the men for in-depth interviews at their homes. She talked with them for hours about their childhood, their relationships to women and children, work, migration, and collisions with Dutch culture. These conversations yielded detailed life histories and self-reflections.

Two of the three Dutch men from The Hague share a history of witnessing sexual abuse against girls in their families. The two Kurds arrived in the Netherlands after a battered childhood and a difficult odyssey that found them illegally working in a number of European countries. During the play's creation and production they remained undocumented. The Sudanese lawyer is also a refugee and lives separated from his wife and young daughter, who are in France. The Turkish participants have witnessed the physical violence of parents against obstinate children, and fathers who do not know how to be loving toward their children. The Moroccan, Surinamese, and Antillean men have all lived through similar circumstances. The Iraqi participant was the only exception.

From thirty hours of interview material, Hautvast distilled exercises in which she asked the men to dramatically reconstruct key moments in their lives. These improvisations, which began in September and lasted well into October, were frequently quite confrontational. Most men were not familiar with the details of each other's lives before this period of intense intracultural dialogic interaction. Gradually the rehearsal room became a safe space, where prejudices were allowed to fly, or partially vanish when a cultural "other" suddenly recognized familiar patterns of behavior in someone else. Taboos were tackled in ways that Dutch public and domestic space do not yet allow; incest, male sexuality, and female circumcision were all openly discussed.

Here's a scene from the eventual play, which was based on the interview with George and an improvisation exercise that was distilled from it:

GEORGE: *(Staring straight ahead)* He cleaned ashbins.

HAINLY: Who?

GEORGE: My dad. In the old days when people still used coal to heat the houses. They were cleaned along with the garbage. He walked behind the garbage truck to clean the ashbins and put them back on their heads. Enormous hands he had to grab these ashbins with.

HAINLY: OK.

GEORGE: And he grabbed my sisters too . . .

(Silence. Hainly gets up slowly and looks at him in shock.)

GEORGE: But then I grabbed him!

(Looking at audience, as if talking to himself.)

GEORGE: I am 16. I have the old man by his throat. I work in the slaughterhouse so I have my knives within reach. I have the boning knife in my hand and nab him to the door. My mother jumps in.

(Looks at Hainly)

GEORGE: You get it? It is because my mother jumped in . . .

(Gathers his fishing gear and closes his bag.)

GEORGE: Look, that was my dad. I wish it were easy to store all that away and close it off. But nothing is what it appears. That day I signed on to become a sailor. I had to get out of there. Oh, we got the police to come, but a few hours later he was back at the kitchen table. They got away with it in the old days. And now I flee again, to the waterfront. It never goes away. Not for me, let alone for the girls.[11]

The father-son relationship provided the thematic platform for exploring differences and similarities among the participants, and the theatre process provided the vehicle. All the improvisations and subsequent discussions were recorded on video or audiotape and later transcribed to inform the playwright, Jos Bours. In addition Bours attended all the sessions and took notes about body language, idiosyncratic humor, facial expressions, pronunciation, and the like. As Marlies Hautvast said of the experience:

I could give you so many examples of what I wouldn't necessarily call prejudices but simply different ideas about life, which prompted the men to react quite strongly to each other. For instance, when an Iraqi man says that in his country men are boss and in Holland women are economically independent and therefore here men and women are both the boss, Dutch men respond that the everyday reality is not as simple as all that. And then a whole discussion ensues. The thing is, if you really become interested in each other's point of view, what once were ethnic clusters turn into individuals. It's no longer: "Oh those Antilleans, or those Moroccans," but "oh, that is typically Hainly, Osman, Nasr, or Hendrik." They become individual human beings, each with their own quirks.[12]

By the middle of October 2006, Bours was ready to collate and analyze all the transcripts from interviews, improvisations, and group discussions, which he read at least four times. He then locked himself into his office to compose a first draft of the script.

Scene Nineteen: It Is Their Honor

(Faris serves tea to George, Allatin, Osman, and Hainly in his workshop.)

GEORGE: Why do Turkish men always walk around in the bathhouse with a towel around their waist? They even keep that thing on when they take a shower! I don't get that.

FARIS: *(Laughs)* Oh, I understand that very well . . .

OSMAN: *(Seriously, to George)* What do you think it is?

GEORGE: What I think? They're ashamed. But for what?

HAINLY: Yeah, for what?

OSMAN: No. It's pride. For Turkish men it is very important how big they are.

HAINLY: How big they are?

ALLATIN: Is this really necessary?

(Allatin walks off to stage right.)

HAINLY: Oh, you mean . . .

(Hainly makes a gesture underneath his belly.)

OSMAN: Yep. That's where their pride resides. You see: that is very important for Turkish men. And if you're not big down there, then you don't want others to see it.

TAKY: . . . Look, the distance between the top of your middle finger to the point where your hand becomes your wrist, that is the measure. That's how you can tell how long a man's tail is.

(All the men measure themselves.)

HAINLY: I was once at a women's meeting. Someone said that women who have a big mouth also have a big. . . . And then I saw all the women do like this.

(Hainly presses his lips together and pushes them out to create a very small protruding mouth.)

GEORGE: With men you can also tell by how big their nose is, people say.

(They all turn to look at Osman, look at each other and shake their heads.)

TAKY: No. You can also tell by the size of men's feet.

(All men look at their feet. Willem enters. All men look at his enormous shoes and start laughing. Willem stops, looking at everybody.)

GEORGE: It's nothing bad, Willem. We're just a bit jealous of you, is all.

WILLEM: Jealous? Of what?

GEORGE: Of your shoes![13]

Respecting Difference

The idea for the "It Is Their Honor" scene was born relatively late in the process, in March 2007. It was prompted by a spontaneous question from George while the cast was rehearsing another scene. He openly wondered why Muslim men had become so prudish in comparison to the 1960s, when after the shift in the slaughterhouse where he worked the first generation of guest workers from Morocco and Turkey never thought twice about taking group showers in the nude together with Dutch colleagues. Nowadays, he noticed, they all shower with their underpants on. This started a heated conversation that playwright Jos Bours aesthetically condensed into scene nineteen. It reveals a level of openness about male sexuality that is seldom heard in the public domain in the Netherlands and is typical of the non-stereotypical, multi-layered, and differentiated "insider" portraits that Bours always seeks to construct of working-class Dutch and immigrants. Even for some in the cast, that openness was troubling; two of the younger Muslim men, a Kurd and a Moroccan, found scene nineteen so embarrassing that they never dared to invite their sisters to the show. But rather than cutting the scene altogether—which might have been the easy and politically correct thing to do—the artists and cast found another way to keep the material. The Moroccan man was not in the scene to begin with and the Kurdish "objector" was allowed to explicitly demonstrate his disagreement with this conversation on stage and walk away.

This deceptively light-hearted scene caused more tension within the group than another potentially much more explosive episode in which Bilal admits he is no longer a practicing Muslim. Bilal had volunteered this information in the initial interview with Hautvast before the summer of 2006. Partly because the issue of secularism among Muslims had suddenly become "hot" in the Dutch media, Bours had included it in the first version of the script.

> BILAL: *(Slowly turns around, to Faris)* I had a dream. I am twenty years old. I live in Turkey. I'm still in school. A beautiful girl comes from Europe to Turkey. I think: she must be modern because she lives in Europe. I fall in love with her. We correspond. We get married. I go to Holland. I tell her: I am not a Muslim. She doesn't like that. She's afraid of the neighbors, afraid of the other Turkish women. Other Turks tell me what I should and should not do. And my wife tells me the same.
>
> The first few years we're having a very hard time. I don't get any attention, feel no warmth. I have no family in Holland, no friends, no language. I feel cold.[14]

Until the first reading of the play, Bilal had been quite open about his secularism. Although there are several devout Muslims among the other participants, they had no difficulty accepting Bilal's position. But Bilal reminded them that because

of his secularism other visitors had stopped coming to the Father Centre, where he holds a paid staff function. He feared that the play might only make matters worse. For a few days in November 2006 he even contemplated pulling out of the project altogether, until—to his own surprise—his wife convinced him to go through with it. Bours also encouraged him to stay: "Religion tends to toughen people's positions. With this play we want to do the opposite. Soften things and open them up."[15]

In the Name of the Fathers further opens this window by showing Osman's silent submission to his father's physical coercions to pray[16] and Taky's proclamation that science and religion do not mix.[17] But it is nowhere so effective as in Bilal's disarming soliloquy, in which he reveals his many personal and relational struggles after coming to the Netherlands, which include his wife's objection to his secularism for fear of what the Turkish neighbors might say. The scene required him to extensively discuss the text at home with his wife and daughter, thereby expanding the play's intracultural dialogical process well into the domestic realm. After opening night he was more than relieved with his relatives' reaction:

> My wife said that it was terrific. And you know what was really strange? Almost all my in-laws were here tonight and you know what? They are proud of me. Really. And my father-in-law even told me just now, "I never knew you were having such a hard time back then. You almost made me weep."[18]

In an interview after the fact, Hautvast reconstructs the exploration of difference that fed into Bilal's soliloquy and how it relates to the controversial scene nineteen:

> At one moment Taky said: "I am a medical doctor; there is no way I can be religious." To which Nasr responded: "I don't agree." And each and every one of them then vented a different opinion about the subject, which Bilal subsequently made explicit in the play by saying that he is no longer a practicing Muslim. More than anything, that triggered the internal dialogue. In Bilal's case his thinking about this issue visibly evolved. First he was really apprehensive and even said at one point, "I'm not doing it!" George also reacted quite strongly by saying, "This is still a big taboo within your culture and only now some people are beginning to publicly discuss it." The astonishing thing was that no one had a problem with this kind of dialogue. And that is exactly why Willem objected to the idea of scrapping scene 19, because he argued that both subjects are taboo. In the end I said that I wanted to keep that scene as well, but also that if anyone had to say something that they really didn't feel comfortable saying that they shouldn't have to do that on stage. And I added that we should theatrically do something extra to clarify that this is a sensitive issue within our group. That's when we proposed for Allatin to say: "is this really necessary?" And then to walk out of the tea house setting to another position on the stage.[19]

Looking Back in June 2008

By May 23, 2008, *In the Name of the Fathers* has been performed close to twenty times. The public response, particularly from Laakkwartier residents and those who frequent the Father Centre, has been overwhelmingly positive. Scene nineteen invariably prompted widespread laughter from men as well as women, Muslim or otherwise. They apparently appreciated the differentiated cultural attitudes towards male sexuality. The emotional power of Bilal's dilemmas equally resonated in the auditorium, as did George's story about incest and Arjen's and Willem's painful tales about divorce, which they tell elsewhere in the play.

But obstacles continued cropping up until the very last performance. A little over a month before the premiere, continuing throat problems experienced by Hendrik, who was supposed to sing in the play, necessitated his replacement with another Hindustani-Surinamese singer, Kris, who initially had trouble coming up with the right melodies and the confidence to sing them in public, but who improved with every performance. Then, after the summer, Kris suddenly disappeared on an open-ended holiday to Surinam, and Hendrik was brought back in, until his doctor stopped him from performing further. Bours, sporting a turban, then had to replace him for the final performances. Conversely, Mr. Hilali unexpectedly showed up again a few weeks before opening night—after an unannounced absence in Morocco that lasted several months, and well after another older Moroccan man, Mr. Laziz, had already been worked in as a substitute. After delicate negotiations involving other Moroccan elders and a bit of matriarchal pressure from Anita Schwab, Mr. Hilali gracefully stepped aside and attended the premiere as an honorary visitor who was publicly thanked for his creative contributions to the play. He has attended several other performances since. But the cast also overcame much more painful problems, including the tragic death of Nasr's daughter in January 2007 and the deportation of Allatin in August 2007. He is now back in Turkey, where Hautvast and Bours visited him in the summer of 2008. In the meantime, Osman also felt coerced to leave the project, ostensibly pressured by fellow Kurds in the wake of the flared-up conflict in Turkey and northern Iraq.

In the course of *In the Name of the Fathers*, which lasts an hour and ten minutes, ten men sit on the floor at the foot of three high thrones—occupied by Laziz, Taky, and Kris (or Jos or Hendrik). Together, they create a temporary intra- and intercultural space. This is a theatricalized version of the Father Centre, which has been aesthetically fashioned to allow the more vulnerable dimensions of male sensibility to be revealed. It is the artistically condensed public manifestation of a series of sophisticated inter- and intracultural dialogues that would never have been possible with the same level of intensity and frankness without this theatre project.

In the course of a year, the thirteen men developed the strength to tackle very difficult subjects indeed. Thanks to the artistic process, they mustered the generosity to support each other through hard times in the theatre space and beyond, telling painful as well as funny stories. As a result, cross-cultural understanding among them has grown and relationships have strengthened. Nasr is better able to understand the openness with which his Dutch friend George talks about the incest in his parental home. George, in turn, is able to frankly express to Nasr his objection to female circumcision. Without exception, all the men in the play have experienced similar leaps across gaping cultural divides. The aesthetic and ethical quality of their dialogues clearly resonates in the auditorium and spill over into animated conversations after each performance. But undoubtedly the strongest impact of the play was felt by the thirteen actors and their immediate circle of friends and relatives. Or as Bilal put it in June 2007:

> These thirteen men come from seven different cultures. All the topics we address are different in all these cultures. Yes, we had lots of heavy discussions, but the process was always under control. It was necessary for us to get to know each other's strong and weak points and to be confronted with cultural differences. But it went beautifully. Now, after more than a year of working together, these thirteen men really know each other very well. They still have many cultural differences between them, but believe me, they have become very good friends.[20]

Yet by the end of May 2008, when I interviewed him again, Bilal's earlier optimism had dwindled considerably. He admitted to having grown tired of the project, although he continued to perform until the very end. While he still did not regret having participated, it had obviously become more and more difficult for him to speak in public about his personal life. More than his secularism, he found scene eight, where he criticizes his adolescent daughter, increasingly difficult to perform. He faults her for always asking for money and being disrespectful to him. "I am glad she never came to see the play," he sighed.[21] George and Willem, however, were as enthusiastic as ever and would have happily continued to perform for another year if they could have. They will have to wait for a new project of the Laakkwartier Neighborhood Theatre—a tangible, sustainable outcome of the project that is now an officially registered cultural organization.

In the aftermath of a controversial anti-Islam pamphlet/video *Fitna*, produced by the populist rightwing member of parliament Geert Wilders, the warning from Indian cultural theorist Rustom Bharucha that the most dangerous trap out there is "assuming the existence of inherently homogenized communities with fixed religious identities" has not lost any of its relevance.[22] Projects like *In the Name of the Fathers* heed Bharucha's call by working towards "coexistence through a respect for

difference within and beyond religion."[23] They don't negate difference in some kind of blurry melting pot notion of multicultural sameness, but respectfully engage it, tackling taboos and differences of class, sexuality, gender, ethnicity, religion, language, generation, and other subtle variations in subject position. Partly as a result of his involvement in this project, Sahir is not just another troubled loud-mouthed Moroccan immigrant, but a young man who is far from at-risk. He needs to negotiate many different realities. He studies while working a part-time job. His father is a poorly educated villager from the northern Atlas who came to the Netherlands as a guest worker while Sahir himself is on his way to becoming middle class. He feels more Dutch than Moroccan, speaks better Dutch than Berber, but has to pay respect to his father at home. And he adopts Dutch street codes when moving through public Dutch space. He also carries parental responsibility for his sister and brother. "The oldest son is a second father, the slave of the family," explains Nasr in the play as he compares Sahir's predicament to his own and extends it across the Arabic world, while sketching it in with his own distinct local Sudanese details. Nasr, too, had to take care of his siblings back home in Darfur while studying to become a lawyer in Khartoum. There, for a while, he was "someone." Now, as an undocumented asylum seeker in the Netherlands, he is a mere jobless "nobody" on welfare. These are two additional examples of how intracultural differentiation through performance works to create subtle self-portraits of "others." It turns "Muslim migrants" or other amorphous groups from one-dimensional objects within someone else's imagination into complex human subjects named Sahir, Nasr, Bilal, George, or Willem—active and creative citizens who speak, listen, and participate in artistic creations in which they represent themselves. They gain confidence from thus presenting themselves in public and learn that their stories matter.

A few thousand people eventually came to see the play, which received a fair amount of hype in The Hague. National and local media picked it up. The performances demonstrably succeeded in breaking down stereotypical notions of Muslim, Caribbean, and working-class men and caused a shift in public thinking, including among progressive women, about how men also needed to be included in emancipation processes. So strong was the play's impact, in fact, that an all-women jury selected the *In the Name of the Fathers* cast for the city's most prestigious emancipation award, The Kartini Prize. During the official ceremony on March 6, 2008, Arjen dedicated the award to Allatin, with a moving reference to his deportation. It was the first time ever that a male group received this honor.[24]

Part 2: *BrooKenya!*

In this section, Kate, who founded the BrooKenya! *project, provides a first-hand account of how she created community-based theatre with an international group of*

volunteer writers, actors, and filmmakers, many of whom never met one another in person.

BrooKenya! embodied the Community Theatre Internationale's vision of "creating community through performance across borders local and global." What do I mean by this? Our era of globalization presents us with dangers, along with opportunities to investigate an inclusive notion of community expanding beyond our age-old framework of "us" and "them" and to more fully realize our species' extraordinary capacity for cooperation. You might say we face the necessity of building new kinds of human relationships never before possible.

BrooKenya! was an experiment. Through a synthesis of old-fashioned theatre with new digital technologies of Internet and video, I wanted to bring together culturally and geographically disparate people in an effort to create an optimistic shift in the existing social arrangements—in my neighborhood in New York City, as well as in my home in the world. As it turned out, from 2002 to 2005, *BrooKenya!* brought together 150 people, from three cities on three continents, to create a grassroots global soap opera. Residents of New York, US; Kisumu, Kenya; and Lima, Peru, produced an ongoing story and a continuing community, touching tens of thousands of others around the world via simultaneous international events, a website, festivals, conferences, and public access television.

I launched the theatre ten days after 9/11 and immediately went in search of someone from another country who would join me on such an adventure. I found Kitche Magak, a Kenyan community development consultant, educator, and poet, at a conference on social theatre applications in New York. After nine months of e-mail correspondence and an intercontinental poetry jam on the Internet, he accepted my invitation to collaborate on what became *BrooKenya!* (Citizens from a shantytown in Lima, Peru, became involved late in the process after one of our collaborators went to work there and videotaped scenes telling their stories.)

When Kitche asked that we address the theme of HIV/AIDS, I quickly agreed. In 2002, up to 39 percent of the population of western Kenya was infected with the virus, but drugs were virtually unavailable.[25] Building a close relationship with a New York HIV/AIDS clinic, I learned that Brooklyn was the epicenter of the pandemic in the US. However, this difficult topic scared people away—no one in my neighborhood knew how to touch it. But at some point I realized that it fit perfectly within the genre of "soap opera"—the "universal" entertainment of our time. People couldn't resist the chance to make their own soap out of their own dramas—AIDS being just one—and suddenly I couldn't keep people away.

The creators of *BrooKenya!* came from many walks of life: from the streets of one of the world's busiest cities, the shores of Lake Victoria in East Africa, and a shantytown in Peru. The youngest was fourteen, the oldest seventy-two. Some had six-figure incomes; others lived on less than a dollar a day. A mix of race and ethnicity,

they shared no political or religious affiliation—just a desire to make something powerful out of their lives.

They wrote, acted, filmed, and funded one hundred scenes inspired by their lives and imaginations, including an interwoven plot between Brooklyn and Kisumu that gave the project its name. The fictional story they jointly created revolves around Pete Centrali, a young man of mixed race who is adopted and doesn't know the identity of his biological parents.

With input from Kitche and comments from some of our collaborators, I offer a glimpse into the *BrooKenya!* story—onscreen and off—and how a group of people thousands of miles apart became closer than they ever imagined.

Brooklyn Boys in Kenya

Uh-uh uh-uh
I can still feel the jam
I know who I am
I never even 'eard about no fuckin' Uncle Sam
Picture me walkin' in the land of Dahomey
Well-worn path laid out to guide me
I hear da rustle in da trees but I let it be

Onscreen, Duane Brown, graphic designer and aspiring writer, is playing Dante and rappin' Jamaica-style to his old college friend, Marlon Hunter, who plays Pete Centrali. The leafy green backdrop of Prospect Park would belie its location in urban Brooklyn were it not for the roar of jets flying in and out of nearby international airports. Marlon is pounding out a reggae beat.

It's January 2004, and I'm in Kenya showing this scene to fifty residents of Kisumu at the Abila Cultural Center. Kitche has persuaded these mostly unemployed young people that *BrooKenya!* might have something to offer them. So, they are here to check it—and me—out. After many months and several failed attempts to pull together a team of volunteers, Kitche had convinced me that some of our meager funds should be spent on bringing me to Kenya for one visit: "They have to see you, or they'll never believe it's real. And, they don't believe me when I tell them there's no money. You're American, so it just can't be true in their minds." He laughingly adds, "They think I've taken it all."[26]

We also have to counter the assumption that we're doing Participatory Educational Theatre (PET). Building on Kenya's long history of activist theatre, PET was developed to promote public health campaigns among the country's primarily rural population. With low literacy rates, little access to radio or television, and over fifty different languages, PET is a popular tool for Western-funded campaigns battling

Setting up a Brooklyn scene where Pete and Dante rap about their ancestors being taken as slaves out of Africa. Peter Marlon Hunter; Dante Duane Brown; Kate Gardner, director; and Theresa Brown, cinematographer. Photo by Ximena Warnaars, Courtesy of Community Theatre Internationale

chronic poverty, disease, and disempowerment—the HIV/AIDS pandemic being just one example. Many of those attending this first *BrooKenya!* screening in Kisumu belong to theatre groups that compete for whatever funds are available.

Most in the room are Luo, with a few Luyha, Kalenjin, Kikuyu, and other ethnicities. The Luos, the country's third largest group, dominate western Kenya. Since independence in 1963, they've been locked into being the political opposition. Violent protests against discrimination and poverty break out in the streets of Kisumu every few years, as they would do four years after my first visit, during the country-wide bloody protests following the December 2007 presidential elections.

DANTE: But I still need a hook. Pete, can you help me out with a hook?

PETE: Help you out? Maybe if I knew what you were talking about. Dahomey? Fon?

DANTE: That's Africa, son. Dahomey's a place in West Africa. Today it's called Benin, and Fon is one of the languages spoken there. A lot of our ancestors were taken out of there during slavery times.

PETE: Is that what your rap's about—your ancestors?

DANTE: Yeah, the way I imagined it would have been for one of them being taken out of Africa. It could easily be one of your peeps.

PETE: I don't think so.[27]

Why did I give so much money to *BrooKenya!*? One, I had complete faith in the person leading it. Two, *BrooKenya!* is not a measurable product—I'm a great believer in the reliability of human experience. Three, at the risk of sounding sentimental, *BrooKenya!* is about love. Putting that into a world where there are so many horrible things going on is who I want to be. —*Amy Samelson*

The scene is written by Donna Whiteman, born in Trinidad over forty years ago and raised in New York. Pete is based on one of her acquaintances. Similar to his real-life inspiration, the character of Pete is grappling with the confusion of being a young man of color raised by adoptive white parents during a time of deep racial polarization in New York City.

Like the other scenes I've brought with me from New York, this one bears little resemblance to the standard Hollywood exports featuring wealthy white characters. Our characters (and their makers) are mostly working- and middle-class people of color. None of us is a professional filmmaker. Still, *BrooKenya!* often manages to achieve a sophisticated layering of the artistic, social, cultural, and political.

Kitche and I have chosen a rather unusual way of bringing together our neighbors in Kisumu and Brooklyn. *BrooKenya!* has been called soap opera, theatre, film, cultural exchange, community building, and education-entertainment. It is perhaps all of these and more, and we do it by the seat of our pants. With Kitche's agreement, I've launched the project with no institutional support, just whatever the two of us and our friends can pull out of our pockets. I've raised US dollars for basic production equipment, small stipends for some of the production staff in each country, and food and travel in Kenya. Not having to meet the expectations of an outside bureaucracy gives us carte blanche to fully pursue our experimental vision.

The Kenyan Team Comes on Strong

MIDERMA: *(Throwing a book at her husband, Lela)* What is this? Who do you think you are?

LELA: *(Sees the letter inside the book)* Oh, no!

MIDERMA: Oh, yes!

LELA: Look honey . . .

MIDERMA: Don't you honey me! How could you do *this* to me?

LELA: I can explain everything.

MIDERMA: What is there to explain? It's all here—in the letter!

LELA: It's not what you think. It's a long story, but it ended years ago.

MIDERMA: Oh, yes, it's a long story that never ended. Huh! You men are all the same—liars and cheats! All this time I have trusted you . . . given you everything you needed. But all you give me is nothing, nothing but lies . . .[28]

"Cut!" yells Kitche, who is directing. The country's official languages are English and Swahili. But as many people in western Kenya don't speak Swahili and he wants to avoid aggravating ethnic tensions by using tribal languages, he chooses to do the Kenyan scenes primarily in English. Miderma, her face distorted with fury, instantly transforms back into amiable Christine Ombaka. Christine is a senior lecturer at Maseno University, an expert in health, culture, and gender, and now a community actress creating a boldly melodramatic character who will become the favorite of our audiences. Playing Miderma's professionally successful husband Lela is Jack Ogembo, owner of the house where we are filming. Jack is finishing his doctoral dissertation on traditional African healers. Doing wonders with our inexpensive video camera is Felix Otieno. Felix works professionally documenting NGO projects on video. All three are trusted colleagues and friends of Kitche, all lecturing at the university and working together on development projects.

Holding the mic is Caroline Ngesa, a student in computer science at Kisumu Polytechnic. She has just completed her scene as Kiku, Miderma and Lela's daughter. Earlier in the week I saw her in *Mis-educating Achieng*, a play by the Peer Educators Club, which she chairs; Caroline acted the part of a schoolgirl coerced into a sexual relationship with her much older male teacher. During my short visit, I read many such stories in the newspapers. Caroline will go on to write, act, edit, and produce some of *BrooKenya!*'s finest scenes—including a very powerful one in which her character is raped by a family friend who later dies of AIDS. She is developing as the group's most influential young leader.

The Kenyan cast and crew reflect the country's difficult economic situation. Most of the younger people, whether educated or not, are part of the urban poor—

The biggest challenge to *BrooKenya!* in Kenya was the environment of widespread poverty in which it operated. People came to it expecting to "make something little." But when they realized that there was very little or no material benefit, some of them drifted away. The majority of the people involved in the project here were young people who were unemployed. What I found unique is that those who ran away because there was nothing materially for them ended up drifting back because of the friendly and creative atmosphere for personal and group growth that *BrooKenya!* created. —*Caroline Ngesa*

scraping by on the occasional odd job. Some are orphans and solely responsible for their younger siblings. The older educated professionals came of age during better economic times and are loosely described as middle class. But with the economy in shambles after decades of corruption, they too are engaged in a perpetual struggle to make ends meet.

The rainy season is crashing against Jack's metal roof tonight, nearly drowning out the dialogue on the set. At any moment, the region's power grid could flood and leave everyone in complete darkness. It is hot and humid, but most of the windows are shut against malarial mosquitoes. Jack's daughter is in the kitchen pouring soda and preparing tea and coffee. Take twelve: Christine as Miderma shouts: "I feel so violated! Your family has been putting pressure on you to have a second wife to give you a son. But you knew you had a son with a white bitch in New York!"

A Group Mind Stretching Over 7,000 Miles

> *Dear Lela,*
>
> *I have read and re-read your letter so many times that I think I can almost conjure up the sound of your voice. You seem to have chosen your words very carefully, for they so poetically express your warmth and affection for me—and that leads me to remember you and our romance...*

Inspired by the Kisumu scene, Carol Morrison, social worker, budding artist, and my partner, reads aloud her draft of the letter that will spark Miderma's outburst. Sitting with her and me at our dining room table in Brooklyn: Donna Whiteman, a neighbor and financial analyst; her friend Theresa Brown, an independent film-maker and school secretary; and Ximena Warnaars, a cultural anthropologist whom Eugene introduced to me in the Netherlands. These four women and myself form the core of the *BrooKenya!* team in the States, for nearly two years meeting every Friday night at what becomes known as the Roundtable. Providing critical support behind the scenes are two other friends: Amy Samelson and Linnaea Tillett, who not only max out their own financial resources, but tap those of their families, friends, and colleagues too.

Scattered amid assorted snacks are drafts of scripts that have been written during the week. They've been circulated by e-mail for further revisions and have now arrived here for collective refinement. I listen, ask questions, and weigh in as a last resort, which isn't often. To get things on track when drama veers into stereotype, I depend on Donna, whose sensitivity to American race relations intertwines with the instincts of a writer. Carol, with the panache of a true iconoclast, makes sure our social messages are clinically sound. Ximena vigorously defends the project's community-based process as it bumps up against the constraints of filmmaking. From the corner of my eye, I watch Theresa, with her encyclopedic knowledge of

I was born in Trinidad and raised in Brooklyn. When Kate first told me about her vision of creating community using theatre, I was feeling marginalized and frightened by the climate in New York City. In 1999, four white police officers fired forty-one rounds into Amadou Diallo, an unarmed Black African immigrant. When they were all acquitted, it sent a wave of hopelessness through New York's immigrant communities of color like no other police brutality case. Her idea sounded like a positive alternative to my growing antagonism and the widening chasm between various groups in the city. The actualization of her vision has profound implications for the rigidly segregated communities that exist within our societies. We all worked together to produce a story that represents us. Imagine an "us" incorporating those living on the fringes of these societies. —*Donna Whiteman*

Hollywood movies and popular culture. If Theresa hadn't volunteered to shoot and edit our US scenes, *BrooKenya!* would have been an entirely different project.

On most Fridays, other members of the US team join in. There is much hilarity, but everyone is dead serious about creating engaging, authentic stories about their lives. Whether they live in the neighborhood or travel from miles away in cosmopolitan Manhattan or beyond, they arrive by what I can only describe as a fractal grapevine. Some meet us filming in the streets; others are recruited by coworkers, family, and friends. The opportunity to participate in a multicultural soap opera makes it easy for many to accept this invitation to cross barriers of social segregation and mistrust. The New York cast and crew is African Caribbean, African American, Puerto Rican, Italian American, and Jewish, gay and straight, middle-aged, youthful, and from the middle, working, and poor classes.

BrooKenya!'s evolving plotline linking Kenya and the States reflects a cooperative and spur-of-the-moment process. The project itself is an ongoing improvisation. Spontaneous, but never random, it uses lightweight structures such as those found in comedy improvisation, which are based on the creative act of figuring out how to agree rather than disagree. My posture was to say yes to whatever anyone offered and then build with it. I used games to teach people how to accept each other's ideas, add something new, and thus, piece-by-piece, make a collective story. So, when Carol writes the letter to Lela for her character Jaxx Aaron—the Jewish-Italian-Catholic owner of the corner bar in Brooklyn who brings chicken soup to her new employee, Pete Centrali—she is essentially saying "yes, and . . ." to her collaborators in Kenya, thousands of miles away.

> *. . . I also remember the last time I heard from you—also in a letter. The one announcing to me that you had returned to Kenya. I remember how many times I read and re-read that note too. So, forgive me, Lela, but I thought I had closed this chapter in my life twenty-five years ago, when you left.*

It still amazes me what we did—that we did it. It was hubris to think that we could connect these two places so far away. And that people could tell their stories through soap opera, of all things. And that people watching could relate to them as human beings—not just as issues—people could absorb feelings that seem so big and beyond them. I don't think you can measure this kind of thing. But I do know we did it again and again in workshops from Brooklyn Public Library to the International Community Theatre Festival in Rotterdam. —*Theresa Brown*

I have kept my relationship with you a private matter—telling no one, sometimes not even myself. I have put the memory of you and of the son that was born to us away. After you left, I gave the boy up for adoption.[29]

The Plots Thicken

(Two characters are sitting in the saturated colors of the high equatorial sun. Miderma is confiding in Jaber, one of Lela's sisters. Jaber, a professional musician and single mother, is the open-minded black sheep of the family.)

MIDERMA: Your mother and your family still want him to marry a second wife. Lela wants a son so desperately. I can see he's already given in to the pressure.

JABER: Our people are so crazy still about sons. They don't think girls are important. I don't know when this culture will change . . .

MIDERMA: . . . Nothing, nothing like marrying a second wife will happen! Not as long as I'm alive.

JABER: Ohhh, I like that. That's my girl, Middy.

MIDERMA: He will never marry a second wife. What with HIV/AIDS and all that? It's dangerous for him—for both of us.[30]

Rather than approaching AIDS as an abstract "issue," the soap opera allowed people to focus on the human relationships—how we love and don't love each other, which is the real story behind the pandemic. *BrooKenya!* showed personal and sexual relationships, and how the larger political relationships of gender, race, economics, sexual orientation, age, globalization, and war shape our most intimate moments.

A lot of people ask, "Why soap opera?" I've no quarrel with those who label American exports like *The Bold and the Beautiful* cultural imperialism. But, for better or worse, soap opera is *the* global entertainment form. Most people can speak its familiar language of domestic melodrama. I would suggest that putting soap opera and communications technology—two of the most ubiquitous tools of globaliza-

tion—into the hands of ordinary people allowed them to have a hand in shaping the process of globalization.

BrooKenya! may sound similar to the education-entertainment soaps that activists and NGOs produce in "developing" countries to promote behavioral change. Indeed, *BrooKenya!* scenes overflow with the drama of polygamy, racism, homophobia, sexual abuse, teen pregnancy, terrorism, you name it: Kiku's rape as a girl by a family friend who later dies of AIDS; American high school student Angelique's naive affair with an older man, resulting in her pregnancy; or Daniel's struggle to take care of his alcoholic mother traumatized by the terror of Peru's civil war. But our educational purpose wasn't to change this or that particular "bad behavior" or even present good behavioral models. Our purpose was to help people get to know each other, to see each other's different experiences *and* our shared humanity.

We also played against the stereotypical characters found in mass media. Just as the US scenes featured ordinary New Yorkers, most of whom were neither rich nor light-skinned, the Kenyan scenes showed ordinary Kisumuans who looked nothing like the images of Africans as victims so favored by Western media.

"When you see the young Kenyan characters, you see a depiction of both how they actually live and how they dream to live—all rolled into one," says Kitche. He explains:

> They were creating with their lives and having fun. In *BrooKenya!*, they weren't forced to play to any particular gallery, especially the Western philanthropists that are so frequently taken in by pitiable portraits of African poverty. Like the characters in *BrooKenya!*, these educated young people are very poor and—thanks to very cheap used clothing from the US and Europe—they also look like "they're doing okay." Their characters should be a good advertisement for assistance because they show that people here have resources that can be built on.[31]

We loved this project so much—it really touched us. There was very little conflict, not the usual squabbling and competition. Everyone wanted to participate and make it succeed. It was so unique. It connected us with each other here and with others in another country. To have our story seen by others—not just Kenyans! The scene between Miderma and Jaber is my favorite. It shows how we African women have to scheme—how women's power is plotting ahead of time to solve problems. If Miderma's husband marries a second wife, he will shift his love to her and break Miderma's heart, putting her in an unstable emotional situation. To keep the peace at home, she figures out a softer option. —*Christine Ombaka*

In Kisumu, Kenya, Kitche Magak directs the scene of Miderma's fury at husband Lela for his infidelity with a white woman in New York. Felix Otieno on camera and Caroline Ngesa on mic.
Photo by Kate Gardner, Courtesy of Community Theatre Internationale

BrooKenya! is also much more than a soap opera. Its many scenes are fragments of juxtaposed and layered narratives. Its makers and viewers—without thinking about it—understand the pattern of storytelling. When stories are generated by ordinary people—rather than Hollywood screenwriters—they seem to strike some kind of universal, yet culturally specific, chord. With our recognizable but unconventional choice of genre, we gently led people into the unknown territory of cross-cultural intimacy. Naming it a soap opera gave the project just enough structure and attracted a broad cross section of people who don't normally do this sort of thing or share a common culture. It offered a reasonably level playing field in a world of enormous inequity.

MIDERMA: I know what I'm going to do. It's a secret, and don't tell anybody. You see, Lela has a son already.

JABER: A son!

MIDERMA: A son with a white woman in New York. When I heard about that I was thoroughly devastated. But now it's a blessing in disguise. I'm going for the boy, Jabby. Then Lela will never marry another woman. That is my son![32]

BrooKenya! Live

For a year and half, scripts and videotapes have flown back and forth like migrating birds. We've held lively cyber chats on the trial of Michael Jackson, debates on polygamy, and how the American lesbian and gay characters will play in religiously conservative Kenya where homosexuality is illegal and taboo in most local cultures. We've held a simultaneous screening in Kisumu and Brooklyn. A hundred scenes of *BrooKenya!* have been completed. It's time for a party!

Saturday, November 20, 2004, at *BrooKenya! Live.* Four hundred people come together in three cities on three continents to celebrate and continue the creation of *BrooKenya!* We kick-off in a tent next to the Abila Cultural Center in Kisumu, Kenya, a time zone eight hours ahead of New York City and Lima. Kitche and his team cheerfully balance on the edge of chaos as droves of uninvited Kisumuans join the festivities. Kenya begins with speeches and live performances by young artists from local theatre companies—a piano concerto, a dance solo, traditional music, poetry, and mime. All are received with increasing enthusiasm.

Meanwhile, the US team and I greet New Yorkers as they gather at the International Center for Tolerance Education. Popcorn in hand we drink imported Kenyan Tusker beer, chat, and watch videos of *BrooKenya!* scenes.

These *BrooKenya!* scenes include late entries from Villa El Salvador, a shantytown in Lima, Peru. Having moved to Peru some months ago to continue her work with a local community theatre called Arena y Esteras, our collaborator Ximena Warnaars took a camera and a passion for *BrooKenya!* with her. Two days before *BrooKenya! Live,* she flew to New York carrying fourteen videotaped dramatic scenes of the lives of immigrants from the Andes—a resourceful but traumatized community still suffering the effects of the country's violent civil war. Now Ximena is sitting just a few feet from me in front of a webcam linked to our new partners in Lima. Americans and Peruvians wave and holler greetings to each other against a background of live traditional music playing in Lima.

Finally, everyone settles into their seats to see some scenes on the big screen: an age-old tale of love and betrayal takes on the intensity of its Kenyan actors, underscored by their swelling soundtrack of Celine Dion. Public school teacher Nicholas Lopez improvises a powerfully emotional scene in a Brooklyn clinic with a real-life HIV/AIDS counselor. A furious father drags his daughter out of her lover's arms in the streets of Villa El Salvador. The crowds cheer on all the passionate players, but especially their own.

Connecting these autonomous local dramas is the plot between the US and Kenya, which is now coming to a climax. On screen, Miderma has arrived in Brooklyn. She stands silently in front of the bar owned by Jaxx, the former lover of her husband and mother of his son. Miderma goes inside. With bartender Pete Centrali hovering nearby, she confronts Jaxx, telling her she is her former Kenyan lover's wife and that she has come for the son Jaxx gave up for adoption twenty-five years earlier. (This was the very first scene we ever filmed—it was spontaneously written and shot during a fortuitous trip by Christine to a New York conference one year earlier.) Jaxx, stunned and anguished, doesn't know where her son is: "I don't even know his name." Softening, Miderma whispers, "I do. His name is Pete, Pete Centrali." The audience gasps, then hoots and hollers. Pete runs off distraught, and Jaxx is speechless. But ever-intrepid Miderma tracks him down and insists on adding herself to his list of mothers. As Pete quiets in the face of her firm resolve, Miderma hands him a plane ticket, telling him to "come home to Kenya."

The lights go up. In Kisumu, it is past midnight, but it will take hours to disperse the crowd that continues to demand reruns. Text messages continue to fly between Kisumu and Brooklyn. In the States, the audience is invited to help shoot a scene for a future episode—a farewell party that Pete's friends and families are throwing to send him off to Kenya to visit his father, Lela. Prompted by a live scene of Pete and Dante rappin' about Africa and the US, the room explodes into a rollicking bash. Rubbing elbows are white middle-aged professionals, Black and Latino teenage boys from inner-city neighborhoods, and twenty-something lesbians of color, just to name a few. Video teams record people pretending to be Pete's friends or sending good wishes to Kenya and Peru. In rhythm to the music, teenage peer educators from a local agency gaily pitch free condoms and safe sex. What a demonstration that cross-cultural *communitas* is indeed possible.

Epilogue

BrooKenya! was created with an estimated 1,500 people who attended live events, workshops, or screenings in the three participating countries, as well as in Mexico, the Netherlands, and Canada. Over 20,000 visited *BrooKenya!*'s streaming video website, and the project was featured on New York's public access television and in *The New York Times*. The complex web of conversations and connections that both created *BrooKenya!* and were created by it continue to ripple and echo.

Most dramatic is the impact these friendships had during the post-election violence that swept Kenya in early 2008. On New Year's Eve, with a few phone calls and e-mails, I raised over $4,000 in cash from the *BrooKenya!* network to help Kitche Magak get safely back home from New York, where he was visiting. Once Kitche got to Kisumu and secured his family, he and a close colleague (who had participated in *BrooKenya!)* took the leftover money and—risking their own lives—went out into the

countryside to buy food and have it secretly cooked. Undercover and with the help of the police, they delivered it to Kikuyu refugees fleeing Luo violence—feeding the starving in police stations as they waited for safe transport out of the area. Americans supported their Kenyan Luo friends to save lives a month before international aid agencies arrived in Kisumu.

BrooKenya! lives on in other ways as well. With the violence ended and reconciliation efforts underway, Kitche launched a pioneering program to train teachers in how to use participatory art-making methodologies in the classroom. This is the first phase of the Dunia Moja Centre for Education and Social Change, which was inspired by *BrooKenya!* Two of the performers in Kenya parlayed the skills they learned as volunteers into coveted jobs in the NGO sector. One of the New York performers credits his *BrooKenya!* experience with giving him the confidence to become a high-profile activist on behalf of people living with AIDS and other disenfranchised New Yorkers.

BrooKenya! was not made in the heat of war, or even in its aftermath. I do not know how such a process might work in these situations. However, as Kitche puts it:

> With *BrooKenya!*, people came to realize that, no matter how great or small, they each have a contribution to make towards building an all-inclusive community. *BrooKenya!* created an avenue for intense social interaction where people appreciated and built with their differences. In its making, divisive issues such as culture (tribe) and class took a backseat.[33]

With the tensions and inequities of a rapidly globalizing world, it seems important to cultivate, wherever possible, places like *BrooKenya!*—places without familiar borders, perhaps no borders at all, but palpable as any country yet invented.

Part 3: Thoughts on Theory and Practice

In parts 1 and 2, we showed how artists are collaborating with ordinary people to create stages on which to make theatre in diverse ways and forms. In the process, they are collectively constructing new kinds of relationships across boundaries of social conflict, inequality, and culture. Both projects exemplify the growing need in our globalized society for us to learn how to interact with those different from ourselves.

We'd also like to share some of our ideas on theory as it relates to community theatre efforts, and on community theatre as it relates to peacebuilding and coexistence. Over the years we've mulled over these issues by phone, e-mail, and in person. We've distilled our thoughts below into various themes, trying to keep a bit of the push and pull of our discussions.

Processes of Community Art-Making and Peacebuilding— "Simplicity on the Other Side of Complexity"[34]

KATE: Reading John Paul Lederach's book *The Moral Imagination* was like meeting a kindred spirit. He identifies four simple essences of the complex process of peacebuilding, all of which he says require imagination—relationship, paradoxical curiosity, creativity, and risk.[35] How apt this feels to community-based theatre.

EUGENE: *BrooKenya!* and *Fathers* are both good examples of moral imagination at work. Maybe they operate in places that are less spectacular than the war zones Lederach refers to, but they contain the same four ingredients. The projects contributed explicitly to imagining oneself as a substantially different "other." The participants learned to see themselves as part of a "historic and ever evolving web," as Lederach terms it. The art in both our cases "rises from human experience and gives meaning and expression to that experience." And curiosity was also a primary engine in both our projects. Finally, they clearly provided spaces for the creative act to emerge.

KATE: In both projects, the diversity of players was seen as a desirable force of creative energy, not a problem to be solved. Rather than trying to control participants by imposing rules of "political correctness," the professional artist-leaders cultivated the group's capacity to "self-organize"—i.e., to successfully transform perceived weaknesses into visible strengths. As Lederach points out, our power lies in the web of relationships that underlie all human discourse, which we can enhance with the right bit of structure. By helping to create conditions conducive to the artistic process, project leaders unleashed talents and enhanced the quality of the group's relationships and interactions—assisting them in creating a vibrant micro-ecosystem.

Through the web of connections, small changes in any organism can generate big effects. For better or worse, interactions among a few people can produce changes that cascade and multiply throughout the system. You could see this in the rapid spread of post-election violence in Kenya in early 2008. You could also see it in the creative friendships built during *BrooKenya!*, which—years later—were activated and expanded to save lives.

Cross-Cultural Dialogue and Development

KATE: I see myself less as a theatre director and more as a facilitator of "performatory dialogues." The language of communal art-making allows people to hold in one hand contradictory viewpoints and feelings, rather than locking people into dualistic adversarial debates or superficial reconciliations.

In studying encounters in which dialogue was attempted between opposing groups in Israel—between religious and secular Jews and between Jews and Pales-

tinians—the sociologist Z. D. Gurevitch came up with the concept of the "power of not understanding."[36] He makes the case that if we go directly to trying to understand people whom we don't understand, we will end up simply fitting them into our existing dehumanizing framework—precluding the development of the new understandings necessary for a more productive coexistence. First, he says, we must use our capacity to "not understand. . . the ability to recognize and behold the other (or [our] self) as an other. . . a moment of 'making strange.'"[37] It's only then that we can bring in our capacity to understand at a much deeper and more effective level.

I think community theatre allows people to safely "make strange" with each other—to engage in the kind of paradoxical interactions that both Gurevitch and Lederach believe are necessary to build tolerant relationships among people who have very different ways of thinking and seeing.

EUGENE: The process in The Hague that led to the creation and performance of a play about fatherhood could be regarded as an aesthetically structured dialogue between very different individuals.

The Fathers' Project loosened the tongues of the participants in ways that other activities of the Father Centre do not. Professional and sensitive artist-facilitators gently coaxed men from different generations and social and cultural backgrounds—men who've never learned to share their feelings with other males—to open themselves up to their peers. Not that the voices of the thirteen men were necessarily in harmony, mind you. American art critic Grant Kester quotes Jürgen Habermas to explain how the language of individual participants in community-based art is often far from united: "This egalitarian interaction cultivates a sense of 'solidarity' among coparticipants. As a result, they become 'intimately linked in an inter-subjectively shared form of life.' While there is no guarantee that these interactions will result in a consensus, we nonetheless endow them with a provisional authority that influences us toward mutual understanding and reconciliation."[38]

So community-based art projects like ours constructively and creatively explore difference, which may contribute to a stronger, more sustainable kind of social cohesion than the simplistic version of multiculturalism, which keeps homogenized groups of others safely in their place.

KATE: Both these projects were psychologically developmental. Participants and audiences learned to do some new kinds of things—not only in terms of creating drama. They created new capacity for coexistence, for compassion—which demonstrably extended beyond their own ethnic, racial, or national group to the so-called "other."

EUGENE: I think it is important to note that neither *BrooKenya!* nor *Fathers* was intended to be instrumental [in the sense of art as an explicit instrument for social change]. Undoubtedly, these projects had the side effect of enhancing cross-cultural kinship.

KATE: Exactly my point. I'm proposing that the power of these projects from a coexistence perspective is in their tangential "side effects." Indeed, they were *not* instrumental in their methods. The instigators of these projects weren't trying to change people's behavior. We weren't teaching people that it's "better if we all get along" or how to do that, etc. Rather, we invited people to join with us in a creative process. As with any group of artists (professional and amateur alike), we didn't know exactly what the project would turn out to be or how we would do it. But to achieve our artistic aims, we had to collectively produce a creative environment— i.e., the creative relationships that would allow us to make art together.

This is akin to the developmental learning of very young children, which is not the instrumental pedagogy of school learning. It is essentially creative. As older teens and adults, we are rarely supported to engage in developmental learning— learning that requires us to grow, not just to apply what we've previously learned. It's only recently that scientists have come to see that adults can indeed develop and learn new things.

EUGENE: It seems you are suggesting that we view these projects through a psychological frame, which to me sounds limiting.

KATE: I think we can find helpful insight here from Lev Vygotsky, a Soviet psychologist in the 1920s and 1930s whose dialectical theories challenge the dominant modern scientific understanding of human development.

Vygotsky didn't look at the child as a discrete entity. He believed that a child's cognitive development is a function of human communities and collaborative problem solving, which he called the Zone of Proximal Development (ZPD). In lay terms, the ZPD is where young children learn the collective knowledge of a particular culture through social interaction. It's what we pick up along the way as we relate with adults and older children—long before we undertake formulistic schooling.[39]

Vygotsky saw imagination and play as critical features in the developmental process at any age. He also asserted that creative imagination is necessary for effective social functioning, as it gives one the ability to abstract oneself from the concrete situation so as to figure out creative ways to change it.[40]

BrooKenya! could be viewed as a ZPD in which a diverse grouping of people with varying expertise were creating a collective notion of community as continuously created and broadly inclusive—rather than pre-existing and exclusionary. *BrooKenya!* was an experiment. Kitche and I didn't know how far it would go.

EUGENE: Arjen, the retired tram driver, formulates it very eloquently when he says that "through the play people learn that immigrants are also normal human beings with normal stories to tell, just like Dutch people. And when it comes to human emotions, there is not so much difference between cultures. The reason why you are hurt may differ, but the emotions and how you deal with them is quite similar for everyone."[41] Arjen and the other twelve men discovered this in the margins of

making a play together, in the process of rehearsing for a performance, which was their unifying aim.

KATE: Community theatre employs the developmental learning activity of performing. Through "pretend play" that is intimately connected to "real" lives, people in these projects developed new relationship skills in a way very similar to how young children do. Decreasing prejudice was both a tool and a result. It was a necessary tool for the making of these projects and it was also a result of that making, and so forth.

Within this framework, performance is not merely an aesthetic activity; it also represents the inborn human ability to perform (as young children do) beyond what we already know. I believe it is this capacity that we must tap into if we are to develop more peaceful and productive ways of living together. And community-based theatre can offer the opportunity for this performance—both on and off stage.

EUGENE: Grant Kester draws on the work of the Russian literary theorist Bakhtin and the Lithuanian-French philosopher Levinas to explain this process. They both describe the development of a cross-cultural sensitivity through dialogical interaction. Kester cannot quite make up his mind whether in these two thinkers this openness to dialogue is ultimately a selfish or a selfless act, but he is quite sure that community-art processes bring about a "reciprocal, rather than a sacrificial, view of intersubjectivity [which is] essential to a dialogical aesthetic."[42] In other words, community art, when done right, is beneficial for all participants, who contribute something to others and get something back in return. The real art of *BrooKenya!* and *In the Name of the Fathers* occurred in these mutually beneficial, "reciprocal" spontaneous inter- and intracultural conversations on the sideline of the rehearsals, script writing, and filming.

KATE: I witnessed an intracultural process among New Yorkers during *BrooKenya!* It was fascinating to see this facilitated by the long distance *inter*cultural dialogue. When Miderma confronts her husband Lela about the illegitimate son he had with a "white bitch from New York"—it was a bit shocking and very politically incorrect. When we showed the scene to New York audiences, who came from all racial backgrounds, they loved it! There was something about an African Black woman saying it that gave us the room to take it all in and laugh together about what we know people are often thinking but don't dare say to each other because of potentially explosive consequences.

We created a safe space in which Miderma's angry statement was not divisive but actually helped bring people closer together. You could see often-painful experiences being transformed into new possibilities through the collective storytelling process.

EUGENE: I imagine that certain things that might be perfectly normal to talk about in Brooklyn might not be so easy in Kisumu or in Lima.

KATE: Indeed. The Americans featured openly lesbian and gay characters and themes, which would have been very difficult for the Kenyans to do given the legal

and cultural prohibitions there. Showing these scenes gave them a bit of room to acknowledge that, in fact, there are gay people in Kenya despite suppression.

EUGENE: So in that sense you were negotiating the intercultural across local, national, and even continental borders. In Holland everything happened within that one space, within that one neighborhood, across multiple cultural differences but also in between cultures, and intraculturally between fathers and sons, husband and wives, Turk and Turk, Turk and Kurdish, middle-class intellectual Sudanese and working-class Moroccan.

KATE: One border I barely touched in *BrooKenya!* was that between the grass-roots and institutional and government power—as most of our funds were from private sources. How did Anita Schwab and Marlies Hautvaust negotiate the double-edged sword of government funding? How did they manage to both fulfill the requirements of the government and maintain the integrity of their relation-ship with the men?

EUGENE: Grant Kester talks about this tension when he points out that profes-sional artists involved in community-based projects may unwittingly become the instruments of someone else's political agenda.[43]

Anita and Marlies each have one foot in the grassroots and another in the official system. They are employed by municipal social services and also receive funding from non-governmental sources. They were, however, robust enough to carve out space to carry out the project on their own terms. They created the safe space that is indispensable for generating the trust from the men with whom they worked. Rooted in that trust, Marlies could become the necessarily stern director as opening night approached, firmly telling these grown men—including those from cultures where women have no official power—what to do. Although the artistic and budgetary decision making remained in the hands of Marlies and Anita—who aren't marginal and vulnerable—the voices of the participants were always clearly present. They even possessed veto power.

Aesthetics and Assessment

EUGENE: Conventional commentators tend to dismiss community art as "failed art,"[44] or to regard it as valuable only in terms of social intervention, not in terms of aesthetics.[45]

Kester calls for a fundamental change in art criticism. From the Enlightenment through modernism and postmodernism, traditional criticism has favored *objects*—produced by *individual,* divinely inspired artists—whose true excellence can only be determined by highly qualified scholars capable of placing a work in a long ar-tistic and philosophical tradition. When considering participatory community art projects like ours through such a unifocal lens, one fails to appreciate the complex

collective processes that precede a production and the dialogical interactions that form the very essence of this context-sensitive way of creating art.

KATE: My explicit aesthetic vision for *BrooKenya!* was to build community through performance across borders local and global. The theatre making and community building were inseparable—one did not "cause" the other. Viewing it separately through the lens of art criticism or social science would miss its essential value.

EUGENE: In this vein, Rustom Bharucha also believes "there is a great need to differentiate between the collaborative dimensions of community art and the more bourgeois readings of art in terms of autonomy and individual talent."[46] He alludes to the aesthetic components that make up authenticity and that render community performers more powerful and credible to the intended community audience than any professionally trained actor.

This kind of theatre requires that we communicate with our audiences via cultural particulars. A recent arts funding application by Stut Theatre in Utrecht specifies several of these, including: linguistic particulars—neighborhood-specific

The *BrooKenya!* cast and crew conducted workshops like this one at the Brooklyn Public Library where cast member Rosemary Salinger gives a leg up to an improvised scene. In addition to local events, the core team shared their scenes and creative process at festivals and conferences in California, the Netherlands, and Mexico. Photo by Felicia Reyes, Courtesy of Community Theatre Internationale

slang, the poetry of street language in older working-class neighborhoods, and the language of older and younger immigrants, which in turn influences a new cross-cultural urban language; physical particulars—e.g., the gestures and body language of people who earn a living with their hands; existential attitude—vis-à-vis those who are perceived to have more status; self-deprecating popular humor; and specific cultural codes and traditions of multicultural working-class environments.

All of these aesthetic elements are deposited into the bodies of the shows' participants. Their intrinsic power is mobilized through theatre to communicate with local audiences, who may in turn easily recognize these attitudes and decipher the cultural codes—in ways that an outsider may not. The effectiveness with which a professional artist involved in these projects manages to do that may be a crucial new aesthetic criterion with which to judge their work. Because it also can be done badly.

KATE: As we move through globalization, art-making that is integrated with the small acts of daily life may be extremely relevant. Evolutionary biologist and anthropologist David Sloan Wilson suggests that art making may have developed in response to the need of early human groupings to "coordinate many different activities." For example, music in hunter-gatherer societies appears to play a critical role in synchronizing the group's emotions, motivations, and actions. Wilson goes on to say, "a general feeling of unity is not enough"; rather, specific "forms linked to specific social contexts approach the complexity inherent in the [group's] 'physiology.'"[47]

Evaluating *BrooKenya!* in these terms might entail looking at the intrinsic relationship between the group's artistic process and the cross-border coordination and innovation it developed. This multimodal synchronization was later implemented in an act of species survival.

EUGENE: So, we can see how assessing this kind of work is no small task. At a basic level, professional artists involved in community performance need to be competent writers, directors, designers, or videographers. But in order to create multi-layered, rich, and subtle authentic plays, they also need to be excellent interviewers and highly sensitive, reliable social partners attuned to the socio-psychological dimensions and cultural circumstances of their actors. That is why I insist that the artistic quality of community performance can only be determined on the basis of meticulous documentation of processes. We also need to assess the quality of the experience for all stakeholders, as well as the ethical quality with which the project has been facilitated. This may come as close as we can to an overall validation of projects like the ones discussed in this chapter.

KATE: Communication scholar Arvind Singhal used Paulo Freire's pedagogical approach of "handing over the tools of knowledge production" to evaluate a grassroots education-entertainment project in the Peruvian Amazon.[48] He gave pencils, markers, and cameras to participants so that they themselves could illustrate how

they had changed in the course of the project. This method avoids a primary problem with measuring, which is that it distorts the very thing it is measuring.

EUGENE: Certainly, Lederach opposes it in peacebuilding, in favor of "art and soul" approaches that cannot be objectively measured.

François Matarasso statistically documented the social impact of participation in the arts extensively in Britain, but he has now also moved on from an evidence-based approach to what he calls a knowledge-based approach.[49] With that he means making all stakeholders understand the processes involved in this kind of art-making. In my view, polls and questionnaires fall short of illustrating how participants are affected by their active involvement in these projects. That's why I favor meticulous documentation of community-art processes. Although a one-on-one relation between an arts project and improved coexistence in a larger community (let alone an entire nation or the world) is impossible to assess, I think analyzing the process gives us useful information—"knowledge"—for future projects.

We also have to be careful not to overstate our claims. In *The Fathers' Project*, Bilal is clearly not one hundred percent positive about his experience, and the solidarity of the group apparently was not sufficient to keep Osman on board. Then again, the group also stays in touch with Allatin after his deportation. That would never have happened without this play.

At a more philosophical level, I tend to agree with Matarasso, who points to an essential link between community-based arts and peacebuilding and reconciliation:

> Participation in the arts is a guarantor of other human rights because the first thing that is taken away from vulnerable, unpopular or minority groups is the right to self-expression. If people have the right to participate in the cultural life of their society, they can represent themselves as their own active subjects, as they see themselves. If they do not, they become the objects of others' representations and interpretations. The removal of German Jews from the cultural life of the Nazi state was a prerequisite of their persecution: when they could not represent themselves, the state propaganda machinery had a free rein in presenting them as it wished.[50]

KATE: This can also look like "cultural genocide." I saw an interview of the Dalai Lama in which he—not surprisingly—expressed this concern. A Nobel Peace Prize winner, he is also deeply aware of how necessary seemingly tangential and frivolous cultural activities are to building peace amidst longstanding hostilities. When asked about the Middle East, he replied:

> There's too much emotion, too much negative emotion. This should be cooled down, reduced. Forget these things, I think, for the time being. I think more festivals, more picnics! Let them forget these difficulties, these emotions, and make personal friends—then start to talk about these serious matters.[51]

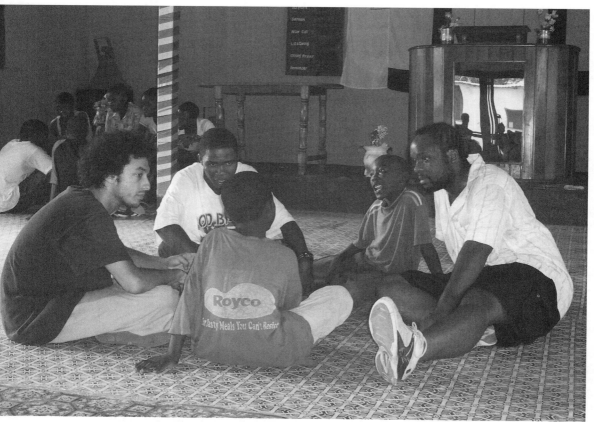

New York University students and Hip Hop Theatre Initiative members Wade Allain-Marcus and Archie Ekong leading workshop with RESPECT Ghana participants in Buduburam Refugee Camp, Ghana. Photo by Daniel Banks

2 Youth Leading Youth

Hip Hop and Hiplife Theatre in Ghana and South Africa

Daniel Banks[1]

Welcome to the Cipher

Imagine yourself in a tight circle of people, backs to the world, a soundscape of rhythm, rapping, riffing, dancing, and poetry lifting and soaring from your midst. Knees bouncing, heads bobbing, fingers snapping. Each member steps forward and "spits," dances, or sings something, supported by the community and the ensemble of sound and movement.[2] Each member has the opportunity to express her or his own creativity and, then, to be a nurturer and supporter of the next person's expression of self. It is an equalizing and freeing event. This is the cipher—one of the central experiential moments in Hip Hop culture.

Nigerian playwright, theorist, and Nobel Prize winner Wole Soyinka describes theatre's highest and most vital potential as a "symbolic arena for metaphysical contests" where the "stage is brought into being by a communal presence" and becomes the "affective, rational, and intuitive milieu of the total communal experience."[3] In the cipher, people lose themselves in the delirium of sound and in the act of improvisation that releases the mind and body. In the supportive, creative love offered in this circle, they also find themselves—they find their voices, recount their life experiences to each other, and make sense of the world around them. This is Victor Turner's notion of "communitas": "the liberation of human capacities of cognition, affect, volition, creativity, etc., from the normative constraints incumbent upon occupying a sequence of social statuses."[4] This is performance as community building and community healing.

I have stood in ciphers from New York to Johannesburg. In Buduburam, the former UNHCR refugee camp outside Accra, Ghana, I heard young Liberian refugees create the sung refrains (aka, "hooks"), "Liberian brother, Liberian sister, let's come together and find a better future" and "We are all one people, no matter where we come from, no matter where we are." In the East Rand, a poor community outside Johannesburg, a group of women chanted, "I am the Mic," signifying ownership of their own voices and power. The cipher is a space of empowerment and, when functioning well, healthy competition. It is a collective happening where people demonstrate and practice their skills, as well as a place to enact self-definition and theorize one's own existence in the presence of community.

In this chapter, I am going to "mix" various voices and experiences in recounting my journey towards developing a methodology for using Hip Hop Theatre as a path towards youth empowerment, leadership training, and community building. To begin with, for newcomers to the culture, I will offer some important background information on Hip Hop culture and Hip Hop Theatre. Then other voices will enter, layer, and carry the narrative.[5]

Welcome to the cipher. Welcome to the world of Hip Hop as a vehicle for peacebuilding and social and economic change.

Back in the Day . . .

> Hip hop didn't start as a career move but as a way of announcing
> one's existence to the world. —Nelson George, *Hip Hop America*[6]

There are many Hip Hops. In the early to mid-1970s, large numbers of young people around the United States began to use music, movement, poetry, visual arts, and other performance forms to carve out a presence for themselves in geographic areas that were cutting youth, cultural, and social services.[7] The West and South Bronx of New York City, in many narratives considered the home of Hip Hop, was especially hard hit. With gang violence rife and few alternative activities for young people, the community members now mainly credited as being the founders of Hip Hop created opportunities for youth to gather and dance, rap, DJ, and write (one of the Hip Hop terms for aerosol art). In 1973, Afrika Bambaataa, a former Black Spade gang member, founded the Universal Zulu Nation to provide young men and women a safe space to "battle," using creative and artistic means rather than physical weapons. As Nelson George reports, the Zulu Nation was (and still is), "a collective of DJ's, breakers, graffiti artists, and homeboys that filled the fraternal role gangs play in urban culture while de-emphasizing crime and fighting."[8] Hip Hop culture, therefore, began as an agent of peace and coexistence.

Thirty-five years later, this core ethos of Hip Hop is manifest worldwide: a 2007 *New York Times* article, "In Marseille, Rap Helps Keep the Peace,"[9] discusses the role of Hip Hop in peacemaking in Marseille, France, during that year's riots; Ishmael Beah in *A Long Way Gone*, his memoir recounting experiences as a child soldier in Sierra Leone, describes a harrowing moment where rapping along to a cassette tape of the group Naughty by Nature literally saved his life.[10] Later, at a re-absorption center, he wrote and performed "a short Hip Hop play about the redemption of a former child soldier."[11] And the film *Democracy in Dakar* (2007) shows the role Hip Hop played in the 2000 elections in Senegal and in national political commentary surrounding the 2007 elections.

At the same time that Afrika Bambaataa founded the Zulu Nation, DJs such as Grandmaster Flash and Kool Herc created outdoor parties where young people had the opportunity to release and express themselves via the performance practices now commonly known as "the elements" of Hip Hop (or, as KRS-One—the founder of the activist group the Temple of Hip Hop and known as the "Teacher" in Hip Hop culture—calls them, the "refinitions"). These are:

DJing/Turntablism
Emceeing/Rapping
Dancing (known as B-boying/B-girling)
Writing/Aerosol Art
Human Beatboxing[12]

KRS-One (whose name is an acronym of "Knowledge Rules Supreme over Nearly Everyone") also includes in his list of refinitions: Street Fashion, Street Entrepreneurialism, Street Knowledge, and Street Language. These are crucial in considering the making and producing of theatre, as well as the other Hip Hop arts.

In the past thirty-five years, these forms have developed and morphed, embracing, re-shaping, and driving technology (such as the development of CD-turntables and computer programs for scratching, a DJ technique invented on LP turntables). Rap, one of the fundamental elements of Hip Hop culture and performance, was invented as DJing grew more complex. It became difficult for DJs to spin, cut, scratch, and be on the mic at the same time, so they enlisted Emcees (MCs) to get the crowd excited and, in the case of DJ battles, attract party goers to one side of the basketball court or recreation room or the other. Emceeing then became its own genre of improvisatory solo rap performance. Soon after, rappers developed their own craft through writing and reciting lyrics over composed beats, and their popularity and skill made them ripe for the kind of exploitation that has become a global industry.

Thus, for many people, "Hip Hop" is synonymous with commercial Rap music. This association obscures the fact that Hip Hop is and always has been much more.

It is currently a global, multiethnic, grassroots culture and justice movement committed to social change and empowerment. KRS-One reports in *Ruminations*, his book on Hip Hop culture:

> On May 16, 2001 (at the United Nations headquarters in New York) 300 Hiphop members, along with government officials and a variety of ministers, philosophers, and students, gathered at the Delegates Dining Room for the revealing and signing of the Hiphop Declaration of Peace … presenting Hiphop Kulture as a unified, self-governing community of peace and prosperity.[13]

The commercialization of the Rap recording industry and what is often called Hip Hop music do not do justice to the politically conscious forms of self-expression and activism happening around the world in Hip Hop's name. As KRS-One explains, "Rap is something you do; Hip Hop is something you live."[14] He also makes a crucial distinction, "Sometime around 1990, Hip Hop the culture became Hip Hop the product."[15] Hip Hop, at its core, is a way of life for hundreds of thousands of young people across the globe and has its own set of values, rituals, and commitments that are oftentimes in direct opposition to capitalism and the Rap record industry.[16] The activists in Hip Hop culture work hard to expose the role of capitalism in polluting urban environments with product placement and the exploitation of young consumers.[17]

Another misperception perpetuated by the commercial world of Rap music is that Hip Hop is an explicitly or predominantly African American culture. While this is most frequently true of the artists who are chosen by the commercial record industry to represent the genre (and, hence, in the commercial sphere, the culture, itself), Hip Hop began as a more diverse, inclusive gathering space. The South Bronx was—and still is—to use Robert Farris Thompson's phrase, "a multicultural happening."[18] While the founding DJs of Hip Hop were, in fact, of Caribbean and Caribbean American origins, many of the early aerosol artists and dancers were Latina/o.[19] There were also some European Americans and folks of mixed heritage who came into the scene and helped bridge the uptown/downtown divide, bringing Hip Hop into a more "mainstream" sphere and transforming it into an industry.[20] As KRS-One states, clearly sampling Martin Luther King and echoing his egalitarian ethos:

> Hiphoppas are judged by the *content of their character* and skill, not by the color of their skin, their choice of religion, or social status. Since the early days of our cultural existence, our moral pillars have been peace, love, unity, and happiness. And such virtues have been expressed throughout Hiphop's history in a variety of ways even though many editors, program directors, and radio Deejays continue to ignore the existence of such virtues and artists within Hiphop Kulture.[21]

This is crucial information to remember and foreground because it reveals that, at its core, the ethics of Hip Hop are inclusion, cooperation, collaboration, and community—not the separatist politics of previous revolutionary movements in the US and certainly not the exclusionary and psychological manipulation that the record industry uses to make Rap music so appealing to specific consumer demographics. This marketing glorifies a "thug" life, both to young Black men who are taught to emulate the industry stars and by selling a "cool pose" to youth from various other communities.[22]

Praxis

There is an inherent connection between the performance elements of Hip Hop and Hip Hop Theatre and the politics of these performances. As mentioned above, the very origins of Hip Hop culture lie in using its performance elements to: 1) teach underserved populations of youth an alternative to street violence; 2) develop skills with which these youth can express themselves, giving them a voice and a sense of empowerment; 3) establish a context of community building and positive peer inter-actions; and 4) create a leadership environment that provides a societal infrastructure where one had previously been missing or eroded by oppressive, dominant social forces and structures (such as redlining, police harassment, institutional racism in schools, and adultism).[23]

Hip Hop Theatre is, thus, the creation of theatre out of all the performance elements around which much of Hip Hop culture revolves: e.g., rap, poetry, DJing, beatboxing, and dance. Hip Hop Theatre organizes these forms so that, rather than using an improvisational structure involving perhaps only one of these forms in a concert or "battle" setting, these performance practices are combined and integrated with theatrical conventions.

Hip Hop Theatre is both current and connected to the aesthetics and politics of previous movements and genres. Its content and form are uniquely Hip Hop, and yet the integration of poetic diction, music, movement, and visual composition—i.e., "total theatre"—was initially created by a generation of theatre artists raised on (or around) the staged dramatic poetry of Ntozake Shange (known as "choreopoems") and the Black Arts Movement's revolutionary dramas of the 1960s and 1970s. Examples of Hip Hop Theatre vary: from Hip Hop Theatre Junction's *Rhyme Deferred*, a re-telling of the Cain and Abel story through the lens and performance practices of Hip Hop culture, using all the "elements" as storytelling devices; to *Flow*, Will Power's virtuosic one-man show in which he plays multiple characters, speaking over a nearly constant interactive set by DJ Reborn, changing rhythms and moods with Reborn as a sort of drummer accompanying him; to Chadwick Boseman and

Ben Snyder's evocative youth-centered Hip Hop landscapes as the backdrop for their social dramas. Boseman's play *Deep Azure* is written entirely in verse and relies on multiple cultural frames, as it stands with one foot self-consciously in Shakespeare and the other in the history of African *Djelia* or *Orature*, the storytelling traditions of West Africa that embody the history of a people through poetry, song, movement/ gesture, proverb, riddle, and other conventions of live performance. Many Hip Hop Theatre pieces invoke the legacy of the *Djeli*, the oral artist, using the full range of body, voice, and rhythm to tell contemporary tales of epic and cultural importance. Finally, some excellent Hip Hop Theatre pieces do not use text as their motivating force but dance, as in Rennie Harris's *Rome and Jewels*, or sound, such as *From Tel Aviv to Ramallah* by Rachel Havrelock, in which Yuri Lane's human beatbox sound-scapes are performed simultaneously to Sharif Ezzat's VJ'ed visual images.

In short, Hip Hop Theatre is the "theatre of now," in that it interweaves the most cutting-edge of popular culture and art practices with the political concerns of today's youth. It is, at its best, the perfect amalgam of the virtuosity of Hip Hop skills, the concerns and values of Hip Hop culture, and the alchemy that makes the theatre a dynamic, communal, and vital space.[24]

This is a journey . . .

In 2006, I traveled with ten students and alumni from the Department of Under-graduate Drama, Tisch School of the Arts, New York University, to Ghana. There we met with students from the University of Ghana, Legon, and with two students from other US colleges. Together we spent four months working on projects under the umbrella of the NYU-in-Ghana program and the Hip Hop Theatre Initiative (HHTI). I then traveled to South Africa on a program funded by the US State De-partment where I spent six weeks, primarily working at the Market Theatre in Johan-nesburg, while also leading workshops in townships near Johannesburg and Cape Town.[25] During this nearly six-month journey, I encountered many artists committed to using Hip Hop as a tool for social change. One example is Rush Hour, a group of young dancers in the so-called "Coloured" township of Atlantis outside Cape Town. In a document to raise funds for their travel to perform at Hip Hop International in Los Angeles in 2006, they explain:[26]

> Currently Hip Hop suffers from some negative connotations, yet Rush Hour hopes to transcend the "battle"-culture and focus on their main passion of training and entertaining others, showing the positive side of the culture. They take pride in being a clean-living, fun-loving yet respectful and disciplined unit, and will set this reputation as a standard for all future endeavors.[27]

Over the pages that follow, the reader will meet other groups and individuals who, like Rush Hour, use Hip Hop as a tool for youth empowerment and social change. These individuals, as with other Hip Hop activists, consciously struggle against the images of violence and misogyny that the record industry propagates through albums, videos, and the marketing of its stars.

One of the great powers of Hip Hop and Hip Hop Theatre is their ability to transcend national-cultural boundaries and unite people under the umbrella of the Hip Hop Nation. This planetary Hip Hop culture has a relationship-building potential through cultural memory, shared political frustrations, and a communal archive of musical, historical, and counter-hegemonic influences. Time and again I have experienced Hip Hop heads, upon entering a room, immediately recognizing each other and being able to work together. For example, at the end of every Hip

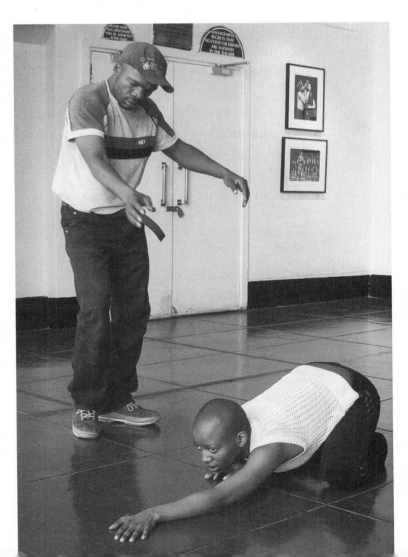

Moshe Maboe and Xoliswa Hlophe participating in Hip Hop Theatre Lab at the Market Theatre, Johannesburg, South Africa.
Photo by Daniel Banks

Hop Theatre workshop I facilitated in South Africa, participants acknowledged that they came from "rival crews" and that they never imagined talking to each other, let alone working together. However, when assembled in a creative space, these artist-activists let down walls of separation and found common and fertile ground for collaboration and art-making. This is the import of Hip Hop as a culture of resistance to dominant power structures, degradation, and oppression; and it is all the more inspiring that it continues to thrive despite the commercial market's attempts to co-opt and defuse its revolutionary power.

The Bass Line

Every "truth" I represent here could easily be contradicted. Jeff Chang writes a similar sentiment in *Can't Stop, Won't Stop*, his brilliantly researched history of Hip Hop culture: "It's but one version . . . There are many more versions to be heard. May they all be."[28] This is an important, heuristic point—not a footnote or disclaimer. Consider the cipher, as described at the beginning of the chapter. Standing in the cipher, a person might experience, among other things:

- That many truths can occupy the same space peacefully (or not peacefully, but certainly powerfully);

- That contradictions can co-exist and do not need to be resolved;

- That discord can be harmonious, while harmony can sometimes be deceptive and lacking efficacy;

- And that a person can be an individual and part of a collective simultaneously— in fact, to be a strong individual requires the presence and attention of the collective and to be a strong member of the collective means being able to maintain one's own rhythm, beat, or focus.

Many people of the Hip Hop generations have multiple heritages and histories running through their veins. So this is embodied knowledge—it starts with our DNA, combined with life experiences. Our very presence reveals the fissures and failures of modern language to include our realities in its social-scientific vocabulary—in other words, the inability of others to identify us as we are or would like to identify ourselves. Hip Hop provides a space for this process of self-definition, creatively and collectively—so much so that many Hip Hop artists and citizens take on names of their own choice.

Hip Hop is, therefore, a space where everyone is allowed her or his own truth— and Hip Hop knows that two individuals' truths do not need to be the same for them to live, create, and work well together. This is the kind of nation Hip Hoppers have created for ourselves, especially when it is not available within the political and physical borders where we live.

Hip Hop and Hiplife Theatre in Ghana

> The Youth of Ghana have found their voice—Hiplife. It is time for the world
> to listen! —From the documentary *Homegrown: Hiplife in Ghana* (2008)[29]

> This a whole movement, you know. They talk different, they got they own slang. The
> way they dress, you know. But what Hiplife don't have... They haven't developed
> their own culture. Everything is a bi-product of Hip Hop. I mean probably straight
> up imitating. But Hip Hop is fly. So there's nothing wrong with that. You understand
> me? I know a lot of my friends from out-up-top, when they come, they like, "Well you
> know, he only hittin' up the African"; and I'm like, "What is African? Hip Hop is Afri-
> can!" Matter fact that blueprint—that very art form—that you talkin' about is from
> Africa. You see what I'm sayin'? And it's your own brothers and sisters so they—they
> the foundation, you know what I'm sayin'? The way y'all talk. Everything. —Interview
> with *Reggie Rockstone*, Ghanaian Hip Hop icon and creator of the term "Hiplife"[30]

When we arrived in Accra, Ghana, in early 2006, US rap artists—especially 50
Cent and Tupac Shakur—were so popular they could be heard fairly constantly on
radios and boom boxes. Some local rap groups emulated the dress and posture of
their commercial US counterparts, putting forth an "American" image and rhym-
ing in English, often called Ghanaian Hip Hop; other rap artists rapped predomi-
nantly in local languages, such as Twi or Fanti.

In the mid-1990s, Reggie Rockstone, a Ghanaian-born rap artist who had been
living in London for fifteen years, coined the term Hiplife to point to the uniqueness
of Ghanaian rap artists rhyming in local languages, thus riffing off the "traditional"
Ghanaian cultural form called "Highlife":[31]

> I was in London.... I was in a group called PLZ and... we went on tour with the
> Jungle Brothers... And in the changing room, I overheard one of the members of
> the Jungle Brothers talking about coming to Africa and how there was a movement
> called "Panafest." So when I heard "Panafest" now I was like, "Where? What part of
> Africa are you going?" And he said Ghana. I said, "That's where I'm from." So I tried
> to be there 'cause for me this was like a big movement with a group like the Jungle
> Brothers coming home to my country... So I spoke to my father, copped two tickets,
> and me and my partner Freddie Funkstone... we came home. I hadn't been home
> for maybe 15 years. I mean, I was out, you know, totally disconnected. And to my
> surprise, Hip Hop was here. I mean, all the kids, they knew about Leaders of the
> New School, right down to Busta Rhymes, and they knew all the songs. And when
> we went to the clubs, that's the music they was dancing to. And they would make
> up words for chorus lines we didn't understand... And then, of course, the words
> "bitch," "nigga" was being thrown around like crazy. I mean, it still is. But back then,
> it was like, they didn't know. It's like, if they see you on TV talkin' it and then they'll
> put their pants [down] right here, with the bandanas, the whole shit. But at the same

time, before they get home, they pull their pants up, take their bandanas off, put it in their pocket. So it was safe, you know?

So, of course, with my Pan-African side of things, I decided to stay in Ghana. But then, what do I do now? I need to find—I didn't go to school. I mean, in Africa, either you're a doctor or you know . . . So I decided to rhyme in Twi. Which my mother taught me. So I wrote, I remember I wrote "Cho Bway." Call and response. "Yay." Very easy chorus line. And I wrote 16. And put the chorus line after 16. And then repeated the lyrics again. Plus I was new to it. I couldn't write. I could write in English, but to write in Twi. . . The language is such that you need—you know, like if you do English, "hat, bat, cat," you could just talk shit. With Twi, you need to make some sense and the language itself is poetic. I don't know how to explain it, but you say anything deep and it comes off sounding deeper. They [the listener] could find three ways of reading into what you said. . .

So every time I had an audience, I would do the English. . . And then when I do the Twi, they go crazy. So okay, we got something here. . . So we started building, doing shows, ciphers, whatever. And now, of course, we had a lot of kids from out of town. All sorts of ex-pats. So they all from Hip Hop . . . so it was more English Hip Hop with just me standing out with that one Twi 16 verse. That's how this shit started. So the kids started picking up and then, of course, great minds think alike. I got word from Germany, there's another kid called . . . I can't remember his name. But he was doing something similar. So I got his tape and it was weak. So I knew that I was the founder—I knew. I knew that was my shit, so I held onto that. And then it was still Hip Hop, Hip Hop. So my father's the one that suggested . . . "Reg, why don't you name it something else?" So I thought about it and, of course, all the feedback and all the stick I was getting, "You're bringing foreign music home, why you don't do traditional, da, da, da, da, da." So I said, "Look man, lemme grab the 'life' from Highlife and the 'hip' from Hip Hop, put it together—hip life." Highlife, Hiplife. Sounds smooth and it go down real easy. So we started throwing it around. Hiplife. Oh yeah, Hiplife, Hiplife. Highlife, Hiplife. Boom. Revolution right there . . .

You gotta understand, before, Africans had a complex about being African when they're outside. Ghanaians, because it was colonized by the British, they still got that funny loop [gesture: in the head]. So sometimes, they will refuse to speak their language in public and shit like that. It's the whole class system and Hiplife broke all of that shit down. So now you be at a party in New York and cats just be proud to show their I.D, you know. They're reppin' flags and Hiplife has really changed shit. And, also, put food on a lot of kids' tables. Kids are feeding their families and getting to travel—exposure. I mean sometimes I think—or I believe—that without Hiplife, you would've probably had a different crime rate here. For real. If some of these kids that I know from Nima [a poor neighborhood in Accra]—they some serious hot heads and I know that if they wasn't rhyming or . . . keeping busy,

they're probably robbing y'all. I know. And, for me, it's really sad that the govern-ment hasn't recognized it properly and [said], "Look man, what's going on here?"[32]

Prior to our arrival there was at least one instance of the term Hip Hop The-atre being used in Ghana. Kobena Sam, a choreographer with his own company, The Dance Factory, created a show called *Hip Hop Theatre* in 2003. This perfor-mance piece was a collaboration between dancers and rappers that fused contem-porary Hip Hop dance with traditional Ghanaian styles of dance, while focusing on the pressing topics of HIV and AIDS prevention, teen pregnancy, and poverty.

According to Korkor Amarteifio, then director of programming for the National Theatre who invited Sam and his company to create the piece, *Hip Hop Theatre* was enormously successful, bringing a younger audience to the National Theatre for a performance that reflected their taste and interests. It generated two outreach pro-grams, "AIDS Is Real" and "Living with AIDS":

> The Theatre at that time [1994-2004] laid a lot of emphasis on children and youth-related programming and had three children and youth residence groups. The Dance Factory, in particular, traveled around the nation with dance theatre on HIV/AIDS and, wherever they went, incorporated district-specific stories into the show through interaction with the public.
>
> Hip Hop Theatre was not known at all in Ghana at that time and, in fact, Hiplife, as we called it, was frowned upon as youthful gibberish by the intellectuals, who felt that it would not last. I heard about Hip Hop Theatre at a seminar at NJPAC [New Jersey Performing Arts Center] and was quite impressed and convinced that, consid-ering how crazy the kids here are about Hiplife, this might just be the medium that we needed for edu-tainment [entertainment that educates].
>
> The Dance Factory got hooked onto the idea and, together with Hiplife artists, created a piece that showcased how the kids feel about this devastating illness [HIV and AIDS]. This was the highlight of Kiddafest 2003 and traveled to schools thereaf-ter to rave audiences. From the reactions of the kids, we realized that this had more impact than just the dance theatre and it seemed like kids remembered the message longer.
>
> I left the National Theatre soon after this. . . There was nobody to move Hip Hop Theatre forward and it has been quiet on that front. I understand from Kobi that he is still interested in HHT [Hip Hop Theatre] and so am I. It is innovative, speaks to the youth, and, in terms of peacebuilding and coexistence (for example, regarding the fights in Northern Ghana), I think it is a great medium for it. The Goethe Institute in Accra is very interested in Hiplife and seems to be interested in the Dance Factory, and we will propose this to them. I believe that HHT has the potential to become quite big in Ghana, but it needs the time to be developed and for bigger audiences to see it.[33]

Such was the landscape of Hiplife and Hip Hop Theatre when we arrived in 2006.

I taught two courses at the University of Ghana that each met once per week for fourteen weeks. One was an academic course, studying the histories of Hip Hop and Hiplife and examining international Hip Hop Theatre performances. The other was a practicum that had two stages: 1) students explored making Hip Hop Theatre using a devised theatre process—meaning creating theatre from the ground up, starting with a set of skills and common thematic interests rather than a script; and 2) students considered and practiced how to teach this work to others, as well as how to facilitate dialogue about the issues raised by the work.

It was always my intention to move beyond the classroom, putting the pedagogical work into practice through community engagement, during which students would facilitate workshops and classes geared towards self-expression and self-empowerment. Within several weeks of arriving in Ghana, I visited Buduburam, a United Nations High Commission for Refugees (UNHCR) camp that has since been decommissioned (many former residents must now pay rent and still live on the land because, although the UN has deemed it safe to return to Liberia, this has not actually proven to be the case for all people). Buduburam was twenty-five square miles and housed over 55,000 refugees. Originally set up in 1990 for refugees displaced by the violence of the Liberian Civil War, other refugees from other parts of Africa later settled in the camp: according to RESPECT Ghana, 65 percent were from Liberia, 15 percent from Sierra Leone, 4 percent from Togo, and 6 percent from Ivory Coast.[34] The camp members lived in overcrowded, basic structures mostly of their own construction, as do residents still inhabiting the camp area. There is no running water and only minimal electricity—in essence, a large shanty city. According to camp residents I met and worked with, when refugees arrived at the camp, they needed to find or build their own accommodations with no official help; the only help came from any family members, kinfolk, or friends they may have found there. Buduburam is twenty-seven miles west of Accra and, with traffic and road conditions, takes up to two hours to reach by private transportation and much longer by public transport.

On the day we first visited, we were met at the head of camp by Jenkins Macedo, a volunteer for RESPECT Ghana, "a non-profit organization specifically working to create positive change through linking refugee students with non-refugee students in Canada, the United States, Europe, and far East Asia."[35] Macedo describes Buduburam:

> The Buduburam Refugee Camp was established on the 19th October, 1990, upon agreement between the Government of Ghana and chiefs of the Gomoa District,

Central Region on one hand and the United Nations High Commission for Refugees (UNHCR-Ghana) and her implementing partners, on the other hand. . . The camp is one of the most talked about refugee camps in Africa because of its residents' ability to develop beyond their situation as refugees in establishing educational institutions, churches and mosques, initiating micro-businesses, developing grassroots organizations to create awareness of refugees issues, implementing community service projects to meet specific targeted goals, as well as creating awareness in meeting the United Nations Millennium Development Goals.[36]

There was a strong survival spirit in Buduburam, as Macedo describes, despite the challenges the residents faced. Except for money sent to residents from family members abroad, there were virtually no opportunities for those living in the camp to earn money and pay for necessities or school tuitions. As a result of sheer ingenuity, there were two libraries in the camp, stocked out of donations solicited by volunteer librarians. There were over forty-five schools on the campgrounds and one school, Dominion Christian Academy (DOMICA), of which Macedo was a faculty member, was just off the campgrounds and was funded and staffed through persistence and international fundraising alone.[37]

Macedo took several of us from NYU to DOMICA and we were met, among other people, by the sports and drama coach, Randolph Banks. Struck by our shared surname, Banks asked if my students and I could help them with a drama project that had lain dormant since some volunteers had returned to Europe. We committed to helping them complete an HIV/AIDS awareness and prevention piece in our remaining time in Ghana (approximately seven weeks), meeting every Monday to work with the Drama Club.

Macedo then asked us to lead Hip Hop Theatre workshops in the camp through RESPECT Ghana. We were already working on another project with the Children's Christian Storehouse, an after-school arts program in Accra, so I was concerned with questions of feasibility, including adequate time for preparation and research, and the sustainability of the work after we left. However, another New Yorker that I knew through theatre and activism circuits was, at that time, living in the camp. She was working with a child welfare organization and agreed to participate in the workshops and to continue facilitating them after our departure. We designed a program where we would come to Buduburam on six successive Fridays and work with three teenagers from ten individual schools in the camp, with different participants attending each week (plus members of our Monday workshop from DOMICA). The NYU and University of Ghana (UG) students immediately dove into researching the camp, Liberia, and the political situation of refugees, and we held briefings on the two-hour drive to and from camp as we circled Accra to pick up all the student-facilitators.

We received funding to pay for writing materials, snacks, and space rental for the sessions, which were held in the Church of Christ in Zone 8, a striking blue building standing brightly out of the rain-damaged dirt roads of the camp.[38]

Macedo describes his rationale for setting up the workshop at Buduburam:

> The main objective of the workshop was to develop a group of young people that could serve as mentors of other youth in the event of training and producing shows locally... Most of the students who went through the program weren't from the same school and, as such, didn't know much about each other originally. Very few of them knew each other before we started the program. Those who previously knew each other were quick to start the process of getting to know others, reinforcing the identity games and fun that we introduced to get everybody into the program and gradually to be together. After the program, the friendships and relationships amongst those students became so close until most of them met weekly. As a result, whatever became a problem for one person was generally handled by the entire group to gain the person's confidence in the group.[39]

Since the core ethos of our work is to foreground young people and model youth empowerment, the college students mainly led these workshops. I was there on an as-needed basis and would side-coach them occasionally through teachable moments. Depending on who was taking the lead on a given week, the NYU/UG crew based the progression of the workshop on the methodology that had been developed at NYU and that was unfolding at UG at the time. The workshop generally consisted of:

- Warm-ups, where both the participants and the facilitators would suggest and lead theatre games, songs, children's rhymes, word and rhythm exercises, calls and responses, raps, and tongue-twisters;

- A basic beatboxing workshop;

- An improvisational exercise to create character out of sound and physical posture;

- A sharing circle, where youth discussed what was present for them at the moment—either challenges or joys;

- Time for individual writing based on what was shared;

- An opportunity to share this writing in the cipher;

- Small group time to take some of the writing and create mini-compositions as an ensemble;

- Final check-in and closing with an *ashé* circle (see below for description).

Significant to this process was that, as Macedo describes above, most of these youth did not know each other—they went to separate schools, lived on different

sides of the camp, and often came from different cultural or ethnic groups. Nevertheless, they were united in the camp experience—both in terms of the poverty and family challenges, as well as the isolation of being refugees and outcasts within Ghanaian society. Much of the writing and composition had to do with envisioning a better future and with unity as Liberians and across one human "race" (see, for example, the sung hooks cited earlier).

We left time at the end of each session for a cipher where people could add their own verses to these hooks improvisationally or read their own writing. We generally closed out the session either with one of these hooks or with a crescendoing circle chant of *ashé* (pronounced "ah-shay"), the Yoruban word that, similar to "amen" or "let it be so," suggests that the actual saying of the word enacts the performative power of the desire —that it "is so" by the saying/sealing of *ashé*. This ritual of using *ashé* as an energy builder and completion exercise was introduced to the HHTI work a few years earlier by a Nigerian American NYU student, Archie Ekong, who studied with the Ghana program and helped lead the workshops.

At the end of the workshop series, we used our remaining funds to rent the Liberian Dance Troupe's rehearsal hall at the head of camp so that the students from DOMICA could show the piece they had been working on and participants from the Hip Hop Theatre workshops could perform their work. We also invited local musicians and artists to perform. We were warned that, since the event would begin around dusk, we should have a back-up generator in place just in case. As soon as we began the community arts celebration, the electricity did, in fact, cut out. We then discovered that, although we had ordered fuel, it had not yet arrived. So, during the thirty-minute wait in the dark, everyone who had a cell phone held it up to light the stage. Fortunately, a cipher can also happen in the dark. While we were waiting for the fuel to arrive or the lights to come back on (both of which magically happened simultaneously), a gorgeous, polyphonic cipher took place onstage. It was the perfect first act in the final showing of our work in Buduburam. The show did eventually happen; but the cipher in the dark created a safe, ritualistic space that paved the way for the audience to experience fully the creative power of these young artist-activists and other members of their community.

Impact—Buduburam

Macedo explains the significance of this project in Buduburam at the time:

> During the implementation of the program, the student participants were more involved, because they were part of [creating] the event, meaning that the team from Accra never came with any set planned activity; but rather through constant observation of the group, they worked with the young people in devising activities that could meet their immediate needs and that could also fit into their

immediate resources. Also, one of the most important things that we observed during the course of the program was the periodic absence of [some] youth members. This can be attributed to the fact that some of the youth participating into the program live by themselves or have to search for their own food or medication. However, we were able to have a number of committed participants that completed the program successfully. As a result of this training and program, some of the students—such as Gardea, Prince, and Nyuowo—were able to be writers for the local newspaper, some write poems, while others plan and participate in talent shows, plays, drama, and others write stories that can be dramatized. In general, most of the young people that participated in the program are no longer afraid to showcase their skills and are more than willing to help others develop such skills as well. What they actually need is our support in terms of mentoring, finance, and other logistics.

Given the fact that some of the young people are now involved in bigger events at the camp where they are part of the planning demonstrates that the workshops at the camp were very effective and had more impact on the community than expected. What can actually make this program more effective now is for us to develop a plan wherein we could seek financial assistance for those who will be involved in the program, so that they could be able to pay their school fees, because UNHCR has withdrawn financial support from the camp and most of the schools are now very expensive. Most of the young people are living by themselves, while others live with their parents, who cannot pay their school fees because of the low economic status of the people at the camp. If we are able to find funding for scholarships for each of the students in the group, that could also continue to attract them to be in the group, because most of them usually leave in order to search for money for food and education.

The UNHCR recently withdrew their support from the camp stating that there is now peace in Liberia and refugees can return home. Unfortunately, there are several reasons why one can be a refugee, of which the major reason is war. On this note, not everybody is going to return at the same time, because we feel the country is not yet adequately safe. So, more people prefer to be at the camp for the next three to four years before gradually repatriating to Liberia. As such, there have been huge transitions in the camp and the program played a significant role in the process of defining the youth in their current responsibilities to the community and themselves. There has been no way in which the program hindered anything at the camp, because it was through the program that young people are now able to talk in public and communicate more effectively. We just need to reinforce the program with our constant support. They really need it right now, as the camp is three times as difficult as before in 2006.[40]

Impact—Accra

Marcia Olivette, one of the University of Ghana students and already an accomplished television actress, participated in both the work in Buduburam and at the Children's Christian Storehouse Conservatory (that also concluded with an end-of-term performance with the students and youth counselors, aged two to twenty). Olivette was inspired by the debates in class with Reggie Rockstone, who visited one day, and her peers about the value of Hiplife—whether it was a culture like Hip Hop or not and whether it was derivative, original, or a vibrant, continuous mixture of the intertwined histories of the US and Ghana. As a result, she decided to form a Hiplife theatre company even before we had left. Olivette gathered a group of high school students with whom to work and created a piece in anticipation of Ghana's upcoming 50th Anniversary of Independence in March 2007:

> I called my piece Hiplife theatre and gave it the name *Independence*. Hiplife music is enjoyed by all Ghanaians. It is not a culture where you get people having a lot in common and imitating. What I mean is, we listen to the music and dance to it, but you don't get us dressing like the artist. When I compare American Hip Hop artists to Ghanaian Hiplife artists, I realize that I see Ghanaian youth imitating the way the American Hip Hop artists dress; but here you don't get anyone trying to imitate the way our artists look. To us Ghanaians, Hiplife is another form of music for the youth. With Hiplife theatre being a new kind of theatre, it was enjoyed and accepted by a majority of the youth. Hip Hop music is the same as Hiplife music—the only difference is the lyrics, where you have the Hiplife artist rapping in our native language. The experience I got from the project was that it's a platform where you can use music to incite change in the society positively. With my performance, I involved students from the second cycle schools [aged fifteen to nineteen— the equivalent of high school in the US]. It is normally this group with whom Hiplife music is most identified. To them it was a new experience, where they can express themselves from within and easily, through entertaining, get their message across.
>
> I see Hiplife theatre as a theatre of purpose. I say this because it can be done at any time—no need for studio work, costume, make-up—and, most importantly, no script is needed all the time. It's greatly improvisational, which means it doesn't follow a particular trend, which you mostly can identify with plays that are put up where there is a sequential arrangement of events. With *Independence*, the actor interacts with the audience and picks up the ideas from the comments being made by the audience. In Ghana the linguist (*okyeame*) plays an important role in our palaces; so I called my actor the *okyeame* to give it a kind of African setting where the *okyeame* steers affairs.

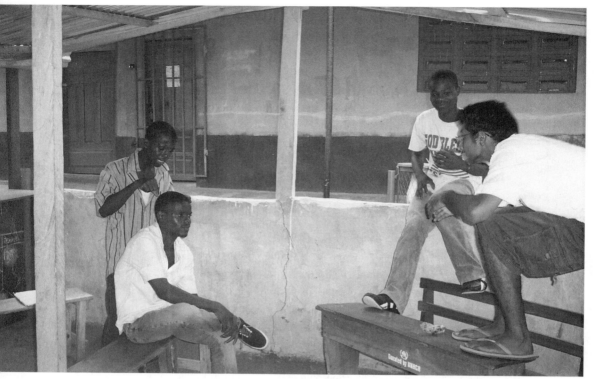

NYU student and HHTI member Utkarsh Ambudkar working with Drama Group at the Dominion Christian Academy, Buduburam Refugee Camp, Ghana. Photo by Daniel Banks

I chose the subject matter "Independence." Ghana was fifty years [old] on March 6, 2007. I took that opportunity to educate the youth of Ghana about our Independence and the relevance of it and, during this period, the participating students came up with what they considered to be "independence" in Ghana. During rehearsals I asked them what this independence meant to them. Back here in Ghana there was a lot of noise about Ghana being fifty years old. When I asked them what they thought of the celebration, this is what they said: "There is too much corruption, poverty, so many strikes." And, most importantly, the majority of them felt there was no need for us to celebrate because, to them, when a man is fifty years old, he is seen in our society to be one that is old and must be one that has achieved something meaningful with his life; but, unfortunately, they, as students, realize that the economy in Ghana is not getting better. I asked them how the economy affected them and the majority replied that the corruption of our leaders is affecting them in terms of retrogressing the growth of this country.

The participating students talked about how they felt as Ghanaians through rapping, dancing, and beatbox. Throughout the performance process, the students enjoyed every bit of it and, after the whole show, they wanted more. There was dialogue between the actors, myself, and the audiences—and from the interaction I realized that they, as Ghanaians, are better off than people from other African countries because, even though there is so much corruption and poverty, we still had peace—and for that they are grateful to our leaders.

Coming together and sharing helps us to have something in common. Through music, much can be said and positive results can be achieved because, as you listen to the music, the lyrics keep reminiscing in our minds. Peace can be achieved within our world if people come to understand that the music we listen to says a lot about who we are, what we do, and what we can achieve to make this world a better place to live in. Moreover, the majority of the students suddenly came to admire themselves and appreciated what their leaders had done. To them, they felt proud to be Ghanaians.

To me, Hiplife theatre can be effective and accepted if studied in our schools because the larger society is the youth and it's the youth who will be the future generation.[41]

Olivette funded *Independence* herself and, at this writing, is working to raise money for her second production.

All our contacts in Buduburam and Accra have commented on how Hip Hop and Hiplife theatre offer alternatives to structural violence and oppression and how the individuals who participated in this work have stepped into leadership roles. But these same individuals desire further training in and experience with this methodology and wish to share it more broadly with their peers and societies. At the end of this chapter I have suggestions on how this can be done.

South Africa

In his seminal, self-published text, *My Hip Hop is African and Proud* (2005), Emile Jansen, a.k.a. Emile YX, a founder of the influential South African grassroots Hip Hop group Black Noise, discusses the importance of Hip Hop in South Africa, echoing the words of Rush Hour.

My Hip Hop is not what the world sees on MTV and in the general media. In the last ten years hip hop has been associated with everything negative that the financially elite world that controls the media could associate with it. I have found this ironic, while in the hip hop underground globally it has helped many youths away from drugs, gangs, and violence. It has occupied the minds of youth from every country on the planet and has been a powerful tool to bring youth together. Hip hop has become the voice of the youth, globally. . .

I am a product of the REAL HIP HOP and the AFRICAN upbringing influenced by great Africans and family. My Hip Hop entered my life at a time when the revolution against Apartheid was being fought in the streets of South Africa. My interest in Hip Hop was sparked by the power of dance and art. I was drawn to b-boying (breakdancing) and writing (graffiti). I started dancing for the Pop Glide Crew in 1982. We were the first to win the biggest local b-boying competition at the Route 66 in Mitchells Plain. I disliked MCs (rappers) because the first ones I heard were all about themselves. I did not like the way they showed off. Later, I heard "The Message" and Run DMC's "Proud to Be Black." This made me aware of the fact that MCing (rapping) could be used to inform the masses. In 1987 I started MCing with the "Chill Convention" who later became Black Noise. In 1988 I wrote my first rhyme called "Apartheid Sux" and got to perform it at the South African Teachers Training College Sports Championships in Johannesburg.

My Hip Hop has given me the insight to use my talent to educate others and earn an income from a skill that can never be taken from me nor dictate how and where I work. I am my own boss, my own company, and can decide to work for free if the situation requires it. My Hip Hop is the attaining of the title DJ, MC, beatboxer, writer, etc. by your action and time contributed to mastering your skill. My Hip Hop gives respect to the founders of the culture that have paved the way and sacrificed for this form of expression.

My Hip Hop has a history that goes back to the beginning of time when we danced, sang and clapped around fires and transcended this world to the next. I think it was that force that drew me to the circle. That ancient energy that feeds the soul and not "how much one is going to be paid." The San writers with their rock paintings, the capoeiristas and their ability to liberate themselves with the trance-induced clapping and energy of the circle, the DJ creating from what has been discarded by modern society, the beatboxer that creates the ancient beat for rhyme and dance to flow over. My Hip Hop is this energy that is subconsciously linked to the very essence of humanity. Finding oneself in the circle. The ability to create what is new and different. To develop your own style of dancing, of writing, rhyming, of feeling the beat and most importantly catching the fire. This is always difficult to explain, as it takes people who are able to see and feel to understand these concepts. Like most people, I also thought that it was cool being involved with Hip Hop and, only after years of living HIP HOP, was I able to see its real power. My Hip Hop gave me the opportunity to read deeper into myself and find my African greatness, that meant finding my human greatness (as we are all of African origin).[42]

I was invited to South Africa to direct a workshop of New York-based playwright Zakiyyah Alexander's Hip Hop Theatre play *Blurring Shine* at the Market Theatre in Johannesburg. *Blurring Shine* is a brilliant satire on the relationship between the

media and the current state of Hip Hop fashion, style, Rap music, and the industries of trend prediction, trend-setting, and product placement. Although set in the US, I knew intuitively it would resonate in any metropolis where Hip Hop was a presence.

At my first meeting with the South African cast—five male actors and a male stage manager—I asked them about their relationship to Hip Hop.[43] As compared to Accra, where what most people knew was the highly marketed and hyped names of the Rap record industry, at our rehearsal table in Johannesburg, these men talked about KRS-One, Talib Kweli, Common, Lauryn Hill, Tupac Shakur, Immortal Technique, Grandmaster Flash, and Jean Grae (a US based female Emcee who was born in Johannesburg)—all artists considered inside Hip Hop culture to be "politically conscious" or "grassroots" (meaning, among other things, that they do not sell as many albums as the commercial heavyweights). They knew their US Hip Hop history and they also considered Hip Hop a culture—a very important culture to disenfranchised young people. They all considered themselves, if not full-out Hip Hop heads, at least deeply influenced by Hip Hop culture. From the depth of their knowledge and passion, I sensed that there must have been a chapter of the Zulu Nation established in South Africa. As Jansen later told me, "[One was] started by King Jamo . . . around the late '80s and early '90s in Mitchells Plain, a so-called coloured township on the Cape Flats."[44]

This background and cultural knowledge made rehearsing the play and the lengthy audience dialogue following its performance go very deep, very quickly. I encountered many of the same concerns and misperceptions about what Hip Hop is or isn't as I do when facilitating these conversations in the US with people from all experiences and backgrounds. These include whether or not Hip Hop condones misogyny and violence, whether or not it promotes greed and consumerism, and other important contemporary social concerns. I learned that the people I encountered in Newtown, the downtown cultural center of Johannesburg where the Market Theatre is located, had access to a broader range of music, primarily through the Internet, than the people I worked with in Ghana. But it was also clear that Hip Hop's reputation—and work—had a different history in South Africa.[45]

As soon as the word got out that someone from New York who had something to do with Hip Hop was in Johannesburg (somehow the "theatre" part was always omitted and people thought I was going to be a major Emcee or producer), there were always Hip Hop heads waiting for me before and after rehearsals. I began to explain to them what Hip Hop Theatre is and—especially after the performance of *Blurring Shine* and the ensuing dialogue—Hip Hop and theatre artists alike saw the potential value of this form in an ever-changing society where there are still not adequate avenues of expression for people of their age, interest, and class.

Almost all the young people I met in Johannesburg were "Black" according to the caste system that is still very present twelve years after the fall of legal apartheid.

Most of them lived in townships, such as the South Western townships (a.k.a. Soweto), with a few living in Johannesburg proper. Most were freelance artists and one artist with whom I worked had been living under a bridge, until a few months before my arrival. At the time that I met him, he shared one small room with ten other male Hip Hop artists. By contrast, an actor I met had just returned from a two-year drama course in Europe, but was back living with family in Soweto; another, a poet, regularly tours Europe. So there is a vast range of opportunity and experience; but, as with the arts in US, very few artists are either financially comfortable or secure.

I asked the artistic staff at the Market Theatre if I could organize a Hip Hop Theatre Lab, drawing on the methodology of the Hip Hop Theatre Initiative, and they graciously and enthusiastically supported this idea. I invited anyone who showed up to participate. There was a core group of about twenty, while some people came and went, due to work, transportation costs from where they lived, child-care, and other personal issues. I was not in a position to pay people to take the workshop, which would have been a preferable structure for the Lab; but, as described earlier in regards to Buduburam, I have learned that sometimes we just have to get in there and work, even under imperfect circumstances. After three days of working together, the regular participants and I chose to close the doors to further newcomers.

We used the Hip Hop Theatre Initiative progression as a jumping off point, adapting and adding elements based on the needs and interests of this particular group—such as a rhyming workshop that two of the participating Emcees led with beats they had produced and several dance sessions with a B-boy who was in the group. At the end of the sixth day, we did a showing for an invited audience. As with *Blurring Shine*, the discussion afterwards lasted longer than the actual presentation.

This time, the focus of the community dialogue was more on the form of Hip Hop Theatre, rather than the content of the play: Was it all that new (especially in a country known for poetry and protest drama)? Was it a fad? Was it something that would be appropriated by people not in the culture and turned into large musicals (something that had already happened in the US and UK)? Does it somehow diminish the work to have the name Hip Hop attached? In Accra, by calling it Hiplife theatre, there was the excitement of something new being born out of a local act of simultaneous synergy with and resistance to US Hip Hop. In Johannesburg, however, the term Hip Hop only really seemed a draw for people for whom it was a self-identifier. For others, it was either a curiosity or, even, a deterrent. In other words, I found myself at the eye of the very same storm of questions that people ask at the numerous panels, gatherings, and conferences hosted by such organizations as the Hip Hop Theatre Festival, New York University, the Ford Foundation's Future Aesthetics program, Theatre Communications Group, and others that explore, dis-

cuss, and critique Hip Hop Theatre. Nevertheless, despite the unanswered questions and similar to what had transpired in Ghana, the Lab members formed a strong bond and committed to continuing the work on their own. Many of these performers, in fact, soon after collaborated on a workshop of a commercially produced Hip Hop Theatre musical, *Le Club*.[46]

I was scheduled to give a three-day workshop the next week at the Sibikwa Community Theatre in the East Rand, the oldest existing community theatre in South Africa. Sibikwa caters to local teens and young adults. It has after-school, weekend, and continuing education programs that offer life-skills training, conflict resolution work, a pre-professional arts training program, and teacher training. Concerned once again about questions of hierarchy, sustainability, artistic imperialism, and issues of balance in leadership, I invited six of the Hip Hop Theatre Lab participants to come and facilitate the workshop with me. This time I found the funds for them to be paid.

At the end of the three days, we again did a showing—to the staff and other "learners" (i.e., students) at Sibikwa who were part of the Youth Against Violence training. This visionary program is made up of at-risk and/or formerly incarcerated youth training to do interventions with young people in their own communities. There was a rousing appreciation for the work and immediate connection to its relevance in the "new," but ailing, South Africa. Sibikwa participants, like Leboxa Kolani, expressed how it made her see Hip Hop in a different way:

> I didn't realize that Hip Hop was part of my life, my everyday life... It's something that's there. It's something that you live everyday... It has really taught me something about Hip Hop that it's not something about gangsterism, but it's something that happens around me every day.[47]

Argony Mokena, another Sibikwa participant, explained, "I used to think that Hip Hop was bling-bling. But now I know that Hip Hop is life and we can't live without it."[48]

The Lab participants from Johannesburg were also deeply affected by the experience. Moshe Maboe, the B-boy who led the dance sessions for both the Market and Sibikwa workshops, expressed about meeting the youth at Sibikwa, "It's like being introduced to yourself again."[49] I interviewed the participants about their experiences as both participants and as leaders in working within the genre of Hip Hop Theatre.

> As far as youth and change and this medium goes, I think there is space for this here. I have been reading about this work for a long time, Hip Hop Theatre, Hip Hop Theatre, Internet, Hip Hop Theatre. But I have always seen it as something from outside. So now this gave me a chance to see it, how I can get in on it, how I can use it

as a medium for me. And I think it is relevant to South Africa and our youth and what they are going through now because . . . we do relate to Hip Hop. Hip Hop is ours and that's what makes Hip Hop because it goes across all margins, everything. So, if you tell a story through Hip Hop, it's still the same story, it's just a different medium that you are using, and I think it's about that time. —*Bonolo Imbawula* (Dancer, Actress, Poet)

People like me, people from . . . the townships, they're not that well informed about what's going on. They don't know their life is Hip Hop. So the whole workshop has helped me—we can find a way to educate people in the townships because they need to know the information. It's important for them. —*Zweli Mkize* (Emcee, Actor)

For me it was empowering at a completely different level. I understand it was Hip Hop; but for me it was just human; and that's more important to me than all the names we fix to it. It was human, it was an encounter with a human experience, with other people's thoughts, about themselves, about the spaces in which they find themselves. With the whole experience, I felt enlarged by the end of the whole thing. I was a little more inspired to go out there and to live and to create and do things. And, for me, that's the value I give to the whole workshop. . . And I suppose we can do work without having to wait for anyone else. It will take much more than just having been in those workshops. It will take commitment from us towards whatever goal we set for ourselves. It will take time, it will take resources, and patience. And those are the things we have to find ways of coming together about. Because it is not just about coming into a space and creating work. It is much more than that. We have to also make ways of benefiting from the work, as well as other people benefiting from the work. —*Monageng "Vice" Motshabi* (Actor, Playwright, Stage Manager/ Assistant Director of *Blurring Shine*)

What we can do is learn from each other. (To Zweli) You know your writing. I know my stuff. We each know our stuff. When you know your stuff, there's a collective. When you bring it to the table, to people, you've got that power. You've got the power to say, "No I won't be ripped off like that, these are our terms." You come from a position of power. You've got the say [as to] where it goes. And that's the way I think it all starts.[50] — *Bonolo Imbawula*

I also led a daylong workshop at the Guga Sthebe community center in the Langa township outside Cape Town. It was set up by the Hip Hop Connected organization that works out of Artscape, one of the major cultural institutions and edifices in Cape Town.[51] I arrived to meet approximately thirty young men (with two women from the Artscape group) most of whom, once again, expected a workshop that would somehow forward their careers in Hip Hop as Emcees, producers, and Hip Hop entrepreneurs. Theatre was not what they expected.

Nevertheless, halfway through the workshop, we were standing around in a circle and all the participants were sharing their most intimate fears and concerns—for the men, these were about being able to support their families as Hip Hop artists or their deep grief at feeling they had "sold out" by taking a job that would support their families, but took them away from Hip Hop. There were deeply embedded issues of class and gender that they had not previously had an opportunity to express, but that they felt safe sharing in this setting: to make money meant to give up a certain look, a certain way of speaking, a certain affiliation with "the people." A few men shed tears while expressing the feelings of being at a standstill in their lives inside a society that did not respect the depth of their commitment to the art and the socio-political ethos of this movement. This was remarkable for such a male-dominated space in this cultural context. We then took this material, used it as the basis for character development and writing, and created small theatrical moments, paying attention to the elements of composition.

Monishia Schoeman, a.k.a. Eavesdrop, one of the event organizers and female participants, discusses these gender dynamics as they relate to South African Hip Hop and Hip Hop Theatre:

> To establish the element of Hip Hop Theatre in S.A. would be like the discovery of a vital missing ingredient in our New World Pie. Right now conscious/political (opinionated)/alternative hip hop is being marginalized because it is viewed as rebellious, ill-mannered, irrelevant, and destructive. We need to move into uncharted territory; equip ourselves with the ability to break barriers and make people listen. To tell our own stories and maintain the balance through the approach of theatre to enhance both creativity and professionalism is forward thinking.
>
> When the opportunity for a workshop in Langa came about, no one knew what to expect. As much as we're "characters" in our respective disciplines, whether Emcee, beatboxer, breakdancer, etc., the idea of venturing into the imagination and setting ourselves free seemed, for some, overwhelming as we embarked upon the various necessary warm-ups and exercises. What we took from the workshop was used in our Hip Hop Connected rehearsals. But how do you explain to a group of ego-centric males that they may want to sharpen their skills without stepping on some toes? The connectedness wasn't there because each one was trying to shine alone and not as a whole. At that point, I realized just how far we all still have to go regardless of how much (raw) talent S.A. Hip Hop boasts. It's also a journey we have to be willing to take with united vision.
>
> Hip Hop is still heavily male-dominated and, although the female presence is there, women tend to be a lot less conspicuous. Why? Because they allow themselves to be bulldozed by the stereotypes and stigmas attached to the archaic ideology of their male counterparts instead of claiming their space! Nobody can take away what

you've been granted, so why hand it over? When we speak of equality, it should be holistically.

There's a lot of mysticism surrounding the strength of women because we don't need as much appraisal as men do; and so we quietly allow ourselves to be discouraged and begin to second-guess our abilities as we fade into darkness. Women need to persevere! We fight for our voices to be heard and you have to be 150 percent more dedicated, determined, and resilient than the next man because when you come into a space where you are the minority, the only way to rise is to exhibit quiet confidence like a skilled Samurai with sharpened sword and tough skin.

What chauvinistic men have yet to realize is that it's about artistic integrity and, when you know who you are, there's the ability to turn the isolation and opposition into victory. Hip Hop is competitive.[52]

At the end of the workshop, in the closing circle, people acknowledged, as they did at the Market Theatre, being in the room with other participants they would not have previously talked to or even stepped into the same room with—whether from opposing crews, gangs, social classes, or walks of life. They commented on how this work brought them together, both physically and mentally, revealing the commonalities in their experiences and struggles. Several participants said they were inspired to collaborate and bring their crews together to support each other's goals. The very love that they shared—Hip Hop—had become, via its commercial expropriation and its misrepresentation in a capitalist market, the obstacle to joining forces and coalition building. Capitalism, like the South African government under apartheid, protects itself by implementing segregation—both across and within cultural lines.

Hip Hop Theatre and Peacebuilding

> Hip Hop and Hip Hop Theatre have a lot to do with opposing irresponsible
> or unthinking assertions of power, and challenging people to use power
> and privilege in constructive ways.[53] —*Dr. Cynthia E. Cohen*

Several commonalities in methodology emerged from the various projects in Ghana and South Africa in the context of peacebuilding and conflict resolution:

- A continual revolution of roles: young people taking on leadership, moving from student to facilitator, using their own skills—newly and previously developed—to work with other young people;

- Creating and defining a new psychic space in which to work, one owned by the participants, often in contrast to hegemonic and/or Eurocentric practices;

- An acknowledgement that new agreements can be made around time, authority, and communication, and that they can be structurally renegotiated and re-invented;

Community Creativity and Self-Expression Workshop in Atlantis township, South Africa.
Photo by Siona O'Connell

- Creating a porous pedagogy that relies on local knowledge, practices, values, and concerns—i.e., encouraging local voices (thus feeding back into the first point, creating leadership, and supporting individual and communal visions).

It is important to recognize how this work builds avenues of communication and collaboration not only across constituency groups, but within them as well. When embarking on these projects, I had been clear about the importance of creating a space where cultural and regional circles of youth could find their individual and collective voices through self-expression and political activism. I discovered, however, that the principles of activism espoused by Hip Hop have currency in just about any setting, generated by the very power and vibration of the performance techniques, which at origin were themselves responses to oppressive conditions. I have used this work in settings of people who do not consider themselves in any immediate way personally connected to Hip Hop; and, yet, the work that is produced out of such a workshop is arresting.

In both of these settings, this work is often inter-generational, almost always cross-cultural, and dives into issues of oppression and inequity. It is not only moving to an audience, but life-giving to the participants, as well, to share these moments of détente and reconciliation. In almost every venue HHTI has worked, a theatre or poetry group has been born that has had its own life. This devised process is hardly new—it has been used by political theatre movements in every generation around the globe. And yet there is something about Hip Hop Theatre's particular relevance and resonance to youth today that better situates its possibility for growth, conflict resolution, and the imagining of futures than any other art form or interactive technique I have encountered. Perhaps it is the shared reliance on improvisation—a necessary element both in Hip Hop performance skills and everyday life skills for overcoming systemic marginalization.

One ethical consideration that presented itself over and over again, in addition to embarking on a project without ample lead time, is that of sustainability. I had concerns that a one-off or one-day session could possibly do more harm than good by getting people excited and motivated with no follow-through. In one such situation, a colleague and I were invited to colead a daylong workshop in Atlantis, a township near Cape Town. I questioned the session organizer, Siona O'Connell, whether a one-day workshop would be anything more than cosmetic. "Get over yourself, man," she replied, explaining that taking even one youth of Atlantis off the streets for a day could have an immeasurable impact in terms of her or his contact with violence, drugs, and street life in the township. Indeed, when we arrived at Atlantis, my co-facilitator, Adam McKinney, saw a young man who was not participating in our workshop in the midst of an altercation in which he was (non-fatally) stabbed with a screwdriver, while the session participants were already safely inside the workshop venue.

O'Connell has since reported to us that one of the young girls who participated in the workshop "has been transformed from a shy, traumatized twelve-year-old to a charming and confident teenager, who has realized that there is life beyond Atlantis. More significant is that she is using her newfound confidence to challenge the many issues that still pervade Atlantis."[54] One day could, indeed, make a difference. Although I do still believe it is crucial to consider questions of preparation and sustainability for working cross- and inter-culturally, sometimes these notions may be academic in the face of actual need. I have come to understand that, in addition to an ongoing re-evaluation of ethical considerations in our work, HHTI must also let people be the judge of their own need. I had been overly concerned with *not* assuming that people felt "oppressed" or that they were in need of help or intervention; however, I learned that this principle needs to operate in both directions and, if someone asks for the work in her or his community, not to let my preoccupations with sustainability get in the way. We have found an even better solution—to weave

sustainability into the workshop by discussing with the participants future action steps and creating leadership roles within the group.

HHTI's future steps include training several teams of facilitators—like the students at NYU who have gone on to use this work in New York City schools and after-school programs, Marcia Olivette, and the Lab participants in Johannesburg—to work with youth, bringing their stories to the fore and creating environments where they can see each other as allies. In the meantime, there are masters of Hip Hop performance skills who could travel from city to city, country to country, and, during a month's time, lead a group of local participants in an intensive Hip Hop Theatre Lab, integrating local skills and knowledge with a Hip Hop Theatre methodology. As I write this in the spring of 2008, such a group of professionals is training a new cadre of twenty-one NYU students. Children's Christian Storehouse in Ghana, artists in Newtown and Cape Town in South Africa, and people I am in communication with all over the world are hungry to have such a team of peacebuilders come to their cities and lead them in this work so they can then use it with the youth in their own communities. By training young people all over the world to use Hip Hop Theatre practices in the service of youth empowerment, leadership training, and community development, Hip Hop Theatre will be able to fulfill its own "declaration of peace."

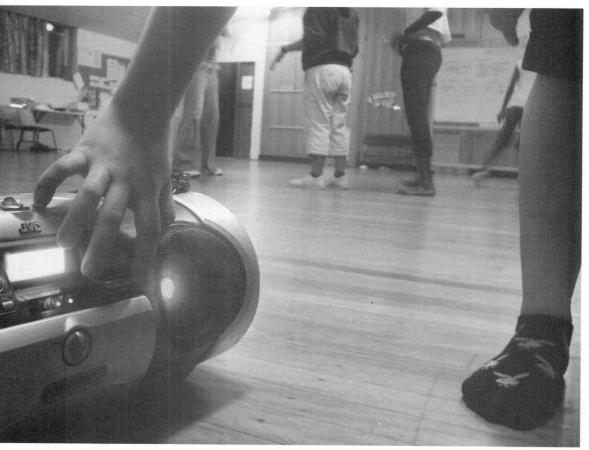

Turning up the Volume, Peace Initiative workshop, 2006, Sunnybank. This and all further digital images reproduced in this chapter were taken by workshop participants Kaiya, Rebecca, Taisha, Gabrielle, and Jasmin to help document the process. Photo by Peace Initiative participants Kaiya, Rebecca, Taisha, Gabrielle, and Jasmin. Courtesy of Contact Inc.

3 Change the World as We Know It

...

Peace, Youth, and Performance in Australia

Mary Ann Hunter[1]

.......................................

In societies fraught by conflict and violence, the promise of peace is often symbolized by the imagery of youth. Young people and children, fashioned as exuberant and optimistic, are often projected as innocent victims and also as collective reminders of the future on which conflicting parties trade. But these projections can also be blatantly tokenistic, particularly when young people are rarely afforded a role in the management of conflict in their communities. A utopian "youth as the future" discourse can unwittingly ignore young people's "youth as now" real-life experiences and, as a consequence, devalue the immense contributions that young people can and do make in building pathways towards peace.

This case study aims to unmask the ways in which young people transform conflict on their own terms and, through art, contribute to peacebuilding across cultures, genders, and generations. In particular, the study focuses on performance projects in Australia whereby young people attempt to "change the world as we know it" through self-narration[2] and self-representation, integrating the grounded aesthetics[3] of hip-hop, skateboarding, video, and martial arts with more conventional theatrical approaches to performance. But not all projects result in harmonious, feel-good interventions. In some cases, bringing public awareness to latent conflict—and even provoking it to some extent—has enabled strategies for sustainable peace to unfold.

Despite growing globalization and intense commercial efforts toward cultural homogenization, the concept of youth cannot be distilled into a single category or profile. Ethnicity, gender, sexuality, location, education, ability, and age (even within the widely accepted UNESCO definition of youth as fifteen to twenty-four years)

provide diverse influences on young people's worldviews and on their opportunities to live lives of peace and security. Even in economically advantaged and relatively peaceful democracies, young people grapple with serious cross-cultural and intergenerational issues that lead to social conflict, racial tension, and domestic and other violence. As a growing, culturally diverse population, it cannot be assumed that young Australians share the same modes, interests, and styles of "symbolic struggle"[4] to deal with these issues. What is clear, however, is that many young people are active arts participants who engage in forms as diverse as graffiti, festival culture, classical music, contemporary dance, and theatre to express ideas and identity—be they collectively constituted or individually designed. And as the works profiled in this case study document, it is through performance that young participants create strategies for dealing with conflict and activating social change.

The approaches documented in this case study are most appropriately described as "transformative practice." They do not focus solely on *resolving* conflict but on restructuring "unpeaceful relations. . . over a long term by education, advocacy (nonviolent activism) and mediation,"[5] as peace researcher Raimo Väyrynen has written. As Väyrynen further points out, this transformative approach differs from conventional conflict resolution in that it

> stresses the dynamic and discontinuous nature of conflicts . . . recognis[ing] that
> for many conflicts there is no easy and obvious solution. . . In the best of the cases,
> the redefinition of issues, actors, rules, and interests may transform the nature of the
> conflict so that resolution becomes possible.[6]

This case study is therefore concerned with how young people transform conflict through cultural action. The Peace Initiative program of Brisbane-based Contact Inc. is profiled as an example of Väyrynen's "best of cases," whereby projects are not charged solely with finding solutions to specific conflict situations, but are cognizant of the cultural issues and diverse worldviews of the "actors" involved. Through the Peace Initiative, which respects the contribution and creativity of peer leaders and artist mentors, the transformative potential of young people is uncovered and their role as drivers of change in their own communities is valued. Alongside the Peace Initiative, this case study highlights other Australian performance-based projects that have similarly integrated contemporary youth cultural practice with transformational aims. Collectively, these examples show how youth-specific performance can go far beyond the idealizing of young people to highlight their real-world contributions to social change.

* * *

> My mum once, when I was ten, came home from the pub and got into a fight with
> the neighbours and came over and got me and my little sister to come over and fight
> them with her.

I feel frightened for my family . . . for my cousins and all of that . . . Wherever
you go around here [the Greater Sunnybank area] there are always people after you
. . . Does this get exhausting? . . . Yep.[7]
—*Peace Initiative participants, 2002–2003*

In recent years, angry young Australians have come to the world's attention
through widespread media coverage of riots in Redfern (February 2004), Macqua-
rie Fields (February 2005), and Cronulla (December 2005)—all neighborhoods in
Sydney, Australia. In these events, young people identifying with various cultural
communities were depicted as threatening and dangerous protagonists who rou-
tinely incite racial hatred and violently antagonize figures of authority. But it is not
only in these well-known Sydney hot spots that these conflicts occur. The suburb of
Sunnybank, in Brisbane's southwest, is an economically and culturally diverse area
where young people similarly face racial tension and dysfunctional intergenera-
tional relationships, and are subject to sensationalist media reportage that exacer-
bates stereotypes of restless and disaffected youth. A common societal response has
been to call for more policing in an attempt to limit young people's powers. But
what of initiatives that take a longer-term view of positively empowering young
people—positioning them not solely as protagonists, but also as peacebuilders?

In 2001, youth services and cultural groups in Sunnybank noted increasing vio-
lence among Polynesian, Indigenous Australian, African, and Asian young people
in the area, particularly with the arrival of large groups of Sudanese and Congolese
refugees. Together, these organizations[8] sought to initiate peacebuilding activities
that would actively involve young people as collaborators and peer mentors. They
focused on the potential of collaborative goal-oriented projects and on the possibili-
ties of art—not as a leisure-based diversion to violent activity, but as an intervention
that could contribute to consciousness-raising, relationship-building, and sustain-
able long-term change in cultural attitudes and awareness.

As explained in one of the reports about the program, the initial idea was:

. . . inspired in part by a local youth accommodation worker reflecting on the cycle
and culture of violence expressed by one of her clients—whose response to a con-
flict in the house was to yell, "Don't punch him or I'll bash you." . . .

We envisaged a project that would engage young people identified as "peer
leaders" within three identified communities: Indigenous Australian, African, and
Polynesian. Once relationships were established, processes of dialogue would be
explored. It was envisaged that this would include both "culturally specific" dialogues
(intracultural) and then cross-cultural dialogues (intercommunity).[9]

Contact Inc., an arts organization that had previously worked within the local
community, was approached to plan and facilitate a project along these lines. Hip-
hop was the chosen art form, as it provided diverse means of expression (dance,

music, emceeing, graffiti art) as well as a grounded philosophy of respect for self, others, and culture. To carefully build this project through phases of awareness-raising, mentoring, and eventual collaboration was seen as a "local, innovative and effective way to build a sustainable and peaceful community."[10] From Contact Inc.'s perspective, the Peace Initiative marked a development of its work in youth-specific arts and furthered its commitment to working with a "Third Place Policy"[11] to provide spaces where cultures can safely and meaningfully meet. The Third Place approach had informed Contact Inc.'s work in and across communities for over fifteen years and prioritized the provision of safe and comfortable spaces, cultural appropriateness, dialogue, and fun for young people in engaging arts and cultural activities.

In 2001, Jane Jennison, who at the time was Contact Inc.'s artistic director, started eighteen months of preparatory consultation in Sunnybank, which involved gaining trust and recognition from various cultural groups, support organizations, governmental bodies, and, most importantly, young people. The project officially began in 2003, with ten weekly workshops using a variety of drama-related activities and the sharing of hip-hop skills to guide participants through an exploration of the concepts of peace, conflict, culture, and honor. This culminated in an original song recording and DVD with contributions from over fifty young people from Indigenous Australian, Polynesian, and Sudanese backgrounds.[12] Thirteen people, including artists from the participants' own cultural backgrounds, facilitated the project and became key mentors who could encourage, motivate, and challenge the participants as they explored their own values and attitudes while getting to know—and collaborating with—others. As Jennison stressed,

> We were homing in on longer-term development. We felt this was more relevant to working with young people in this area, and the project afforded us the opportunity to speed up and slow down whenever we needed to in response to the kids and the community.[13]

At no point was it suggested that Sunnybank would be or should be conflict-free as a result of the project. As proponents of conflict transformation argue, conflict is a necessary part of a healthy and civil society. What becomes important is how that conflict is manifested and transformed in nonviolent ways. In the Peace Initiative, the transformative aim was to identify common ground, interact face to face,[14] and build shared knowledge through a collective goal. This was facilitated by Contact Inc. with a view to provide the conditions for safe intercultural interaction whereby participants—some of whom had participated in group violence—were not expected to immediately sit with "enemies" and talk the issues through. Rather, the Contact Inc. artists sought to establish safety zones for the young participants through intracultural workshops and then to expand those zones in highly facilitated artistic collaborations with others through hip-hop. Within this aesthetic mediation, the

Filming the emcee workshop with workshop facilitators and participants, Peace Initiative, 2006, Sunnybank. Photo by Peace Initiative participants Kaiya, Rebecca, Taisha, Gabrielle, and Jasmin, Courtesy of Contact Inc.

participants learned and shared new skills and expressed their views of peace, culture, conflict, and honor in a process akin to grassroots second-track diplomacy.[15]

By focusing on building long-term sustainable relationships, the founders of the Peace Initiative felt that the initial project's main achievement was the development of a group of young people who were:

- Actively working towards creating a peaceful community;
- Equipped to build contemporary cultures of non-violence and to advocate for peace;
- Peer leaders within their community;
- Working towards a model of community practice [which] discourages violence and encourages non-violent responses to conflict;
- Identifying opportunities, issues, and problems within their communities and working towards resolving them;
- Developing a model responding to racism and intercultural violence that is grounded within the cultures of their communities.[16]

In the following years, the initial project grew into an ongoing program with both an annual workshop series and public performances (variously called the Peace Project, Peace Potion, and Symphony of Survival). Although it is impossible to measure the full impact of the project, repeat participants such as Moses, who is now a facilitator, laud the personal, artistic, and community benefits.

Moses's Story

My name is Moses, and I'm from Sudan—well, I was born in Sudan but moved to Egypt due to the conditions in my country. I lived in Egypt for ten years before we moved here [to Australia], and I've been here for about six years. I got involved with the Peace Potion program in 2003. I was called in by a friend of mine who was actually doing what I'm doing at the moment—getting people to come along and all that—so I came along and I liked it. I liked it so much. It was a really welcome environment for us. It actually gave me the chance to nourish my talent as a rapper and that's how I got into it.

I think it's a really good project because it doesn't just look into the artistic aspect of it, it also works in so many ways in encouraging young people. . . it works as a place for young people to share their stories.

There were a lot of conflicts between Polynesian youth and African youth, and there were a couple of clashes that I was even involved in. The fights were basically ridiculous, [is] how I see it now. It was sort of like a hate thing because there was not much understanding of who those people were. It was like judging a book by the cover. You look at something and then you make these judgments in your mind without knowing what the actual content of that actual person is. So you then start up something and that person reacts back because they also have the same assumption. It's just a total misunderstanding that leads into physical fights. You try to be cool, you know, you fight, and peer pressure also has something to do with it because. . . we used to roll in groups, and it even led to youngsters attacking elder people. So the community sat together and talked about it. But I refer to the Peace Potion as the main thing because it actually dealt with the young people.

An older person once told me that young people, if they have a problem, you can't get an older person to come and solve it, they have to solve it themselves. Even if you have two brothers and they have problems between themselves, a father cannot come in between them and solve their problem, they'll have to work it out themselves. It's a similar thing. The Peace Potion thing, it dealt with the young people. These are the young people who have the problems, these are the young people who did not understand each other. So what happened? They became close to each other, they know much more about each other, they did something. Out of all the time that they spent together they have produced something that is actually of value. I think that's how peace will happen: the more you start like that, and if it keeps on going it's just going to get better.

—*Peace Initiative peer facilitator*, 2006

Apart from the annual workshops, other spin-offs from the Peace Initiative have included hip-hop classes at the local Police Citizens' Youth Club and *The Hope Tour*, a hip-hop theatre performance produced by Contact Inc. in association with one of the state's major cultural institutions, the Queensland Performing Arts Centre (QPAC). *The Hope Tour* was a watershed in the artistic development of

Week Three with Contact Inc.[16]

Week three of the 2006 Contact Inc. Peace Project workshops: after twenty minutes of informal interaction, the group is called together for a "check in." An arc of chairs is arranged, open toward a map of the world pinned to the wall. Participants are invited to convey their personal trajectories with bold pen lines on the paper map. Encouraged by the artist-facilitators and each other, stories of journeys—from Sudan to Senegal to France to Australia, from Samoa to New Zealand to Samoa again and Australia—are conveyed and imagined in the lines of ink. Big silences, but big respect is evident in the room. "Okay, so all the Sudanese don't share the same story and neither do the Murris [Indigenous Australians]." The semi-formal prescribed use of space works effectively to facilitate a broadening and deepening of the safe space experience which has until now been constructed mainly around the safe distance afforded by the concentrated focus on developing new moves or new MC poetry.

There is tension of past and present here, as well as the tension of not being certain about what to present to a public audience at the end of the workshop series. Half an hour later, smaller groups form—one group, the emcees, gather around a table trading rhymes, but despite encouragement from the facilitator, Moses, a Sudanese participant in last year's project, it takes a while to get any flow happening. Frustration is evident especially with participants clustered uneasily around a table in such close quarters, but the tension soon transforms into competitive creative energy as each emcee presents what he or she is up to, and eventually they're all keen to share their work with all the others at the end of the workshop. —*Participant-Researcher*, Peace Initiative, 2006

Contact Inc.'s work, as it took the Peace Initiative's public interface beyond a "show-and-share" mode into full-scale theatrical performance with associated professional production values.

In *The Hope Tour*, conventional theatrical features merged with hip-hop forms to create a Brechtian-inspired music theatre event attended by young people from around Brisbane as well as families, friends, and the general public. *The Hope Tour* involved performers—some of them participants from earlier Peace Initiative projects—from backgrounds including Aboriginal and Torres Strait Islander, Afghan, Sudanese, Samoan, Congolese, Iranian, Burundi, Thai, Cook Islander, Rwandan, and Fijian. Set in a world inhabited by three fictional tribes, *The Hope Tour* mixed "beats, old school moves, rhyme, and multimedia, with traditional cultural expression"[18] to convey a loose narrative whereby the tribes explore ways to peaceably coexist while respecting each other's differences. As with early Peace Initiative work, professional artists mentored the young participants in devising rhymes, developing narrative, and choreographing moves, and they performed alongside the participants in a work that was part of QPAC's performance calendar.

Why Hip-Hop and Peacebuilding?

"With a hip-hop song you can tell a story about something that's happened to you that you feel really deeply about and you can just spit it and let it out and there's just nothing else like it. It's like poetry with a flow, y'know, you just feel it. It's like the Dreaming, the Aboriginal belief—when you're performing, when you're dancing, you're in the Dreaming, you're in the zone, and that's like hip-hop for me. I'm in the Dreaming when I'm rapping or dancing, when I'm up there and there's nothing else like it." —*Peace Initiative participant*, 2005–2006

"It's like an emotional outlet . . . I mean if you're an emcee, you can put down your whole perspective of the world and your issues and stuff and it's just about the message and what you can portray within that." —*Peace Initiative participant*, 2005–2006

"It's a universal thing, it's the emotions, it's the feeling, it's the vibe, it's melodic sound that comes out of it." —*Peace Initiative participant*, 2003–2006

"You don't need money to buy a radio, you just use your mouth—like emceeing you can just basically start to rhyme, like you can just say, 'I had a crappy day at work . . .' Basically it just responds from your own experience, your perspectives and what you can actually give to that art form." —*Peace Initiative participant*, 2005–2006

"With hip-hop, you can just flow and just keep going and express so much because each song in hip-hop has so much more lyrics than in just an R&B song or something just about partying or shallow stuff like that 'cause [in] hip-hop you can express really deep stuff, like philosophy and your own belief and you can tell a story." —*Peace Initiative participant*, 2005–2006

"I traveled all around the world last year and a lot of the places that I went, they'd keep the tourists away from the places where people really lived—I know in Brazil it was like that. But because I'm a dancer, it helped to break down those boundaries 'cause it was like, OK, I'm a breakdancer, so people would just start asking me, 'Oh wow, where did you learn to do that or this' and they'd show me other dances. In every country, in every city, it was sort of like my passport, my hip-hop passport." —*Peace Initiative facilitator*, 2003 and 2006

At the time of this writing, the Peace Initiative in Sunnybank has evolved into a totally youth-led program with continuing support from Contact Inc. The Contact Crew of young leaders (all former Peace Initiative participants) was at work developing a map of their local area's arts and cultural facilities and organizations with a view to initiate new projects. In addition, Contact Inc.'s Each One Teach One program was training young people to deliver workshop programs which actively address young people's local issues, including racism, gangs, police harassment, and safety. According to Contact Inc.'s artistic director, Zoe Scrogings, this is the natural next

step for ongoing peacebuilding in the area: for young people to initiate, develop, and deliver programs themselves. It has also enabled Contact Inc. to take stock of its peacebuilding work to date and identify the keys to the Peace Initiative's relevance and sustainability.

Identifying Common Ground

As leaders in peacebuilding attest, the first step to imagining peaceful coexistence is to find and explore common ground. Contact Inc. prioritizes and cultivates this common ground through its Third Place Policy, which ensures that all Contact Inc. projects and processes are founded on creating spaces where cultures can safely and meaningfully meet. As the historical evolution of this policy shows,[19] the concept of safe space is one predicated on communicating with respect, without undervaluing the often difficult and challenging nature of cross-cultural interaction. An important part of this involves identifying the contemporary cultural interests and expressions of young people themselves: that is, recognizing where young people are creating their own sense of common ground. For the communities where Contact Inc. has recently been working, that common ground has been hip-hop (in previous years and in other communities, it has been multimedia and other music and theatre forms). In the Peace Initiative, and particularly *The Hope Tour*, grassroots hip-hop's core values of respect and self-expression have synergized well with Contact Inc.'s peacebuilding aims. To achieve their goal of presenting a public performance, participants have had to find ways of working together with trust and without major conflict. No young person would want to shame themselves with a substandard performance in front of their own community, so the tension of creating a "good" performance has contributed to a clearer sense of group focus and more peer-led attention to effective communication and collaboration.

Self-Reflexivity

Throughout the Peace Initiative's workshop processes, Contact Inc. artists and facilitators have been explicit about their peacebuilding intent. They aim to help young people be self-reflexive and develop their ability to identify and unpack attitudes and perceptions of each other's cultures. Contact Inc. recognizes that recently arrived refugees and many young people from Aboriginal and Torres Strait Islander backgrounds already have a heightened understanding and experience of peace and conflict issues in their communities. Many believe that art-making processes that encourage self-reflexivity can assist young people to express and further explore their experiences and opinions. In the song-writing-, music-, dance-, and narrative-building workshops of the Peace Initiative and *Hope Tour* projects, a framework of

self-narration, collaboration, and reflection encouraged participants to integrate their workshop experiences with their broader everyday experiences, both past and present. As one participant commented, "Anytime that one of us fights now everyone always says, 'what about Contact?'"[20]

Professional Artists as Mentors

While peer mentoring is important, the professional artistic context of the workshops and public events has helped inspire and motivate the participants and their audiences. In the Peace Initiative, accomplished artists were engaged as facilitators, including the internationally acclaimed hip-hop dance artist Nick Power and Polynesian funk dance ensemble Polytoxic. Input from artists established in their own practice helps erase the process-versus-product divide prevalent within community-based practice and ensures that participants are developing works "in the real world." Young people are valued as artists in their own right. These are not projects where young people simulate their experience or "rehearse" for social change. Instead, they walk away with honed skills in performance and useful tools for intercultural interaction that become part of their "real-world" experience. And by working with modes of contemporary youth cultural expression such as hip-hop, the projects become an extension and integration of how young people communicate and express themselves in everyday life.

Valuing Youth-Specific "Ways of Knowing"

In the Peace Initiative projects, youth-specific ways of knowing have been validated on a number of levels. In the initial project, the participants were exposed to each other's life narratives—they shared their attitudes towards conflict, their experiences of violence, their thoughts about honor, and their dreams of peace, first within their own intracultural groups and then more openly with others through music, dance, and emceeing. Participants have made clear that this has had a positive effect, and has paved the way for future projects to begin on a more integrated intercultural level. Expression of youth-specific and culturally diverse ways of knowing were openly validated and encouraged from the start, as a rhyme developed by participants during *The Hope Tour* workshops shows:

> Young Hip-hop artists, some with horror in their bellies and Hope in their minds,
> Some with one kid at soccer the other running to make it on time
> Some who come cos they know it feels right
> Others that know it's their voice they use to fight
> Those who crave for bbq chicken don't get there last
> Others who must wait til sunset to break their fast

Butchers paper, photos, lyrics, laptops and mic's
Suss'em out, new friendships, creativity and insight.

Youth-specific ways of knowing have been validated on a broader, political level as well. From 2003 to 2005, the Peace Initiative's DVDs and CDs were distributed to government agencies and other community groups with influence on the political decisions that affect young people in the region. This alternative media provides insight into young people's everyday lives and ways of knowing for those decision makers who are culturally and generationally remote, and whose youth priorities are more often about *law and order* than *peace and culture.*

Valuing the Long Term

In each Peace Initiative project, new futures were imagined and articulated through performance, both live and recorded. And these recordings have been an integral "touchstone" for the participants year to year, particularly as each new workshop series has begun with a group viewing of the previous year's performance. The impact of this simple gesture is clearly evident as repeat participants have the opportunity to share stories of their participation and reflect on the changes they have noticed in themselves and in their community since then. For new participants this helps contextualize the work as important and assists in developing a sense of shared time and space—and helps foster an appreciation of the progress of peacebuilding in the community over the long term.

Contact Inc.'s Peace Project was explicitly about peacebuilding. But in the last ten to fifteen years, there have been a number of youth-specific performance projects around Australia that have sought to transform conflict through different means.

Devising lyrics in emcee workshop, Peace Initiative, 2006, Sunnybank.
Photo by Peace Initiative participants Kaiya, Rebecca, Taisha, Gabrielle, and Jasmin, Courtesy of Contact Inc.

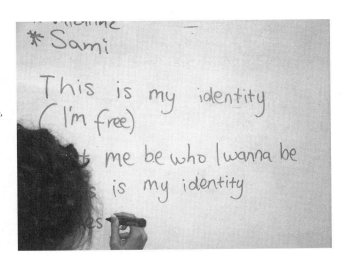

"The program was really good 'cause it got people from different communities—like Polynesian, Aboriginal, African—all different kinds of peoples working together and expressing their point of view and learning about each other and learning from each other how to keep the peace, y'know." —*Peace Initiative participant*, 2006

"It helped tear down some assumptions and stereotypes I had about different cultural groups, so that was pretty beneficial to me at least. I've developed more as an artist. I've learned a lot about myself." —*Peace Initiative participant*, 2006

"You've got all these cultures and all these different people and then you've got like the universal, the dancing, and it makes you feel like you're belonging. . . And it just brings all these cultures together." —*Peace Initiative participant*, 2006

"Identity is like showing who you are and what you're interested in. Like, if you're here for dancing, like, if you want to show who you are, like, if you go out there and dance, people will know who you are—your identity and what you like." —*Peace Initiative participant*, 2006

"[The Peace Initiative] works in so many ways. It works in peacemaking . . . it works as a place for young people to share their stories as well. Not so many people get that chance." —*Peace Initiative participant*, 2006

"It's made me think a bit more about different cultures." —*Peace Initiative participant*, 2006

"I think that Brisbane has a really good feel for process: like Stylin' Up and Peace Potion—they're not just flash in the pan. They've got an ongoing process and that process has integrity and a vision, so I think it's really great for peacebuilding and I've seen it happen, y'know, that people become friends and cultures mix and people tell their stories through rhyme and through the dance and I think that it helps just throw away all those boundaries and just see people for who they are." —*Peace Initiative participant*, 2003-2006

"I heard about it through a mate. I was just looking for a place to just freestyle and see how people come to a place and just freestyle and see how they do it—see if I can learn off them and they can learn off me. And I was thinking this is good, maybe I can come here every year if they have it. . . And I've got better since I've been coming here. I've learnt different ways of how to rap and techniques about it and how to hold the mic properly and how things are like recorded and set up, and for all the people that want to rap and record it, keep following your dreams and hope they come true." —*Peace Initiative participant*, 2006

"A lot of times when I do youth projects, I find that a lot of the audience that comes to see them are just arts workers and people in council, but with this project . . . the Polynesian community and the Aboriginal community and the African community really came out to see the participants, which was fantastic." —*Peace Initiative facilitator*, 2006

"You have like these different cultures and this medium that a lot of the cultures are doing so when you have that kind of common ground, you can build the basis of a friendship and say, 'oh, man, I like that rhyme,' or 'I really like that move that you did,' and then you start to build rapport with that person and then you start to build a friendship and then you start to find out more and more about that person and, y'know, 'I didn't know you were from Sudan' or 'you were from Nigeria' or something, y'know, well there's some of those assumptions that I had and you start to find out a lot more about different cultures." —*Peace Initiative participant*, 2006

"My dad bought a DVD player just to play the film clip and now he shows it to everyone who comes into the house . . . it is kind of embarrassing but I love that he supports us." —*Peace Initiative participant*, 2006

"I think a lot of conflict between the groups comes from ignorance, not knowing much about each other and I think if we can have more projects like this where people can come together and learn about each other and become friends through it, there'll be less conflict in the community because they can go away and if somebody says something about another culture, they won't be negative against it. They'll be like, 'I've got friends in that culture. . .'" —*Peace Initiative participant*, 2006

Giving Form to Conflict: Backbone Youth Arts' *Sk8 Grrl Space*

In 1996, a group of young women from Backbone Youth Arts (formerly La Boite Youth Theatre) devised a performance combining theatre, skateboarding, and music to explore issues about women's access to and ownership of public space. Directed by Louise Hollingworth, who was then Backbone Youth Arts' artistic director, *Sk8 Grrl Space* involved thirteen young women aged sixteen to twenty. Alongside theatre games and playbuilding workshops, the project began with the participants learning (and in some cases refining) skateboarding skills. Through merging skateboarding—which at that time was a predominantly male-centered activity—with theatrical performance, multimedia projection, and music, the group, calling themselves the Hereford Sisters, sought to raise awareness about young women's lack of access to so-called "public" recreation facilities in Brisbane. Their devised narrative parodied the genre of a "Wild West" story where "out-a-towners" (the young women) crossed risky frontiers to enter unfamiliar enemy territory: a public outdoor skate park used almost exclusively by young men. Derided as hustlers, the young protagonists confronted the park's male "sheriff," projected on a giant stage screen, who laid down the law/lore in a satiric portrait of the ways in which unspoken rules frame women's public engagement and visibility.[21]

Sk8 Grrl Space was a one-off free public performance in a public skate park in the inner-city neighborhood of Paddington. The production consisted of the Hereford Sisters' devised scenes interspersed with satirical country and western style songs performed by an all-girl "cow-poke" band. The Hereford Sisters had earlier negotiated with a number of regular park users and representatives to access the site for planning and rehearsals. But on the evening of the performance, a group of young men continued to skate in the performance area after the production had started, trying to cause disruption. In addition, a group of young audience members called out abusively to the performers, with one throwing and smashing a glass beer bottle onto the high-sided skate bowl in which the Herefords were acting. Although this was not the prevailing attitude of the entire audience of more than 200 people, the incident had a negative impact on the production quality of the event. The threat and conflict that surfaced during the event became part of the performance itself. As the Hereford Sisters left the park during the final actions of their parody Western—crossing the street at nearby traffic lights in search of further frontiers—many people lingered in the space unsure if the event had ended.

Although not explicitly intended as a peacebuilding project, *Sk8 Grrl Space* brought previously veiled local conflict and gender issues to the surface. The very nature of the event and the reactions it provoked provided the audience—including local government decision makers—with a glimpse of the very access issues the group was attempting to address through its analogous parody. For the performers, the project had a major personal and artistic impact, as one of the Herefords, Roxanne Van Bael, describes in the following interview ten years after the event. Though it was not entirely successful as an outdoor production, the project led to shifts in the ways that young women were perceived in the skating community. While it is difficult to measure quantitatively, there appeared to be more women using the Paddington skate park in the months that followed; and there was certainly more awareness of the ways in which youth-specific performance could alter the social environment.

● ● ●

Multi-mediating peacebuilding among generations, the Street Arts' *Zen-Che* project involved a group of young men who, through a video performance, represented their way of life in an under-resourced outer suburban area of Ningi, near Brisbane, in 1997. Like the Peace Initiative and *Sk8 Grrl Space*, the project facilitated young people's self-expression and self-narration, while giving them skills in cultural and arts practices that were very much a part of their everyday existence. Without being a peacebuilding project by name, this project effectively addressed a major issue associated with conflict in the Ningi community: cross-generational conflict, fear,

Extract from an e-mail interview with Roxanne Van Bael, March 2, 2007

The Sk8 Project was over 10 years ago now. What are your recollections of the project? How did you get involved in it and what did it mean for you back then?

Wow, it's such a big question. . . I was the oldest in the group at the time, so I was around twenty. There were about thirteen or so in the troupe. We were challenging ourselves and the notions of what public space can be used for. Entering a somewhat foreign environment and reinterpreting that for the purposes of a theatre event. How did I get involved . . . I kinda drifted in on the wind, I had spent some time as a La Boite [youth theatre] kid when I was ten or so, and reintroduced [to La Boite's Backbone Youth Arts] by friends at the time. I was also skating at the time a lot!!!! What did it mean for me back then . . . hummmmm, tuff one, making friends, being involved in something; it kinda gave me a bit of purpose I reckon, focus. Participating in group work was a challenge for me back then, I was pretty aloof. The SK8 Grrl Space project accepted me, listened to me, and expanded on my ideas . . . helped me to develop as a person amidst a pretty void time in my life. Herefords and Backbone helped shape who I am today, standing on my own feeling pretty powerful and strong.

Bringing skateboarding and theatre and music together was pretty innovative for a community-based show in those days. How did that come about?

An accumulation of many things really, I'd say a lot had to do with how Louise Hollingworth worked . . . in terms of group facilitation—asking questions, discussing topics, drama games . . . creating an environment in which the group would share stories and experiences . . . this in turn would inform the process and continue to shape and inform the direction for which the outcome would be . . . being a multimedia event (experimental in those days), colliding with an independent individual sport, brushing shoulders with local safety issues and access for young women.

There was a fair bit of tension on the night of the performance with the audience. I recall at least one guy throwing a glass bottle into the skate bowl in which you were performing. What was all that about? How did you feel about it? And how did the group deal with it afterward?

Yes, the glass bottle incident. . . I guess part of the challenge was using the space in an unfamiliar way. Perhaps threatening to some. I think the crew that threw the bottle had been drinking, didn't like what we were doing, didn't understand why there was a crowd watching, and generally thought it was lame. And in doing that (the bottle throw) really emphasized the purpose of the event!!!! There was a bit more than just a bit of glass though, as I recall, we walked up the stairs on the way out, a girl (from that crew) launched herself at one of the Herefords (a physical threat/attack). These were amidst other verbal not so niceties. It's hard to say how we dealt with it, it was just a part of the whole story . . . especially in terms of the entire point of the performance piece, being "out-a-Towner's not welcome," don't challenge what we know or attempt to highlight change, and don't take the spotlight if part of society thinks you're not skilled.

(sidebar continued on the next page)

Do you think the project was an effective strategy in addressing particular conflicts you, as young women, were experiencing at the time?

I think it looked at many issues, and engaged a broad range of young women . . . from diverse backgrounds. That's a pretty powerful tool to raise issues for discussion, to workshop them and look for an outcome! And alternately the support was very strong, we met regularly . . . as I said earlier, I drifted in and stayed for a while. I'd say I was otherwise a pretty disengaged youth, Backbone and Herefords (at the time) got through to me. And did for a lot of us.

How has this and/or other arts projects you were involved with at that time helped shape you and your ideas about art, community, conflict?

Mmmmm . . . in so many ways, almost beyond words! I understand the importance of process, and I believe this is the key ingredient to all (art, community, conflict). Getting involved can be life changing (whether individual or group). The notion of conflict is a little hard for me to address, I don't think that conflict was directly addressed with any of the arts projects I have been involved in. Perhaps an indirect approach may have been an outcome. The process is what shapes the art; a process also shapes a community. Combining a process of engagement through art can bring unity and understanding, a forum for expression and so on. Creating a trusting environment in which to engage, sure, conflict solution could be approached within this realm.

And, generally, do you see a role for the arts in addressing or transforming contentious issues or outright conflict?

From my own experience, I'd have to say yes. Again it all comes back to the process. Creating an environment through which issues can be discussed; art can unlock, connect, empower, engage, create audience, give voice and so on. Through art (in whichever form) connection can be made, between the self and others. When this is a community process (group process) the art can be a platform or the voice for sharing experiences and stories. An indirect approach to problem solving.

and misperceptions. Conflicts in the area had been framed by the local media as a "youth lays siege to us" issue; the *Zen-Che* project laid the groundwork for alternative views.

In devising the project, seven young participants filmed their everyday lives through the guidance and mentorship of professional videographers, including the internationally acclaimed public artist Craig Walsh. Unused to theatre, but with a strong interest in the skills and performance of martial arts, the participants constructed a ten-minute video[22] around images of their martial arts practice and their research about a number of old military bunkers on nearby Bribie Island. At the beginning of the video is a clip of one of the participants on a couch at the Ningi youth center:

> Well, there's not really that much to do in Ningi: walk the streets . . . come down here basically, do martial arts and play a game of pool . . . something like that. . . We want to do something . . . everybody thinks we just want to sit around and do nothing . . . like, drink beer and watch TV.[23]

This self-representation is partly satiric (it's clear the boys would love to just drink beer and watch TV), but the topic of the video is expanded as the military bunkers become a central motif of the video and act as a link to wider themes of fear, war, and conflict. The young participants record interviews with a local Korean War veteran, Alex Clode, and the bunkers function as a historical referent, offering a suitable focus for a cross-generational dialogue about the thematic issues at hand. The concepts of fear and conflict are introduced through a text of questions and answers "performed" by the participants and their guest interviewee. The request, "Tell us about the history of the Bribie bunkers" is repeated and answered three times by different young participants before leading to increasingly stylized and confrontational provocations, such as "what is war?" and "what is fear?"

Interestingly, the participants video each other's responses to the concepts of conflict and fear, ironically in front of a poster for the movie *Independence Day*, and more seriously via the signifying codes of interrogative television journalism. Their answers to performed questions about fear—such as fear is "an emotion," "a heightened sense of self-preservation," and asserting they had no fear—resonate with the background poster images and with the wording of various T-shirts that they wear. The commodification of fearlessness and risk as male- and youth-specific is pervasive throughout the video (although more as a desirous re-inscribing of these qualities than an interrogation of them). The participants' manner of self-narration indicates the project's complicity with dominant discourses of masculinity, including an idealization of risk.

The project was lauded as an innovative approach to community-based youth-specific performance (Street Arts was formerly a community theatre) that privileged young people's self-narration. As reviewer Shane Rowlands remarked:

> By extrapolating their keen interest in martial arts training to broader considerations of fear, conflict, and (self-)defence, the young men sought to address issues of particular relevance to them, that is, the presumed threat posed by youth to older people in the community and the consequent resentment by youth for being "written off."[24]

In addition, *Zen-Che* can be valued for its intergenerational peacebuilding effort in drawing attention—if somewhat ambiguously—to the contemporary commodification of risk and conflict, and in acknowledging the past, present, and future of conflict and its local and international manifestations.

Judging by the young participants' responses at the community launch of the video in 1997, they were proud of their efforts and enjoyed their participation.

However, it was also evident that the project was driven by a strong political imperative to attract more community resources for the region. Framed by speeches by community workers and politicians, the video's purpose was clearly manifold. In a context where the young men themselves were shy of live performance, they chose not to directly address the families and government workers in attendance, but left it to their mediated performance to "do the talking." And while their self-narratives were prominent, it was also clear that these young men were acting out complex desires to be viewed both as fun-loving guys (albeit without the community resources to keep "entertained") and powerful men subscribing to historically codified constructions of masculinity which valued strength in conflict.[25] With little political or social power available to them, this desirous identification with military strength became an aesthetic substitute for real empowerment. (These concepts of fear and war were far more comfortable and distant propositions to idealize than they might be today, in a post-9/11 environment).

However complex, this youth-specific self-narrative by its very nature valued young people's perspectives and for the first time in that community put those perspectives in conversation with those of the elders'. Through its repeat performance on television screens in the offices of government and non-government service organizations, *Zen-Che* aimed to garner political support for providing social infrastructure for young people in the community.

Conclusion

Issues of justice are animated when young people express their own voice in their own ways. The participatory projects by Contact Inc., Backbone Youth Arts, and Street Arts explicitly utilize young people's grounded aesthetics as a vehicle for young people to examine and transform conflict at a local level. By facilitating young people's direct involvement as artists in their own right, these projects center them as activists seeking just examination of the past, realistic understanding of the present, and positive envisioning for the future. While not all aspects of all projects were successful in *making* peace, these projects offer snapshots of the diversity of youth cultural action in addressing conflict through evoking their "moral imagination."[26]

In Contact Inc.'s Peace Initiative, these moral imaginings are sustained through long-term objectives, empowering opportunities, and a refusal to see the arts as just a vehicle for rehearsing real life or playing with the consequences of "what if." This project sought to marry peacebuilding with real life experience by ensuring that participants gained skills in art-making and intercultural communication. With the common ground of hip-hop, young people could gain new performance skills, a new awareness of each other's cultures, and a new understanding of how conflicts arise from ignorance in their communities. As testimonies from participants show, personal growth was an important corollary of their participation in the work.

Participants hanging out after emcee presentations at Peace Initiative workshop, 2006, Sunnybank. Photo by Peace Initiative participants Kaiya, Rebecca, Taisha, Gabrielle, and Jasmin, Courtesy of Contact Inc.

The Backbone Youth Arts and Street Arts projects similarly sought to integrate cultural development with community development by helping participants learn new artistic, cultural, and social skills. As one-off interventions, the performances of *Sk8 Grrl Space* and *Zen-Che* brought new awareness and multiple perspectives to conflicts that were more latent than those in Sunnybank. The participants in these two very different projects sought to draw attention to the common cultural stereotypes of young people and their interests, and motivate change in the allocation of community resources. By also questioning dominant gender representations, *Sk8 Grrl Space* brought further conflict to light in the process. These projects demonstrate that establishing pathways to peace can be laden with complexities arising from the nature of the conflicts themselves and from young people's diverse influences and experiences.

Peacebuilding through the arts allows for a play of paradox and an expression of diverse realities that help reflect the complexity and insolubility of many kinds of everyday community conflict. Art allows for the coexistence of the rational and the not-so-rational; it can invite emotion without value judgment; and it can encourage expression and psychic release through the use of creative metaphor. And when the mode of art-making (in this case, the grounded aesthetics of hip-hop, skateboarding, and video performance) is so strongly a part of participants' cultural lives, it can create a fertile ground for communication and understanding—common ground on which young people can both map and construct multiple pathways to peace.

In a camp for internally displaced persons outside Luanda, Angola, actors portray an audience member's misery about the hard, heavy work he had to do to earn money to live on. Photo by Bev Hosking

4 Stories in the Moment

Playback Theatre for Building Community and Justice

Jo Salas[1]

Introduction

Playback Theatre[2] grew, starting in 1975, from Jonathan Fox's idea of a grassroots theatre in which ordinary people would make theatre on the spot from the true stories of other ordinary people.[3] This theatre would release drama's magic from the rarefied world of proscenium stages and the finely crafted stories of fictional characters, and return it to its place as an accessible part of ordinary life. When the idea dawned, Jonathan and I were a young married couple already involved in experimental theatre and music. He had studied oral storytelling traditions, and had recently encountered psychodrama.[4] I'd played music since childhood and was drawn to the arts of all kinds, as well as to political activism. Jonathan and I had both lived in the developing world as volunteers, he in Nepal with the Peace Corps, I in Malaysia with New Zealand's Volunteer Service Abroad. Naïve as our motivation undoubtedly was, choosing to volunteer says something about our youthful stance in relation to the world; and the learning we gained in our respective placements played a part in shaping Playback Theatre.

Along with others who were attracted to our vision of this new theatre, we began to explore how to make it work, forming an ensemble which was simply called "Playback Theatre"—now often referred to as the "original company."[5] (One of the key founding members, Judy Swallow, was also a former Peace Corps volunteer.) We developed forms and protocols so that audience members would feel both the trust and the excitement necessary to come forward with their stories. That essential but

paradoxical task of creating safety along with the artistic embrace of the unknown has been a major focal point of training for Playback Theatre practitioners.

Within a few years other people wanted to do Playback Theatre, as we soon named it. Some of us began traveling and teaching. At this point, thirty-six years later, Playback Theatre is established in about sixty countries and used in an extraordinarily wide variety of settings ranging from theatres to prisons, schools to refugee camps, weddings to staff retreats, street festivals to government departments. Later in this chapter I'll focus on two uses of Playback Theatre: addressing school bullying in the United States, and working with victims of war in Afghanistan—very different applications of Playback with the common element of training members of the intended audiences to become performers for their peers.

Playback Theatre is improvisational and interactive: personal stories are told during a performance and enacted on the spot. In its most familiar form, three or four actors listen to a story told by a volunteer from the audience, mediated by an onstage emcee, the "conductor." The actors act out the story without discussion or planning, accompanied by improvised live music. In the first twenty minutes or so of a performance, the warm-up phase, audience members speak briefly from where they sit and the performers respond with short, movement-oriented pieces. Later, tellers are invited to sit onstage with the conductor and tell longer stories, choosing actors for one or more key roles. In a one-and-a-half-hour show, there might be eight or ten brief statements or narrative fragments, and three or four longer stories. The "stage" itself—usually not an actual stage but the front of a room—is set up with chairs on one side for conductor and teller, chairs or cubes for the actors, a stand with fabric props, and a set of musical instruments. There are no costumes or sets since the stories, settings, and characters are unknown ahead of time.

Playback Theatre embodies these principles:

- Emergence: the events of the show emerge out of the moment and are not preset. Stories or tellers are never chosen prior to the show.
- Any story is welcome.
- We honor the teller and the story: we want her or him to feel heard, comprehended, and respected.
- The story of the group is ultimately significant. It takes shape through attending fully to one person at a time.

Playback Theatre's versatility is both a strength and a weakness. What can be the common purpose of such a mercurial form? Those of us engaged in this work wrestle endlessly with questions posed by others, and sometimes by ourselves—"What *is* it? And what is it *for*?" Ultimately, in my view, it is for dialogue and the building of connection and empathy—the moral imagination—through the potent medium of theatre, which means invoking aesthetics, imagination, and the physical self.

John Paul Lederach's discussion of the moral imagination is described by the editors in chapter 6 of this volume. Robert Wright, the author of *The Evolution of God*,[6] defines the moral imagination as "the ability to put ourselves in the shoes of other people, especially people in circumstances very different from our own."[7] Both in peaceful settings and in situations of conflict, the exchange of stories in the ritualized space of Playback Theatre has the capacity to engender empathy and create or strengthen community bonds as multiple voices are heard with respect and responded to with creativity.

Context in Playback Theatre

Playback Theatre's impact depends on a subtle weaving of artistic and social-interactive elements. And, to add enormously to the challenge, the requisite balance between these elements varies according to context.

In the early, idealistic days when people outside the original company began to adopt the work, our message to them was open and encouraging—sure, anyone can do it! We did not know enough ourselves to articulate the reality that this work is complex and highly context-sensitive. "Anyone can do it" is much too simple. Anyone can tell a story, yes. As Jenny Hutt and Bev Hosking[8] write below about Kiribati, it is a basic value of Playback Theatre to accept and enact any true story, whether joyful, tragic, disturbing, funny, anecdotal, or epic (which does not mean that all stories are handled the same: those that embody trauma or prejudice, for example, demand special considerations, which I'll write more about later in this chapter). But who can *enact* a story, who can *do* Playback, depends on the context.

Playback Theatre takes place in both workshop and performance formats. In a workshop setting, the work is at its most intimate and informal, with one or two trained leaders but not with a performing team or a defined audience. The members of the group, whether one-time or ongoing, adult coworkers or children, etc., take turns telling stories and acting them out for each other. In this contained context, almost anyone can enact a story in a way that has meaning for the teller and the other group members. (The rare exceptions are people who lack the personal stability to step into the role of another, or a person who is unable to access

Fostering Social Inclusion in Kiribati

In 1998–99 Bev Hosking and Christian Penny[9] from New Zealand taught Playback in two villages of the South Pacific nation of Kiribati [pronounced *Kiribass*], as part of an overseas development project funded by the New Zealand government. The project complemented other training aimed at increasing the participation of women in decision making, and tested whether Playback Theatre could influence and empower women within their families and local communities.

Story is itself to some degree an indirect communication. Stories are multifaceted, allowing a listener many entry points to understanding or learning. Jonathan Fox notes that "in stories, the value, the meaning, often reveals itself only indirectly."[10]

Bev and Christian used Playback Theatre to work with the whole community and all its stories, rather than focusing explicitly on the topic of enhancing women's role in the community. As stories from women and men were told and performed, enough trust developed between them for some of the core stories and conflicts around gender to emerge. This happened privately in the workshop sessions and then more publicly in the performances.

A woman told of her relationship with her father, which involved criticism, an overuse of power, and physical beating. Her father had told her that she was bound to marry a good-for-nothing man. In fact she married a fine man who involved her in decisions, shared his successes and difficulties with her, and was respectful of her. The teller and the audience were deeply affected by the enactment of this story.

The workshops provided an environment for modeling and enacting equality in the relationships between men and women. The trainers demonstrated an equal and respectful working partnership. Women aged from fourteen to fifty-six years participated actively and equally as participants in the training workshops, in group decision making during the workshops, and in leadership groups established in each community. They willingly told stories about their experiences, which made visible and acknowledged their contribution to community life. Impacts of the project were immediately observ-

even a small degree of spontaneity.) It requires minimal skill or training on the part of the "actors" for the process to work. The teller readily enters a mild trance state—the creative space of lending your imagination and your belief to what you are seeing. (Any theatre performance must evoke this trance if audience members are to believe in the characters and events on stage.) In that trance the teller is likely to accept the enactment, however simply or even poorly done, and feel that the actors have captured his or her story effectively.

However, in performance settings, with a defined audience and team of performers (actors, conductor, and musician), the actors have to convince not only the

able: the women's shyness and self-consciousness dropped away and their confidence in presenting themselves in front of the group increased noticeably.

The process of learning the basic skills of Playback Theatre in the training workshops created many opportunities for a growing understanding and strengthening of the relationships between women and men. They worked closely together and built on each other's work in creating dramatic enactments. They regularly chose actors to play roles in their stories without reference to gender and there was little difficulty in playing roles of the opposite gender. Stories of ordinary daily activities from the lives of both women and men were listened to without judgment and the dramatic enactments were received with appreciation and delight. New pictures and possibilities of relationships between women and men were beginning to be voiced and witnessed in the community.

One participant in the group was marginalized in his community because of his sexual orientation. He was isolated in the group, and often on the receiving end of harsh jokes. The trainers worked hard to include him at different points in the workshop and to value what he had to contribute. They also worked to build a strong enough relationship with him and with the group to create the conditions conducive for him to tell a story.

Bev reflects, "When we finally invited him to tell a story he accepted and came to the teller's chair with a vulnerability that was very poignant to witness. He told a story about building, then losing, a close friendship. His love for this friend was evident and there was a sense that perhaps for the first time he was able to say his friend's name in public. As they listened, the group was able to go beyond their stereotyped view of this man and to see his humanity. They enacted his story with a great deal of tenderness, compassion, and respect. This proved to be a turning point in the relationship between this man and the group. That evening we observed a warmer, more expressive connection between a number of the participants and this man. For the rest of our time together we noticed a marked decrease in people singling him out for ridicule."

—*Jenny Hutt and Bev Hosking*, excerpt from *Playback Theatre: A Creative Resource For Reconciliation*[11]

teller but also a roomful of others who are not so easily caught up in the trance—unaided, in this kind of theatre, by sets, costumes, or lighting.[12] The requirement for skill becomes much higher. The larger or more heterogeneous the audience, the more necessary it is for the performers to be competent, not only in their stage skills but also in their ability to work as an ensemble. Without those skills the performance will fail both as art and as dialogue because in Playback Theatre they are indivisible. The artfulness enables the dialogue; the dialogue is the basis for the art.

It is important to say that the kind of dialogue that can happen in Playback is not cognitive: it is not a process of discussion, of thought and logic. Instead, it is a

dialogue in the language of story, image, emotion, and physical action—an embodied, imaginative dialogue. We call it a dialogue because, in the unfolding of a show, the stories are summoned and prompted by each other, often unconsciously—it may not be until long after the event, if at all, that one can discern the actual pattern of the dialogue, the "red thread."[13] (This metaphor, common in the German language, is borrowed from weaving, where a red thread allows the weaver to follow the pattern in process.) The teller is welcome to say something after seeing his or her story enacted, but there is no invitation to the audience to comment or analyze. Instead, they're invited to offer the next story.

In a performance in which conflict arises, participants' opinions may not necessarily change. But each person's comprehension of their own and others' experience is altered and expanded, however subtly. I've noted, as a teller myself, that when my experience is reflected accurately in the spontaneous, artistic, and physical expression of others, I have the *kinesthetic* conviction that I have been understood. Others speak of a similar experience. That sense of certainty creates a kind of softening and relaxation, and an increased openness to another point of view. Listeners, hearing the human voice of the teller and seeing her or his story brought to life, find a little more space within themselves to accommodate the humanity of that person and her or his perspective. The moral imagination grows.

As I said earlier, the necessary level of skill for the actors depends very much on whether the event is an intimate workshop or a performance, and what kind of performance. However, in contrast, the conductor requires sophisticated skills in any context. This role is by far the most demanding in Playback Theatre, calling on those of us who adopt it to synthesize a distinct set of abilities and learning.[14] We must be able to listen deeply to any individual story with courage and openness; we must be able to build, read, and guide the dynamics of an audience or group of (usually) strangers, taking care to include those who are isolated, as in the Kiribati community described by Jenny Hutt and Bev Hosking; we must have the artistic sensibility of a storyteller or theatre director as we hear the story and elicit key information; we must be able to pace and shape an event so that it remains engaging for all present; we must be educated about the world that our audience members and tellers live in; we must have the humility to remember that we're part of a team, not a soloist; we must have the knowledge to respond wisely to stories that contain danger or pain for the teller or audience. This knowledge encompasses both a deep understanding of the form—of how to use Playback Theatre—and of the human psyche.

It takes extensive training and solid experience to be a competent conductor—and likewise to be an effective performing ensemble. (Most Playback companies aspire to last indefinitely, and several have been going for twenty years or longer, giving them time to develop enduring relationships within the group as well as considerable

skills.) As Jonathan says below in "A Theatre of Personal Story," this inescapably long learning curve has been an obstacle in the use of Playback in troubled parts of the world where extended time for development is unrealistic and resources for in-depth training are not available.[15]

The Participant Performance Model

What I am now calling the participant performance model is emerging as a use of Playback Theatre that may allow for the impact and scope of performance without requiring the years of development that ordinary performing companies need. Playback practitioners over the years have carried out projects that, as I look back, were akin to this model, but I am now suggesting that we name and develop the concept as an alternative to other designs. Participant performance has the potential to make Playback Theatre more portable and adaptable in situations of crisis. While a typical Playback company strives both for longevity and the ability to perform for any audience, the participant performance model is based instead on training a small number of members (ten to twenty) of a particular interest or population group to carry out performances *for other members of that same group*, often for a time-limited project. Because of this very specific focus, it is possible to perform effectively after a relatively short, targeted training, which builds knowledge and skills relevant to the purpose at hand. The performing team is congruent with the audience and tellers—they come from the same community, they share background and concerns, and may be known to each other. The actors' portrayals of stories, even if not highly skilled, are convincing and satisfying to the audience because actors draw on the life experience they share with the audience: the audience's trance is successfully evoked at a lower level of artistic sophistication than in more traditional uses of Playback.

Training for participant performance varies according to various factors: the existing skill and relevant experience of the performers; their maturity and emotional readiness in relation to the stories they will be called upon to act; the number and variety of the performances that are planned. The trainers themselves (ideally two, so that one person supports the actors' team while the other guides the overall process) need to be seasoned practitioners with the wisdom and perspective to distill the aspects of practice most essential to the task at hand. Training might take place in a two-month series of weekly workshops (as with the children in the anti-bullying work) or in intensive training sessions lasting from six to twelve days at a time (as in Afghanistan and Angola).

Some important questions about participant performance are not yet answered: most pressingly, what about the conductor or conductors? There seems to be no way to shortcut the training process of a conductor, and without a high level of

competence a conductor can get into deep water, especially in situations of social fragility and individual or collective trauma. In some situations it may also be necessary to include one or more experienced actors along with the participant-group actors. What does this mean about offering Playback Theatre in a place where there are no trained conductors or experienced actors? If the work is too risky without them, these key figures may need to be imported, raising logistical and practical questions (funding, language, duration) and also questions about the congruence of the leadership; how to make this resource available without being yet another Western-derived form dependent on Westerners for implementation. I'll discuss these issues more after describing the two participant performance projects I mentioned earlier: one addressing bullying in the conflict zone of schools in the United States; and one working with victims of war in Afghanistan.

Participant Performance and School Bullying

Emma—not her real name—is a seventh grader. She's small for her age, slender, very smart, and very artistic. She's not part of the "popular" crowd in her class. Emma's interests are different, she doesn't make friends easily, she can be a bit sarcastic and prickly. For a long time, she's been the target of daily, relentless, cruel bullying. She comes to school every day knowing that other kids are going to make fun of her, isolate her, and humiliate her. She feels powerless to stop it. She's talked to her teachers and her parents. Her parents have talked to the assistant principal. The assistant principal has scolded the bullies. Nothing seems to help. She says: "It feels like they're tearing my heart out." All she wants is for the other kids to leave her alone. She would also like it if a couple of the other girls would ask her about her artwork.

Emma has five more years of school. She doesn't know how she's going to survive.

Old Problems, New Initiatives

The problem of school bullying is far from new. Kids have been brutal to each other for generations. In his autobiography *Goodbye To All That*[16] the British poet Robert Graves described being viciously teased and humiliated at school because he enjoyed studying more than sports, he didn't wear the same expensive clothes as the other students, and he had a German middle name. His description of how he was treated could have been written yesterday—but he's talking about 1910, not 2010. Many adults have vivid memories of experiencing or witnessing bullying as children, and the memories may remain raw and painful throughout their lives. In mid-life Graves wrote: "I suffered an oppression of spirit that I hesitate to recall in its full intensity."[17]

Two boys enact a classmate's story. They were both members of a group of twelve- to fourteen-year-olds who learned to do Playback Theatre and then performed for audiences of other students, listening to their stories about bullying and creating theatre on the spot. The boy in front described the whole experience as "exhilarating." Photo by Elissa Davidson

In those times, and until relatively recently, school bullying was accepted—even condoned—by adults who justified it as normal behavior, an inevitable part of growing up. Now, at last, teachers, parents, community members, and researchers are attempting to do something about it. We're no longer shrugging our shoulders and pretending that the damage is insignificant. In the past twenty or thirty years there has been a deliberate and growing trend to figure out what's going on when kids treat each other cruelly, and how to stop it. School bullying is a profound problem without easy solutions: in spite of these decades of attention and concern, it seems to get worse, with the development of online weapons for bullies and the enormous tragedy of young people who have been literally bullied to death.[18]

Defining Bullying

There is still a considerable amount of confusion, among both children and adults, about what school bullying is and how to deal with it. The differences between bullying and fighting are not always understood, for example. A teacher who sends a bully and his victim to peer mediation, with the implication that both share responsibility for the conflict and the power to end it, may be subjecting the victim to further trauma. Another common misperception is that children can and should deal with bullying by ignoring it, or by standing up for themselves. Such tactics may work for some kids, but many who are targeted are not equipped to defend themselves, nor will the abuse end if it is ignored. It is essential to understand the salient elements of bullying if we are going to address it effectively:

- Bullying is when one or more students deliberately target other students to make them feel bad.
- Teasing is bullying if the person being teased feels hurt or humiliated.
- Students may be targeted because they are perceived as different in some way, including race, color, ability, sexual orientation, class, etc. Difference may be none of these, but just a personal style or quality.
- Bullying is typically repeated over a long period of time.
- Bullying can be physical or verbal, including name-calling, racial slurs, and cyberbullying.[19]
- Ostracizing someone is bullying.
- There is always a discrepancy in power between the bully and the victim (size, popularity, age, numbers, majority race, etc).
- Bullying is different from fighting in that it isn't between friends or equals.
- In a fight, both sides are usually angry. In bullying, only the victim is upset. The bully is often enjoying himself or herself.

The most essential thing is the first point: bullying is deliberately hurting or humiliating another person. The personalities of the children involved are a factor, but bullying is not primarily a matter of individual personality, nor is it generally a dyadic interaction. Bullying happens within an ecology of peer group, school, family, and community: "Internal factors in the individual interact with the social environment, which then serves to reinforce bullying and/or victimization behaviors."[20]

Bullying is a group phenomenon: one child may initiate bullying but other children are almost always involved as active supporters and enablers of the bully as well as passive bystanders. A bully generally wants and needs an admiring audience.

The group nature of bullying creates a crucial opportunity, since peer involvement can be mobilized for positive, not negative, ends.

Why Does Bullying Happen?

Why do children bully? There is little truth to the stereotype of a bully as someone who hurts others because he or she feels bad about himself, although there is some correlation between bullying behavior and harsh punishment in the child's home.[21] But there are plenty of bullies among the "popular" kids—the pretty girls, the athletic boys. The attractive girls from prosperous families who tormented Phoebe Prince to death in Massachusetts were not lacking in self-esteem.[22] The explanation for why some children bully others is elusive and complex, not a simple matter of victims turning on others to make themselves feel better. Nor is it accurate, in fact, to speak of "bullies" as though this is a fixed identity. Many (though not all) children move between the roles of bully, bystander, and victim: in a given incident there may be a clearly defined bully, but on another occasion that same child may be a witness or a victim.

Bullying is impossible to comprehend or address without looking at a much larger picture. It is a phenomenon that has to do with the legacy and challenges of being human. We are all capable of cruelty as well as compassion and we make decisions—not always conscious or rational—throughout our lives about which aspect of ourselves we are going to develop and express. Young people whose innate empathy and altruism are supported by the adults around them, who are treated with respect and empathy themselves, are more likely—though not guaranteed—to strengthen that part of their character.[23] And conversely, kids who see cruelty and disrespect modeled and tolerated, or even rewarded, in their family and close community, are more likely to show that kind of behavior.[24]

The human capacity for cruelty is enacted throughout society. Our species is magnificently capable of kindness, empathy, and altruism. But children also see heartlessness and disrespect replicated on every level, from family and community interactions to television shows and video games, to local, national, and even international politics: the United States, where I live, is viewed as a bully by much of the rest of the world. Children constantly absorb images and stories of adults being hateful and unjust to other adults, treating them unkindly, disrespecting and excluding people on the basis of differences.

The role of negative adult modeling is evident in cyberbullying. The anonymity of the Internet allows people to publicly express their worst selves without consequences to themselves. It used to be that anonymous letters—the old-fashioned kind that arrived in the mail—were generally viewed as morally unacceptable, a very low

form of aggression. That distaste seems to have vanished: anonymous comments that are rude, intolerant, offensive, and intentionally hurtful have become ubiquitous online. These comments would not be made face-to-face, nor if the commenter's identity were known. If all online discourse had to be identified, can anyone doubt that it would quickly become more civil? I believe that we cannot begin to address cyberbullying among youth without facing this adult version of it.

Expecting young people to end school bullying within this wider framework of human harshness may seem a gargantuan, even hopeless, task. And yet the cycle of cruelty and indifference to suffering must be interrupted wherever possible. Idealistic as it may sound, a generation of children who learn to treat each other well, to stand up for what they know is right, may grow up to be a generation of adults who bring consciousness, compassion, and justice to all their interactions and decisions. In their *New York Times* op-ed "There's Only One Way to Stop a Bully" Susan Sandstrom and Marlene Engel wrote, "Our research on child development makes it clear that there is only one way to truly combat bullying. As an essential part of the school curriculum, we have to teach children how to be good to one another, how to cooperate, how to defend someone who is being picked on and how to stand up for what is right."[25]

Conversely, as another team of researchers discovered, if bullying is not prevented, "middle schools may unfortunately serve as laboratories for the development of individuals who feel indifferent to the victimization of others."[26] Unfortunately, in the absence of intervention, children's natural capacity for altruism decreases as they get older and their capacity for cruelty or indifference becomes stronger.

Playback Theatre and Bullying

The first systematic approach to addressing school bullying was based on research conducted in Norway in the 1970s by Dan Olweus.[27] By now there are numerous other anti-bullying approaches as well, all of which can help if certain basic principles are met:

- There must be a school-wide and preferably district-wide commitment to address bullying for the long term. Controlling bullying is a multifaceted, never-ending task.

- All the adults involved—teachers, aides, administrators, bus drivers, as well as parents, ideally—need to be educated about bullying and prepared to respond consistently and promptly to any instance or report of bullying.

- Interventions need to be based on knowledge and research about bullying.

- Along with consistent consequences for children who bully, the approach must actively foster respect and empathy.

The Playback Theatre approach that my ensemble and I have developed, called "No More Bullying!" (NMB),[28] works alongside programs such as OBPP (Olweus Bullying Prevention Program)[29] or PBIS (Positive Behavioral Interventions and Supports),[30] deepening and extending their impact.[31] We use Playback Theatre to engage personal stories, emotions, and the physical self with the intention of fostering empathy and the capacity to take responsibility for fairness. As a theatre-based form, NMB draws on the unique potency of the arts, which invoke creativity, synthesis, vision, and imagination. Artistic expression is available to all children, regardless of gender or other identity factors, and allows them to access their fullest selves in dealing with the complexities and challenges of their world. Art engenders new visions and new possibilities—for example, a school where everyone is safe, welcomed, and respected. Change begins with vision: the educator Maxine Greene says: "It is imagination that draws us on, that enables us to make new connections among parts of our experience, that suggests the contingency of the reality we are experiencing."[32]

In Playback Theatre performances, children are invited to speak about an experience as a victim, a witness, or a bully, then watch as their feeling or story is enacted on the spot either by a team of professional adult actors—or, using a participant performance model, by student actors and adults together. The performances take place in an atmosphere of respect and safety in which children, often including the most hurt or isolated, feel empowered to speak up. This atmosphere arises from several elements: the consistent modeling of respect on the part of the adults; the immediate addressing of any instance of disrespect during the show; the structuring of space and time to create a sense of containment; and the welcoming, nonjudgmental embrace of every comment or story that the students offer.

These live performances have a different kind of impact from other presentations. If you're a child, you can sit in an assembly and tune out a visiting speaker or a video. You can ignore the slogans in mass-produced posters along the hallway. But if a girl in your class is right there in front of you, telling her story and feeling her feelings, if her story is then enacted by real people who use her words and embody her emotions, you're likely to be riveted and your own feelings stirred. You are likely to remember that story.

NMB acknowledges the innate capacity that young people have for empathy and decency, and seeks to strengthen this capacity so that it is more resilient than the impulse for cruelty. The program is also based on the fact that, as I mentioned earlier, bullying is essentially a group phenomenon. It is not a problem between two students. It is a problem both of the immediate group of kids who are involved in an incident as bullies, witnesses, and victims; and of the larger group of the school and the community. But if the group is an essential component of bullying, it also has the potential to be an essential part of the solution. The greatest potential power

to shift the climate of a school towards safety and respect lies with the majority of students who are neither bullies nor targets. Most are troubled when they witness bullying but do not know what they can do about it—nor do they realize how many others share their feelings. NMB focuses on the role of the witnesses or bystanders, empowering them by letting them realize how numerically strong they are, and by offering a creative setting in which they can identify and rehearse actions that are practical, accessible, and effective.

Although we sometimes use the more traditional performance model in this work, particularly with young children, we prefer whenever possible to use the participant performance model—training a group of children to become actors in performances for their peers. (Whether we include student performers or not depends on the school's choice and resources as well as grade level: elementary school students are too young to take on the considerable responsibility of enacting sensitive stories.) We call it the No More Bullying! Leadership program because many of the young people who are involved become leaders in the school, with the knowledge, courage, and solidarity to stand up to bullying in an ongoing way.

For the NMB Leadership program, school personnel choose about fifteen students, representing the school's diversity in terms of age, gender, ethnicity, ability, and social standing, to take part in a series of training workshops led by two Playback Theatre leaders. Over a period of seven or eight weeks, meeting once a week, students learn the basics of Playback, and they also learn about bullying—an expanded version of the learning that takes place for audience members during the performances. They all have a chance to tell their own stories, which they enact for each other, developing considerable empathy as well as concrete knowledge about what bullying is and how students can address it. (The necessity to elicit and emphasize this knowledge is somewhat at odds with the fundamentally emergent nature of Playback Theatre: fulfilling both makes the work exceptionally demanding for those leading a performance.)

By the time the performances take place, the students have bonded well and are confident in their skills. They join adult performers in rotating teams so that all have a chance to take part: each team consists, typically, of four students and two or three adults, including the conductor. Student observers from the group take notes and report on what they notice.

For the audience members, seeing their peers onstage increases the impact of the content: as one of our teenage actors said afterwards when we were evaluating the project: "Grown-ups are always telling us about drugs, and bullying, and things we shouldn't do, but if a child hears it from a child, they listen." The young people's performance skills of course do not approach those of the professional actors, but they make up for it in unselfconscious authenticity and familiarity with the audience members' frame of reference.

Over the course of this two-month experience of training workshops and per-formances, the student group members also become empowered to be anti-bullying leaders in the school in an ongoing way. This capacity emerges organically: as they learn in depth about bullying, they feel their own power to take action, knowing that they are not acting alone. Their comments at the close of this project consistently express notable insight and the resolve to do what they know is fair and right. A ninth grader said: "It made me think a lot, to bend a bit. I feel like I learned a lot because it made me more open to how people are different from me and to look at who they are and not where they come from or what they can and can't do."

The Performances

Performances generally take place with an audience of between twenty-five and fifty students. They can be at any grade level from kindergarten to twelfth grade, though it's most effective with fourth to ninth graders (nine- to fifteen-year-olds). Prior to the show, teachers receive a lesson plan with guidelines for helping students focus their thoughts about bullying (as well as a lesson plan with follow-up activities). The show begins with performers speaking briefly about and enacting their own experiences relating to bullying. Then we invite audience members to generate a definition of bullying and to describe what kids actually do to make other children feel bad. Students typically bring up physical and nonphysical bullying, and cyber-bullying. We make sure there's a clear understanding about the difference between bullying and fighting.

Once we've all generated a definition of bullying—a vocabulary—we begin a kind of dialogue through theatre: we ask the children about their thoughts and ob-servations and feelings about bullying, and we perform their responses on the spot.

"What's it like for you when you see someone being picked on?"

"I feel sad."

"Let's watch," and then the actors enact that feeling with sound and movement, along with improvised music. Watching, everyone in the room understands what that child meant. They understand it viscerally—it's not just about the words, it's about the physical expression. The kinesthetic response mentioned earlier plays an important part. If you're the "teller," seeing your feeling expressed in the bodies, faces, and voices of the actors allows you to know beyond a doubt that you've been heard and understood. This certainty is very significant, especially for children who've been victimized and are very painfully aware that their feelings are not usually understood at all.

We hear from a number of students in response to a series of questions, and then we invite them to cocreate a short scenario about an imaginary character who's being bullied, played by one of our adult actors. (Role-play is not a traditional part

A Theatre of Personal Story

All of us need to tell our story. It is—as Barbara Myerhoff[33] claimed—core to our definitional identity. Those whose lives have undergone upheaval have an even greater need because their identity has been changed by events. To have the chance to tell what happened—and even more to see this narrative embodied on the stage—can help a person move forward with life. It can move traumatic memory into narrative memory (Judith Herman[34]); it can crystallize awareness of pressing social issues (Paulo Freire[35]); and it can open a doorway to the future through the integration of the past (Robert Bellah[36]).

The receptivity to a theatre of personal story is much greater now than it was thirty-six years ago at Playback Theatre's start. Due to the Internet and the rise of social networking we now live surrounded by the everyday narratives of our neighbors. This is not a bad development, except that it is not face to face and the stories are all too often trivialized and truncated. Playback Theatre, in contrast, draws on the intimacy of oral communal experience. One story told and enacted publicly in the immediate present leads to another from an audience member. These stories build on each other, reply to each other. A dialogue emerges through the stories told and enacted on the stage. It is unpremeditated, indirect, almost always empathy-building, occasionally transformational. Ultimately the emphasis is not on the individual's story but on that tapestry of interconnected stories that paints a picture for the community of its concerns.

Our societies suffer from a politicization of history in which those in power control the official narrative. Playback Theatre, often performed in intimate venues out of sight of the authorities, keeps alive a people's (unofficial) story. These stories are often complex, as stories are, and the medium of live theatre can render them on multiple levels at once in a way that invites recognition from others present.

The original vision for Playback Theatre consisted of a stage and an audience, with a team of "citizen actors" comprised of members of the same community, ready to act out with aesthetic sensibility the local stories. Playback Theatre started in upstate New York, spread slowly to other American communities, then made a leap to Europe, Australia, New Zealand, and Japan. Afterwards it spread to Eastern Europe, Israel, and the developing world, including Latin America, South Asia, Africa, and Central Asia. In the course of this growth we have been confronted with more than artistic challenges.

of Playback Theatre, but it's helpful in this context to intensify focus on the topic and the actions we want to explore.) Other actors, as well as volunteers from the audience, play bullies and witnesses. Audience members are asked to make suggestions about what witnesses could do to help, and we act out each suggestion. Invariably, children suggest getting an adult to help; befriending or supporting the victim; and telling the bullies to stop. We also emphasize the importance of not

Training is one major issue. Playback Theatre has a long learning curve. Actors need dramatic skill, deep listening skills, and enough personal maturity to separate a teller's story from their own. Musicians need to learn a new kind of improvisation. The role of the conductor (our term for the emcee) is highly complicated. Yet field workers face great pressures to implement new knowledge fast, bringing just-learned concepts to community audiences brimming with big stories that novices are not ready to handle. How to resolve this tension, especially when economic pressures are added?

The issue of safety is of particular concern to a theatre of personal story. This is especially true in regions of conflict, where the traumatic experiences of audiences and performers alike are just under the surface.

Respect for all persons is a fundamental premise of Playback Theatre, but tellers' stories sometimes contain prejudice, whether unwitting or not. As community-based performers, we are unwilling to disparage or objectify any group on our stage. In other words, we believe that while it can be salutary to share narratives, healing cannot come at the expense of justice. There will always be social groups who are isolated and disparaged. We seek to have their voices heard. The first step towards this goal is to look deeply into one's own prejudice and the biases of one's performing team.

In fact as Playback Theatre is introduced to new regions, congruence is another ethical issue: how to prevent old imperial injustices from being perpetuated as Playback spreads from world power centers?

Playback Theatre's development has been very incremental. This slow, organic growth, while we work out congruent, sustainable ways to transmit our knowledge, is a good thing. In the long term it will hopefully increase the chances of communities everywhere to make use of this approach to communicate about their experiences, especially following times of crisis. The world lacks adequate methods for community groups to tell their big stories, those that may be risky to bring to a public forum but even more dangerous to bury in silence. Playback Theatre's aesthetic emphasis enfolds any story, whether ordinary or unspeakable, in art's embrace, providing a heightened dramatic event to help a community find new reserves of empathy and hope.

—*Jonathan Fox*, founder of Playback Theatre

making the situation worse by joining in (a temptation, since the bullying may look like fun). Sometimes a child suggests violent retribution for the bullies. We don't enact that suggestion, instead pausing for discussion about the way that violence tends to backfire.

Once the set of constructive actions has been identified and practiced, we explore in further vignettes how they can also be used with cyberbullying. These common-sense actions, springing from the sense of fairness, altruism, and responsibility that is the basis of decency and good citizenship, readily translate to the world of online bullying.

And then we invite children to tell their own stories, which we act out on the spot—stories about when they might have felt like the character in our scenario, or like one of the witnesses. Or a bully. In each enacted story, we spotlight the actions that witnesses took, or failed to take, or that the teller wishes they had taken. Each story becomes an opportunity to revisit and further rehearse the empowerment of the witnesses.

Children who are isolated and vulnerable often respond to this opportunity to be heard. We are aware of the delicacy of such stories, and the risk that telling them might make things even worse for the teller. However, such consequences do not seem to ensue. We have not been told of instances where a teller was further victimized as a result of telling his or her story. (So far, resources have not permitted extensive follow-up: however, occasional follow-up surveys and informal reporting from school personnel and children themselves over twelve years of performances have indicated only positive outcomes. We are currently developing a research project with Fordham University to further explore and measure outcomes of the project.)

Several factors account for the fact that vulnerable children are apparently able to tell their stories safely. One is the norm of respect that is established strongly at the outset of every show and maintained throughout. We may explicitly recruit the audience's respectful attention when a story unfolds to reveal a particularly tender situation. Following the show, we make a point of ensuring that a responsible adult will take action to address any ongoing unresolved situations that emerged in the stories, and that any child who is especially in need of support will receive it.

Emma, the seventh grader I mentioned at the beginning of this section, told her story in one of our shows. It was hard for her to come forward. She waited until the show was almost over. She decided to speak up because, as she said, "This is the end of the trail"—meaning she felt it was her last chance to make things change. She's tried everything else. The only thing that can make life better for her is for the kids who witness the bullying to speak up, do something, be friendly and supportive to her.

When she told her story the fifty students in the room were silent and attentive. The student actors, her peers, listened intently. At the end of the show, two thirds of the children present raised their hands solemnly when we asked if they felt they could take one of the actions we'd explored the next time they witnessed bullying.

After the performance ended and the audience left, the student actors spoke urgently about Emma's story, which had shocked them. They resolved to find out more about her artwork, and to stand up for her if they ever saw her being bullied.

Adults can and must help too, but they cannot solve the problem without the students' involvement. Emma herself certainly cannot solve it. It would be nothing but cruel to tell her to ignore the bullying, not to let it bother her.

Participant Performance in Afghanistan

A very different example of participant performance appears in the Afghanistan project created by Hjalmar-Jorge Joffre-Eichhorn, a theatre practitioner of Bolivian and German background who had worked in Theatre of the Oppressed (TO) for some years and had participated in several Playback Theatre workshops. This account is based on Hjalmar's written account[37] as well as e-mails and conversations. His work shows the use of Playback Theatre in an extremely fraught context where trauma, both historical and current, is constantly present. As he describes, Playback Theatre's impact has been both constructive and at times problematic. For myself and other longtime practitioners, Hjalmar's work presented a new frontier for Playback Theatre—could it really work in this shattered and volatile setting? As the project unfolded, e-mail bulletins such as this seemed to indicate that yes, it could:

> "Now I understand the power of Playback Theatre" is what one of the participants of our participatory theatre training said after performing for a group of thirty widows,

Two participants enjoying their fellow-actors' performance in the Playback Theatre project in Afghanistan. Photo By Karin Bettina Gisler, Playback Theater Zürich

earlier this afternoon. The performance was almost cancelled, as the women initially did not accept any (young) male actors and insisted that only our four women plus me as the foreigner could perform. In the end, they accepted all of us and we had a very strong one hour and forty minute performance, with many tears, laughter and small moments of beauty, such as when an old woman put her leg on the (female) conductor's leg to calm her down. Tomorrow and the day after tomorrow we will have another two performances for victims' groups, and then finish off the week with performances at Kabul University, a children's residence and an organization that works with hearing-impaired children and adults... ten performances in six days... Playback has arrived in Afghanistan.[38]

Hjalmar first came to Afghanistan in 2007 to work as a civil peace worker. In 2008 he joined UN-Habitat, United Nations Assistance Mission in Afghanistan, and the Afghanistan Independent Human Rights Commission as a theatre consultant, planning to combine theatre and transitional justice (TJ) activities.[39] After decades of violent conflict and human rights abuses without hope of official redress—and with a recent ruling on amnesty for war criminals[40]—the idea of transitional justice was embraced by many Afghan citizens and organizations, although viewed with mistrust by officials.

In 2008 Hjalmar created a project that would offer Theatre of the Oppressed and Playback Theatre as well as more conventional theatre approaches as vehicles for victims of violence to address transitional justice. He recruited twenty-four men and six women, training them first in TO and then in Playback Theatre. Between them they represented fifteen different organizations.

The Playback training (Hjalmar has written elsewhere[41] about the project in its entirety but here the focus will remain on the Playback Theatre segment) consisted of an introductory six-day Playback Theatre training which Hjalmar led, followed by sixteen "on-the-job training" performances for various audiences of twenty to thirty

A Kabul Story

"I was forced to marry when I was twelve years old. During the civil war my husband disappeared and I was left alone with four children, two girls and two boys. I worked very hard for all of us to survive but one day, because of the cold weather, one of my sons died. Shortly after, both my daughters married when they were around eleven years old. Now I am basically alone and do not have enough money to put food on the table." —*An audience member in Kabul*

people, including victims' and widows' groups, children, and the hearing-impaired. (Hjalmar speaks Dari but also used Dari, Pashto, and, at times, Afghan Sign Language translators for the workshops and performances.) Six months later, fifteen participants—the group reduced in part because of a change in location—took part in a further six-day workshop with Karin Bettina Gisler, the founder and director of Zurich Playback Theatre and a graduate of the Centre for Playback Theatre in New York. The training with Karin was again followed by multiple performances.

In early 2009 ten of these participants, with Hjalmar's support, created an Afghan-led community-based theatre platform, the Afghanistan Human Rights and Democracy Organization (AHRDO). Hjalmar writes:

> AHRDO was founded with the desire to bridge ethnic and gender conflicts as well as run a largely non-hierarchical local organization (something basically non-existent in Afghanistan). Originally, there was a total gender balance in terms of the theatre staff. Lately, this has changed as some of our female staff got married and have consequently left AHRDO.[42]

The ensemble, which also includes people of different ages and two hearing-impaired men, uses both TO and Playback as well as more conventional theatre approaches. Their goal as they set out was to provide opportunities for Afghan men and women to explore human rights, democracy, and transitional justice. They also hoped that through the theatre projects, victims' groups would build contact and cooperation among themselves, allowing them to speak with a coordinated and stronger voice in their discourse with policy makers.

During 2009 and 2010 AHRDO carried out more than fifty performances, most of them in Kabul, though they also ventured to other parts of Afghanistan. In the ethnically divided capital, members of the ensemble had to face their own prejudices and fears as they performed for different communities. In the end they found it expansive and rewarding to encounter these diverse audiences and to hear the stories of fellow citizens who had previously seemed alien to them.

The performances took place in sheltered circumstances with small (thirty or fewer) audiences. Hjalmar had conducted shows as part of the training, but in these and subsequent performances, the conductors as well as actors and musicians were Afghans, dealing as best they could with the very daunting challenges of guiding the Playback process with people whose painful stories were so raw. As is always the case in Playback Theatre, the actors also carry a major responsibility for realizing and embodying the stories: the enactments are a cocreation of teller, conductor, actors, and musician.

Audience members embraced this structured, ritualized opportunity to speak about what had happened in their lives. They spoke of appalling hardships, losses,

abuses, and injustices. Most were people of low social standing, many of them women, who had not had other opportunities to tell their stories. They lived silently and alone with their tragedies, unreflected in the official accounts of Afghanistan's history. An audience member, coming forward as a teller with the full attention of

"A Counterflow of Little Stories"

In a Playback Theatre event, when memories are (re-) told, they transgress the original boundaries of the individual storyteller's space, time and body, and are relocated in the bodies and minds of the performers and audience. The experience of others becomes our own as we participate in a performance, whether as a teller, a performer, or an audience member. Theatre as a memory-creating process can invite people to transform traumatic personal memory into collective historical memory and consequently help society to move on.

In summary, I strongly believe that Playback Theatre contributes to "build[ing] up a network of stories to reconstruct the trauma of what happened… a counterflow of little stories, anony-mous tales, tiny incidents and statements… which condense… a plural and open feeling. The truth is there, we have to look for it and it has the form of a story—not a single story. We have to build this truth; we have to go and look for it. No single subject holds it entirely. We have to create channels for information to flow."[43] Telling their stories can provide the victims of torture and atrocity a way back from atomization and disconnection. It can also be an extremely painful renewal of their own expe-rience. We saw both effects during the various performances with victims' groups in Afghanistan. And yet, the overall feedback from the tellers was overwhelmingly positive. They expressed a deep sense of gratitude that someone finally bothered to come and visit them in their own community, truly interested in getting to know them and their stories, without forcing them to share what they might not want to speak of. This happened in an environment where the vast majority of people have never seen or even heard of theatre, and certainly have not participated in any performance. It suggests that Playback Theatre might have a role to play in creating spaces of trust and respect in which those who have been silenced by the historical narrative can legitimize and document their own experiences.

Two of the widows who told their stories during one of our performances expressed afterwards that they had not been able to tell their stories when approached as part of a more formal truth tell-ing initiative a few weeks before. When asked why, both said that they had not felt enough trust to do so and bemoaned the formality of the questioning procedure. "We had never seen any theatre before but this theatre is really useful for our country. It is respectful and we felt like there was no difference between you (the performers) and us. Please do more of this theatre."

—*Hjalmar-Jorge Joffre-Eichhorn*, in *Tears into Energy: Theatre and Transitional Justice in Afghanistan*[44]

the performers and the audience as she told her story, gained affirmation and the knowledge that others heard, comprehended, and respected her experience. After the shows, tellers often spoke of a sense of empowerment as well as emotional relief. Pride and dignity were restored as they told their stories in this respectful context.

Tellers also learned, through the responses of the audience, that their stories were shared by others who were present—a mitigation of the terrible isolation so often suffered by victims of violence. The informal ritual of tea together following performances deepened the experience: "In this post-performance space one could see that a bond had been created among the group, suddenly allowing people with different and sometimes opposing life histories to sit down together and meet each other in their full humanity."[45]

Playback Theatre invites the telling of stories by those who have lived those stories. For audience members all too familiar with the tendency of national and international NGOs to speak on their behalf, this was an important step in rebuilding a sense of agency. And in a society where personal testimony has been deliberately suppressed, the exchange of stories within a Playback Theatre performance became a means of keeping them in the public memory, as Hjalmar comments in the sidebar on the previous page.

Asking people to tell their stories shaped by a war setting makes for stories penetrated by life and death, fear and pain, horror and sadness. For example, a woman told this story:

"During the civil war in Kabul, my husband was killed and I left with some of my children for Bakh province. When the fighting started in Bakh, I left the city with one of my sons to escape into the mountains. On the way we saw a lot of people killed and injured. There I lost my son. I finally reached Kabul, where another of my sons was living but once I had arrived there I was informed that my third son had been killed as well."

Faced with the almost impossible task of representing stories such as this, there is a danger of the actors losing themselves in a role rather than remaining critically detached from it. Some of the actors could not hold back their tears while listening to such stories. Listening to and enacting these difficult, almost unbearable stories places an enormous burden on performers, the majority of them having their own histories of painful loss and the incommunicability of permanent war.

Others in the audience also reacted strongly to what they heard and saw. In some cases, the whole audience would engage in collective crying. In other moments audience members nodded in silence whenever they recognized similarities with their own lives. These spectators become witnesses and co-owners of each other's stories through the very act of listening.[46]

—*Hjalmar-Jorge Joffre-Eichhorn*

Challenges

In a context such as Afghanistan it is clearly crucial to have performers who emerge from the same population as their intended audiences—"citizen actors," to use Jonathan's term—and who are trained especially to enact their stories. It is hard to imagine performers who did not share the audience members' background being able to effectively enact their stories, with all their specific details and unspoken resonances, and even harder to imagine audience members entrusting their stories to outsiders.

On the other hand, that commonality also means vulnerability on the part of the performers. At times performers—both conductor and actors—were overwhelmed by the tragic content of the stories, so reverberant with their own.

Potential conflict among audience members presented another challenge. In a country with so many intertwined and contradictory histories, it is inevitable that renditions of the past are sometimes at odds. Playback Theatre honors the subjective account of the teller, trusting that the sequence of stories within an event will yield a collective story that has meaning for those present—the "red thread" or dialogue of themes, perceptions, and images that I spoke of earlier. It does not and cannot seek to establish an objective account of the past. Hjalmar describes a performance in Bamyan province in Central Afghanistan where two audience members of different ethnicities accused each other of distorting history. The conductor was eventually able to help them reframe their dispute by seeing themselves both as victims of violence rather than perpetrators. But sometimes the disparity between perspectives is too great to be encompassed. As Hjalmar comments, "the result of a transitional justice-focused Playback event is often a highly fragmented, partial and seemingly incomplete account of what could be called the truth of the past."[47] Because of the potential contentiousness of this aspect of Playback, the AHRDO ensemble decided to work with more homogeneous groups before attempting again to bring together people whose historical understanding is widely divergent. (A similar conclusion was reached by participants in the "Healing Sri Lanka" project—see sidebar on page 118.)

Other weaknesses apparently arose from choices or mistakes made by the newly trained performers. Hjalmar described moments during performances when the process went awry: in one performance, the conductor broke down and wept, only to admit later that he did so in order to stimulate more "meaningful" stories from the audience. Some actors were at times carried away with their prowess on stage and became more interested in impressing the audience than honoring the story.

Most difficult of all was the constant pivoting between a constructive, healing exchange of stories and the danger of re-traumatization, about which I'll comment more below. Virtually everyone in the room at these events, including the performers, had suffered violence and loss: a performance presented a minefield of trauma.

Sometimes the process broke down in the face of unbearable pain. And yet, reading Hjalmar's bulletins as the project unfolded, I was struck by the degree to which audience members evidently embraced the shows and welcomed the chance to tell, hear, and witness stories.

Reflections

Any written account of a theatre project must necessarily be "fragmented, partial and seemingly incomplete," as Hjalmar characterizes Playback stories themselves. Although I did not witness the trainings or performances in Afghanistan, I understand from Hjalmar's account that this project gave an extraordinary opportunity to many women and men, victims of the brutal wars in Afghanistan, to find insight, meaning, and dignity in their stories; to affirm commonality with other victims; to release feelings of pain and anger that had not previously found expression; to comprehend the humanity of those whose experience or backgrounds were different; and to record stories in the public memory that otherwise might be forgotten or suppressed. The members of the performance ensemble, additionally, experienced the satisfactions of using theatre in service to their fellow citizens' stories and "to help society to move on."

The ensemble also faced the considerable challenges and dilemmas that predictably accompanied the use of Playback in such a fraught setting. How to ensure that the process is constructive and not re-traumatizing? Stories of uncontrollable weeping among performers and audience (and in one case, fainting on stage) suggest that there may have been times when the performers, particularly the conductors, were not equipped with the depth of knowledge that they needed. It remains a question, in my mind at least, whether the intensive training they received was enough in this exceptionally difficult situation, and whether it may have been preferable for more experienced conductors to remain in this role. The degree to which the project was successful warrants its continuation, but the questions also demand some rethinking of the content and design of the training and the ongoing support of the performers. (They routinely debriefed after shows, which must have been essential to cope with the intensity of the performances.)

Playback Theatre in a war zone is guaranteed to elicit stories of trauma, as is Playback following natural disasters such as the Indian Ocean tsunami and Hurricane Katrina in New Orleans.[48] Victims of these and other catastrophes have welcomed the chance to tell their stories and see them enacted (in Tamil Nadu by an experienced local company; in New Orleans by a visiting team of Playbackers who stayed long enough to start and support a local ensemble). Preparation for such work must include performers' telling and enacting their own stories within the safe space

of rehearsals. And the training for a participant performance project, though necessarily streamlined, must ensure that certain basic "rules" are thoroughly absorbed and upheld in order to create a resilient and capacious container. For example, a teller of a full-length story sits beside the conductor. This is a safety measure, so that the conductor is physically close enough to monitor how the teller is responding as she tells and watches her story. Sometimes would-be tellers are reluctant to leave their less visible seat in the audience. But the conductor must insist, gently but firmly.

Stories of trauma can emerge in any performance.[49] We can never know who is in the audience and what stories they may tell. So it is essential to know the capacities and flexibility of the form, and for performers to be sufficiently strong within themselves to take on the enactment of someone else's anguish, especially if it might resonate with their own. As Jonathan wrote, "You have to know… where your own self ends and the other begins."[50]

The Healing Sri Lanka Project

The Healing Sri Lanka project began with a one day Healing the Wounds of History (HWH) workshop led by Armand Volkas.[51] The workshop attracted twelve people of Sinhalese and Tamil descent aged 22–78. The morning session involved storytelling, where the participants shared experiences relating to the conflict and their hopes regarding peace and reconciliation. These stories were played back by three professional Playback Theatre actors. The afternoon involved sociodramatic and psychodramatic processes.

Following this initial workshop, the facilitators and a group of between four and six people began to meet approximately every seven weeks. This core group included Tamil and Sinhalese participants. Trained actors would sometimes playback stories in the beginning of the sessions as a way to open dialogue and build connection.

After seven months, a public PT performance by the Living Arts Playback Theatre Ensemble was held where members of the Tamil and Sinhalese communities were invited to tell stories around the theme of peace and conflict in Sri Lanka. Members of the core group told stories, as did one member of the wider community. Powerful stories were shared that had a deep impact on the tellers and the audience. Two weeks after the performance, we held a session where members of the core group shared their experience of the performance. We spoke in particular about the impact of PT when telling stories of trauma and oppression. Here are some quotes from that meeting:

Teller Responses

"During this period of repression and injustice, it is hard to maintain hope. But at times like this, we must acknowledge the pain of our community. We need Tamil-only spaces where people can

speak freely and have their stories witnessed. We need a space where we can express grief and do our own healing. We must also keep the stories alive so that someday, the perpetrators can be held accountable."

"People from the perpetrator class also need a separate space in which to process their guilt and shame. Often they are hesitant to bring these feelings forward in a shared space."

"I felt relief at being able to share the trauma which till now had been repressed."

"When we don't share our trauma, we think we are the only ones who suffer. Seeing it played back and having others play roles in my story, helps me to feel less alone."

"Having a witness was very important. It gave me hope that people will do something. It helped me to overcome my hopelessness. I feel like my struggle is no longer one that takes place in the dark."

Witness Response

"PT gave me a visceral understanding of the conflict."

This feedback revealed three main forms of benefit for tellers and their audience:

- Expression of grief, guilt, and pain was an emotional relief.
- Reduced sense of isolation for tellers: relief in knowing that one is not alone.
- Education: raised awareness of audience/public.

—*Ben Rivers*, assistant director of the Healing Sri Lanka project in Oakland, CA.

With adequately prepared actors and a highly skilled conductor, trauma stories told in Playback Theatre can indeed contribute to the transformation of experience from traumatic to narrative memory for both individuals and the community. When a teller is ready, telling a traumatic story to a group "represents a transition toward the judicial, public aspect of testimony."[52] There are by now some established principles and techniques for using Playback Theatre with trauma. For example, stories that are evidently or potentially traumatic for the teller should not be enacted literally. The teller needs to "see" his or her story, but in a way that maintains a safe distance from it. Horrific events like a bombing or a rape can be depicted with minimal gestures, narration, or suggested offstage. The conductor might instruct the actors to use a short form rather than enact a story more fully, even if the teller is already in the teller's chair. In a recent performance for incarcerated women on World AIDS Day, a teller could not bear to watch even the stylized enactment of her story of violence and tragedy. She wanted the actors to stop. We paused and talked, and with her agreement enacted only the key feelings, not the events, of the remainder of the

story, using fluid sculptures—short sound-and-movement responses with few or no words that depict the nuances of the teller's expressed feeling. This was satisfying to her and to the audience.

Playback Theatre has the tensile strength to work with here-and-now conflict or shock. Bev Hosking recounts an experience:

> In Angola an incident occurred where we were able to apply Playback Theatre in an immediate situation very effectively. Part way through the performance someone in the audience had an epileptic fit. At first it was very unclear what was happening and everyone experienced some degree of fear, panic, and shock. Nearly everyone, performers and audience members alike, fled screaming from the *jango* (compound). The young man recovered well and was taken outside to rest.
>
> The question then was if and how to proceed. Everyone was still in shock and it seemed important at least to bring people together, even briefly, before we finished, and the actors and the conductor agreed to this. The conductor invited the audience to talk about their experience of what had just happened. The first person told

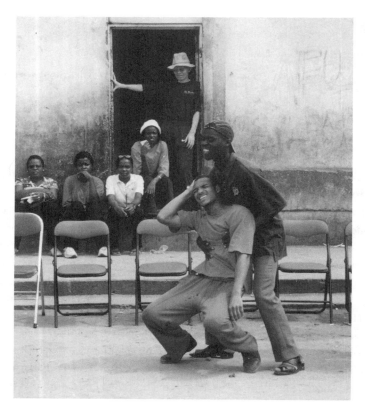

Actors enact an audience member's story in an IDP camp outside Luanda, Angola.
Photo by Bev Hosking

of feeling confused and not knowing what was happening, the second told of having felt really shocked and frightened and the third person told of feeling worried and concerned for the man. The actors were quite courageous and did some wonderful work playing these back as fluid sculptures. The second fluid sculpture very accurately mirrored the experience of the shock and there was awkward laughter and murmurs of recognition in response. My own experience with this sculpture was feeling the 'shock' leave my body.

Following this, everyone seemed to be able to relax and wanted the performance to continue. There was one last story and we finished with some singing and dancing. Although rather shocking in itself, this incident provided a very immediate experience of using Playback Theatre to work with a tense and difficult moment in the life of this community."[53]

Although not described at the time as participant performance Playback Theatre, this series of performances was carried out by an Angolan conductor, actors, and musician who had received a short, focused training from an outside trainer, and then performed for audiences of Angolans. Audience and performers alike shared the background of their country's civil strife.

The need to respond creatively and constructively to traumatic stories comes up occasionally in the anti-bullying shows. (Many stories depict problematic situations without being traumatic.) Those stories tend to announce themselves with the young teller's body language: the lowered head, the barely audible and shaky voice warning that tears are not far off. The conductor and adult actors must be instantly alert at such times, guiding the telling and the enactment to give this moment the greatest possible chance of being empowering and healing for the child. It can feel too risky to have a student as teller's actor (the actor playing the teller), even though customarily that choice is left to the teller. When Emma told her story, the conductor, recognizing the delicacy of the story and of Emma's state of mind, asked me to take Emma's role in the enactment. (I was in the musician's spot for that particular show.) She felt, and I agreed, though we had no chance to discuss it, that it was too big a challenge for one of the students. The student actors did a wonderful job in their supporting roles as the mean kids and the adults who tried but couldn't help.

Our ensemble, Hudson River Playback Theatre, also carries out frequent performances with groups of mostly Latin American immigrants, many of them undocumented.[54] Unprompted by us, audience members have wanted repeatedly to tell the trauma stories of how they came to the United States—the despair of living without resources or hope; the terrifying, dangerous journey across river and desert. Tears flow, and yet over and over again our audience members insist on telling these stories. One woman commented: "It makes us sad to remember, but happy to see it." They find relief in bringing these stories to a semi-public forum and seeing them

transmuted into artistic form. Another man said: "It helps us to know that someone listens to us even though sometimes we tell our stories with pain."

Trauma is not the only challenge that Playback teams may face. Stories occasionally express prejudice, unconscious or otherwise. On the one hand, we are committed to honoring the teller and his or her story. On the other, we are committed to justice. Again, it takes awareness, intentionality, and skill to negotiate these values.[55] The conductor and the actors must find a way to distance themselves from the teller's prejudice. If they do not, they perpetuate it and they risk alienating those in the audience who are hurt by it. The story from Kiribati illustrates how the Playback process addressed prejudice gently but effectively—made possible by the fact that the group was together over time. The trainers themselves (male and female, Maori and Pakeha/European) modeled respect, equality, and acceptance. They did not confront those who taunted the gay man, but nurtured the relationships within the group to the point where it became possible for him to tell his story. In a briefer event, such as a single performance, other actions might be necessary—an actor playing the object of the teller's prejudice, for example, could make a point of bringing out that person's humanity in such a way that the audience, at least, would know that the performers do not share the teller's views. Or, with tact and compassion, the conductor might find a way to question the teller's problematic assumptions.

In a world where personal story is increasingly commodified it is important that Playback Theatre is clearly based on values such as respect, authenticity, and inclusiveness. Manipulation of the teller or the audience—as in the example of the conductor who wept in order to stimulate "meaningful" stories—is unethical by any standard, and particularly out of place in Playback where stories are invariably told because they are important to the teller. A joyful story, or an apparently slight story, can hold great meaning for all present, if listened to with open ears and heart and enacted with creativity.

Playback Theatre offers the possibility of a socially contained but artistically unlimited space in which ordinary people can listen to each other and accept each other's stories. It holds promise as a resource in situations of conflict, where moral imagination has been truncated. In the organic dialogue of the stories, in the spontaneous exchange of images, memories, and allusions, a group of people may create a new collective story that embodies new understanding, new connection, and possibly new hope. The women in Kiribati enacted their rightful place in their society and found space within themselves and their community to accept an outcast. Children dealing with bullying in schools acquired the empathy and practical tools they needed to stand up for what they knew to be fair. Audience members in Afghanistan spoke the unspeakable to each other and shed some of the voluminous tears built up in thirty years of violence. In the Healing Sri Lanka project, former enemies were

able to hear at least some of the stories that needed telling. An outdoor audience of displaced people in Angola, in the midst of telling stories of terrible loss, used the Playback process to cope with a moment of immediate shock.

The use of Playback in troubled areas has so far been limited by the assumption that it is necessary to have a fully trained, ongoing ensemble, on the model of the permanent companies established in the Western world. The participant performance concept that I have described here—a reiteration of the original idea of the citizen actor—may prove a more portable model for Playback in the future, and perhaps a more accessible structure in cultural settings where group participation and membership are traditionally fluid. Training local performers is both congruent and efficient. A project may be conceived as time-limited: lasting indefinitely, on the model of the Western Playback ensembles, does not have to be a goal.

The success of future participant performance projects will depend on conceptualizing and carrying out training that distils knowledge and principles fundamental both to Playback Theatre and to the issue at hand; and, in an area of conflict, this must include training in addressing trauma. Moving in this direction also demands an honest assessment on the part of the Playback community: what does it take to be ready to lead such projects and how can we best prepare these courageous trainers?

I look forward to seeing, and taking part in, this new development of Playback Theatre. Many stories await the chance to be told.

A production of the Free Southern Theater, founded in 1963 by Doris Derby, Gilbert Moses, and John O'Neal. Photo by Roy Lewis

5 "Do You Smell Something Stinky?"

Notes from Conversations about Making Art while Working for Justice in Racist, Imperial America in the Twenty-First Century

John O'Neal[1]

> "Power concedes nothing without demand.
> It never has and it never will!" —*Frederick Douglass*

> "If you're raised in a cesspool you're bound to grow up smelling of shit!"
> —From *Sayings from the Life and Writings of Junebug Jabbo Jones*[2]

Introduction

I've come to prefer sharing stories to other forms of dialogue because stories are a fuller, richer way of promoting the consideration of how things fit together. Story sharing relies on a different set of muscles than is typical in arguments or debates. "Logical" argument more quickly comes to winners and losers who're more likely to make the leap to martial means than those who rely on the more wily analogies of the storyteller.

Storytelling rests on *analogical*—as distinct from *logical*—thinking. Stories affect our understanding of things in different ways than arguments do. Stories conjure images that mimic the experiences to which they refer as opposed to "proving" things through a series of logical exercises. Arguments are cooler, more abstract, less engaged, and less passionate. At the end of an argument you have winners and losers. Stories yield deeper, more empathetic understandings. Stories often presume the "character" of the storyteller. If a character understood to be a horribly foolish person says in a lofty voice, "To thine own self be true, And it must follow, as the

I am a storyteller. Now I say storyteller instead of liar. A liar is somebody who covers things over, mainly for his own, private benefit. But a storyteller, that's somebody who uncovers things so everybody can get something good out of it. I am a storyteller.[3]

night the day Thou canst not then be false to any man,"[4] at the very least you have to wonder, "What's this guy up to?! What's really going on here?"

Arguments seem to stand independent from the speaker. The forms of arguments and stories actually strike the body in different places too. Argument aims at the capacity of the brain for abstract reasoning. But *stories* ride on metaphor and simile, like the ache in the heart of the rejected lover, whose pleas fly directly to the hearts of those who hear the stories and who, after hearing, carry the pain, the drama of the story as if the experiences portrayed were indeed their own.

My peers and others whom I proudly join in this volume are artists more than scholars. We take things that we've learned from things we recall and *believe* to have happened. We spin those yarns into stories that make sense to us. We weave and reweave them into new but still familiar images fit to present to others as evidence of our common bonds and heritage.[5]

Initially I was prompted to attempt this essay by the following three questions: What does it mean to say "Racist, Imperial USA?" Is it possible to have peace without justice? And how can we make it better?

As they often do, these stories have taken on a life of their own. They know things that I do not know. They say things I would not think to say.

1. Racist, Imperial USA?

> Before I'll be a slave, I'll be buried in my grave!
> And go home to my lord and be free!
>
> —*Traditional Song*

Growing Up in Cesspools

Racism stinks. It arose in human history as a justification for unethical, immoral behavior.

Before the idea of race, there was no racism *as such*. The powerful simply identified those they thought themselves capable of besting in battle and asserted that GOD had already determined that it was their divine fate to serve as slaves and

chattel to those with superior arms and lust for blood. A loss at battle was *prima facie* evidence that god(s) wished for them to serve as domesticated beasts, heathens, infidels, demons, etc. People just got separated from the fact that all of us were born of the same Mother . . . Africa.

Over time, as people began to recognize that the "others" were indeed just different branches of the same family, the need arose for a new *moral* justification for exploitation. Therefore the *social construct*[6] of race developed. The ideas of conquest

My mentor as a playwright is James Theodore "Ted" Ward. Ted was well past seventy when I met him. He was a dignified, dapper fellow who wrote thirty-six plays, most of which are histories.[7] I believe Ted's masterwork, *Our Lan'*, is the best play in the English language written in the twentieth century, bar none! The play's about what happened to that "forty acres and a mule" after President Lincoln's assassination. It tells the story of a heroic ex-slave and a band of his peers who followed as General Sherman burned his way across Georgia on his journey to the sea.

Although they were unable to hold on to the land that had been promised them, the story about the band of ex-slaves leaves us ennobled and proud despite the tragic failure of their efforts, which damned these children of slaves to further generations of poverty that have yet to end.

Our Lan' only ran for five weeks on Broadway in 1947. Ted felt that the director made critical errors in interpretation that distorted the intention of the play so much that the Black audience for theatre in New York at the time rejected the production. Few whites at the time saw the work because racist biases in the culture prevented them from seeing themselves in the Black vagabonds.

I remember the way Ted described the challenge of the Black artist: "The problem of the Negro drama is that the Negro never has had the opportunity to meet his antagonist! His proper antagonist is not the overseer on the farm or the policeman on the beat . . . they're only like messengers from the king. The real interests of the people most commonly presented as antagonists to the Negro are usually more complementary to our interests than not. The true antagonists of the Negro are the captains of commerce and industry! Nowhere in the normal course of events do we meet them in direct conflict except as master to servant. Hell, 99 percent of the time we don't even know who they are or where to find them!"[8]

Certainly, there have been some significant changes in Black life and theatre since Ted wrote his first play in 1916. Bunche, Rice, Powell, "Uncle" Clarence Thomas, Obama, and many other people of African descent now attend the councils of the mighty. Yet our problems remain essentially the same. Racism is still a dominating force in contemporary life and culture. Ted's dictum about the impact of racism on "Black drama" still holds true. In order to win his post as president, Obama had to turn his back on his spiritual and intellectual father. Now there's rich stuff for tragic drama!

and slavery as appropriate ways for one group to satisfy *its* needs at the expense of *others* began to spread a funk to all the places where people lived and died. When there was not enough food, clothing, or shelter to go around, conquest and domination were accepted as legitimate ways to get what was needed. The pause that followed prosperity, when it followed after conquest, became known as "peace."

The stink soaked in everywhere. People became accustomed to it.

Increased wealth that comes from pillaging the enemy's home turf is the engine that drives this whole process. As the conquerors expropriate more and more resources, conquest leads to occupation and slavery; occupation graduates to colonialism; and colonialism leads to imperialism. Each stage in the expropriation of wealth requires more force and the imposition of more human suffering—as more ill-gained resources are laid before the rulers, their friends, and their allies. Race becomes the marker that identifies the victims who provide the necessary work to fuel the funky process of separating people from their birthrights and the fruit of their labor.

Inevitably, those who sit at or near the top of the pyramid of empire began to see *themselves* as the *generators* of the wealth that spills from the cornucopia rather than as those who benefit from the efforts of others. The longer such systems prevail, the more the principals of empires become convinced that they are more potent and righteous than all others, and that they and those whose efforts comprise the base of the pyramid that supports them are weak and less worthy. The thing is like a huge, immoral, extralegal Ponzi scheme. In time the whole structure becomes self-verifying and is enforced by the military apparatus loyal to the relevant royalty. Power and authority become separated from justice and responsibility. The social contract is shattered. Racism becomes essential to keeping the whole vile, funky system in place.

On the Big, Black Elephant in the House

A season of high profile assassinations[9] was inaugurated in August of 1963 with the assassination of Medgar Evers, NAACP Regional Field Secretary, outside his home in Jackson, Mississippi. John Kennedy was assassinated in November of 1963. Malcolm X was assassinated in February of 1965. Martin L. King was assassinated in April of 1968. In June of the same year Robert Kennedy was assassinated. More than thirty-four members of the Black Panther Party were gunned down by police authorities or died in otherwise suspicious circumstances. Each of these murders was carried out by functionaries of various right-wing factions with suspicious connections to highly questionable government agencies.

The response of the Black masses to these atrocities was to burn the cities. Every summer from 1964 to 1971, more cities were torched and the "Black Power Movement" was born. For a time the "Black Arts Movement" waxed as well.

Race and racism are ubiquitous realities in the Western world. Those who're stuck with the sticky end of the stick never escape from the harsh reality of it all, though most of us urgently *wish* that we could. Racism is the rock in the road to the realization of the dream of a fair and equitable society upon which the democratic ideal has always stubbed its toe. Racism is one of those things that is really difficult to talk honestly about across racial boundaries. The pain and the shame of it all are so deep and profound. At the same time it's overwhelmingly clear that these issues *must* be worked through if the human race is to have a chance to survive in a world that is anywhere similar to the best of what we know now.

"White skin privilege" is a direct outgrowth of the conquest of the darker people of the world by various European development schemes. I know more about North American culture than other places, but no matter where we look in the world, the darker people always suffer the greatest burdens and the fairer people receive the greatest benefits. Like other oppressive paradigms, for racism to work a significant number of its victims must buy into its terms. The task of constructing such a pliable population of oppressed people has been a major function of the cultural institutions of the oppressed. Just as the path from conquest to neo-imperialism has seen many stages, so has the movement of resistance to these patterns.

Among artists, educators, and activists who are otherwise allies, the issues of race and racism are still present and pose challenges for our work within and between racial and cultural groups. Even for the close friends and colleagues who attempt this work, the challenges are great.

I've noticed over the years of working with "hot" issues in theatre (i.e., issues that are socially and politically active among the persons working on the project) that often in the midst of the effort the issue tends to *bite back* at those who set out to work together. If you decide to take on a cross-cultural project, you'd best be prepared to face the "devil" in the work you set out to rout. Even if you think you've thoroughly vetted the ideas and the people that you expect to confront, be prepared! There's always a snake hiding in the woodpile!

In the mid-1970s I had an experience that brought the elephant front and center. I was working on a play about the Southern Tenant Farmers Union (STFU), an effort to build unity among Black and white sharecroppers in the segregated South for their mutual benefit. Myles Horton, the legendary founder and director of the Highlander Center for Research and Education, had himself been active in the effort to organize STFU. I'd asked him to listen to a reading of the nearly finished script to advise us on the authenticity of our effort. After the reading, Myles suggested that I connect with the Roadside Theater of Appalshop, based in Whitesburg, Kentucky. "You ought to make it a point to meet them," Myles told me. "They call themselves 'Appalachian nationalists.' They all come from these mountains around here," Myles

said. "They get their stories from these people around here and these people make up their audiences. It seems to me that y'all are trying to do the same kind of thing. So maybe y'all could benefit from working together." I knew Myles to be a careful thinker so I didn't take his opinion lightly.

It was about a year later that I had my first opportunity to see Roadside's work. It was at the first festival and annual meeting of Alternate ROOTS (Regional Organization of Theaters South). The show I saw Roadside perform that night was called *Red Fox's Second Hanging.*

The narrative is built of traditional stories and information drawn from history. It paints a picture of the way mining practices in southern Appalachia affected the cultural and economic life of the region. Rich with Appalachian music—some traditional and some composed especially for the show by Ron Short, a brilliant instrumentalist, composer, singer, and actor—the show flows with accumulating force, but in the end it left me unsatisfied.

After the performance, I found my way to the Roadside compound on the campgrounds. It wasn't hard to find because there was music, singing, beer, and an abundance of conversation. Frankly, I was more than a little surprised by the proficiency with which they addressed the music of Sam Cooke, Otis Redding, Aretha Franklin, and Motown artists, among many, many others. I was even more surprised that Tommy Bledsoe, one of the best singer/musicians in the company, didn't know tunes like "Down by the Riverside." Soon after I got there, Dudley Cocke, the director of the group, came over to where I stood at the fringe of the crowd. After an exchange of pleasantries, he said: "Well, what do you think of our work?"

Most of the groups involved in ROOTS at the time were white. Very few Black people were present. Despite Myles Horton's recommendation, I'd come to the event with more than a few reservations. I took a reflective swig of the Roadside beer and tried to size up Dudley; we regarded each other with equal measures of wariness. With a polite neutrality of tone and as friendly a face as I could muster I said, "Since you asked for my opinion I assume that you really want to know what I think, so I'll speak frankly. If what I hear about your work is true, then you have a lot of potential Klansmen in your audience. Frankly, I didn't see anything in the show that would make a potential Klansman any less likely to be a Klansman after the show than he would have been before he saw it."

Normally, that kind of challenge was enough to put a white person on the defensive if it didn't make him turn red and start to stutter unintelligibly. But Dudley totally disarmed me with his response: "Hmm. What do you think *we* ought to do about that?"

He landed so soundly on that "we" that there was no doubt that he intended to include me in the subject of his question. I'd done what I was *planning* to do. I'd

only watched the show to discover something about the nature of "the enemy." The aim of my remark was to leave him like a butterfly on a pin, stuck like a specimen on display. Instead I was then caught in a web of my own weaving.

We talked till the crack of dawn, as we have many times since. We've worked together for most of the forty-eight intervening years. I count Dudley as one of my best friends in the world, but in fact, we *all—every single one of us—*live within the terms and conditions created by the age-old scourge of racism. Racism *infects every single human institution* in the *whole* of human culture. It has been so for thousands of years and unfortunately will continue to do so for a long time to come. It is so integral to our ways of seeing and being in the world. The only social system that is more ubiquitous than racism is that which supports and gives definition to the system of male privilege that has come to be called "The Patriarchy." These deeply embedded value systems and attitudes are insidious. They operate *below* the level of consciousness. No one comes into the world with the attitudes and values of chauvinistic systems like racism and patriarchy fully developed. Unless our life circumstances bring us into direct confrontations in which the injustices of the prevailing order are exposed, we can live our whole lives and more or less "honestly" offer as defense, "I didn't know the gun was loaded!"

After many years of working together with my friend Dudley to unpack some of the problems that race and racism come loaded with, I told him that we still need to confront the fact that our friendship does not mitigate the necessity to deal with the way racism impinges on our work and even our friendship. I'd made several efforts to try to address the matter but our plans "to deal with the issues of racism between friends more 'politely'" kept falling off the agenda.

I had a small group of actors in Whitesburg to rehearse a new version of a show that we'd toured with Roadside for several years. We were all together at an outdoor café on a lunch break. I was sitting alone moping about some long-forgotten issue that had come up that morning in rehearsal. Dudley, who was directing the rehearsal, came over to sit with me. I don't remember what it was that set me off but shortly after I exploded (I almost never explode about anything!), loud enough for everyone in the diner to hear. I said, "You couldn't direct your way out of a paper bag!" Dudley and I certainly have our artistic differences but none so severe as to warrant such a rude outburst. Suppression is seldom a good way to face difficult problems, certainly not between friends.

This incident occurred about the same time that my daughter, then a twenty-year-old student at Spellman College and an advocate of a doctrine she called "Afro-fem-centricity," told me, "Daddy, I love you dearly, but we're going to have to deal with the fact that you're a patriarchal, male chauvinist." I was shocked by the accusation!

"Daughter!" I exclaimed, "Where do you think you got your politics from?"

"Some from you, no doubt. But what difference does that make?" she said. "The fact remains that this is something that we'll just have to deal with."

In time I've come to recognize the wisdom of my daughter's assessment. Just like "White skin privilege" and "class privilege," "penile privilege" exists as a set of social givens in our society. They are endemic, systemic, institutionalized constructs that often operate subconsciously to influence and control our social behavior. These value sets establish what is expected, what is acceptable, and what's not. When Black people can no longer accommodate the racist presumptions of their white friends, of which they often are entirely unaware, it's similar to what happens when women can no longer accommodate the patriarchal presumptions that are largely invisible to the men they otherwise love and respect. The same pattern holds regarding class.

It was years after this incident that Dudley and I started to work through how to deal with the problem of racism among friends. To be friends means that we take the responsibility to share critical evaluations of each other more seriously rather than less. If our friends don't help us to recognize and correct our errors, our enemies will use them to defeat us.

Dudley's still one of my best friends and so is my daughter.

In the fall of 2005 the opportunity arose, through an anonymous contribution to Alternate ROOTS, for ROOTS artists who had been affected by the disaster of Rita/Katrina to make a piece together dealing with the experience. Eight of the twelve ROOTS members who qualified for the project were Black, three were white, and one—who eventually dropped out of the project because he couldn't afford to work for the rates that the project would pay—was a Latino from Ecuador. Despite the fact that Rita and Katrina ravaged the Gulf Coast from Beaumont, Texas, to the West Florida Panhandle, it happened that nine of the artists in the remaining group came from New Orleans and two from Mississippi. New Orleans and its culture became the focus of the theatre piece that evolved.

Altogether, it was an aesthetically diverse group of theatre artists, poets, dancers, singers, and musicians, including both solo artists and ensemble players. The group includes some of New Orleans' and Mississippi's best performers for whom social justice is an inescapable concern.

All in the company agreed that addressing race and racism was essential to the overall success of the project. After all, the mass media coverage of the disaster had revealed the high level of discrimination against the city's Black citizenry, and the racial demographics of New Orleans had shifted significantly, but still New Orleans is the most African city in North America.

Though we tried to open the dialogue about racism several times, we failed. Remember, we are a group of friends. We share a high degree of confidence and mutual trust. But despite the fact that it was a good artistic collaboration--we got

high marks for the quality of our performances and artistic effects from critics and audiences—we were unable to get a frank and honest dialogue about race on our internal agenda and therefore did not reach the necessary depths with our audiences. These are problems that will not yield to cosmetic adjustments. It seemed to me that some of the white people were afraid they'd be subjected to bitter personal attacks and the Blacks among us were afraid to risk being seen in that light. I know that I was.

The elephant in the room kept taking up more and more space and leaving more waste on the floor. By the time it was founded in 1720, New Orleans was more than 60 percent Black. The indigenous people of Louisiana who had not been exterminated had been reduced to negligible percentages. After the Vietnam War, the Asian population exploded. The Spanish-speaking population of the city has quadrupled since Katrina. Up until August 5, 2005, New Orleans was 67.5 percent African. Now (June 2010), the population of the city is back to 60 percent plus. The city has always been less than 45 percent white. Still, one of our white actors created a character to symbolize the "Spirit of New Orleans" with no apology for the European colonial mentality which always considered "ownership" of the Louisiana Territory to be settled, except in European courts. All of us—including me—stood mute in the face of this glaring error!

For ten thousand years or more, the place now called "New Orleans" has been a dream-making place where people of many nations have come to meet and trade. How long this will continue to be the case depends on how well the human community conducts its affairs. We've been here more than sixty thousand years but there's no guarantee that we'll be here sixty thousand more. If I were a betting man I'd say the odds are not very good. The planet will be around and probably do alright for another two or three billion years. If humanity refuses to tighten up our game, the planet could be better off without us. One important key to how long our present quality of life will survive will be decided by how we who consider ourselves "progressive" own up to, confront, and work through the problems that arise from racism, European chauvinism, and similar forms of behavior.

I herewith apologize to my colleagues in this work for my personal failure to raise a challenge to what I felt to be the faulty analysis that supported the "Spirit of New Orleans" character simply because I didn't wish to force a conversation that would have been uncomfortable to work our way through.

2. Honor to Whom Honor is Due

They say that Freedom is a constant struggle.
They say that Freedom is a constant struggle.
They say that Freedom is a constant struggle.

I've struggled so long,
I must be free!
Oh, I must be free!

The Movement and the Obama Phenomenon

There's a rhythm to everything that moves. To recognize that a thing is alive is to recognize its capacity for autonomic motion.

It is axiomatic that oppression breeds resistance. The struggles of the 1960s were preceded by more than 400 years of constant effort by millions of people who'll remain unknown for all time except to those who loved them.

Human sociopolitical life seems to crest in thirty- to sixty-year cycles, which result sometimes in great leaps forward and sometimes in outstanding failures, but even the failures bolster hope for the future. The pace of change increases as we come closer to a particular target of change. It slows down when the vision and the dreams become blurry. But still the compelling struggle for justice continues.

The greatest difference between the work in the 1960s and the work that's going on now is that the broad, mass movement that directly challenged the old, unjust institutions of Jim Crow and wage slavery no longer exist. Our movement was overcome by the idea that the gains we made—as great as they were—were greater than they were in fact. Our movement was also damned by our failure to clearly understand the depth and power of those who stood in opposition to the struggle for justice. Some called it the "Second Reconstruction in America," a part of which was frankly revolutionary in outlook if not in fact. It may still be too soon to name this period properly.

Like others, I never expected to see a Black man claim the post of US President. It may still be too soon to claim the victory. We have seen heady times before. The ceremonial aspects of President Obama's term and the remarkable things he has accomplished have hardly brushed the blush from the rose. Too few people are actually *doing* the hard, grassroots work of building a people's movement that's able to make and sustain such effort, which is essential to advance the interests of oppressed people.

President Obama, an able advocate of his own vision, repeatedly reminds us that it's our duty as citizens in a democratic society to organize ourselves to demand accountability from those whom we elect to represent our interests. We must study to gain an ever clearer understanding of the issues we face, make ever clearer assessments of who our friends and foes are. Then we must get busy making plans to achieve our goals with options A, B, and C just in case. Then we must organize, organize, organize! We must fight like hell to *gain* ground and fight harder still to *hold* the ground we gain.

Two events in recent years had the potential to spark this kind of movement. One was the disaster that followed Katrina (for the war against racism, New Orleans was and still is "ground zero"). The other potentially galvanizing event in Louisiana was the case of the "Jena Six." Jena is a small town in central Louisiana of 3,000 people, in a parish of about 14,000 that's 86 percent white, 12 percent Black, and 2 percent other. The town's Black high school was recently closed, leaving only one high school. There's a long history of racial hostility in the area.

On the campus of the "white" school that remained, there was a large tree. White student leaders claimed it as "their spot" based on historic precedent. They discouraged, even tried to prohibit, Black students from sitting under that tree. One day in 2006, three Black stars of the football team decided: "We have as much right as anyone else to sit under this tree!" There was some pushing and shoving, but the situation rested with minor hostilities. The next day, three nooses were hung from the tree, the implication being, "Come here again, Nigger, and you will be lynched!" Once more (this is the first time we've heard that they appealed to authorities) Black students appealed to school authorities to no avail. Larger confrontations ensued.

Eventually, six Black students were arrested. In short order they were tried, convicted, and jailed for beating a white student, but none of the white students were punished for hanging the nooses or any of the incidents that followed from the controversy. School and law enforcement officials clearly favored the white students and brought more heat than light to the situation. Eventually the tree was cut down in an ill-considered effort to eliminate "the cause" of the problem.

These tangled events gave rise to an intense but short-lived movement that focused on the little Louisiana town. The Black community there felt abused. For several weeks the incident was a focal point for the region and for the country. But the nation is so anxious to avoid issues of racism that it wasn't long before the passion and attention faded. We progressives were unprepared to make the transition from a short spurt of outrage into a real, sustainable movement. Just as in New Orleans, the efforts in Jena to take steps toward justice did not succeed. But neither did they fail.

Although the legal status of the cases is finally resolved, the hostile relations among the people in the town appear to be as tense and overtly antagonistic as ever. The matter was pushed from the national spotlight by the landslide election of the first Black President of the USA, the worst economic disaster since the Great Depression, two ill-considered and unpopular wars that refuse to end, and proto-fascist goons who consider torture, assassination, and murder acceptable instruments of public policy.

The most profound lesson to be learned from the "Jena Six" is that no matter how great the odds against them, those who hold fast to principle in the struggle for justice can win.

The most interesting thing about "the Obama phenomena" is that it raises the stakes. It suggests the *possibility* of success for a larger movement for change. It's the biggest indicator of public dissatisfaction with the major trends in American public policy—of people's willingness to engage with "the dis-privileged other." People see him and some think, "It's the end of our American Way of Life!" Others think, "If a Black man can be elected president, then we can have health care, we can put an end to a degenerate war, taxes can be made less unfair, we can have a good public education system."

If we roll the big snowball up the hill, we can roll it down again! "Yes, We Can!"

Of course, no single person, no matter how well positioned or well intentioned, no matter how smart or charismatic, can create solutions to all the problems we face. The government itself is still bound by law and precedent to the interests, conditions, and terms of "America Inc." They are incapable of being as responsive as such institutions should be. They cannot work without an active populace that demands

Devised as part of the cultural and educational extension of the civil rights movement, theatre companies set out to "use theater as an instrument to stimulate the development of critical and reflective thought among Black people in the South." Photo by Roy Lewis

the needed changes. No one can make this happen except the citizens whose inter-ests the government is bound to serve. Justice demands the effective and thorough engagement of an activated populace that believes in and is committed to the dream of winning peace through the struggle for justice.

Justice, Peacebuilding, and Theatre

When America, her allies in Europe, and their client states talk about peace, most often they seem to refer to the *absence* of active military engagement, not the pres-ence of justice. "Peace" has no positive meaning. Without a positive idea of what peace is, we could easily be trapped in an endless series of negatives. What may appear as peace to the party that has the power in a given relationship may seem like war to the party who is disempowered. To be effective in the effort to establish "peace" it must first find its center in the struggle for justice. When the struggle for peace is separated from the struggle for justice, we ensure the continued domi-nation of oppressed people at the end. Clearly, as long as there is no active search for justice, there can be no peace! Our challenge as citizens who are also artists is to support the effort to mobilize all to join the struggle for justice, from which will follow a legitimate but still impermanent peace.

A number of questions arise: How should we relate, in our struggle, to our "enemy" or to the person who is perpetuating or benefiting from the injustice? Do we need to be fair to our enemies? Is violence against an oppressor ever justified? What kind of world do we want to live in? Lolis Elie, a Black lawyer friend of mine, said, "Some people talk about killing all white folks! If that were even possible, who would want to live in a world like that?"

Then we are forced to consider the question: Is nonviolence always the answer? In the face of the evidence from Hiroshima, Rwanda, Serbia, Sudan, and other more recent sites where "ethnic cleansing" is seen as a viable basis upon which to rest public policy, is nonviolence a viable answer? Nonviolent methodologies seem to require the oppressed and the oppressors to find complementary bases for values. Nonviolence only works when you can exploit an internal moral conflict among the oppressor class. And that takes time. You have to wait for the conflict to mature and for people to say, "I'm sorry and I won't do it again"—and mean it. That doesn't always happen. I do believe that sometimes it's necessary to fight and perhaps to die or even kill. If violent resistance to evil is sometimes necessary, when is it so? On what basis can we make such judgments? What, if anything, do we owe to those who are really being destructive? I'm glad that I've never reached the point in my life where the confrontation with these questions required me to act.

What I do know is that, for me, whether or not art has value depends on how much it contributes to people's efforts to improve the quality of life available to themselves and to others in similar circumstances. The art that is relevant is that

which, working with larger movements in society, seeks to right inequities and to win just circumstances. Most art and most theatre today are not responding to or addressing their audiences on society's need to find out *how to make it better for EVERYONE in the world!* Most of us limit our concerns to those whose interests we see as complementary to our own.

Now, for the first time in human history, we can literally say, "everyone in the world," and really mean it.

Certainly, art can offer people an opportunity to laugh and enjoy themselves; that's important for life. "The rich get rich and the poor get poorer, in the meantime, in between time, ain't we got fun?"[10] We need that fun in order to survive all the terribleness we sometimes face. We need to have a laugh and a moment of relaxation in order to focus our energy on transforming things.

It's important, though, that the fun, the "entertainment value," is just the threshold. As Sean O'Casey asserts, "At the very least, art must entertain!" Ultimately, the greatest art addresses the higher goal of transformation. It calls us to be wary of that which threatens us and to celebrate that which accrues to our benefit. Who "we" are is the key!

One of the things that happened to us at the Free Southern Theater was that some people questioned our focus on "important" historical subject matter, most often before they knew any more than the name of the play we were doing. "Why do we need to be reminded of all that serious stuff?" they'd say. "Do something happy." And it wasn't just white people. Black audiences said that too.

Our idea was that we had a larger mission than *simply* to entertain those who had achieved a certain measure of comfort in a hostile environment. The larger purpose of art in the context of injustice is to challenge the norms of those who are benefiting from the injustice. My college mentor Dr. William Harris, a specialist in

The Free Southern Theatre (FST) was established in 1963 by three Black students—Doris Derby, John O'Neal, and Gil Moses—who were active in the civil rights movement. Created under the umbrella of CORE and SNCC, the FST aimed to help Blacks create performances that would support their struggle for freedom. The FST dramatized the message of Black liberation at protest demonstrations. It encouraged community members to write, read, act, direct and produce performances, urging them to re-interpret their history, experience and culture in order to counter white stereotypes and white oppression. FST envisioned theatre as a critical analytical and political tool, arguing that protest must be accompanied by cultural productions which combated the effects of poor education and inadequate information.[11]

the philosophy of religion, often said, "Some people seek to comfort the afflicted. I aim to afflict the comfortable!"

Artists, Activists, and Educators

Going to school is one of the few experiences that most of us hold in common. More than church or work, more than anything else I can think of, most of us share the experience of going to school. Most of us begin our education with art: singing, dancing, drawing, learning poetry and reciting it, etc. Those who get the most significant reinforcement for their artistic efforts develop into artists. Whether we become artists or not, these early experiences determine much about what and how we learn throughout life. Art is a subset of the learning process.

People who don't specialize in the practice of the arts themselves often see art-making as "just having fun." Most people in our highly individualized society, including artists, don't grasp the work of organizing, of movement-building. We're taught to do the individual thing; our training, the techniques we use, the instruments we use, our capacity to make a living, all are predicated, directly or indirectly, on the star system, the idea that each individual artist must seek to outshine the rest. In this way, art and politics (the way they're practiced in our society) have a lot in common. This reality draws many theatre artists away from activism and community-based work. Ironically, theatre and music rely on ensemble and teamwork to reach the highest standards of accomplishment.

But this kind of focus on the success of the individual artist is central to the American theatre scene. The focus on the individual is embedded even in the dramaturgy itself. At the heart of Western drama, there is the idea of the individual as ultimate. Classic plays of bygone times put the figure of the king at the center—no matter how many people the king has oppressed and abused for his own narrow benefit—when obviously there are other ways of thinking about what makes people great. I think this is a problem with a lot of dramaturgy and with the way some artists are thinking, this idea that the *individual* is the most important thing.

The individual is important, but only in the context of one's social relationships. The only thing we can actually do by ourselves is to die, and even then we leave the mess for someone else to clean up.

This glorification of the individual does not serve contemporary circumstances very well, and it certainly doesn't serve oppressed people well. No matter how noble or able an individual leader is, the welfare of a people depends on the collective action of the masses of people. It's more true that the individual is an expression of a community than that the community is the expression of some great man's dream. Great leaders don't make great movements; great movements make great leaders. I certainly saw that in the civil rights movement.

Many artists have trouble seeing themselves as an expression of or even part of a movement. I remember learning this first-hand when I had the chance to meet the playwright Joseph Walker. Walker's *The River Niger* is one of the best examples of Black "kitchen drama." Set in the late 1960s, the play centers on a young Black Panther and the tragic consequences that result for his family when his idealistic dreams turn sour. The tragedy that the young man brings upon himself and his family is heart wrenching. Beautifully drawn characters render the issues clearly and poetically.

When I saw the play in 1972, I was so impressed that I raved about it to a friend who subsequently bought the film rights and produced a moderately successful film version of it. Some years later, when I met Walker at a conference, I anxiously seized the first opportunity I could to tell him how much the play had impressed me, particularly because it solved the problem of the relationship between the personal and the political so brilliantly. Walker responded scornfully: "Politics?! Politics is nothing more than the projection of the artist's imagination!" There would have been no point to further conversation.

Walker's scorn at the notion that his work had anything to do with politics is not uncommon among artists. On the other hand, it is also not uncommon to find politically engaged people who don't respect or appreciate the role of art in the process of building society. They like the concept, they like the idea, but it doesn't make it to the level of programmatic implementation. The most common role they see for art is to help them raise money. And that creates a curious situation where if you're not a star you can't help them very much.

It's really important that we artists recognize ourselves as being connected to the community and vice versa—that we are working together, that artists' resources are the same resources that educators and activists need. Ted Ward describes Shakespeare "as the last great poet to rise to prominence with the support of the state." We who live and work today cannot count on that kind of support. We live in times that call us to the role of "critical witness." We live in a time of revolutionary change. We must pay careful attention to the historical moments as they unfold around us, then we must share the observations that may be helpful to our collective efforts to make things better. The resources for arts and social justice work in America are severely limited!

I think the arts can and should be more integral to the work. Art can help people find ways to be engaged in the process of figuring out how to make the situation better. Art can empower people to tell their own stories and to search for the reasons why those stories are important to them. As people seeking change we *must* work together!

Our strategy is to build on existing relationships with community activists, educators, and artists in the hope that our efforts will be mutually beneficial to all

who participate. *Activists* will extend the reach of their work by expanding and deepening their interactions and influence, by learning ways to apply the techniques of collaborative practice and ensemble development to membership activation efforts in their community. *Educators* can develop their own educational objectives by creating opportunities for students to engage with art both in the classroom and in the community.[12] *Artists* will develop deeper insights into the experiences, ideas, and concerns of people in the communities in which we hope for our performances to have their most profound impact. Of course, the activists and educators will also be able to make direct use of the art for their own purposes. If we're all working as part of the same big constituency of oppressed and exploited people, then we will all be well served by following the same agenda; in other words, whatever angle we approach from, we'll have complementary concerns and will individually benefit from the collaborations we create.

New Orleans after Hurricane Katrina

There is evidence from the flood of 1927 showing that Louisiana levees were blasted to divert water toward poor and rural areas and away from more comfortable urban areas.[13] In 1965, with Hurricane Betsy, it was the same thing: the flood was diverted from well-to-do white communities on New Orleans' Lakefront toward the poor Black communities of the Lower Ninth Ward. The results were devastating.

Because of those two events, a popular understanding of Katrina arose that the same thing had happened again.[14] Respectable scholars who have studied it say it's unlikely that explosives were used this time, but what you have instead is equally if not more atrocious. It was a failure to maintain the infrastructure upon which the life of the city depends: the pumping, drainage, and sewage systems. We're in the bottom of a bowl and below sea level to begin with; our ability to inhabit this area depends entirely on the viability of these systems. By failing to maintain them, the government *guaranteed* that there would be a disaster. That lack of planning could only have been the result of a mindset that says those people who don't have the power to advocate for themselves don't count. Awareness of such injustice exposes the links between poverty and race. As the civil rights movement became less focused, such exposure uncovered a lot of racial tension and conflict in New Orleans and all over the country. Without the focus that the movement had provided, the new direction that things would take was completely unknown. All who believed in the necessity of the fight for social justice had to address two questions: What would justice look like in this situation? And how can we accomplish it?

In the mid-1980s, while touring with the Roadside Theater, the story circle process, one of the best tactics I've seen for justice, peacebuilding, and for problem solving, began to emerge. We invite groups of people to sit in a circle(s) to tell stories with a purpose decided on by the group. In so doing, people learn the technique

For Junebug Productions, the story circle has emerged as a key instrument for doing our work. We recommend storytelling and the story circle process as tools for a wide range of purposes that rely on deep communication and exchange. Anybody can learn better when the subject matter is based on stories that come from or affirm your own experience. In fact, the story circle is just a way of focusing communication. It can be used for any purpose that a group of people wish to pursue. If you trust the circle, when it comes your turn to tell, a story will be there. Sometimes you may be tempted to think of it as magic.

Like the stories it aims to collect, the story circle process is essentially oral in nature so it's not easy to communicate in writing. Everyone needs to know the purpose and have the chance to buy in or out. Maybe they can do this as they introduce themselves and describe what they'd like to accomplish in this particular story circle. We don't make too many rules. Less is more. Listening is more important than talking. You mustn't be thinking about what you will say while someone else is talking. Trust the circle to bring your story to you. You don't have to like other people's stories but you must respect their right to tell it.

Junebug Productions Inc. is the organizational successor to the Free Southern Theater (FST). Critically dependent on the civil rights movement for its access to audiences and resources, the Free Southern Theater finally dissolved in 1980. Born in the post-segregation era, Junebug Productions is still conscious of the bloody, difficult struggles that created the equally challenging conditions of this era. Our name, in fact, is taken from the mythic Junebug Jabbo Jones, a character invented by members of the Student Nonviolent Coordinating Committee (SNCC) during the 1960s to represent the wisdom of common people.

An important lesson of the FST and Junebug Productions is that the greatest subsidies required for the development of cultural programs and products usually come from the artists themselves. Junebug Productions has therefore evolved a working style based on collaboration among creative artists, managers, and community organizations who share a commitment to similar goals and a desire to maximize scarce resources.

We exist within and depend upon a growing network of organizations and persons around the country who agree that the conditions and circumstances hindering Black people in the United States are the same in principle that limit oppressed people the world over. Regardless of ethnic origin or national identity, it is essential to build bridges of shared understanding and bonds of unity that reach across regional, national, ethnic, or cultural boundaries—remembering always that strong bridges must be firmly grounded at each end.

John O'Neal as the folk character Junebug Jabbo Jones in *Don't Start Me to Talking or I'll Tell You Everything I Know*. Photo by Roy Lewis

of working through a democratic group process, where the object isn't to win, but to share.

By the early 1990s the story circle process became the center of a long-standing Junebug Productions initiative called the Color Line Project (CLP). The goals of CLP are:

> To collect stories from people who participated in or who recognize that they have been influenced by the civil rights movement; to archive those stories in the communities in which they are collected; to encourage artists, educators, and activists in each community to use the stories and the process by which they are collected in their work; and to network project participants together.

CLP uses the story circle process to "bring people together in an equitable, collective experience to share their stories, building connections among participants and offering them opportunities to participate in the on-going creation of the community's consciousness. Artists, activists, and educators who lead story circles are able to learn from, and create work that is grounded in, the daily realities of the people in their communities."

Junebug Productions introduced the story circle technique to Students at the Center (SAC), a progressive educational program in New Orleans. Since then, Jim Randels, founder and director of SAC, has collaborated with the Color Line Project in several communities where we found teachers who were interested. Teachers organize their classrooms in circles and structure their teaching objectives around the telling and hearing of stories. The first story circle I did for SAC was one of the best ones ever. There were maybe twenty people in the room—students, parents and families, faculty, and staff. Most of the students took a pass the first round. But then the kids started telling stories. They were so heart-rending that we were all sitting there in tears. I remember one kid talking about how he had no idea where his parents were anymore; he was raising himself, sending himself to school. Others told stories of drug-dependent caregivers. I remember thinking, *"And we wonder why these kids are having trouble in school."* And this was two years before Katrina!

I believe that the story circle process could play a valuable role in getting people together to talk about racism in New Orleans and the aftermath of Katrina. If you get people thinking and talking about real stories, suspending argument for a time, and building relationships through sharing narratives, from there I believe you can expand the process to the exploration of real issues and alternatives. Having laid a basis of mutual respect and listening, people can then approach points of contention and issues of injustice productively and with fresh perspectives.

We're interested in sharing this tool with more artists, activists, and educators. Artists, because if they use the story circle process to generate material, it will naturally improve their connections with their audiences; activists, because the process will help them gain deeper insights into the concerns and issues of their constituencies; educators, because the process can help them manage their classrooms and make connections between their curricula and the lives of their students. If each group collaborates around the common goal of making their whole community better, then it's a win, win, win arrangement.

3. How Can We Make "It" Better?

Until he died in 1996, C. Bernard Jackson was the founder and director of The Inner City Cultural Center in Los Angeles. I heard Jack say at a conference that he was profoundly disappointed with the trend toward "the sanctification of the scientific process . . . We're learning more and more about less and less! Forget such analysis!!" The normally quiet man almost screamed. "What we need is to better understand how things fit together!"

The Free Southern Theater

In making art, the central question is, *"How can we make it better?"* The more important the "it" is that one addresses with his or her work, the more valuable the work

has the potential to become. If the question under consideration in a given work of art is of little or no consequence, why bother? The effort required is too great. The price is too dear.

How can we make the conditions of life in the communities we live in better? This question is always a political question, considering that the term "politics" refers to the ways people make and carry out decisions about their common welfare. The relationship between theatre and the struggle for racial justice has provided the context for my life and work since 1963.

It was early spring. The plans for Freedom Summer were well under way. Doris Derby and I were staffers of the Student Nonviolent Coordinating Committee (SNCC) in Jackson, Mississippi, and Gil Moses, a student at Oberlin College in Ohio who represented a student collective there, had come to Jackson to serve as editor of *The Mississippi Free Press*. Doris and I were working on the Adult Literacy Project at Tougaloo College. In the evenings, I had the assignment of translating Charlie Cobb's[15] idea for Freedom Schools—free schools that would foster civic participation and empowerment among school-aged Black youth—into a doable plan. Like most movement staffers I was soon to take on yet another task: to help make a Free Southern Theater.

It was late one night in the small, cluttered, smoke-filled apartment that Gil and I shared. Doris, Gil, and I had talked way past midnight and the smell of the meal we'd shared had long since turned stale. But oh so passionately did we still carry on about art and the theatre we thought *ought* to be—the theatre we wanted to work in.

It was long after two a.m. when the heady conversation came to a pause. Simply and profoundly, Doris broke the heavy silence. "Well, if theatre means anything anywhere, it certainly ought to mean something here. Why don't we make a theatre?"

The three of us passed a silent, open-mouthed gaze around the room. I don't know how long we sat like that before it was settled. In that quiet moment, the Free Southern Theater (FST) was born.

The historical context into which the FST was born was definitive. It was an optimistic period. We were buoyed by the dynamic civil rights movement that had been born in the mid-1950s after the 1954 Supreme Court decision in *Brown vs. the Board of Education* called for the desegregation of schools. The movement had strengthened in the aftermath of tragedies like the 1955 lynching of Emmett Till. Then, in rapid succession, we saw the Montgomery bus boycott, the Little Rock school desegregation case, and—abroad—the unraveling of African colonialism and its replacement by neo-colonialism. By 1960, the southern student movement began to coalesce, inspired by the sit-ins.

The optimism of the era was reflected in the American theatre in an explosion of significant, sometimes successful off-Broadway and Broadway productions that were politically and socially relevant: *The Diary of Anne Frank, South Pacific, A Raisin in the Sun, In White America, Amen Corner, Purlie Victorious, Slow Dance*

on the Killing Ground, Slave Ship, Bubblin' Brown Sugar, The Royal Hunt of the Sun, and *Ain't Supposed to Die a Natural Death,* among many others. It seemed that the barriers that had historically excluded Black people and their concerns from access to the expressive instrument of the theatre were about to fall.

In 1964, two of the best actors who ever worked with the FST, both white, joined forces to insist that if the FST was to accomplish its mission, it had to become a *Black* theater company.

Murray Levy had participated in the waning days of the Yiddish theatre and he later studied at the Actors' Studio for a time. James "Jamie" Cromwell was recruited to our efforts by director and performance studies legend Richard Schechner during a trip Richard made to Carnegie-Mellon University when Jamie was a student there. Richard met Jamie, whose father had been vilified by the infamous Senator Joseph McCarthy, and told him about our work. Ever a man of strong opinion and definitive actions, a few weeks later Jamie joined us in New Orleans.

After one season of performing and observing audience responses to our unlikely repertoire of *Purlie Victorious* and *Waiting for Godot,* Murray and Jamie arrived at the same conclusion by different paths. They were both proud of what they'd done, but it was the summer of the Black Power march in Mississippi. Murray had some experience in social movements before joining us. Jamie had been less engaged before arriving to work with us. All of us were certain that we were witnesses to the transformation of the civil rights movement into a "Black Power Movement." They believed that the FST should be part of the birth of a Black theatre movement.

At first, Murray maintained that there was no contradiction between the goal of making the FST a Black theatre company and his presence in that company. Murray stayed in New Orleans for a couple of years continuing to work with various theatre companies there. Eventually he left New Orleans to work with the Bread and Puppet Theatre in Vermont for several years. He landed in New York where he worked with a theatre group that I believe was called Theatre for the New City.

No less passionate in his views than Murray was, Jamie framed his arguments with the steely logic and resolve that I imagine his father had been armed with when he refused to name names for McCarthy's witch hunt. (He had stood firm as one of the "Hollywood Ten.") Shortly after leaving the FST, Jamie went to work in the Regional Theatre. I saw his work as a director in Springfield, Massachusetts, and Baltimore. Later he migrated to California where he carved out a successful film career.

Most of the other company members of the second season of the FST left at the same time—some because they envisioned careers for themselves that more work with the FST would not have facilitated, and some simply because they had obligations that required more money than the FST could pay. Most of the people who joined the FST came out of the desire to make careers in theatre rather than to satisfy the requirements of a lifetime commitment to social justice for which

theatre could be a viable instrument. A larger percentage of the *local* people who became involved as apprentices expressed their desire to be involved in the struggle for racial justice.

In founding the FST, our goal was to support the efforts to end the practice of public discrimination in all of its manifestations in the United States and the world. After the drama of the attack on segregated public accommodations, the SNCC, on the advice of Mrs. Ella Baker and the senior, indigenous leadership that she identified, came to focus on ending discrimination at the polls. The FST was to be a professional touring theatre company, but we also had other aims. As we stated in one of our founding documents:

> The Free Southern Theater plans a unique program of community involvement with theater through a program of workshops and community productions. The workshops will serve not only to educate the audience of the theater but will serve also to strengthen the relationship of the Free Southern Theater to its audience, and will stimulate the growth of indigenous community theater . . . The Free Southern Theater is committed to the promotion of "the growth and self-knowledge of a new Southern audience of Negroes and whites," and to the addition of a cultural and educational dimension to the Southern freedom movement . . . the (FST) intends to provide a forum in which the Negro playwright can deal honestly with his own experience, express himself in what may prove to be a "new idiom, a new genre, a theatrical form as unique as blues, jazz, or gospel."[16]

With a belief in a kind of "populist theatre" and "participatory democracy," the FST toured the South, performing for free in rural areas and cities for seventeen years.

A Slave "Ain't Supposed To Die A Natural Death": The Birth of Junebug Productions

There is some controversy about the date of the death of the movement of which the FST was a part, but there's no controversy about the death of the FST. The FST died of "natural causes" in October of 1980 and was immediately succeeded by Junebug Productions, which took up a complementary mission. Since then, Junebug Productions has been a professional touring theatre company and arts organization based in New Orleans. Its mission has been "to create, produce, and present high quality theater, dance and music that inspire and support people who work for justice in the African American community and in the world-at-large."[17]

While the FST did excellent work in its time, I felt that by 1979 we had reached an artistic plateau. In 1980, I was forty years old, and I was worried that I'd have to spend another fifteen or twenty years without the chance to do the work that I felt I was capable of doing.

Other colleagues had solved this problem by moving on to New York or Hollywood. I didn't want to do that. I was committed to working from a base in the South, the historic home of African Americans. It seemed to me that to do otherwise would be to betray my mission.

I knew that in order to survive long-term, we'd have to produce enough revenue to pay people. I set out to create work with revenue-producing potential. In New Orleans, audiences that could pay would mostly be from the colleges and universities, and I knew that they would only buy tickets to see work of predictable quality. I set out to match or exceed the expectations of the market that was available to us.

Part of my work at Junebug has been creating and performing in *The Junebug Cycle: Sayings from the Life and Writings of Junebug Jabbo Jones*. The cycle consists of four plays, all of which are "filled with stories, songs, and poems drawn from the rich trove of over 100 years of African American oral history."[18] Junebug is a folk character. He is:

> An expression of a archetypical character type as old as the ages. Wherever and whenever oppressed people have taken stock of their situations and begun to consider what to do about it, Junebug or somebody like him may be found nearby . . . Junebug comes from a long line of African storytellers. Aesop, the African was one of Junebug's forebearers. The innumerable praise-singers, the oral historians who have carried the records of events and the families of African peoples from time immemorial to now, are ancestors to the Junebug. The tales of Anansi the Spider, the Uncle Remus tales, the John and Master tales, Langston Hughes' character Jesse B. Simple, the street corner poets who chime the rhymes of Shine, Stagolee, The Signifying Monkey and The Bucket of Blood . . . all these and more are ancestors to this keeper of dreams and other sacred things.[19]

In the plays in which he's featured, Junebug moves through a world of cotton fields and churches, plantation life and rural schools, cities burning in the '60s, and finally to present-day neighborhoods. He is concerned about but has not yet tackled the future. The trove that I mine for Junebug's stories is as broad and deep as the history and culture of all who have struggled against oppression and exploitation. Junebug Jabbo Jones is rooted in his African American identity and culture. The main thing about Junebug is that he opposes oppression and exploitation and supports the efforts of all the oppressed and exploited people who sing with Grand Master Flash and the Furious Five:

> Blessed are those who have struggled. Oppression is worse than the grave.
> Better to die for a noble cause than to live and die a slave![20]

In support of the struggle against oppression, Junebug Productions has been a part of several collaborations with other theatre companies of diverse cultures—Appalachian, Asian American, Jewish, and Puerto Rican. Junebug Productions has

staged plays and musicals and has organized festivals addressing themes such as environmental racism, the role of art in social change, the ever-present struggle for racial justice, how romantic love and social-change work can coexist in one relationship and sometimes can't.

We've also enjoyed extensive collaborations with community organizing and educational efforts at home in New Orleans. Whenever possible we try to combine the two kinds of work.

If you went out knocking on doors in New Orleans to find what kind of theatre Black people there appreciate, you'd find that many more people have memories of and experience with the FST than with Junebug Productions in spite of the fact that we've done more and, I believe, better theatre with Junebug. The FST had a stronger impact in our community. One reason for this may be that the FST provided the community with an avenue for direct engagement—classes, workshops, and numerous homegrown productions. Even when money was sparse, we continued to provide those opportunities. The FST operated programs in New Orleans for only fifteen years. We often sacrificed touring in order to maintain our educational programming in the local community.

The fact that the FST had more impact than Junebug Productions makes me think about our new work in an old way. We're now building the Free Southern Theater Institute—an interdisciplinary consortium presently involving people from three universities, artists who share our concern of building stronger relationships with people in communities like ours, and several community organizations who are also working for change.

Our intention is to work on all sides of the equation: educational programming linking matriculating students with community organizations and artists. We're trying to mobilize a constituency of progressive people who have academic careers within universities. We are also building a multigenerational, community-based approach and exploring ways that art and artists can support people who are working to build a grassroots movement for change. In this way we hope to guarantee that the vision from which the FST arose in the 1960s continues to grow and bear fruit.

A premise of our programs, then and now, is that people learn more from what *they do* than from what is done to or for them!

Junebug Productions celebrated its thirtieth anniversary in 2010.

On Aesthetics, Ethics, and Impact

Discipline is a critical element in the process of making art. It's important to note, however, that discipline is *always* voluntary. You can't make anyone do anything! They might pretend to do something that others try to force them to do but *real* discipline, the kind that artistic creation requires, flows from the desires of the heart. The artist's discipline must be grounded in the place where *the needs and interests*

of the audience, the content and style of the artwork, and the aspirations of the artist all intersect. Otherwise the work will not be fired by passion, the content and style will be tasteless and bland, and the audience in the palace of culture will pass it by like trash spilled on the way to the junkyard.

The tendency to vacillate between the needs of the audience and the aspirations of the artist was brought home clearly when the New World Theater in Amherst, Massachusetts, commissioned Junebug Productions to work on a play called *Trying to Find My Way Back Home*, which I wrote for my son, William Edward Burkhardt O'Neal (WEBO). It was directed by Gilbert McCauley.

We were doing a staged reading of the new play in Amherst as part of a New World Theatre festival in the summer of 2005. It all went very well. After the performance, WEBO was so proud of his work in the play. Later, at a reception, feeling good about the job he'd done, WEBO was feeling a bit like a star looking for a place to shine.

There were several good performances at the festival. And one called *The Triangle Project: Journey of the Dandelion* was especially remarkable. It was a dance-theatre collaboration featuring three women, each of whom was the artistic leader of her own company. Yoko Sujikimoto leads a company called Kodo from Japan; Nobuko Miyamoto runs The Great Leap, a dance-theatre company from Los Angeles; and PJ Hirabayashi leads San Jose Taiko, also in California. The production we saw was stunning. Elegant in its visual simplicity, it also has a haunting score. The text of their performance is rich and poetic. Like me, WEBO was overwhelmed. Like me, he couldn't stop raving about them.

When he met the ladies of *The Triangle Project* he was profoundly flattered that they liked his work too, but he wanted to know how they do what they do to achieve the magic that their performance evoked. He wanted to know what he could do to be like them. After a moment of quiet reflection, PJ zoomed right past his question to his core concern. "It may be that the greater function of art is less to *impress* than to *inspire*!"

That observation landed on WEBO like a ton of bricks. It was devastating and uplifting at the same time. When he told his director, Gilbert McCauley, and me about this conversation the next day he was still glowing. I thought of how I must have looked when I left the lectures of one of my gurus, Dr. Harris. Everything seemed so clear—so long as I was *in* his presence! WEBO realized that he'd spent so much energy trying to impress people with his talent, ability, energy, and charm. Now he was beginning to realize that that's not what it's all about. I don't know if he has integrated the idea into his life practice yet, but it's an important realization for any artist at any stage in his or her life. It's a big idea that's easier to say than it is to do. It's similar to the injunction that anchors much of "Stanislavski's method": "love yourself in art, not the art in yourself." That which we strive to realize through our work as well as the work itself is greater than we are.

My friend Dudley Cocke, director of Roadside Theater in Appalachia, tells a story of the popular folk singer Joan Baez, who, when she was at the height of her fame, was starring at a festival in Whitesburg, Kentucky. Baez poured her heart into her performance. After her performance, the regional audience gave her the respectful applause due to one of her standing. But Baez was followed on stage that afternoon by a local string band whose performance was favored by a thunderous ovation. When the band gave up the stage, Baez, who had attended the performance from backstage, was no less enraptured by the band than the audience was. She caught the arm of the elderly gentleman who led the band that day as he left the stage. She told him how very much she enjoyed the show and told him, "Sir, you all sounded wonderful! I play a number of the songs you played today; I've never heard them played the way that you play them! What did you do to make them sound like that?"

The man, whose name would have only been familiar to people from that area, smiled politely, removed his straw hat, and said, "Why thank you, ma'm, we really do appreciate that."

Sincerely pressing for a musical explanation for the difference, Baez asked, "What key did you play in? Do you use a special tuning or what?"

The man shuffled uncomfortably before saying deferentially, "The only difference I can see between what you do and what we do is that when we play those old songs, we get in up behind them."

I remembered this story when we talked about *Journey of the Dandelion* in rehearsal. We tried to underscore the point that a cardinal rule for artists must be to observe the discipline that artwork should be more firmly grounded in the needs and interests of the audience rather than in the aspirations of the artist. If artists don't see themselves as being included in the circle of interests that describe their audience, then artists are likely to see themselves as having been set apart from and probably above their audiences. No matter how skilled we are, our real attitudes will be revealed in our work.

Content and Form, Community and Conflict

Opposites tend toward each other. Top tends toward bottom; in to out; young to old; particular to universal. One is only comprehensible through the careful examination of its relationship to the other. In the opposing relationship between content and form, content is primary in art. Form is essential to the *perception* of the content; however, *most*, but *NOT all* of the time, content is the determining element.

Every time I start a new project, the hardest part of the work for me comes when I have to answer for myself the questions: What is this story about? Why should it be important to the people I am making it for? What do I wish for as a result of the work that I want to share? And since there can be no action without conflict, what is the central conflict between the characters?

The effort to deal with these questions invariably compels one to think of the community that shapes the characters we meet: Which of them might share my concerns? Which might oppose them and why? What are my hopes for my community? How do I feel about these characters? And how will others feel about them? The fact that we're all part of one large, interdependent, global community requires us to consider these questions.

We make the best answers that we can. These aren't metaphysical questions. With modern technology we all literally sit on each other's laps.

For performing artists, the relationship between the work one does and the community of which one is a part or the audience for which one performs is at the core of the effort. My goal is always to make the relationship deeper, ever more direct, more dynamic, and more interactive.

The value and, ultimately, the power of art flows from the strength of this relationship between art and the community through which it is expressed, filtered through the skills, abilities, and understandings of the individual artists who work together to realize the vision upon which a given work of art rests. The clearer the connection between the art and the central historical trend of the time that gives context to the stories, the characters, and their efforts, the more valuable the work will be to those who encounter it.

Bob Moses (no relation to Gil) was the director of SNCC's Mississippi Project. Like many of the people whom I admire, Bob is a quiet reflective man and an astute observer. He's a math teacher by inclination and training. Bob was the first one I ever heard make this point so succinctly: "The essence of the story of human development is that there's an irresistible trend toward more and more democracy . . . social, political, economic, and cultural democracy."

I don't recall whether or not I ever asked Bob where he got the idea, but I agree with what I remember him to have said. The democratic impulse *and* the resistance to it is one of—if not *the*—major conflicts that drives most of human history.

Whether we know it or not, whether we intend it or not, the great historic conflicts through which we live are reflected in the content and form of the art we make and pay attention to. None of us, artists or audience, can ever step outside of history.

For the last several hundred years or so, Western culture has put the emphasis on form as if the capacity of forms to carry content is sufficient in and of itself. This is like putting the dipper in the water without regard to which side is up or what you intend to do with the vessel when it comes out of the water. The controlling element in the equation is content or purpose. The content permits us to determine what kind of form will work. The content—the examination of the content—tells us about our mission in the world. At some point the artist must answer: What am I trying to communicate? To whom is this important? And what do I hope for them to do as a result of the experience we share together?

A facilitator leads a story circle, a storytelling method first developed by the Free Southern Theater during the civil rights movement in the United States. Photo by Roy Lewis

This is really the hardest part of an artistic project for me—at some point I have to answer these questions. The formal aspects of art are essential to the perception or the apprehension of the content, but one's answers to the questions of content are determinant.

Some seem to fear that artists who try to be clear about content, purpose, and desired results in a political context will reduce their art to "socialist realism." They fear it will become didactic and propagandistic. I don't agree with that. The difference between propaganda and art is the reach of the idea, whatever it is. Effective propaganda is *usually* focused around a specific event, circumstance, or moment. It's time-bound: we want to win this strike or we want to get out of this war. It doesn't address the root causes of things. My view about art is that it goes to root causes and is not so narrowly bound by time. I also believe that if your stories have full, rich characters in a soundly conceived situation, they won't be didactic. So there's nothing to be lost in having a clear purpose and wanting to see results. Neither is anything lost in making a play, or some other work of art, and then building educational activities around it, like writing study guides or asking a teacher to do so. Making the connection between art and the communities with whom you wish to share it is essential.

If we're unclear about our purpose and our content, if we're not conscious of and intentional about the results we are after, we're likely to miss the point entirely. If we fail to do this piece of our work, our desire to tell a story, to perform, to make pictures, can actually make "it" worse. Buffalo Bill's Wild West Show, featuring "real wild Indians," is an example of storytelling that—through its perpetuation of myths about the "savage Indians"—supported "the great European" agenda of colonialism, oppression, and exploitation. These stories influenced generations of Americans.

I remember playing "Cowboys and Indians" as a kid. Like most places in the early 1940s, Southern Illinois was rigidly segregated. The Black kids I played with had big arguments because no one wanted to be the Indians. In time a few of us began to realize that Black people have a lot more interests in common with the Indians than we do with the Cowboys. For me that was the birth of a political consciousness: the recognition that "playing" is serious business.

Skill in the manipulation of art forms is an absolutely *necessary* part of art-making, but it is not *sufficient* for the accomplishment of high quality art. If one is truly engaged with and observant of his or her concrete experience, formal creativity will follow as naturally as dreaming does. Perception itself is a vital creative process. Standing on the same hillside and looking out we don't all *see* the same thing. When I tell you a story, you will imagine things that I've never thought of in ways that I never thought of because you connect my story to your own experience. My story means something to you that it couldn't possibly have meant to me. Creativity is the inevitable and necessary result of experience. But perception is *never* separated from our conceptions of what our best interests are.

The desire to de-emphasize content rises from people whose lives and circumstances are basically satisfactory to them. "God is in His heaven, and all's well with the world!" They talk about beauty as a goal, as if there's only one thing that can be called "beauty." Whether something's beautiful or not, whether it's funny or not, whether it's sad or not, it all depends on who you are and how you relate to the content of a given moment. Some oppressed and exploited person who hasn't learned to keep his mouth shut and go along with the program comes along saying, "But the Emperor has no clothes!" In time such people find themselves in opposition to those who wish to keep things as they are or sometimes return to an image of things the way they were.

For a time my late partner, Gil Moses, was fond of quoting Bertoldt Brecht, saying, "The only art that's not political is that which sides with the ruling powers!"

Conclusion: Thoughts on Theatre, Oppression, and Hope

Theatre is among the most powerful and complex of the art forms because it has the capacity to engage all the senses and because the audience is present with the

performers in the same time and place. Because it's interactive, live performance can engage people very deeply in ways that other media cannot. It brings it right down front and center. In a performance, the artists maintain an awareness of the audience and, even as an experience is offered, they can adjust or trim it based on the audience's response. Theatre is a direct and interresponsive form of communication about how to make things better or how to resolve a given conflict.

I think art that inspires self-love, confidence, and hope *is* art that inspires justice and ultimately peace. It is relevant to people's lives. Without self-love, we help the oppressor keep us down. One of the key instruments of oppression is convincing the oppressed that their oppression is appropriate and justified—convincing a little girl, for example, that she is not beautiful or lovable. I'd say that kind of "internalized oppression" is a key element of any "successful" exploitative system. Because if the oppressor has to spend all his resources keeping you down on your knees in the ditch, then this equation is not working for him. But if the oppression is internalized, then it becomes one of the most efficient ways of keeping people down.

Without confidence and an empowered sense of self, a person has nothing. Kalamu ya Salaam, one of the finest poets in the country right now, quoting received wisdom of the people, says, "Anything I give you, I can take away." He is saying that the only things we can keep are those things that we gain through our own effort and self-confidence.

Without hope, people disengage and are automatically disempowered. We had a somewhat famous prisoner here in Louisiana who recently got out of jail. About fifty years ago, Wilford Redeaux was caught committing a bank robbery. He was nineteen years old at the time; he took three tellers hostage and wound up killing them. But while he was in jail, he was converted from a youngster with potential to a man who delivered on his potential. He became editor of *The Angolite*, a serious newspaper run out of the Louisiana State Penitentiary. He became an extraordinarily good writer and thinker. After forty-five years, and three or four parole hearings, he won his petition and secured his release from prison. That must be about four years ago now. When I would go to various prison-related activities, I would always find myself sitting with Redeaux and talking. One of the things he said that sticks in my mind is that the only way to do time is with the hope that you can get out. If you don't have any hope, Redeaux said, you release yourself to the deadening and deathly consequences of incarceration. Hope is the key.

I think this is true for all people—if you have some glimmering of the possibility of another world, when it gets enough energy in it, you can start to make a change.

I also think that theatre helps us move toward justice and peace by providing social, historical, and philosophical perspective and context. In *Our Lan'* Ted Ward took historical material and tried to highlight and frame those important moments

accurately. People who live through a particular moment of history may not be clear about what the significance of that moment might be, but the more perspective we gain on it, the more we may be able to see.

Data reveal that people's hope for something better is the first target of an oppressive state. Art that holds up the vision of that potential for something better inspires and gives people hope. Once we make tangible the expression of hope and the possibility that there is indeed a realistic chance for change, people might start seeing options.

October of 2013 will be the fiftieth anniversary of the Free Southern Theater. I'm reminded of something Barry Opper once said to me. At the time Barry was the managing director of the ProVisional Theater where he was a colleague of the excellent stage director Steve Kent, who has worked with the FST and Junebug Productions for more than twenty-five years.

One day Barry remarked to me, "When we were in our twenties, my family and friends would worry about this work we're doing and say things like, 'Oh, don't worry, they'll soon outgrow it.' Now that we're in our 30s, they say things like, 'What do you think is wrong with them?'"

I thought about what he'd said for a moment. Then it occurred to me to say, "Don't worry, Barry. If we can just hold out 'til we get to our 40s they'll begin to think that we're geniuses of some sort!"

This little story comes to mind because over the last few years several doctoral students have chosen the Free Southern Theater and Junebug Productions as subjects for their research. Could it be that our longevity has something to do with this?

Catherine Michna is one such student from New Orleans, who's now studying and teaching at Boston University. Catherine is planning a career as a teacher after having been motivated by several interviews and observing the teaching of Jim Randels and Kalamu ya Salaam, codirectors of "Students at the Center" in New Orleans. Students at the Center make extensive use of the story circle process in their own teaching methodology.

Catherine and I met for our second interview at a coffee shop not far from my apartment in New Orleans. As our long and interesting conversation drew toward a close, Catherine asked me, "Since so much of what we've talked about was like bad news, how do you manage to keep going?"

I rolled the question around in my mind. It wandered up and down from the corner where we sat at Magazine and Race Streets (yeah, "Race" Street). The old buildings which had once been so magnificent and elegant seemed to remind us that there once was a time not so long ago when houses were made of the best material available and were constructed with the intention that they should last at least as long as the families that built them might need shelter. The streets and sidewalks,

now cracked and pocked, had once sung sweeter songs than they make now as the metal bottoms of motorized cars and trucks rattled along in hasty parades trying to keep the pace demanded by the rhythms that the business cycle and gentrification demanded. My eyes were drawn toward a not-so-pretty clump of hardy grass breaking through a line of cracks in the sidewalk; a sidewalk which had been forced up from its bed by the roots of a twisty little tree that was scattering its small but blazing crop of pink blossoms on the lumpy ground.

My reflections settled on the clump of grass near my foot. I spiraled out from there to the Hubble telescope, which had just received a new upgrade and a five-year lease on life. I flashed on some of the spectacular Hubble images that I'd seen not long before.

A fourteen-year-old white girl had been on one of the morning television shows that day being recognized for having discovered a new nova. It had been named for her. She seemed delightfully well adjusted and normal for one recently promoted to stardom of a certain type.

In my mind's ear I heard Aretha singing, "There is a rose in Spanish Harlem, A rose in Black and Spanish Harlem."

A response to Catherine's question took shape. I heard my mouth remark, "In the contradiction between creation and destruction, I believe that creation is dominant. No matter how hard it is or how long it takes, creation is dominant over destruction; good tends to be dominant over evil."

In the words of the African Revolutionary Samora Machel, "Tell no lies; claim no easy victories—we shall win without a doubt!"

So the questions on my mind now are: How to build a movement that, with its energy, with its spirit, with its intelligence, can help roll the big wheel of History away from inequity and toward equity; away from injustice and toward justice; away from bureaucratic autocracy and toward a genuine representative democracy. African Americans and their allies in particular and oppressed people in general won't be able to make effective demands upon our leaders until we build strong, grassroots organizations with viable ideas about how to construct and maintain local, regional, national, and transnational coalitions with others who are similarly oppressed and exploited. I think art and theatre can help do this. As artists, we can help by telling stories that warn of the dangers that may wait for us down a given path or by celebrating the things our communities have to be proud of.

It's unlikely that there's going to be a sudden surge from the theatre to the barricades. But if we can find a way through performance to create little moments of clarity, then people might be able to see the relationships between themselves and those moments. Maybe then we might be able to work our way through the mess we've made.

Reflections and Recommendations

As part of a theatre for social development project, New York's Bond Street Theatre collaborated with Simorgh Thetre from Herat, Afghanistan, to create two original productions addressing family violence, one performed by women for women and the other presented by men to men. Here, *Rahela's Bride,* a play that addresses the often abusive relationship between young brides and their mothers-in-law, is performed in the Herat Women's Prison for incarcerated women and the children who live with them. This 2011 performance was the first time most in the audience had ever seen a live theatre production. Photo by Anna Zastrow, Bond Street Theatre

6 The Permeable Membrane and the Moral Imagination

A Framework for Conceptualizing Peacebuilding Performance

Cynthia E. Cohen with Roberto Gutiérrez Varea and Polly O. Walker[1]

There's a permeable membrane between art and society. A continuous dialectical motion. Tides brining the estuary. River flowing into sea . . . Likewise: the matter of art enters the bloodstream of social energy. Call and response. The empathetic imagination can transform, but we can't identify the precise loci of transformation, can't track or quantify the moments. Nor say how or when they lead, through innumerable unpredictable passageways, toward recreating survival, undermining illegitimate power and its cruelties. Nor how newly unlocked social energies, movements of people, demand a renewed social dialogue with art: a spontaneous release of language and forms. —*Adrienne Rich*, poet[2]

All of the good peace work being done should be adding up to more than it is. The potential of these multiple efforts is not fully realized. Practitioners know that, so long as people continue to suffer the consequences of unresolved conflicts, there is urgency for everyone to do better. So, in spite of the real limitations and constraints, the question of effectiveness is high on the agenda of peace practitioners. It is posed in several ways: How do we do what we do better, with more effect, with better effect? How do we know that the work we do for peace is worthwhile? What, in fact, are the results of our work for the people on whose behalf, or with whom, we work? —*Mary Anderson and Lara Olson*, peacebuilding scholars/practitioners[3]

The case studies in this anthology tell the stories of playwrights, theatre directors, leaders of community rituals, actors, and citizens who have chosen, through a wide array of performance practices, to engage creatively with the most urgent issues

confronting their societies and the global community. While composing works of beauty, meaning, and imagination, they have simultaneously worked to end violence and abuses of power, and to increase justice, understanding, and inclusion. Their ethically informed creativity, in Adrienne Rich's words, "enters the bloodstream of social energy" locally, regionally, nationally, and internationally; its effects are registered on people, relationships, communities, institutions, policies, and cultural norms.

In the Introduction in volume I, we situated the works described in this book on an imagined boundary between human suffering and human possibility. Calls for both efficacy and beauty can be heard in the anguished and hopeful cries that resound at this border. Our exploration of the ethical, creative actions at this boundary navigates between the themes set out by the two epigraphs above: between the profound, but often subtle and sometimes unknowable effects of artistic productions on the one hand, and the important work of documenting and improving peacebuilding practice, including arts-based efforts to transform conflicts, on the other. This chapter offers a framework to hold the two seemingly contradictory horns of this dilemma in one view.

Let us imagine a performance as a sphere of activity, a dynamic, fluid three-dimensional space—part of, but marked off from, the rest of life by a permeable membrane as a nucleus is suspended within a cell. Propelled by commitments to create moments of beauty and sacredness, to ameliorate suffering and to enhance social justice, elements from everyday life cross through a porous boundary and enter the space/time of ritual and theatre. In conflict regions, these elements almost always include expressions of resilience as well as the suffering, fear, shame, humiliation, rage, trauma, and yearning that accompany violence and injustice.

Within the boundary of the membrane, elements that are free-flowing in the larger world (making them difficult to face, contextualize, or fully comprehend) are condensed, given dimension, and framed so that they can be recognized and re-viewed. Inside the "nucleus," these elements from the real world are transformed. They are then brought back through the membrane, reentering the quotidian world of everyday life, primarily through the consciousness and the bodies, words, actions, and relationships of those who participate in and witness the performance.

What is the "porous membrane" composed of? We propose that in peacebuilding performances this boundary consists of the aesthetic and ethical sensibilities of artists and cultural leaders, animated by the moral imagination—the capacity to be in touch with, and grounded in, the limitations and suffering of the real world, and simultaneously to imagine and work toward a more just and more life-enhancing imagined order.[4] This wisdom can be found in the conscious minds and subconscious of individuals as well as in expressions of collectivities; over time it has also been embedded in the forms and conventions of the performances themselves.

The job of the artist is not to look at what's OK, and keep quiet. The job of the artist is to look and say, "We've got this sorted, now what *else* do we need to get sorted? —*Charles Mulekwa*

The task of art is to answer the question "What can we do to make it better?". . . The more important "it" is, the more valuable the work will be. —*John O'Neal*

We offer the notion of a permeable membrane between art and society animated by the moral imagination as an alternative to what peacebuilding practitioners call an initiative's "theory of change." The remaining sections of this chapter explore this framework in detail, drawing primarily on insights from the case studies in the two volumes of this anthology.

1. Matters from Sociopolitical Context that Enter Creative Spaces

In zones of violence and oppression, suppressed truths about abuses of power, unexpressed stories of suffering, unremembered erasures, unmourned losses, unresolved conflicts and dilemmas, unpunished crimes, unfulfilled yearnings, unacknowledged complicities, unspoken feelings of remorse, and unreconciled relationships are all screaming—in silence and in deafening roars—for focused, creative attention that might lead to healing and justice, and, perhaps, to peace.

An instructor reviews his students' work in Hope North, a living and learning community for refugees, orphans, and former child soldiers in northern Uganda founded by playwright and survivor Okello Sam. For more information about Hope North, visit www.hopenorth.org.
Photo by Terry Torok, Photo Journalist, Crossing Borders

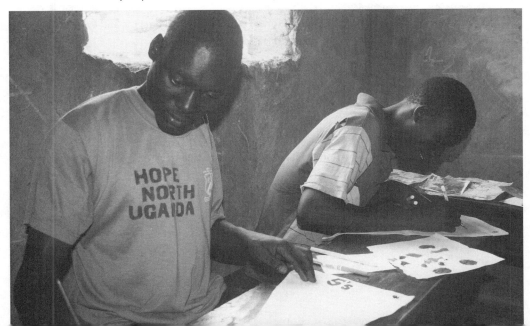

While the content addressed in the performance practices documented in this anthology varies widely, several themes emerge in nearly all of the case studies: *memory, identity, justice*, and *resistance*. In zones of violent conflict, especially when communities face existential threats, most often the imperatives surrounding these four important issues are experienced and articulated as straightforward obligations or demands: the urgency of remembering past atrocities as well as past accomplishments; the need to recreate or celebrate suppressed and threatened identities; the obligation to seek justice; the need to resist attack and restrictions imposed by those wielding power.

However, when perceived through the filter of a robust moral imagination, deep tensions within and among these imperatives become apparent. Spaces of performance allow these tensions to be illuminated and explored; and in the process what first appeared as straightforward and unbending obligations often are transformed in the direction of greater nuance and complexity.

Of course, regions of violence are characterized by more than suffering, dislocation, and despair. They are also places of courage and resilience, of creative resistance to the indignities of war and the culture of destruction, and of solidarity with those whose rights are violated. They are places where the small pleasures of

I **believe** we should work always from our personal needs. But then, if that need is organically connected to the need of your community, and I would use the Greek work "polis," then something really transformative happens. —*Dijana Milošević*

In our way of working, someone tells a story and that story is taken seriously. People are surprised that you're interested in that story, and even more surprised that it is transformed through a process of improvisations into material for a play constructed by a professional writer. The people themselves who told the story are placed on the stage, directed by a professional director, and together they create a performance that is incredibly powerful! —*Eugene van Erven*

In the hip-hop cipher, as people lose themselves in the delirium of sound, in the act of improvisation that releases the mind and body, in the love of the circle, they also find them\selves—they find their voices, recount their life experiences to each other, and make sense of the world around them. —*Daniel Banks*

[Several days into our six-day ritual], participants begin to dance with increasing animation, some becoming quite frenzied and entering a state close to that of a trance. People manifest themselves in different ways . . . [A] man described a vision in which the army was burning a couple's children right before their eyes. He was actually remembering an incident from when he was nine years old. —*Kandasamy Sithamparanathan*

daily life still unfold. They are populated, to be sure, by arms dealers, despots, commandoes, and the willfully ignorant, but also by citizens who exhibit unimaginable compassion, unexpected humor, and unscathed wisdom. Artists and educators, healers and providers remain present. Rituals sometimes still are performed; unifying symbols and practices sometimes still can be found or restored.

Along with suppressed stories, these local cultural resources are also brought into the spaces of theatre and ritual. They take the forms, for instance, of lullabies and candlelit rituals, familiar fabrics and costumes, riddles and proverbs, patterns of color and melody. The resonances they evoke are key to the aesthetic and spiritual power of performance, and they distinguish creative approaches from purely rational and formulaic peacebuilding techniques that draw on valuable scholarly theories but often fail to honor local knowledge and culture.

How is it that suppressed stories, urgent obligations, and local sources of resilience enter into the spaces of performance? We turn our attention next to the pathways through which all these elements from the ongoing life of communities are brought through the permeable membrane into spaces of focused creativity.

2. The Pathways between Ongoing Life and Performance

The elements from the ongoing life of the community can enter the space of performance in myriad ways, including the intentions of the artists/peacebuilders, the stories and embodied memories of the community participants, the associations with the land on which rituals are performed, and the policies and programs of government agencies and nongovernmental organizations. How the resources, the suffering, and the injustices of the sociopolitical and cultural contexts enter the creative and possibility-laden space of peacebuilding performance is itself a matter of significance. The case studies in this volume document a number of pathways, some involving conscious choices and strategies, others in which creative processes unearth material from the realms of intuition and the nonconscious, and yet others drawing from both conscious and nonconscious sources.

In fact, another key difference between performative approaches to peacebuilding and more conventional methods (dialogue and negotiation, for instance) is that material can be brought to attention through nonconscious as well as conscious channels. For instance, Dijana Milošević describes how nonconscious material emerged into the space of performance during rehearsals for *A Story of Tea*: the red liquid of the actors' blood mistakenly covered the hands of one of the performers, leading one of the actresses to realize that the same men who were loved as brothers and husbands in fact *did* have blood on their hands; they were perpetrators as well as beloved kin. This is important because, as explained by the anthropologist and cybernetic theorist Gregory Bateson, unlike information required for the survival

of the individual organism, which is processed through the channels of "purposive rationality," the wisdom necessary for the survival of the species is generally encoded in the nonconscious realms of dreams, ritual, and art.[5]

The body plays an important role in bringing elements from the sociopolitical context into the creative space, in part by reaching beneath the defensive structures that are part of the social psychology of violent conflict. In contexts of violence, people's bodies are marked, sometimes physically and sometimes metaphorically, by the traumas they've faced—physical and sexual violence, oppressive working conditions, poverty, and other assaults on their physical integrity. As Augusto Boal, the founder of Theatre of the Oppressed, writes, bodies are inscribed with "limitations and possibilities, social distortions and possibilities of rehabilitation."[6] Memories that might not immediately be accessible to verbal recall are nevertheless physically held and often can be accessed and transformed through creative work that engages the body.

Likewise, identities, contested or otherwise, are composed partly of embodied traits, such as aesthetic sensibilities, culinary preferences, and accents.[7] In most practices of socially engaged theatre, rehearsals and workshops start with exercises designed to allow participants to access their bodies as expressive tools, vessels where imagery and knowledge are stored. Initial trust-building activities almost always begin with playful physical activities.

At the most basic level, then, the dynamics of the conflict are brought into the creative space through the minds and bodies of the people who create, participate in, and witness theatrical and ritual peacebuilding productions. Socially engaged artists and community leaders, attuned to the needs and issues of their communities, intentionally choose topics, themes, or questions that address the experience of violence and its consequences and causes: the suffering of victims and survivors; the complicity and shame of perpetrators; the stereotypes and fears that impede trusting relationships; and the hopes for a more equitable, just, and inclusive social order. Such issues can be engaged directly or indirectly. Audience members, witnesses, and participants correspondingly bring conflict dynamics into the creative space, as performances invite and support them to attend to memories, questions, emotions, dilemmas, fears, and hopes.

Several case studies in this anthology document examples of performance in which issues and stories are propelled from the sociopolitical context, through the permeable membrane, into the creative space of theatre and ritual not at the initiative of artists or community people, but because of agendas established by civil-society organizations, governmental agencies, and intergovernmental organizations. These studies illustrate that aesthetically powerful work that contributes to the creative transformation of conflict sometimes can emerge from cooperative ventures between

such players on the one hand, and artists and ritual leaders on the other. But this is only true when, to a substantial degree, *the integrity of the creative space* is *respected by the non-arts players.*

This understanding and respect for artistic integrity is key to the transformative potential of peacebuilding performance. It contrasts sharply with recent trends across much of Africa and Asia, where NGOs fund theatre groups to communicate certain predetermined messages, sometimes ignoring the vitality of local expressive forms and failing to cultivate works that are enlivening. These prescriptive practices run the risk of producing didactic and propagandistic performances, perhaps useful in delivering messages, but useless in terms of engaging the full transformative power of theatre and the deeply rooted creative expressions of communities. Such practices can also undermine local initiative and devalue local expressive traditions.[8]

All too often, elements of sociopolitical and cultural violence and injustice disrupt the space/time of performance according to their own destructive logic: indigenous rituals and performance practices are outlawed by colonizing powers; military censors redact scripts; checkpoints prevent artists from reaching sites of performances; artists are targeted by brutal regimes and imprisoned, "disappeared," or forced into exile by threats of death.[9] In these instances, violent forces tear through the permeable membrane that otherwise would mark off the space of creativity from the flow of events in everyday life. Elements of the sociopolitical order impose themselves onto the performance space, not in increments or forms that allow for them to be digested, appraised, and transformed, but rather intentionally injuring the space and violating the spirit of reciprocity required for aesthetic encounters.

Also, even when the integrity of the creative space is itself left undisturbed, the larger meanings of cultural productions risk being appropriated by governments or other centers of institutional power to be employed in the service of strategies of domination or obfuscation of which artists and participants might not even be aware.[10] The risks of unknowingly colluding with larger strategies outside of the control of the artists and participants are particularly acute when the artists are working with unfamiliar institutional partners, across imbalances of power, and across political boundaries.

What, then, are the features of the time and space of performance that facilitate transformation in the direction of justice, healing, and peace?

3. The Creative Space/Time of Peacebuilding Performances

A performance's unique power comes from its immediacy: an exchange of energy among those who journey together through a composed moment in space and in time. It is impossible to fully capture in words (or even in film) the meaning or

experience of live performance, witnessed as part of a group. This is so in part because there really are an infinite number of performances, each constructed in the mind and the being of those who perform, participate, and witness.

However, it is possible to articulate, at a very general level, the characteristics of the space/time of exemplary peacebuilding performances. They are powerful, and they derive their power from their aesthetic, performative, and ethical features, as these dimensions are calibrated to resonate with each other and with the sensibilities and the needs of the community.

Like cultural productions of any form that seek to engage people aesthetically, peacebuilding performances are crafted with great attention paid to their formal qualities. They are marked off from the everyday, offering a bounded space in which particular aspects of life can be addressed with focus and creativity. The space/times of such performances are nearly always meticulously prepared; a first step is to generate conditions for creative work by imbuing the space itself with qualities of care and respect. Attention is paid to the aesthetic and spiritual sensibilities of those who enter, with awareness of how audience members and participants are likely to be affected by compositional elements such as sounds, colors, scale, spatial arrange-

Born in the midst of war, Serbia's *DAH Teatar* works in a number of settings and forms, bravely taking to the streets to confront fellow citizens with the ethnic and gender violence perpetrated in their name. Performed as part of the 2010 global campaign on "Militarism and Violence Against Women," the work depicted here follows the process from the moment of violence to the point when the woman reports the rape to the police. Photo by Biliana Bibi Rakočević

Dedicated to women survivors of sexual abuse, *My Body, My Territory* dares to say: "a woman is never guilty for being raped, the shame is on the perpetrator!" Directed by Dijana Milošević; Actresses: Vesna Bujošević, Zorica Nikolić, Ana Imsirović-Djordjević, and Sladjana Rackov.
Photo by Biliana Bibi Rakočević

ments, lighting, presence, and placement of symbolic objects. These productions engage multiple faculties of their audience members and participants, including their intellects, senses, emotions, and spirits, through the use of symbols—words, gestures, movements, music, color, objects, etc.—that are resonant with meanings, designed to support and challenge, soothe and provoke, and combine in various ways the reassurance of the familiar with wonder at the new.

It is through their beauty (i.e., through their ability to evoke aesthetic experiences for those who participate and witness) that such works are deeply affecting. By definition, aesthetic experiences are characterized by a reciprocity between the viewer and the performance. The nature of this reciprocity can be understood by contrasting aesthetic engagement first with propaganda (in which the work is constructed to impose itself onto viewers' beliefs) and then with analysis (in which the viewer imposes his or her own preexisting categories onto the production). Engagement arises in part because the compositions are calibrated with their viewers' perceptual sensibilities, and in part because viewers open themselves to the works and the reverberations and resonances they evoke. Not all transactions between cultural

productions and their witnesses or participants result in aesthetic experiences, but when they do, it is because the work succeeds in enlivening but not overwhelming the sensibilities of its audience. This happens when productions mediate in culturally sensitive ways tensions between chaos and rigidity, innovation and tradition, provocation and reassurance, humor and despair.

In aesthetic experiences, the encounter between witnesses and the work of art or ritual generates processes of creative meaning-construction, and an exchange of energy that both artists and witnesses find deeply affecting. By virtue of their aesthetic power, peacebuilding performances can be crafted to invite witnesses into paradoxically paired qualities of presence, including alert calmness, engaged detachment, and heartfelt awareness. To whatever degree it is realized, the reciprocity between the work and those who witness it introduces into the social environment the energy of shared vitality, and a quality of respect and regard for the other, an experience of interdependence, that is all too rare in zones of violence, oppression, and exclusion.

All kinds of art forms can evoke aesthetic experience; what makes performance unique is that productions are embodied, collaborative works that are witnessed and experienced by groups. Also, performances engage the imagination with the power of stories. Such work requires a willingness to take risks and the cultivation of sufficient trust and trustworthiness (sometimes referred to as "safe space") to warrant the vulnerability required for an honest engagement with content and innovative formal expression. Performance spaces need and cultivate the capacity for "presence," as Roberto Gutiérrez Varea says, "to what is going on within us, between us and around us." In a sense, this "presence" is the texture of the moral imagination that animates the permeable membrane between peacebuilding performance and society—in that it refers to a kind of awareness that is alert to the moment, vital, and replete with ethical risks and possibilities.

Performances are unique among the array of artistic and cultural forms also because their primary symbols are the human body and voice in action and in relationship, making them more broadly accessible than many other forms of expression. Also, because of the collaborative nature of the creative processes that lead to productions, these performances can reflect, embody, and juxtapose a range of perspectives and sensibilities.[11] And because of the variety of symbols used, and the multiple levels on which any symbol communicates, performances can be crafted to bring together people of different cultural backgrounds, generations, and political beliefs. Because of their multilayered structure, performances can be respectful of audience members who enter the performance space with different allegiances regarding conflicts and who have enjoyed different levels and kinds of educational and developmental opportunities.[12]

In addition to the peacebuilding potential that performances derive from their aesthetic, performative, and epistemic qualities, the contributions of performance to the creative transformation of conflict result also from the ethical sensibilities and political commitments that inscribe particular productions. What are the purposes and intentions of the people who create the production? Are they focused on the transformative effects on those who participate in the production or on those who witness the finished work? Are processes of composition and production designed to strengthen skills and capacities? How are power dynamics addressed? How are disenfranchised and privileged groups represented? Is the production itself animated by commitments to the truth, accountability, and the rule of law? Does it anticipate the possibility of forgiveness and restoration? Does it provide the context for new information and understanding? Does it celebrate the identity of a particular cultural group, or focus on common humanity and interdependence among all people? How does it balance these multiple and sometimes competing ethical commitments?

The defining features of performance outlined here suggest a strong affinity between the underlying ethical sensibilities that over time societies have embedded in theatrical and ritual traditions on the one hand, and the disciplines of the moral imagination as outlined by John Paul Lederach on the other. In fact, these disciplines of the moral imagination—cultivating spaces for creative acts, taking risks in the direction of vulnerability and relationship, acknowledging interdependence, and embracing paradox and complexity—are all defining elements of well-crafted performances. The engagement of these elements in service of the creative transformation of conflict depends, to some degree, on what issues from community and society are brought into the performance space; how they are recast by the creativity, moral imagination, and intentions of those involved; and the courage, creativity, and commitment with which the transformed "matter" is carried back into the community or society.

The next section explores the nature of the transformation that occurs when material from the larger world is mediated by peacebuilding performance.

4. Transformation

In our efforts to synthesize and summarize what can be learned about peacebuilding performance from this collection of case studies, we have proposed the metaphor of a permeable membrane separating art from and connecting it to society—similar to the nuclear membrane that bounds the nucleus within a cell. The nucleus is the intense, creative time and space of a performance; the membrane is moral imagination itself. Through both purposeful intentions and nonconscious impulses of individuals and collectivities, material from the sociopolitical and cultural context,

with its resilience and creativity as well as its violence and injustice, is brought into the performance space and transformed. By what processes, and toward what directions, does this transformation take place?

In this section, we outline three general directions of change: a) silenced words and suppressed actions are expressed; b) capacities that were impaired or underdeveloped are nourished and restored; and c) previously straightforward imperatives—such as those toward justice, memory, identity, and resistance—become animated by the disciplines of the moral imagination, generally resulting in more complex and nuanced understandings and manifestations.

The expression of repressed and suppressed stories, thoughts, and feelings

As the case studies reveal, performance spaces are venues where repressed and suppressed stories and perspectives can be brought to light, given a hearing, and joined with the social imaginary.[13] That which has been unexpressed—because it is too controversial or too traumatic—can be expressed, sometimes through symbols that are open to multiple and nuanced interpretations. That which has remained unacknowledged—because it is too unsettling, too frightening or painful, too disruptive of conventions, too threatening to those in power—can be acknowledged. That which is understood only in stark simplicity can be considered and reconsidered in light of diverse perspectives, broader historical views, the determined voices of young people, the calm and compassionate voices of elders—or it can be refracted through the moral clarity of an enacted underworld or imagined afterlife.

In her chapter on Playback Theatre in this volume, Jo Salas describes transformations that occur in young people's lives after performances in schools in which they were encouraged to tell stories about their experiences with bullying, and were able to receive both empathetic listening and commitments to change from their classmates. John O'Neal describes story circles in which young New Orleanians reveal how racism and poverty create heartbreaking obstacles to their quest for education and explore sources of resilience on which young people draw in dealing with those obstacles. Similarly, many chapters in this anthology highlight performances that offer young people opportunities for self-expression: in hip-hop theatre workshops in South Africa and Liberian refugee camps in Ghana, young people assert identities, build relationships, and experience a sense of agency; in Australia, young women express their claims to use the skateboard park free of harassment; in Palestine, young people collaboratively create plays that honor their lives, in many instances giving voice for the first time to the violations and humiliations they have suffered.

Performance practices constitute spaces where stories can be told and revised, where issues can be named and reframed, where ethical assumptions can be examined and reconsidered, and where feelings and ideas that had been held in the hearts and minds of isolated individuals can be acknowledged by the community. In themselves, these transformations can make significant contributions to peace. For those directly involved, public expressions can make the difference between living lives of isolation, fear, self-doubt, rage, or shame and the freedom of movement and agency that arises from the affirmation of shared values and experiences and the open exploration of differences.

As those who have grappled with trauma can attest, there is enormous difference between keeping a humiliating or injurious event secret and sharing it with others (whether directly or indirectly, in words or in symbols of other kinds). And for communities that have been humiliated, there is an enormous difference between individuals grappling in isolation with unacknowledged degradation and suffering that has been shared and dignified through memorialization or ritual. Through processes of telling and composing, those who have been victimized and objectified reassert the status of subject and author, claiming a measure of power by investing shattering experiences with meaning on their own terms.

The restoration of capacities

Building sustainable peace requires a daunting array of capacities. As noted earlier, those involved are called upon to communicate effectively, to reflect on and reassess their own past actions, to empathize with others' suffering, to rebuild relationships of trust, to make difficult ethical choices in the face of competing values, and to sustain vitality and dynamism in the midst of despair. The need to strengthen and restore these skills is especially important in contexts of violence and oppression in which communicative and reflective capacities have been severely compromised or damaged.

People who have been displaced from their homes, for example, or whose sacred symbols have been violated, may experience disorientation and depression that inhibit their ability to imagine solutions to problems. Victims of torture and sexual abuse may not be able to trust others, to discern when trust is warranted, or to find language to express what they have survived. Those who have perpetrated atrocities or who remained as bystanders while atrocities were committed in their names, may find themselves locked in patterns of shame and denial. Patterns of thought and behavior that contributed to survival in the jungle of Pol Pot's Cambodia, in a Palestinian refugee camp, or in an Argentinian city during the years of disappearance and torture, can constrain the flexibility of thought and feeling that is required for the transformation of conflict and the movement toward a different future.

We can see Turner's "plural reflexivity" at work in many of the case studies in this anthology. For instance, in chapter 7 of volume I, Ruth Margraff describes how performances can be crafted to encourage a community of bystanders to reflect on their inaction. As Hindu actors in India performed the stories of Muslim victims of the Gujarat massacres, Hindu audiences were able to listen, to see the characters as human, and to reflect on their own stereotypes and actions. This kind of performance helps people to see members of the "enemy" community as humans—who suffer, tell stories, cry, laugh, appreciate beauty, and hope—rather than as demons or dehumanized projections of their own guilt and shame. As the cycle of dehumanization and violence is interrupted, audience members are invited to reflect in new ways on their own actions and inactions.

In chapter 1 of volume II, we see how the *BrooKenya!* project helped people not only to empathize but also to imagine and begin to create a new future with others, despite geographic distance, economic disparities, and cultural differences. Drawing on the pedagogical theories of the Russian sociolinguist Lev Vygotsky, author Kate Gardner suggests that the studio spaces where *Brookenya!* was conceived, rehearsed, and performed became a "zone of proximal development"—a learning space where, through play, people of all ages can develop their intercultural skills, learning from each other how to push their existing abilities to the next (or proximal) stage. It is worth noting that during the ethnic violence that erupted in Kenya more than a year after the conclusion of the project, many Brooklyn-based BrooKenyans sent financial support to their Kenyan counterparts, demonstrating a willingness to act on the awareness of interdependence that emerged during the project.

Peacebuilding performances both assume and inspire a citizenry unwilling to be passive or frozen in fear, a community with the power to evolve, to strengthen its skills, and to take action to transform the world. The potential of performance practices to strengthen capacities of collectivities is an especially important resource for building peace. Because productions of plays and rituals are a collaborative process, and because for the most part people witness and participate in performances not only as individuals but also in communities, these practices allow for groups to reflect upon their collective experiences and to experiment with new ideas, sensibilities, and relationships. Victor Turner, the noted anthropologist of ritual and performance, referred to this collective reexamination as "plural reflexivity." Through performance, communities can reexamine and renew relationships, construct and revise shared narratives, and express and reenvision identities.

Enacting the moral imagination

As noted earlier, an analysis of all of the performances described in both volumes of this anthology suggests that there are some themes that are present in nearly all

In Argentina, the human rights organization Las Abuelas de Plaza de Mayo invited the artists of the country to join the social movement, working to reunite "the disappeared" with their original families. Photo by Archives Txl

peacebuilding performances in zones of violent conflict. These themes are: *resistance, memory, justice,* and *identity*. In the balance of this section, we will explore how the moral imagination can transform the framing of each of these issues.

Embodying the moral imagination in acts of resistance

Consider the following example, not included in the case studies in this anthology. *Fuenteovejuna*, the Spanish "Golden Age" play about a community's response to authoritarian rule, was staged in the state theatre of Córdoba, Argentina, in the early 1980s, during the transitional period between years of military dictatorship and a return to democracy. Directed by Jorge Petraglia, the show stressed production values faithful to the original classic: period costumes and stage decorum that would not stir any suspicion that the production was really about the lives of the *Cordobeses* filling the large old lyrical house to capacity. However, given the political climate in Argentina at the time, it was obvious to anyone familiar with this play about a tyrant's abuse of power in fifteenth-century Castile—a play as central to the Spanish canon as *Macbeth* is to the Anglophone—that there were connections to be made. But how were Petraglia and his cast going to bridge the two realities in a way that would go beyond the terms of the equation (oppression in old Spain and in contemporary Argentina) to create a "third space"?[14] The master director did something simple but surprising: when the audience expected to see the peasant girl Laurencia, violated and in rags, come

to the "council of men" to deliver her powerful monologue and rouse the town into rebellion, the whole theatre seemed to crack open. Not one, but a dozen Laurencias burst into the house, from exit doors and behind curtains, each one directly addressing small groups of audience members with her call to resistance. The response of the audience was magical and moving in its simplicity. As one, hundreds stood up, in complete silence, listening to Laurencia's words. A similarly violated people recognized itself on stage. In standing up together, they also *embodied* this most necessary act of resistance. They too were survivors, and they were invited to see that their will to fight on, though beaten into submission by state terror, was nevertheless still alive.

Fuenteovejuna illustrates how artists and communities can make use of the multiple levels on which symbols communicate to give voice to sentiments that otherwise would be too dangerous to express. It also shows how performance can transform what might have been an entirely oppositional impulse fueled by anger, fear, and righteousness into an act of resistance mediated by and infused with the creativity of the gesture itself.

Articulating the struggle not *against* encroaching systems of oppression, but rather *for* the access of all people to a life of dignity within their own communal institutions, histories, and cosmogonies (as well as within society as a whole), is inherent in performative resistance. As HIJOS[15] (the human rights organization founded by children of the disappeared in Argentina) claims, *"la alegría es nuestra trinchera"* ("happiness is our trenches"), a creative space from which to dig in and make a stand. Celebrating creativity as a strategy of performative resistance contributes to developing resources; rather than merely opposing someone else's project, it opens spaces for the moral imagination to take hold.

Embodying the moral imagination in acts of memory Acknowledging, articulating, and framing memories are processes central to both performance and the transformation of conflict. As Richard Schechner, a founder of the field of performance studies, commented, all of performance is "restored behavior," and those who practice it are "synthesizers, recombiners, compilers or editors of already practiced actions."[16] In her groundbreaking work about performance and memory, performance studies scholar Diana Taylor examines the difference between the "archive" and the "repertoire" as containers for collective memory. The former is an entire *corpus* of material—tangible and enduring in physical form and in physical repositories. It is a collection of data and catalogued artifacts that is not "accessible" to aid communities in the construction of memory and meaning, both because it usually requires authorized access and because it is rarely portable. It is clearly associated with structures of institutional power. Repertoire, by contrast, is *embodied*. It is ephemeral and transmitted from generation to generation. It is central to commu-

nity building and to the articulation of identity as a shared process. In contrast with disembodied archival memory, the repertoire requires that the subject be known and become inseparable from the knower.[17]

Scholars of psychosocial dynamics of violent conflict argue that unacknowledged memories do not disappear; in fact, through silence they often intensify, resulting in "trans-generational transmission of trauma" and festering resentments that can easily be manipulated by self-serving politicians. Peacebuilding scholars also recognize that many conflicts represent, or are fueled by, disagreements about historical narratives and the memories that collectivities highlight in order to make meaning out of painful history and to promote in-group cohesion. From the perspective of conflict transformation, communities do need opportunities to acknowledge and honor memories; the suppression of memories can contribute to cultures of impunity and a kind of social amnesia that invites repetition of crimes. However, too much memory, too much dwelling on historical pain and injustice (the "chosen trauma")[18] can paralyze a community and inhibit groups from acknowledging their present power and responsibility. In order to move into the future, communities must meaningfully mourn losses in ways that restore agency without fueling resentments. Therefore, how memories are acknowledged, how actively and flexibly people are engaged in acts of remembering, will influence whether memory work contributes to a more just and peaceful future or fuels cycles of violence.[19]

The case studies in this collection illustrate how, through engaging with a performance, victims of violence may experience the "freeing up" of memories so that they can be expressed, shared, and made part of the narrative of the collective.[20] The very creativity of the performance itself can counteract tendencies toward over-identification with the passivity and powerlessness of victimhood. Some performance practices invite communities from both sides of a historical divide to participate, nourishing relationships that invite former adversaries not only to remember, but to jointly imagine the future as well.

Playwright Catherine Filloux describes the ways in which survivors of the Khmer Rouge remained in the theatre in Phnom Penh for hours after seeing *Photographs from S-21,* her play on the Cambodian genocide. Into the night, these Cambodian survivors shared stories that they had not told in public before, and perhaps had never put into words in any context, "correcting" the depiction of events as portrayed in the play so as to more closely match their own experience. They were able to construct meaning out of horrifying experiences that until then had been too overwhelming and too violating of the elements of meaning-making itself to be shaped into a narrative.

Other factors to consider when assessing peacebuilding performances are the sensibilities that inform acts of remembering: Do they look to the future as well as to the past? Do they surround memories of suffering and destruction with affirmations of life and creativity?

Perhaps especially challenging in relation to the shaping of memories in zones of violent conflict is to ask whether performances acknowledge interdependence and embrace paradox, avoiding the trap of a permanent identification with victim and perpetrator roles. The complexity of this challenge can be appreciated in contrasting two performances described in volume I of this anthology: *Longings,* a play performed by the Arab-Hebrew Theatre in Jaffa, Israel; and *We the Children of the Camp,* performed by Alrowwad, the children's theatre in the Aida refugee camp in Bethlehem, Palestine. In *Longings,* the stories of six different displaced communities, both Jewish and Palestinian, are honored through the interwoven narratives of six different characters, which highlight their shared identity as "exiles." While the invocation of shared identities is useful in offering an alternative to antagonistic discourses and in facilitating empathy, such a production fails to acknowledge the fact that displacement of one community by the other is a defining feature of their asymmetrical relationship. In contrast, by invoking memories of destroyed Palestinian villages, *We the Children of the Camp* acknowledges that displacement. It does so in a way that sustains and strengthens the young people who are enduring the violence of the occupation and offers them a nonviolent way to resist its humiliations. It runs the risk, however, of fueling cycles of violence by energizing enmity discourse and intensifying the sense of grievance as a core element of identity.

Are there imaginative acts that can build on the ethical strengths of the seemingly contradictory impulses that animate these two performances? For both artists and peacebuilders, the capacity to embrace paradox is tested by challenges like this.

Embodying the moral imagination in the quest for justice "No justice, no peace!" The slogan can be heard around the world in struggles for racial, economic, and political

In chapter 3, volume I, Charles Mulekwa points out how a performance in Uganda brought a sense of paradox to the ethical questions surrounding justice and accountability. *Thirty Years of Bananas,* the play that risked telling truths about corrupt and violent postcolonial political leaders, subtly and simultaneously held to account the Ugandan citizenry for its complicity and naïveté in repeatedly bringing to power leaders who would become dictators. It would be incorrect, the play suggests, for Ugandans to hide behind the legacy of colonialism to excuse their inability to mobilize themselves and take actions to ensure their own civil rights.

rights. And it is true: at the core of building peace are processes designed to redress past injustices and create more fairness for the future. Performances play a role in calling attention to injustices and in strengthening the social movements and disenfranchised communities struggling for their economic, cultural, and political rights.

There are many different kinds of justice: retributive, restorative, distributive, and also historical, social, economic, etc. These different aspects of justice can be seen when perpetrators are brought to trial, when victims receive compensation through reparations schemes, when survivors get a fair hearing for their stories of suffering through truth commissions, when economic development programs provide opportunities to those who are poor, when government reforms bring disenfranchised groups into the political system, and when the stories of immigrant and indigenous communities are represented in the dominant discourse, including in school curricula. When oppressed communities are fearful and beaten into submission, a powerful demand for justice in fact can be a step toward peace. In the aftermath of genocide and gross violations of human rights, holding perpetrators to account is necessary to avoid a culture of impunity.

But how the demand for justice is framed and how it is delivered can determine a great deal about how achievable peace might be. While many activists relate to the quest for justice as a straightforward matter of right and wrong, oppressors and oppressed, perpetrators and victims, peacebuilders often are required to take a more nuanced view. (This reality often awakens distrust and suspicion of bias on the part of members of oppressed communities.) The prospect of a war crimes trial, however justified, may prevent warlords from ever laying down their weapons. Can mechanisms be found that will allow the violence to end, but without establishing a culture of impunity that will make future wars and war crimes more likely? In highly charged post-violence contexts, even the most carefully conducted trial may be experienced by some factions more as revenge than as justice.

The peacebuilding field grapples with the tensions that mark the long path toward greater justice, understanding that programs and policies that are fully justified may not always be wise. The needs, sensibilities, and capacities of the whole system, not just particular subgroups, must be considered. For example, judicial processes are designed to hold individuals responsible for their actions. However, in contexts where perpetrators themselves have been abducted or coerced into committing crimes, or where joining a militia was the only means available to feed oneself and one's family, communities are finding it important to balance legal proceedings focused on punishment and retribution with less formal processes designed to balance accountability with the restoration of relationships.

Peacebuilders face other justice-related dilemmas as well. Different factions in a conflict are likely to disagree not only about what kinds of justice are most important and what outcomes they seek, but also about what processes are appropriate to

Grupo Cultural Yuyachkani's performances illustrate that the symbolic world of theatre offers a quality of justice that would be beyond the reach of any court of law. In the imagined world of performance, a mother can embrace her deceased child for one last time, and a peasant, hacked to death in a civil war, can gather up his bones so he can finally be buried with dignity. For members of communities brutalized in war, these symbolic renderings might address a yearning for justice with more visceral satisfaction, more healing, than a formal trial (with cross examinations, etc.), a reparations scheme consisting of monetary payments, a training program, or even public ceremonies of acknowledgement.

attain them. Some sectors of a society, with support from the international community, seek formal trials, based on modern and Western conventions of jurisprudence. Others, pointing to the enormous expense and adversarial quality of trials, argue that their real needs would be met if resources were allocated instead to economic and social development. Still others believe that the community as a whole needs to be healed, including both perpetrators and victims, and seek truth commissions or other processes that emphasize accountability and the restoration of relationships rather than retribution and punishment. And then there are those who wish to pursue justice through local rituals and other symbolic acts; for them, trials and formal truth commissions can be experienced as one more cultural imposition in a long colonial legacy.

Not surprisingly, the case studies in this anthology are animated by differing sensibilities about issues of justice. As a group, the performances documented here illustrate how theatre and ritual are contributing to justice in ways that acknowledge and respond to such complexities. Examples from Argentina and Cambodia, for instance, emphasize accountability; Indigenous reconciliation rituals from the United States and Australia, on the other hand, emphasize the rebuilding of relationships, restorative justice, and reconciliation. These case studies also highlight how one way of "doing justice" to a violated community is to acknowledge the truth of the harms it endured and present its narrative and its traditions at the highest level of artistic quality. The excellence of the work relates to the power released during the performance and to its lasting effect on those who witness and participate in it.

Embodying the moral imagination in relation to issues of identity When asked about the possibility of a "theatre of interdependence," one of the artists featured in the first volume asked why any minority group would be comfortable with such a framework: "Interdependence on its own," he asserted, "does nothing to reflect our needs and desires." In conversation, we settled on the idea of a "theatre of integrity and

As Hindu actors in India performed the stories of Muslim victims of the Gujurat massacres, Hindu audiences were able to listen, to see the characters as human, and to reflect on their own stereotypes and actions. This kind of performance helps people to see members of the "enemy" community as humans—who suffer, tell stories, cry, laugh, appreciate beauty, and hope—rather than as demons or dehumanized projections of their own guilt and shame.
Photo by Naveen Kishore

interdependence" as a framework more likely to be acceptable to communities on both sides of asymmetrical conflicts. How can performances be crafted to bolster and celebrate the unique identities of distinct groups while also acknowledging the interdependence among adversaries?

Ethnic, cultural, religious, racial, national, and gender identities are central to human life in communities, and performance has always played a part in processes of individual and collective identity-formation and of group definition. From songs to ceremonies, from modes of dress and hairstyling to secret handshakes, identities come to life through performance. In times of relative peace, the boundaries between groups and identities are often fluid: individuals can choose how to express belonging to multiple groups, and groups can explore innovations. But when communal identities are threatened, identities generally are held more rigidly. In contexts of extreme alienation such as violence and long-standing oppression, people are willing to kill and to die to preserve these intersubjectively shared patterns of meaning

and behavior. Members of opposed groups think of each other as enemies, a kind of dehumanized identity that both emerges from and justifies the inflicting of injury on another human being or community, including desecration of sacred symbols.

Depending on the context, then, the transformation of conflict can involve affirming and celebrating the identity of suppressed and marginalized groups; negotiating differences within identity groups (such as between people of different ages and economic classes, and between people living in diaspora communities and those living in native lands); rehumanizing people to themselves and each other; and supporting communities to acknowledge their very real interdependence and common humanity.

The case studies in these volumes illustrate all of these approaches to addressing issues of identity. By rehumanizing images of the Muslim victims of Hindu violence, *Hidden Fires* invited Hindu bystanders to acknowledge their complicity. By dignifying the victims of the Srebrenica massacre in a ritualized performance of a Brecht poem, DAH Teatar invited members of the Serbian community to reclaim their own humanity as well. In his chapter on performance and peacebuilding in the Sri Lankan context, Madhawa Palihapitiya suggests that theatre artists from opposite sides of the conflict could work more effectively toward peace if opportunities were provided for them to meet, to understand each other's sensibilities about issues of integrity and interdependence, and to develop ways to support their own communities to understand and interpret cultural productions from the opposing community. The common vocabulary of performance could support such exchanges; as coeditors we have included this idea in our recommendations in the resource section of this volume.

* * *

Within the creative space itself, peacebuilding performances can be crafted to facilitate the expression of what has been silenced, restore capacities that have been blunted, and to support communities to grapple with the ethical complexities of urgent issues of memory, identity, resistance, and justice. But what does it amount to, all of this creative work, these restored capacities and courageously spoken truths, these applications of the moral imagination to the crucial issues that communities confront? What can we point to as the real improvements for communities seeking peace and justice while living in the midst of, and with the legacies of, violence and oppression? How do these new ethical insights reenter the life of the community and the world? We turn to these questions in the next section.

5. How Transformed Material Reenters the World of Everyday Life

The transformations accomplished in the crucible of peacebuilding performance reenter the ongoing life of the community in a number of ways, depending on the

nature of the boundary between the performance and the flow of life, the aesthetic power of the performance and the choices made by those who participated in and witnessed it, and strategic decisions about how to propel the meanings of the performance into the social and political lives of communities.

In some cases, the transformations wrought within performances enter the "bloodstream of social energy" immediately, in the instant that they are performed. In the Indigenous reconciliation ceremonies Polly O. Walker documents in chapter 9 in volume I, the permeable membrane separates the ritual from everyday life by bringing participants into the realm of the *sacred*, but not the *fictional*. She describes moments when participants speak commitments they are honor-bound to fulfill throughout their lives. In contexts such as these, where the violence addressed includes the colonial injury to local cultural practices, the ceremony is, in fact, a real world event that restores a measure of dignity and integrity to systems of knowledge that had been violated.

Similarly, in some community- and artist-based theatrical works, the boundary between performance and the ongoing life of the community is not so distinct. For instance, in Australia, when the Sk8 Grrls enacted their multimedia production in the skateboard park, the performance was itself an act of reclaiming space and asserting rights. And when members of Palestinian communities enter into a performance of Ashtar's Forum Theatre, they communicate with their real neighbors, exercising real courage to speak and making real life requests for support. When, during a fictionalized truth and reconciliation commission hearing, an Israeli actor removes his mask and acknowledges complicity with war crimes, those acknowledgements are not retracted when the stage goes dark. On municipal buses in Belgrade, DAH Teatar celebrates cultures that, prior to the years of ethnic cleansing, enlivened their neighborhoods. In such moments, Belgrade is transformed into a place where diverse people and cultures can once again be encountered and enjoyed. Of course, such

In some cases, peacebuilding performances become annual traditions—such as the performance initiative Teatro por la identidad (Theatre for Identity, TxI) in Argentina, and the annual revisions of plays by Ashtar and Alrowwad theatres in Palestine. Having been ritualized within the life of the community through regular repetition, these performances take on lives of their own and become a part of the social fabric. Similarly, performances are presented by groups that have developed into cultural institutions, such as DAH Teatar in Serbia and Grupo Cultural Yuyachkani in Peru. These institutions also maintain a presence in the social context, ensuring that certain values—creativity, human rights, healing, dialogue, social inclusion, and Indigenous communities' cultural rights—remain present in the cultural and political lives of their societies.

performances do not bring back the communities that were driven away, but they touch the lives of real people as they commute back and forth from work, reminding people of the culture of inclusion that years of war have threatened to erase.

The case studies in these volumes offer evidence that even when the boundary between performance and the community life that surrounds it is clearly drawn, transformations accomplished within the space/time of a performance can and do enter into the ongoing stream of life. Whatever meanings reverberate within the inner lives of those who participate in and witness peacebuilding performances, their words and actions become channels through which new feelings, insights, relationships, questions, and ethical sensibilities reenter the world. This is why the aesthetic power of a work contributes to its sociopolitical efficacy: the more deeply a person is moved, the more likely the performance is to reach beneath defenses, provoke new insights, engender new sensibilities, and inspire action. If the performance is strongly imbued with values of the moral imagination—especially belief in the interdependence of enemies, and curiosity about how seemingly opposing narratives or values can be embraced simultaneously—the actions, relationships, and conversations the performance inspires are likely to contribute, in small or large ways, to the creative transformation of conflict.

The experiences described in this anthology attest to the transformation of many adversarial or alienated *relationships*—for instance, between young Liberian men of different ethnic affiliations who performed hip-hop ciphers together in the refugee camp in Ghana, and who continued to turn to each other for support after the six-week workshop had ended.[21] Performance practices softened stereotypes and led to more trusting relationships between Americans and Cambodians; Serbians and Kosovars, and Serbians and Bosnians; refugees and Aboriginal youth in Australia; and among working class men in the Netherlands, including members of Muslim communities of recent immigrants and Christian Dutch communities.

Reaching into strata of society that remain largely untouched by either conventional coexistence approaches or the progressive theatre scene, the intimate performances by the Palestinian-Israeli playwright and poet Aida Nasrallah created contexts in which unlikely relationships between right-wing women from Jewish and Palestinian-Israeli communities could be "embroidered" together in ways that made real differences in the lives of those involved. When ethnic violence consumed parts of Kenya in the aftermath of the 2008 elections, the relationships built through the *BrooKenya!* project inspired participants from Brooklyn to respond to a request for funds from Kitche Magak, the leader of the Kenyan wing of the project. With the donations, he was able to purchase food for thousands of people in his region weeks before large aid agencies managed to arrive on the scene.

In addition to the people involved directly in a production, other channels allow transformed material to enter life outside of the space/time of performance.

Posters, advertisements, and websites that publicize events draw attention to issues. Talkback sessions after performances provide opportunities for people to learn from each other's responses, and to bring different points of view into dialogue. Sensitive reviews of performances and interviews with artists and participants published in newspapers, broadcast on radio and television, and mounted on websites and blogs in no way replace the immediacy of the performance, but they can serve to extend its reach. Documentation of performances—in books, films, etc.—can reach across time as well as geography. In addition, peacebuilding and human rights organizations, social movements, and in some contexts governmental and intergovernmental agencies can help to propel the relationships, insights, questions, and sensibilities that emerge from performances into the public square, onto the negotiating table, and onto the desks of legislators and policy makers.

The peacebuilding effects of performances documented here extend, indeed, well beyond transformations in relationships and individual actions. The performance by young women reclaiming a skateboard park documented by Mary Ann Hunter contributed to a change in local policies when influential members of the community witnessed not only the planned spectacle but also the unplanned display of violence by the young men whose control of the space was being challenged. On a much larger, national scale, Las Abuelas de Plaza de Mayo approached Argentina's theatre artists to help them address a very particular and anguished legacy of that country's dictatorship: the young adults who as infants, after their birth mothers were "disappeared," had been adopted by members of the military junta and their friends. Las Abuelas so far count some seventy reunifications of families as a result of Teatro X Identidad, an annual series of plays produced on a voluntary basis in theatres across the country.

Several of the case studies in this volume suggest that links between artists, cultural organizations, and the general public on the one hand, and social and political movements, peacebuilding and intergovernmental organizations, and, at times,

Yuyachkani was able to play such a vital role on Peru's social stage because of the decades of work they had invested in building relationships with indigenous communities, learning their languages, their dancing, mask-making, and performance traditions, and accompanying them to political demonstrations demanding more respect for their rights. They also engaged in a wide range of performative methods: participatory workshops, community rituals, works produced in collaboration with community people as well as highly refined artistic productions. This range of approaches allows Yuyachkani to reach deeply into people's experiences and into their communities, and at the same time serve as a bridge between groups in Peru's highly stratified social structure.

At a commemoration ceremony at the site of a massacre, adults share traditional knowledge with Aboriginal children. Photo by Polly O. Walker

government agencies on the other, are key to extending the transformations crafted through performance practices into sociopolitical change. In Peru, Grupo Cultural Yuyachkani enhanced the credibility of the government's Truth and Reconciliation Commission in the eyes of people who had suffered at the hands of the government in the brutal civil war; it is clear that stories of many atrocities entered the TRC's official record because of the participation of Yuyachkani, including the healing rituals that supported victims of the violence (especially sexual violence) to enter their stories into the official record in ways that did not retraumatize them.

Consider again, for example, the reconciliation rituals in Australia, documented by Polly O. Walker. Each ritual is supported by organizations such as Friends of Myall Creek, a group that includes individuals influential in policy circles. The rituals take place in many communities across Australia and are part of a larger social movement committed to equal rights for Australia's Indigenous peoples. In that context, these rituals contributed to the official Commonwealth apology delivered by Australia's prime minister in 2008, and the first ever performance of the Aboriginal Welcome to Country ritual at an opening of parliament. The apology for the abuses toward Aboriginal people of the "Stolen Generations" laid the groundwork for legislation that seeks to diminish the gap in quality of life between Aboriginal people and

descendents of white settler people in Australia, as measured by outcomes such as educational achievement, employment, and longevity.

The African American playwright and director John O'Neal understands the transformative potential of theatre in terms of its links to social movements. The Free Southern Theater grew out of the American civil rights movement and in time became part of the Black Power movement; operating primarily on volunteer labor, it brought workshops and performances to impoverished Black communities throughout the rural South for over a decade. "I wouldn't say that theatre gives people a voice," O'Neal says. "I would say theatre offers perspective and encouragement. People already have their own voice." O'Neal asserts that the impact of theatre could be strengthened significantly if artists and activists could build stronger collaborations. We hope that this book and the Acting Together project are facilitating such relationships.

6. Documentation and Assessment

It is difficult, and in some cases impossible, to measure the kinds of transformation that performances engender. As Adrienne Rich notes in the words with which this chapter begins, it is impossible to document with certainty or comprehensiveness the effects of artistic productions. Someone's choice to speak or act in ways that contribute to better relationships across differences or to more equitable laws and policies, or the choice to refrain from speaking and acting in injurious ways, may have been influenced by participating in a ritual or witnessing a theatrical production—but there might have been other influences as well. The direct and subtle influences of performances on conversations, actions, and decisions are not fully known. Did the stunned silence that followed the Kolkata performance portraying sympathetic Muslim characters and stories in *Hidden Fires* lead audience members to create more respectful relationships and engage in more courageous and conciliatory actions? How did the empathy for each other's suffering experienced by Singhalese and Tamil people while witnessing Dharmasiri's *The Trojan Women* find expression in their lives? What parts of the successes of the civil rights movement are attributable to the hundreds of performances and workshops brought by the Free Southern Theater to rural Black communities in the American South?

We don't know the answers to these questions. But we do know that it is possible to gain a reasonable sense of at least some of the effects of peacebuilding performances through the kind of documentation produced by the contributors to this anthology. Unlike many who situate themselves clearly within the art world, the curators of the *Acting Together* case studies considered the sociopolitical and cultural contexts that gave rise to the performances and that to some degree shaped their

meaning. The curators also inquired about the impacts or effects of the performances, eliciting responses from participants, audience members, community leaders, and others. They considered power dynamics within the process of production as well as in the final representation. Unlike many who situate themselves clearly within the field of conflict transformation, however, they also considered the aesthetic quality and spiritual integrity of the theatrical works and ceremonies they were document-ing. Their vivid descriptions of performances bring us as readers into the time/space of creativity; they support us to imagine the colors, hear the sounds and the silences, and feel the emotional resonances that reverberate within the space.

The notion of a "permeable membrane" between creative spaces and everyday life—between imagination and reality—provides a framework for documenting and assessing contributions of the arts to social justice that honors both aesthetic qual-ity and sociopolitical effectiveness. Each aspect of the framework outlined above suggests questions. (These are elaborated upon in more detail in the guidelines for planning and documentation included in this volume.)

- What are the relevant sociopolitical, historical, and cultural dimensions of the context? What is the relationship between the performance and its context?

- Through what channels are these sources of resilience and these urgent issues carried into performance spaces? Does the work invite both conscious purpose and nonconscious inspiration?

- How robust is the moral imagination that animates the permeable membrane between art and society? How could the capacities of artists, cultural workers, and peacebuilding practitioners be enhanced?

- What ethical and aesthetic sensibilities inscribe the performance space? How does it look, sound, feel, etc.?

- What transformations—in ideas, feelings, possibilities, acknowledgements, energy, etc.—are created during the performance itself? What capacities are strengthened? Does the peacebuilding performance initiative provide oppor-tunities for communities to grapple with ethical dilemmas?

- Are transformations propelled broadly and deeply back into society? Are they reaching both broad audiences and key people? How could their reach and effectiveness be enhanced?

- Throughout the peacebuilding performance initiative, has care been taken to minimize the risks of doing harm?

• • •

We hope this framework proves to be useful in facilitating communication among the various players whose collaboration is required for effective peacebuilding per-

formances. Funders and policy makers demand accountability to criteria of impact and effectiveness. But that is not the primary reason we address these questions here. We ourselves, as practitioners, want to better understand and strengthen our collective efforts to creatively transform conflict through approaches that engage and celebrate the full range of human faculties: intellectual, physical, emotional, cultural, and spiritual.

In the chapter that follows, we propose eight central lessons from the Acting Together project, and offer a related set of recommendations for people working at the nexus of peacebuilding and performance and those seeking to strengthen this emerging field.

One of the guest houses in Hope North, a living and learning community for refugees, orphans, and former child soldiers in northern Uganda. Photo by Terry Torok, Photo Journalist, Crossing Borders

In Jaffa, Israel, the Arab-Hebrew Theatre exemplifies how theatrical works and rituals can expand the range of approaches to justice that societies might consider. As described in volume I, the Theatre called attention to the abuses of the occupation of the Palestinian territories by staging an imagined future truth and reconciliation commission. The performance raised in the consciousness of those who participated in, witnessed, and heard about the production the possibility of restorative justice as one dimension of a larger process of reconciliation. Photo by Arab-Hebrew Theatre of Jaffa

7 Lessons from the Acting Together Project

Cynthia E. Cohen with Roberto Gutiérrez Varea and Polly O. Walker

For more than five years, the Acting Together project[1] has been documenting stories about theatre and ritual in zones of violent conflict and oppression. We have been reflecting on those stories, finding many lessons, questions, and issues.

We encourage critical engagement with each of the case studies in both volumes of this work. Each case study is unique; each example's strengths and limitations can offer valuable lessons for people working in the field. In this chapter, we focus on the project as a whole, including the body of case studies as well as insights from conversations and interviews conducted as part of the larger Acting Together project.

A Summary of Lessons from the Acting Together Project

1. Performances are powerful. They embody a kind of power that can be crafted to contribute to the transformation of violent conflict.

Performances can capture people's attention, reaching beneath the defensive structures of guilt, shame, and rage to restore capacities for agency and heal relationships; challenge existing assumptions; support expression that is otherwise forbidden; bring reluctant adversaries into conversation; propose new ways of framing issues; and more. Even when confronted with the power of violence and domination (economic, political, gender-based, or cultural), performances challenge and subvert widely accepted patterns of supremacy, fear, exclusion, and repression.

What kind of power is this? Where does it come from? The case studies suggest that the power of theatre and ritual derives at least in part from the concentration of energy in the bounded time and space of the performance itself. Rituals and theatrical

works are energized by the focus, commitment, and talent of the actors, artists, or ritual leaders involved; the animated attention and expectant mood of the audience and participants; and by the intensity of the preparation, which takes place through processes of set design, improvisation, direction, rehearsal, script refinement, and/or planning meetings, etc. These preparatory activities themselves are part of the "work"; they are sites of engagement and re-vision, and therefore sites of transformations in relationships and awareness. The peacebuilding performance space is energized also by the mythological, spiritual, historical, and other cultural resonances evoked by characters, costumes, music, and setting (whether natural or designed).

Peacebuilding performances, then, are powerful events that can be crafted to engage people compellingly, but noncoercively, in the issues that confront their communities. They are laboratories for exploring relationships, memories, questions, and meanings, for experimenting with cross-cultural encounters, and for discovering what might be possible. They provide ways of integrating narratives at the intellectual, emotional, and physical levels—a dire need in violent contexts where narratives likely have been torn apart. Performances can be constructed in theatres and shrines, to be sure, but also on buses, in abandoned houses, in prisons and refugee camps, on the sites of battles and massacres, and in public plazas—anyplace where human beings gather and where there is someone to bear witness. Performance's power does not rely on injury or domination; it resides rather in reciprocity, connectivity, and generativity.

That performance is a powerful resource for conflict transformation is evidenced partly by the changes documented in this anthology: the official apology issued by the government of Australia, in which the performance of rituals and enactment of Indigenous ceremonies played a significant role; the testimony received by Peru's TRC, which was enabled by the preparatory work of Grupo Cultural Yuyachkani; the relationships built among the young Liberian enemies through their participation in Hip-Hop Theatre in a refugee camp in Ghana; the abducted children of the disappeared reunited with their grandparents after witnessing plays that were part of the Teatro X Identidad cycle.

Further evidence of performance's power can be found in the threats of colonial, dictatorial, and paramilitary regimes, which seek to keep theatres dark, to silence artists' voices, to forbid Indigenous rituals, and to constrain the range of permitted expression. If performances were not powerful, it is unlikely that illegitimate authorities would bother to repress them.

2. Peacebuilding performances have the potential to support communities to engage with painful issues and to navigate among apparently conflicting and contradictory imperatives.

Whether in the midst of violence and oppression, in their aftermath, or in contexts of social, economic, and political exclusion, communities are filled with unexpressed

and unacknowledged stories of injustice. They are flooded with suppressed truths about abuses of power, unexpressed rage and fear, unmourned losses, unresolved conflicts, unspoken remorse, and unreconciled relationships. Peacebuilding performances, because they can access sources of resilience in ceremonies, rituals, and other collective forms, as well as in the rooted creativity of individual artists and ensembles, are uniquely well suited to break these silences.

In the previous chapter, we explored three different ways in which theatre and ritual transform the material that enters into the space/time of performance: by expressing suppressed and repressed ideas, feelings, relationships, and yearnings for the future; by cultivating, nourishing, and restoring capacities for communication and building relationships; and by embodying the moral imagination in relation to issues of resistance, memory, justice, and identity. By considering the set of case studies presented in the anthology as a whole, it becomes clear that peacebuilding performances in zones of violent conflict can support communities to grapple with conflicting needs such as:

- The need to resist violent assaults, occupation, cultural impositions, and other infringements on individual and collective agency—while avoiding violent reactions on the one hand, and a sense of passive or self-destructive powerlessness on the other;

- The need to remember and fully honor comrades and loved ones who have been killed and to dignify the suffering and the injuries of the past—while avoiding the traps of retraumatization, and building relationships that will support communities to imagine a new future;

- The need to balance justice and accountability with values of mercy and the need for restoration; and the related need to address disagreements about the use of trials, truth commissions, reparation schemes, local community traditions, or other means to seek justice;

- The need for distinct groups to assert, celebrate, and in some cases refashion their distinctive identities while also acknowledging the realities of interdependence and of each individual's multiple allegiances.

Hologram-like, these tensions find expression in the relationships between individuals, communities, and societies. Where opportunities exist or can be constructed, they are brought into spaces of performance where they can be acknowledged, understood in their complexity, and revised. When creative spaces are illuminated by the moral imagination—in particular by the embrace of paradox and the commitment to interdependence—points of intractable conflict gradually become unstuck, and relationships can begin to be transformed.

3. Performances in zones of violent conflict have the potential to cause great harm; precautions must be taken to minimize these risks.

The same power that can be mobilized in the service of conflict transformation can also be mobilized to perpetuate violence and cause injury, in spite of the best intentions of those who plan and participate in peacebuilding performance initiatives. Because performance can reach deeply into persons and communities, and because societies in the midst of and recovering from violence are vulnerable in so many ways, it is incumbent upon those who are engaging in it to understand the dynamics of the conflict and the risks of doing harm, and take robust precautions to minimize those risks.

In communities grappling with the legacy of colonialism, performances can perpetuate violence to Indigenous systems of knowing and being—by ignoring them, trivializing them, appropriating them, or failing to honor the authority of those who protect their integrity.

In contexts of intercommunal violence, performances can worsen divisions and resentments between groups, reinforce victim/perpetrator identities, and perpetuate harmful power dynamics that surround gender, region, religion, age, etc.

In contexts of oppressive regimes and conflicting paramilitary and extremist formations, outspoken artists, participants, and audience members are at risk of being injured, imprisoned, exiled, or killed.[2]

In the aftermath of violence, performances risk retraumatizing individuals and communities. The healing power of the arts rests on their ability to support people to touch emotional and psychological places of injury; it is this same power that creates the risk of doing harm.

War itself is waged through many kinds of performances, and its perpetrators are waging battles over hearts and minds as well as over geographical boundaries and political power. In such contexts, well-meaning but naïve artistic efforts can easily be swept up in agendas of agencies, factions, or governments. These appropriations are sometimes completely obvious, but can also be quite subtle.

Although it is not possible to eliminate all risk of injury, artists, cultural workers, peacebuilding practitioners, policy makers, funders, educators, students, government workers, and activists all have roles to play in minimizing them. (Please see recommendations and guidelines in the next chapter.)

4. Aesthetic excellence and sociopolitical effectiveness need not be competing imperatives; they are often mutually reinforcing.

There are many in the fields of both theatre and conflict resolution who remain skeptical about peacebuilding performances. Many in the art world worry that performances with a social or political agenda might result in mediocre or didactic art.

Those in the world of conflict transformation worry that while arts-based peacebuilding initiatives might produce beautiful works that inspire positive feelings, they in fact do little to make a difference in the dynamics of the conflict or in "peace writ large."

However, this anthology has offered many examples in which the aesthetic power of a work and its sociopolitical effectiveness are linked, and in fact appear to be mutually reinforcing. According to Dijana Milošević and others who witnessed performances by DAH Teatar, it was the focus and discipline of the actors, and the excellence of their artistic craft, that protected them from potential assaults of the armed paramilitary forces present at their outdoor performances. Yuyachkani was able to attract large audiences of European-descended Peruvians in Lima to hear the stories of their Indigenous compatriots because of the unquestioned artistry of the group's productions. It was the artistic power of productions such as *Hidden Fires* in India and *Photographs from S-21* in Cambodia that invited audience members to remain in their seats to grapple, in words or in silence, with what they had witnessed.

The beauty of a work sometimes itself can be a form of communication: "The people who live in the camps are bored with the dullness of daily life," says Iman Aoun of Palestine, whose theatre company travels to refugee camps. "We give them as much as we respect them . . . Good aesthetics is a form of respect."

5. Artist-based theatre, community-based theatre, rituals, and ceremonies all can be crafted to make substantive contributions to justice and peace.

The processes through which material from community life enters into creative spaces are different in community-based theatre, artist-based theatre, and traditional cultural rituals or adaptations of them. Also, the site of transformation is often different: while artist-based theatre mainly affects audience members, rituals are designed to transform those who participate. Community-based theatre is generally focused on the empowerment and transformation of those directly involved, with the intention of also reaching their families, neighborhoods, and communities.

Nevertheless, all three kinds of performances can be infused with the principles of the moral imagination and crafted to contribute to the creative transformation of conflict. To strengthen the broad field of peacebuilding performance, we invite artists and cultural workers to suspend judgments and stereotypes about their different approaches, and suggest that peacebuilders be exposed to strong examples of all kinds of performances, with cautions about their limitations. We recommend that practitioners of artist-based, community-based, and ritual productions be invited into conversation—with each other and with peacebuilding practitioners. Educators and policy makers have a role to play as well, teaching students about the value and limitations of each kind of performance, and revising cultural policies and funding strategies to acknowledge and support the important contributions of all of these approaches, and increase cooperation among them.

6. The transformative power of the arts depends upon respect for the integrity of the artistic process.

The issues confronting communities in the midst and aftermath of violence enter the performance space through many different channels. The case studies illustrate the importance of allowing material to arise from the nonconscious as well as the conscious realms, so that information held within bodies can be accessed and participants are not constrained by existing political discourse.

Prescriptive and message- or agenda-driven theatre may have its place, but such initiatives run the risk of insulting people's intelligence, undermining local cultural forms, and missing out on the potential of performance to build relational and communicative capacities and engage people in exploring and thinking critically about ethical questions and dilemmas.

Effective peacebuilding work requires thinking strategically. This strategizing can be accomplished in ways that are consistent with the integrity of artistic and cultural processes. For instance, artists and peacebuilders can think together about whom to invite as participants and audience members, about what kinds of exchanges might be most effective, about what kinds of post-performance dialogues are likely to work best, etc. As the peacebuilding performance field grows stronger, we imagine that new collaborations will explore and document ways to engage more fully both the creative power of the aesthetic and the focused power of the strategic.

7. Performances could have a greater impact on societies in conflict if more non-arts agencies and organizations recognized their peacebuilding potential and helped to extend their reach.

Under any circumstance, Yuyachkani's work in Peru would have had a profound effect on the individuals and communities that participated in and witnessed their performances, but the invitation from the Truth and Reconciliation Commission meant that their work could contribute to the inclusiveness and thoroughness of the entire country's official transitional justice process. Collaborations between human rights organizations and theatres in Serbia and Argentina helped to extend the reach and impact of performances. In the Netherlands, it was the government agencies responsible for promoting tolerance that provided the resources for the professional playwright and director; the Community Art Lab associated with the University of Utrecht engaged in the extensive research that allowed the project and its effects on participants and communities to be thoroughly documented.

Other players in society—educators, activists, community leaders, peacebuilding scholars, practitioners, and policy makers—have major roles to play in extending the contributions of peacebuilding performances to the transformation of conflict. They can bring artists to the tables where conflicts are being negotiated

and decisions about public policy are made. They can facilitate the development of the physical infrastructure and networks of relationships required for the field to flourish. They can also notice artists and performances that are making positive contributions to social justice and to peace, and then support and amplify their work. The challenge is to align the creativity, spontaneity, and the heartfelt spirituality that animates performances with the purposeful strategies of activists, educators, facilitators of dialogue, and peacebuilders of all kinds.

8. Peacebuilding performances bear witness to the human costs of war and oppression and to its gendered nature. They tell the stories not of heads of state and military leaders, but rather of the children, women, and men whose lives are diminished by the fear and humiliation, the shame and dislocation that accompany violence.

Although we did not mention these themes in our call for chapters, most of the case studies in this two-volume work include references to sexual assault and other acts of violence against women and children. The emphasis on these issues was not by design. This pattern is not surprising, however, especially given the nature of recent wars, more intrastate than interstate, more likely to be focused on issues of culture, ethnicity, politics, and religion than on nationalism. In the wars of recent decades, rape has been used as a weapon of war, and children have been abducted to be killers and sex-slaves. Millions of families have been uprooted from their homes. The performances documented in this anthology open windows onto the experiences of global civil society; they allow us to witness how women, men, and children are experiencing the historical moment in which we live and the cultural, economic, and social forces that shape our world.

● ● ●

In terms of the changes required to transform a violent conflict, each case study in this anthology offers inspiration. Each one embodies both possibilities and limitations, and warrants thoughtful discussion on its own terms and within its sociopolitical context. We hope that by bringing them into relationship and offering a framework for documentation and assessment, we are suggesting lines of inquiry on the part of both scholars and practitioners, in both the peacebuilding and performance fields. Of course this anthology is far from an exhaustive treatment. We hope, rather, to suggest trajectories for exchange, reflection, and experimentation.

As we conclude this chapter in the summer of 2011, there appears to be a proliferation of challenges facing the global community. We believe that a worldwide peacebuilding performance movement, made up of overlapping communities of practice, would strengthen the collective capacity to address these challenges in ways that are creative and generative of life.

Resources

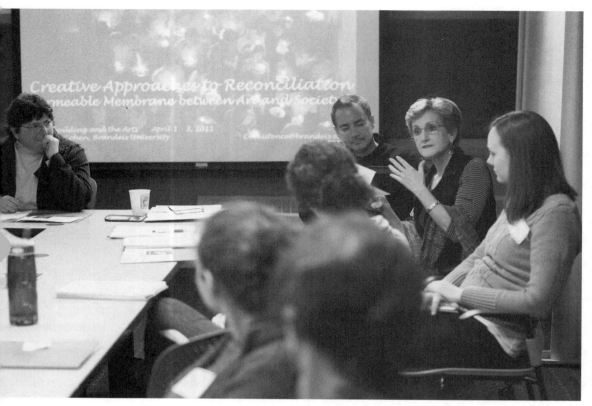

Artists, peacebuilding practitioners, educators, and students explore the possibilities and limitations of the arts as resources for the transformation of conflict at a weekend intensive led by Cynthia Cohen of the Program in Peacebuilding and the Arts at Brandeis University.
Photo by David Yun, the courtesy of *The Justice,* Brandeis University

Introduction to Section III

Cynthia E. Cohen

The two volumes of *Acting Together: Performance and the Creative Transformation of Conflict* explore work at the nexus of peacebuilding and performance. Through case studies and theoretical frameworks, some drawn from the fields of peace and conflict studies and from performance studies, and others emerging from this inquiry, this work has documented accomplishments and the transformative potential of the peacebuilding performance field.

As coeditors, our intention has been to strengthen work at the nexus of performance and conflict transformation—a purpose that can be fulfilled only through the actions of our readers. Whether you are an artist or a peacebuilder, a student or an educator, a policy maker or a practitioner, if you wish to contribute to the creative transformation of conflict, there are conversations you can facilitate, initiatives you can design, implement and document, and action steps you can take. The chapters in this section include resources you may consider using or adapting to support your efforts.[1]

Chapter 8 includes discussion questions that can be used in college and university classrooms and training workshops for artists, peacebuilding practitioners, and colleagues in related fields. They can also be adapted for use in high schools or with audiences at book talks or screenings of the *Acting Together on the World Stage* documentary. We recommend that educators and facilitators review this lengthy list of questions, and select and revise them based on the concerns and the backgrounds of the participants to the conversation.

Chapter 8 also includes guidelines for story circles, the simple but powerful approach developed by John O'Neal (see chapter 5, volume II) to facilitate the democratic sharing of stories—for the purpose of building community as well as generating material for performances. The content of story circles can be either open-ended or focused on a particular topic or theme, making this an extremely versatile resource for classrooms, theatre groups, activist organizations, training workshops, and conferences.

The idea of a permeable membrane that separates and also connects performances to life in the societies from which they emerge, proposed in chapter 6 of this volume, suggests a framework for planning, documenting, and assessing peacebuilding performance initiatives. Chapter 9 presents guidelines for planning and documentation that artists, peacebuilders, and evaluators can adapt to fit their own projects. These guidelines reflect much of the learning generated through the Acting Together project, but they are not at all a recipe or set of instructions. In fact, they consist primarily of sets of questions. We encourage readers to review them all and then choose those that are most salient for their own context to discuss with key players.

In addition, chapter 9 includes guidelines for minimizing risks of doing harm. We hope that these guidelines will be used to minimize the risks of retraumatization and perpetuation of hurtful power dynamics that inevitably accompany interventions in regions of violence and oppression. In addition, these guidelines alert readers to concerns that are unique to cultural productions, such as the borrowing of elements from one tradition for use in others, the importance of artistic integrity, and the balancing of imperatives toward virtuosity and inclusion.

As students, educators, artists, peacebuilding practitioners, activists, policy makers, and funders begin to design their work with the larger field of peacebuilding performance in mind, as they share their learning with each other and build networks of support, their efforts will become more effective and beneficial to the communities they serve or belong to. We believe that policy makers and funders in particular are positioned to strengthen not only particular initiatives, but also the larger community of practitioners working at the nexus of the arts and social transformation. Chapter 10 makes six recommendations in that direction, and follows these with action steps for policy makers and funders in both the arts and the peacebuilding/social justice fields.[2]

Walking The Walk, a performance directed by Rwandan theatre artist Hope Azeda. Hope was commissioned by the Playhouse International Culture Arts Network (*ICAN*) to work with ethnic minority communities residing in Derry-Londonderry, Northern Ireland. This production addressed key issues facing these new communities, involving fifty individuals representing the cultural diversity of the city. ICAN is a three-year project supported in part by the European Union's Programme for Peace and Reconciliation. Photo by Cathyann Keaveney

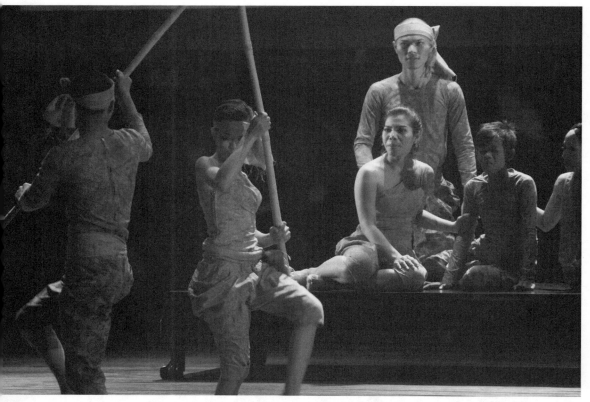

From Scene Ten of *Where Elephants Weep*, described by librettist Catherine Filloux in volume I, chapter 8. When the Flute Teacher sees Sam's despair, he sings *Our Land's Compassion* to help Sam recapture the spirit of his country through memories of happier moments. Sam begins a process of healing when he sees the spirits of his younger self and family perform a Bassac dance in the countryside. Photo by Rafael Winer

8 Facilitating Discussion and Exchange

Discussion Questions

Cynthia E. Cohen, Polly O. Walker

The questions listed here can be adapted for use in classrooms, training workshops, book discussions, and conversations following screenings of the *Acting Together on the World Stage* documentary. Please review them and adapt them for your purposes and audiences. Many of the terms embedded in these questions are defined in the glossary in this volume.

General Questions

1. Which of the Acting Together case studies stands out for you? Why? What would you like to be sure to remember about it?

2. Choose one example from the documentary or anthology. What kind of transformation was sought? What was achieved—in artistic, cultural, and sociopolitical terms? How would you assess the strengths and limitations of that performance in addressing the community needs?

3. What kinds of peacebuilding performances are you aware of in your own part of the world? How are they similar and different from the case studies presented here?

4. Are you aware of peacebuilding performances that have taken place in the midst of violent conflict? In its aftermath? In contexts of exclusion and injustice? What peacebuilding tasks are primarily associated with these stages and kinds of violence?

5. The case studies in the anthology are divided into three sections: in the midst of direct violence, in the aftermath of violence, and in the context of ongoing structural violence. How are the needs of communities similar and different in relation to these different stages and kinds of violence? How are the resources of performance marshaled to address the particular needs of each?

6. Are you aware of performances that would be considered "artist-based," "community-based," or "ritual"? (See the glossary if you have questions about these definitions.) What does each of these types of performance offer to communities seeking peace?

7. How does the language of story contribute to peacebuilding? What are the unique contributions of performed and embodied stories to communities seeking peace and justice?

8. What examples from the Acting Together collection illustrate transformations in the individuals most directly involved in performances? In those who witness performances? In the society beyond the performance space? In policies and laws? What are examples from your own experience?

9. How do artists incorporate the transformative power of ritual into theatre performances?

10. How do the performances documented in Acting Together restore dignity to those who have suffered and died in acts of violence and to those who have survived?

11. What are some examples—from the Acting Together collection or your own experience—of artfully crafted political protests or street demonstrations? How does attention to the aesthetic dimension enhance their effectiveness?

12. What untold stories, unmourned losses, suppressed emotions, unexpressed remorse, unreconciled relationships, unimagined hopes reside in your communities? Can you imagine ways of bringing them into spaces of performance? How might they be transformed there?

Questions Linking Theory and Practice

1. According to Victor Turner, the liminal space of performance offers communities opportunities to reflect on themselves, a process he refers to as "plural reflexivity." How do the performances described in the anthology and presented in the documentary engage with this potential for the purposes of peacebuilding?

2. Justice has many faces: it can be thought of in terms of retribution, restoration, equality of opportunity, historical accuracy, etc. What sensibilities about justice animate the cases in the Acting Together anthology, documentary, and toolkit? What kinds of justice are made possible through theatre and ritual? Are these similar or different to the kinds of justice made possible through truth commissions or trials?

3. In some cases, peacebuilding performances can both contribute to the transformation of conflict *and* perpetuate the dynamics of violence. Do you find this to be true of any examples in the Acting Together collection? How do the case studies measure up against the principles outlined in the "Minimizing Risks of Doing Harm" guidelines (see page 225)?

4. What kinds of power are manifested in peacebuilding performance?

5. What are the effects of that power in different kinds of performance and in the context of different kinds of violence? How can this power be enhanced? What are the limitations of the power of performance?

6. In the aftermath of violence, how do performances create spaces where the horrors of violent conflict can be engaged in ways that minimize risks of retraumatization?

7. How can performance address the legacies of epistemic violence (i.e. violence to communities' ways of knowing and being) and engage respectfully with different ways of knowing?

8. Dijana Milošević says that theatre helped her to transform her feelings of guilt into feelings (and acts) of responsibility. Why is this transformation important in peacebuilding? Do you know of examples of performances facilitating this kind of transformation?

9. What does the Acting Together collection teach about the importance of acknowledging suffering and the complicity of one's own people in causing it? How can people affiliated with perpetrators of crimes be supported to acknowledge their own complicity?

10. How does fear of terrorism threaten the civil and political rights of communities? In what ways might peacebuilding performance deal effectively with such fears and the ways they have been manipulated?

Ethical Questions

1. What are the possibilities and risks of approaching art as a "tool" for social change? How might you reconcile any tensions between the aesthetic imperatives of art and the urgent imperatives toward social transformation?

2. Some artists who bear witness to violence and suffering exploit their observations for personal or professional gain. How do artists in the Acting Together case studies address this temptation? When this tension arises in your work, how do you and others address it?

3. How do the various cases in the anthology—or other examples of peacebuilding performance you are aware of—balance attention to suffering with the acknowledgment of resilience, creativity, humor, or joy?

4. Roberto Gutiérrez Varea cautions against performances being presented prematurely, putting an already vulnerable community on a vulnerable platform. What harms might arise from an insufficient attention to community sensibilities in this regard?

5. Artists and cultural workers in regions of violence absorb many painful stories. In the Acting Together collection, how do artists maintain resilience? What challenges arise for you in this regard, and how do you address them?

Questions about the Permeable Membrane and the Relationship between Performance and Sociopolitical Transformation

1. In contexts of violence and oppression, what are some of the silenced issues and voices that pervade the environment?

2. What are the various channels through which the dimensions of a conflict enter into the transformative space of performance?

3. What different kinds of impacts do performances have on the people who participate in and witness them?

4. How do the audience and participants' responses contribute to the transformative power of performance?

5. What are the various ways in which transformations accomplished in the space of performance reenter and transform the world of "everyday life"? How can effects on individuals, relationships, actions, communities, and policies be documented and assessed?

6. To what degree should the *processes* of creating performances embody principles of peace and justice?

Questions about Gender, War, Peace, and Performance

1. The United Nation's official website for addressing issues of gender (www.women warpeace.org) begins as follows: "War has always impacted men and women in different ways, but possibly never more so than in contemporary conflicts." Choose a story of peacebuilding performance from the Acting Together collection and describe how it depicts the impact of violence and oppression on women and on men. Are the impacts similar or different from your experiences in your own region of the world?

2. The UN website continues, "In contemporary war, as much as 90 percent of casualties are civilians, most of whom are women and children. Women in war-torn societies can face specific and devastating forms of sexual violence, which are sometimes deployed systematically to achieve military or political objectives." Watch the short toolkit video "Performances Addressing Gender-Based Violence." What does the story of the process of creating Kay Punku suggest about the potential of performance practices to support healing, avoid retraumatization, and challenge a culture of impunity? How might this example inform practice in regions of the world where you live and work?

3. Watch the short video "Community-Based Theatre Challenging Gender-Based Violence and Xenophobia," and read chapter 1 in this volume. What does the story of *In the Name of the Fathers* suggest about the impact of war, migration, and domestic abuse on men? What does it suggest about the potential of performance practices to open avenues of dialogue across differences and reduce isolation? How do stereotypical notions of masculinity emerge from and contribute to a culture of violence?

4. Considering examples from the Acting Together collection, as well as from your own experience, how can performances promote social and political equality between women and men? How can they transform the constructions of gender that contribute to a culture of violence? (Suggested resources: toolkit video "Theatre and Building Capacities for Democracy," and anthology chapters 3, 4, 5, and 7 in volume I, and chapters 3 and 4 in volume II.)

5. Both women and men are effective leaders in the peacebuilding performance field. Women are nearly absent, however, in official peace processes. What could governmental and intergovernmental agencies learn from the peacebuilding performance field about the potential for mobilizing women's leadership? How could such a mobilization affect the peace process?

6. Every case study in the anthology and every story in the documentary and toolkit can be explored through the lens of gender. Taken as a whole, what do these examples say about the gendered nature of war, oppression, and peacebuilding?

How does your own practice take gender into account? Are there any examples or lessons from the Acting Together project that could strengthen your work?

Questions Pertaining to Volume I, Section I: Peacebuilding Performance in the Midst of Direct Violence

1. What comes to mind when you hear the word "resistance"?

2. What did the authors of the case studies in volume I, section 1, mean when they used the term "resistance"?

3. In which performances did you see demonstrations of resistance?

4. In what ways were performative modes of resistance effective?

5. What are the risks of engaging with resistance as an end in itself?

6. When does resistance contribute to peacebuilding and when does it contribute to ongoing cycles of violence?

7. Roberto Gutiérrez Varea says that "the forces that are intent on imposing their power sever lines of connectivity, especially the connections between the present moment and the past." In contrast, what kinds of connectivity does performance facilitate?

8. What are the resources of theatre and ritual that communities can use to minimize the risk of speaking openly in contexts of violence and suppression?

9. In chapter 4 of the first volume of the anthology, Abeer Musleh quotes Abdelfatteh Abusrour defining "beautiful nonviolent resistance" as the means to express resistance to occupation as well as love and hope. Under what conditions is creating beauty an act of resistance?

10. At what point would you consider violence to be justified? Compare the resistance Varea describes in *Fuenteovejuna* with principled nonviolence. This story is told in the first act of the documentary, and also in chapter 6 of this volume.

11. In what ways might resistance be propositional (suggesting and embodying proposed changes) rather than oppositional (taking a stand against what already exists)? How do the stories in this anthology illustrate these concepts?

12. In chapter 3, volume I, Madhawa Palihapitiya suggests that in the midst of direct violence, artists from one community can help their own communities interpret and understand the performances that are emerging from communities on the "opposite side." In the conflicts in which you live and work, could artists usefully play such a role?

13. What aspects of your own identity contribute to your understanding of, and responses to, these performances?

Questions Pertaining to Volume I, Section II:
Peacebuilding Performance in the Aftermath of Violence

1. What comes to mind when you hear the word "reconciliation"? Have you ever participated in any reconciliation processes?

2. In her essay "Creative Approaches to Reconciliation," Cynthia Cohen suggests that meaningful reconciliation processes generally include seven elements, performed in ways that resonate for local cultures: rehumanizing self and others; sharing stories and developing more complex narratives; mourning losses; empathizing with the suffering of the other; acknowledging and addressing injustices; letting go of bitterness; and imagining and giving substance to a new future. Which of these elements are present in each of the case studies in volume I, section II?

3. In the communities where you live and/or work, are there unreconciled relationships? What might reconciliation look like in your community?

4. If you were planning a performance linked with reconciliation, what might shape your decisions on whether to use theatre, ritual, or a combination of both?

5. If you were a member of a theatre ensemble that has been asked to work with a truth commission, which "do no harm" principles would you draw on to shape the collaboration?

6. If you were working in one of the regions featured in Act 3 of the documentary or in volume I, section II of the anthology, what could you do in your professional capacity to extend the reach of these performances?

7. How would you work with people and institutions to extend the reach of ritual and ceremony, for example in regard to the apology of the Australian government to the Stolen Generations?

8. If the more powerful group in a conflict has very little understanding of the ways of knowing of an oppressed people, how can their understanding and respect be facilitated to minimize the continuation of the epistemic and structural violence?

9. In Act 3 of the documentary, Augusto Casafranca says that there was a mutual reconciliation between him and the members of the community who witnessed his performance in the plaza. What breach or separation was being healed? What do you think was symbolized by his offering of the flowers, candles, and dry leaves, and by the way these gifts were received by people in the audience?

10. Ana Correa shares an evocative description of the similarity between artists' preparation for their work and shamans' ritual preparations for their connection with the gods. How do artists prepare themselves for the transformative

exchanges of energy that occur between performers and audience members/ritual participants? Why is this preparation important?

Questions Pertaining to Volume II, Section I: Peacebuilding Performance in Contexts of Inequity and Social Exclusion

1. What do the chapters in this section (and also the stories in Act 2 of the documentary) say about the power of performance to build relationships across difference?

2. In what ways are artists vulnerable in peacebuilding performances, and what effects does that have on audiences/participants?

3. How do performances highlighted in Act 2 interrupt the violence that stems from the dehumanization of the other?

4. In what ways can performances maintain the human face of both the victims and the perpetrators of violence? How can they counteract the dehumanization of the propaganda that accompanies violence and oppression? (For an additional example, please see "Hidden Fires" by Ruth Margraff in the first volume of the anthology.)

5. John O'Neal talks about the arts as serving political movements. What can politically motivated performance contribute to peacebuilding?

6. Why are people more able to confront painful memories through performance than through other means?

7. Act 2 of the documentary opens with a powerful story about how traditional ways of expressing identity (in this case through hair style) have been abandoned and reclaimed. How do performances of various kinds transform Ana Correa's relationship with her grandmother and with her own identity?

8. Ana Correa asserts that it is only through reclaiming her own roots that she is able to fully connect with others' humanity. Has this been your experience? Does her assertion ring true?

9. John O'Neal says of story circles: "We will be changed, you will be changed, the world will be changed." What needs to happen after the story circle for people to realize the full potential of these experiences?

10. How could the creation of story circles and hip-hop theatre be adapted for use in your communities? (Please see chapters 2 and 3 in volume II of the anthology.)

11. How are young people affected by racism and xenophobia? How can young people become agents of change? How can they rehumanize themselves and their images of the other?

12. In chapter 4, volume II, Jo Salas writes about how Playback Theatre has been used in schools to confront bullying. How could performances be crafted to strengthen respectful relationships among diverse young people in your communities?

13. In chapter 1, volume II, Kate Gardner writes about an innovative international soap opera project that created enduring and lifesaving ties among people in Brooklyn, New York, and Kisumu, Kenya. How can peacebuilding performance strengthen ties among people living in different parts of the world, and help them perceive each other's full humanity and respond to each other in times of need?

Guidelines for Story Circles

John O'Neal

........................

John O'Neal, author of chapter 5 in this volume and founder of New Orleans-based Junebug Productions, is the creator of story circles. The story circle process can be as powerful as it is simple; it engages groups of people sharing stories that matter to them—to be adapted for performances, to explore issues in their communities, to build relationships across difference, or to reflect on transformative experiences. In the Acting Together on the World Stage *documentary you can listen to John describe a particularly powerful story circle experience in a New Orleans high school.*

My grandfather had a bunch of good advice, not necessarily about story circles, but I don't think he'd be offended if I appropriate some of his ideas that can apply to the story circle process. One thing he told me that comes to mind here is, "Better to have a few easy rules that you can follow than to have a bunch of hard rules that you get lost in." Don't make too many rules. Rules only work if people agree to them. That's why it's better to keep them simple. Some groups take more rules than others, it depends on who you're working with and why. I mean, you might need a few more rules when you're working with a group of schoolteachers trying to develop a secondary school curriculum than you might need if you're trying to teach fractions to a group of third graders. But as a general rule you might say that less is more. Make as few rules as possible and no laws.

Well, maybe there is one law, the law of listening. In storytelling, listening is always more important than talking. If you're thinking about your story while someone else is telling theirs, you won't hear what they say. If you trust the circle, when it comes your turn to tell, a story will be there. Sometimes you may be tempted to think of it as magic. If you don't have a story when your turn comes or you're not ready to share the story that comes to you (which is more likely), it's all right, you don't have to tell. You can pass. After the first round there's usually enough time for those who passed to tell if they wish to. Another rule about listening is that you don't have to like the story that someone else tells but you do have to respect their right to tell it. Some people are surprised with the suggestion that stories can be used to teach math or science. My old friend Bob Moses, who organized The Algebra Project (which specializes in teaching algebra to disprivileged youth), points out that people learn better if you find the lessons you're trying to teach in stories that people in the group tell. Anybody can learn anything better when the subject matter is based on stories that come from or affirm your own experience and purposes. In

fact the story circle is just a way of focusing communication. It can be used for any purpose that a group of people wish to pursue.

Make sure everyone is comfortable and has some time to greet and meet informally; get a feel for the particular mood of the group that day. I think it's always good to have refreshments on hand. At the appropriate time, convene the circle. The convener needs to make a clear concise statement of the reason for calling the circle. Everyone needs to know what you're trying to do and have the chance to buy in. If they already know each other, then each person should simply take a moment to describe how they feel about the purpose and what they'd like to accomplish. If the people in the group aren't already familiar with each other, they should introduce themselves. Now this is where I usually introduce a procedure that helps things to move along smoothly, especially if it's a new group. Without making a big thing of it, I usually start the circle by introducing myself and then begin the process by looking to the person on my left to go next. This gets the group to thinking in terms of taking turns moving around the circle. Setting it up this way saves time—none of that business about who's going to talk next. It also helps the less aggressive people in the group to have a fair chance to speak.

I think it's important to talk about the circle itself. I usually say something about how democratic the circle is. Everybody on the circle is equal. Everyone on the circle should always be able to see everyone else. If you can't see everybody else on the circle you need to make an adjustment. If others join the circle then the group has to adjust.

It's also important to point out that being democratic does not mean being without leadership. The leader or convener of the circle has to get things started and monitor the progress of the story circle to make sure that everyone stays aware of what the rules are, but remember that discipline is always voluntary. You can't make anyone do anything they really don't want to do. Try it and you're likely to have an insurrection. The leader's job in the face of insurrection is to try to make it clear what the choices are and get out of the way. Sometimes the insurrectionists will be right and you'll learn something from them. If, in due course, you still think they're wrong, say so and why, restate the options as you see them, and do what you have to do. You can request discipline in a group but you cannot effectively force them do anything they really don't want to do, and I for one don't think you should. I can hear my Grandfather now, "You can lead a horse to water, but you can't make him drink!"

Most people already know most of what they need to know to do what they have to do already. What they don't know they have to create out of reflection and the critical evaluation of their own experience. As my grandfather used to say, "Anything I can give you, I can take away."

Time. It's really important to be conscious of time. It usually works pretty well if everyone in the group shares the responsibility for keeping track of time. The way I do this is by getting the group to help make the agenda. I ask how much time we want to take for the session. I think that about three hours is the max a group ought to plan on and about an hour is the minimum. Large groups should be divided into groups of five to six persons each. Allow about three to five minutes for each person to tell a story, and then about three minutes per person to sum up at the end of the session. This summing up I think is really important. It provides people time to digest what they've learned or thought about as a result of the stories that have been told. There also needs to be another period of time, roughly about equal to the summary, for people to have cross conversations about the issues that come up and to plan what they want to do about it. There should always be some kind of follow-up activity. For Junebug Productions, the story circle has emerged as a key instrument for doing our work. We recommend storytelling and the story circle process as tools for a wide range of purposes that rely on deep communication and exchange. Frequently we are asked for written material about the process. This discussion paper[1] is for people who want a written reminder of the process and how it can work. After you've run three or four story circles on your own, I'd appreciate it if you'd send stories or suggestions of things that help you understand or think about the process better. Others will certainly benefit from the lessons of your experience.

Now to Review

1. Like the stories it aims to collect, the story circle process is essentially oral in nature so it's not easy to communicate in writing.

2. Everyone needs to know the purpose of the story circle and have the chance to buy in . . . or out. Maybe they can do this as they introduce themselves and describe what they'd like to accomplish in this particular story circle.

3. Don't make too many rules. Less is more.

4. Listening is more important than talking. You mustn't be thinking about what you will say while someone else is talking. Trust the circle to bring your story to you. You don't have to like other people's stories but you must respect their right to tell it.

5. You don't have to tell a story. If you have no story to tell when your turn comes, just pass, you'll get another chance before a second round.

6. It saves time in the beginning if you take turns moving clockwise around the circle.

7. Don't get into power struggles with people on the circle, discipline is always voluntary. You can lead a horse to water, but you can't make him drink!

8. Let everyone in the group share responsibility for keeping track of time.

9. Provide time for sum-up at the end of each session.

10. Leave time for people to digest and have cross conversations.

11. Make some kind of follow-up activity that's viable for the particular group.

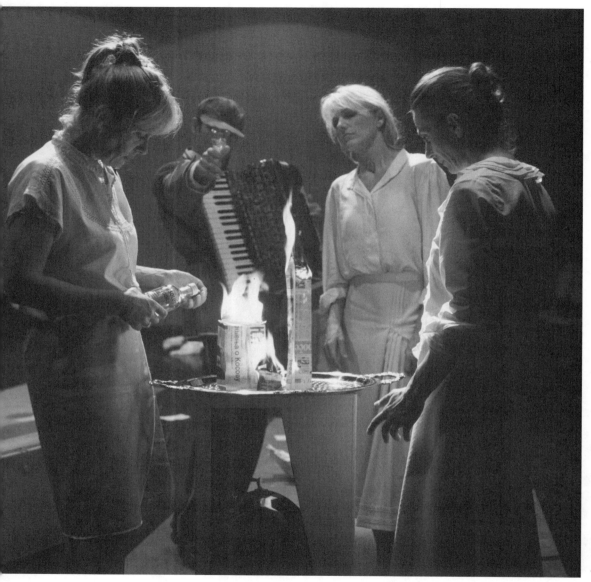

From *The Story of Tea* by Dah Teatar, directed by Dijana Milošević. Photo by Jovan Cekić

9 Designing and Documenting Peacebuilding Performance Initiatives

Cynthia E. Cohen and Polly O. Walker

Planning Peacebuilding Performance Initiatives

Designing a peacebuilding performance initiative requires a combination of strategic thinking and also openness to creative intuitions and emerging serendipities. The following questions are intended as prompts, suggesting areas for inquiry, conversation, and reflection. We recommend that you briefly consider all of the questions, and then focus on the few that seem most relevant to the context in which you are working and to the players who will be involved.

The more candid your responses, the more helpful they will be to your work and to the growing community of peacebuilding performance practice. However, please take care not to place the respondent or others at risk.

Where possible, we encourage groups planning initiatives to discuss these questions together. We also recommend working through these questions after considering several of the case studies presented in the anthology and/or in the documentary or toolkit. What can be learned from these examples that would be of use to your communities?

Context

What are the salient historical, socioeconomic, political, and cultural backgrounds of the communities where we plan to work?

- What are the issues in these contexts that performances might help address? What questions "need to be sorted"?

- What kinds of violence are present? At what stage are the conflicts?

- What relationships are in need of healing or restoration?

- What silences are in need of expression?

- Are communities grappling with questions of memory, identity, justice, and resistance? If so, how? Could performances help communities consider different approaches to these imperatives?

- What are the hopes and dreams of the people you intend to involve or to reach with this initiative? What are the possibilities communities can work toward with the help of performance?

- In many contexts of violence and oppression, the communicative, relational, artistic, and ethical capacities of people have been impaired. Sometimes these capacities are sharpened. How would you assess the strengths and limitations of the communities where you intend to work— especially in term of people's abilities to work toward their hopes and dreams?

- Who are the people and which are the institutions with the power and the resources to make a difference in the conditions under which people create their lives and their futures?

- What are available sources of resilience?

Available Resources

What relevant skills and talents already exist with the performance group or those planning the initiative? (These might include skills in performance, facilitation, outreach, marketing, cooking, photography, sewing, singing, fundraising, etc.)

- What workspaces are available?

- What documents might you wish to drawn on?

- What funds are, or might be, available?

- What local and global performance traditions might you draw on?

- Who are the people who might want to participate or volunteer on the project? Who could be recruited?

- Who holds the relevant and important stories? In whose memories or archives do they reside?

- Who are the important culture-bearers?

Risks of Doing Harm

How can responsible decisions be made in light of the very real risks involved in peace-building performance? (Please review "Minimizing Risks of Harm" guidelines and consider the following questions in relation to your own situation.)

- How can the risk of epistemic violence be minimized?

- How can the risk of retraumatizing individuals and communities that have suffered violence be minimized?

- How can artistic and cultural integrity be protected?

- How can the risk of perpetuating injurious and unjust power dynamics be minimized?

- How can risks to artists and cultural workers themselves be minimized— especially for those working in contexts of government repression and polarized paramilitary formations?

- How can the leaders of the planned initiative minimize risks of unwittingly supporting the interests of unethical players, and unknowingly diverting resources from existing effective initiatives?

Balancing Imperatives

Peacebuilding performances engage with some or all of the tensions that confront communities dealing with violence and oppression. Which of these issues are salient for the communities where you are working? How will your project situate itself in relation to these seemingly competing imperatives?

- The need to remember the past and the need to create a new future;

- The need to validate and strengthen distinct identities and the need to enhance acknowledgment of interdependence;

- The need to honor individual rights and the need to strengthen collective identities;

- The need to hold perpetrators accountable and the need to acknowledge the conditions that gave rise to the violence;

- The need to hold perpetrators accountable and the need to restore relationships;

- The need to acknowledge suffering and the need to cultivate and celebrate resilience;

- The need to honor tradition and the need to innovate and experiment;

- The need to play and the need to be serious;

- The need to respect the "deep pessimism"[1] of people living in contexts of intractable violent conflict and the need to inspire hope and vision for better, more just, less violent, conditions;

- The need to act with urgency and the need to be patient with people and complex processes;

- The need to create spaces of relative safety to support trust within the creative process and the need to acknowledge and prepare participants and audience members for the risks they may face when they return to their homes.

Exploring Potential Tensions

In addition to the tensions that often permeate the atmosphere in regions of violent conflict, there are several questions that can emerge in the context of the cultural productions themselves. It might be useful for members of the planning team to explore the following potential tensions and make notes of the points that seem most salient.

- The need for personal, professional and artistic development and the need for the development of the group and the community;

- The need to nurture relationships and honor emerging possibilities and the need to attend to the requirements of and commitments made to funders and sponsoring agencies;

- The benefits and possibilities of working with mixed groups and the benefits and possibilities of working with homogeneous groups;

- The value of artistic refinement and the value of inclusion of nonprofessionals;

- The value of responding to emerging crises and opportunities and the value of maintaining work in ways that are sustainable over the long haul.

Extending the Project's Reach

The transformations accomplished during peacebuilding performances inevitably will filter out to the surrounding community through the conversations and actions of those directly involved as participants and witnesses. There are also ways to enhance the reach and effectiveness of performances. Which of these approaches—or others—make sense for the context in which you are working?

- Inviting people you wish to bring into relationship to serve as advisors;

- Partnering with other groups and agencies addressing issues related to the production for credibility, outreach, lobby displays, post-performance conversations and related events;

- Inviting particular communities to attend;

- Composing audiences to include people from opposite sides of a conflict, and sponsoring facilitated conversations or workshops following the performance;

- Using social media and websites to reach large and diverse constituencies;

- Inviting key decision makers;

- Including brief essays or provocative questions in print programs;

- Considering ways to bridge linguistic divides, through the use of projected surtitles, written summaries in different languages, non-linguistic performance modalities, bilingual productions, etc.;

- Bringing productions to communities;

- Choosing performance venues that people encounter in their everyday lives;

- Attending to the particular needs of disabled people, especially in contexts where people have been disabled by violence.

Documenting and Assessing Peacebuilding Performance Initiatives

What kinds of documentation do you plan for this initiative, and what decisions need to be made in the early stages of the project? If you plan to document any aspect of the peacebuilding performance initiative in photographs, audiotapes or video, be sure to secure necessary permissions and releases, and information for credits. Moreover, in sharing information, care should be taken not to place the respondent or others at risk. Please develop your responses accordingly.

Documentation

- What is the name of the initiative you are documenting? Is it a performance, an event, an organization's work, a collaborative relationship over time?

- As documenter, what is your relationship to the work you are describing? How do you plan to gather data? What permissions and releases do you need to secure?

- Details of process: Give a rich description of relevant aspects which might include: place/setting, characters/participants, costumes/clothing, backdrop/scene, mood, and sounds/music. Who participated, and in what roles?

- Is the initiative you are documenting already completed? (If so, indicate the time that has elapsed since its completion.) Is it in progress? Is it part of a repeating cycle?

- What resources were needed to develop and present this work? How were they generated? What opportunities and constraints accompanied them?

- What were the most important elements of the context of the community as you understood them before the project began? In particular, what were the sources of strength and resilience? What capacities were in need of being strengthened? What was not being expressed adequately? What tensions and divisions were affecting the community? Which people and institutions were key players? What were the power dynamics at play?

- Which other elements of the context were important?

- How has your understanding of these elements changed over the course of your involvement with the initiative?

- Which of these elements were brought into the performance space? And how did they get there? (e.g., through stories, scripts, the place/space itself, interactions among people involved in the production?)

- Were any of these elements transformed through the creative process? How were they transformed? Please offer stories/examples of transformation.

- Which people, narratives, or ideas were brought into generative relationship during the performance? Were taboo subjects being put on stage? Were former adversaries finding ways to understand each other? Was there a more nuanced understanding of interdependence? Did the participants have fun?

- Have new ideas/plans/relationships/energies for the future been generated?

- What serendipities and unexpected difficulties arose?

- What conceptions of justice—retributive, reparative, historical, distributive, etc.—animated the performance?

- Did the performance celebrate the identity of a particular cultural group, and/or focus on common humanity and interdependence among all people?

- Did the performance strengthen people's capacities to effectively and nonviolently resist abuses of power?

- Were important historical moments embodied and kept alive—in ways that avoided traps of permanent victimhood and strengthened people's capacities to imagine and create a new future?

- How did the changes effected in the performance space enter back into the stream of community life? Did people involved directly in the production speak about the issues with their families, neighbors, and friends?

- Did people witnessing the production relate to people, ideas, or policies in new ways? Did they report thinking about and acting on issues differently? If you are able, please share stories that document the influence of the performance on the community.

- Were there talk back/discussion sessions? (If so, describe how discussions engaged with the elements discussed above.)
- Was literature from related human rights or other civil society organizations made available at the performance?
- Describe reviews of the production that discussed/commented on any of the elements or transformations.

Assessment

- How would you assess the strengths and limitations of this initiative?
- Did you witness any transformation in the dynamics of the conflict? If so, at what level and in what directions?
- Which factors external to the project itself (i.e., funders, political actors, civil society groups) either contributed to, or constrained, your efforts? How did you relate to those outside influences?
- What is your assessment of the aesthetic qualities/spiritual integrity of the work?
- What other initiatives have you seen (or could you envision) growing out of this one?
- Knowing what you (or the project initiators) know now, what would you/they do differently?
- How could the reach of this work be extended?
- What ethical dilemmas arose during the course of this initiative? What choices did you make regarding them? In retrospect, how do you assess these choices at this point?
- What conditions would allow this initiative to fulfill its potential?
- What new questions have arisen for you in the course of this initiative?

Minimizing Risks of Doing Harm

1. Minimize the risk of engaging in epistemic violence

- Involve cultural leaders from relevant communities in the planning and designing of initiatives;
- Include criteria to assess the artists' "knowledge of and sensitivity to local cultural practices";
- Avoid short-term infusions of funding that could undermine local sources of sustainability;

- Honor the wishes of culture-bearers about whether, and under what circumstances, to engage in or "borrow" cultural practices;
- Take the time to deeply understand sacred traditions, especially those disrespected during colonization and other forms of violence.

2. Minimize the risk of worsening divisions between conflicting groups

- Lift up the cultural forms and traditions of all groups;
- Avoid repeating conflict-habituated discourse within and surrounding the production;
- Avoid using negative labels for people and groups;
- Ensure that adequate facilitation skills are present when heated issues come up for discussion.

3. Minimize the risk of retraumatizing communities and individuals that have suffered from violence

- Learn and respect local processes for healing;
- Avoid imposing external conceptions of healing (e.g., the idea that all people need to share their stories) when such ideas are not culturally resonant;
- Engage with the resources of performance to balance painful memories with the building of cross-community relationships;
- Support justice-seeking in its myriad forms as a source of healing;
- When performances are likely to restimulate painful memories, ensure that people with capacities to facilitate discussions and respond to needs are available.

4. Minimize the risk of undermining artistic integrity

- Involve artists in crafting requests for proposals and calls for productions;
- Seek alternatives to didactic, goal-driven, message-centered productions;
- Plan visits to creative projects with sensitivity to potential disruptions by guests and observers;
- Seek spaces for creative projects that allow for movement and messiness.

5. Minimize the risk of creating or perpetuating injurious power dynamics

- Select facilitators who are attuned to multiple dynamics of power;
- Design projects to be relevant and accessible to all groups and sub-groups;
- Compose leadership/advisory teams with awareness of all affected communities, including those that are marginalized;

- Acknowledge factors that differentially affect participants outside and inside the performance space (such as dangers traveling through particular neighborhoods or regions, access to travel permits and visas, etc.);

- Alert all collaborators to the need for sensitivity to class and cultural dynamics in the interactions with artists and project participants.

6. *Minimize the risks to artists, cultural workers, and project participants, particularly those working in contexts of government repression or polarized paramilitary formations*

- Strengthen the ties between national and international arts advocacy and human rights groups so they can mount effective advocacy campaigns;

- Encourage artists to make informed choices about the risks they choose to take when speaking truth to power;

- Avoid engendering among project participants an unrealistic sense of their own power;

- Visit freedimensional.org for information and resources for supporting artists at risks of human rights abuses;

- Read and discuss James Thompson's chapter, "Incidents of Cutting and Chopping," in *Performance Affects* (New York: Palgrave MacMillan, 2009).

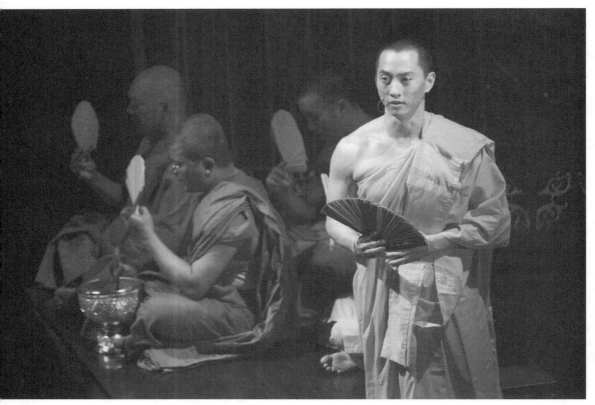

In volume I, Catherine Filloux documented how performances supported survivors of the Cambodian genocide to confront the legacy of the Khmer Rouge. Through witnessing performances such as *Where Elephants Weep*, shown here, audiences regained the capacity to construct meaning out of experiences that until then had been too overwhelming, too violating of the tools of meaning-making themselves, to be shaped into a narrative and shared.
Photo by Rafael Winer

10 Recommendations and Action Steps

for Strengthening the Peacebuilding Performance Field

Cynthia E. Cohen with Polly O. Walker

Whether you are an artist or a peacebuilder, a student or a funder, an educator or a policy maker, you are in a position to act to strengthen work at the nexus of peacebuilding and performance. This field will become more powerful as artists, cultural workers, and peace practitioners build on the strengths of each other's theory and practice and as we learn from initiatives in different parts of the world.

In this chapter, you will find six general recommendations for strengthening the field of peacebuilding performance; for each of them we suggest a series of action steps that can be taken by policy makers and funders in both the art and culture and the justice and peace fields. In addition to this, in some cases we have created a separate list of actions steps specific to each of the two fields. (Action steps for educators, students, artists and practitioners can be found in the *Acting Together on the World Stage* toolkit.) The recommendations here and in the toolkit are based on the frameworks presented in chapter 1, volume I, and in chapters 6 and 7, volume II.

We welcome readers' suggestions about ways to improve these guidelines. Updated versions will be posted on the Acting Together project's website at www.actingtogether.org.

1. Strengthen the emerging field of peacebuilding performance

- Prioritize support for the development of an infrastructure that will nurture the peacebuilding performance field, such as conferences, journals, learning communities, and centers where work can be documented and shared, where critical self-reflection is supported, where methods of assessment can be tested, and where emerging artist/peacebuilders can be educated and trained.

- Advocate for and use frameworks for assessment that account for both the aesthetic power of peacebuilding performances and the transformations they engender at the personal, relational, institutional, structural, and cultural levels.

- Support collaborations among artists, cultural workers, and peacebuilders, and practitioners working in the fields of transitional justice, rule of law, refugee resettlement, human rights, economic development, gender equity, immigrants' rights, youth development, etc.

2. Recognize, establish, and enhance opportunities for peacebuilding performance, including artist-based, community-based, and ritual productions

- Support the creation and production of performances that contribute to social transformation, peace, and justice, ensuring that the expressive forms of all communities are supported.

- Support reciprocal exchanges among artists and cultural workers from communities in conflict; encourage relationship-building, sharing of work, development of new collaborative works, and sharing of learning with communities on all sides of conflicts.

- Request thorough documentation and assessment of peacebuilding performance initiatives, for the purpose of strengthening the field.

- Support international cultural exchange.

Action Steps for Funders and Policy Makers in the Arts and Culture

- Encourage arts and culture groups to involve peacebuilders and social justice activists in activities (for instance in developing content for printed programs, lobby displays, and outreach strategies; and to facilitate pre- and post-performance dialogues).

- Establish and strengthen the necessary physical infrastructure, including theatres, community arts centers, and Indigenous cultural centers.

- Support residencies for artists and cultural workers in social change organizations.

Action Steps for Funders and Policy Makers in Peace and Justice Fields

- Bring artists and cultural workers to the table when planning peacebuilding strategies and funding priorities

- Support social change organizations to collaborate with artists and cultural workers and experiment with creative approaches to peacebuilding and justice.

- Support residencies for peace and justice scholar/practitioners in arts and culture organizations.

3. Minimize the risks of doing harm to individuals, relationships, and communities engaged in peacebuilding performances, as well as to cultural and artistic integrity itself

- Review "Guidelines for Minimizing Risks of Doing Harm" on page 225; reflect on priorities and commitments in light of these guidelines.

- Include in funding criteria sensitivity to local ways of knowing, local cultural practices, and local ways of dealing with trauma.

- Be alert to dynamics of power—between funders and grantees, between grantees and community groups, and between arts/culture organizations and peace/justice organizations.

- Ensure that artists/peacebuilders understand the tensions among conflicting groups and address them in productive, generative ways.

- Consider the safety and mental health of artists, peacebuilders, and participants involved.

4. Create or support cultural productions and institutions that enhance peacebuilding capacities and that, directly or indirectly, contribute to nonviolent resistance, rehumanization, and reconciliation

- Support performances, symposia, panels, and trainings related to the moral imagination, social justice, peacebuilding, culture, and the arts.

- Support documentation and dissemination of exemplary practices, through films, websites, international exchange, conferences, and festivals.

- Support exchanges and collaborations among artists from opposing communities, when appropriate.

Action Steps for Funders and Policy Makers in the Arts and Culture

- Invest in cultural institutions and arts activities in regions of violent conflict and ongoing oppression.

- Support opportunities for artists to learn the skills of conflict analysis and conflict transformation.

- Support arts and culture organizations to host peacebuilders as scholar/practitioners in residence.

Action Steps for Funders and Policy Makers in Peace and Justice Fields

- In regions of violent conflict and ongoing oppression, invest in cultural institutions and well-crafted socially engaged arts activities.

- Support opportunities for practitioners and activists to engage with the transformative potential of arts and cultural work—as both witnesses and participants—so that they can think creatively about incorporating artistic and cultural dimensions into their practice.

- Support peace and justice organizations to host artists and cultural workers in residence.

5. Engage students, educators, peacebuilders, artists, reviewers, and cultural leaders in exploring the concept and the disciplines of the moral imagination

- Support workshops, readings, courses and conversations related to the moral imagination.

- Facilitate opportunities for apprenticeships with exemplary artists and peacebuilders whose practices embody the moral imagination.

- Recognize and highlight artists and peacebuilders for work that embodies the moral imagination.

- Incorporate into assessment criteria elements of the moral imagination, including the recognition of interdependence, engagement with paradox, risking vulnerability, openness to emerging serendipities.

- Support works that display thoughtful and creative alignment between cultural productions and needs for transformation in the sociopolitical contexts in which they are embedded.

6. To the extent possible, ensure that ideas, relationships, attitudes, and behaviors that have been transformed through peacebuilding performances reach the wider community as well as key stakeholders and decision makers

- Support performing groups and peacebuilding entities in planning outreach and dissemination strategies and encourage the inclusion of opinion-shapers, educators, political leaders, people from opposing communities, etc., in the audience.

- Support local, regional, national and international tours of exemplary peacebuilding performances.

- Support the development of program notes, lobby displays, websites and follow-up events designed to link peacebuilding performances with effective action.

- Support documentation not only of final productions, but also of transformations that take place in the processes of creating and witnessing performances.

- Support partnerships between artists from opposite sides of conflicts, so they can serve as interpreters for their own communities of the intentions and expressions of adversary communities.

Aida Nasrallah is a poet, playwright, performance artist, art historian, and critic. She explores the roles of women in peacebuilding in her poetry, fiction, and performance art. In her unique salons and exhibits, Jewish- and Palestinian-Israeli women, often from opposite sides of the political divide, weave relationships of trust. She coauthored a chapter in volume I of this anthology. Photo by Hagit Khrobi

Afterword

..

Reflecting on the Intersection of Art and Peacebuilding

Tatsushi Arai

..

The preceding chapters of *Acting Together* represent an ocean of practical wisdom and theoretical insights into the role of artistic performances in building peace. The task before me is merely to add a finishing touch on this important work by way of reaffirming the vision and spirit with which its contributors have given birth to it. Perhaps the best way of facilitating this closing act would be to invite the reader to a few episodes of my own journey of art and peacebuilding. Imagine being a participant in the following scenarios of human encounters:

• • •

Act One: Japanese Youth Meeting Ethiopian Dancers

The auditorium reverberated with dynamic steps, drums, and songs, all breathtaking to high school students in Tokyo who had never experienced Ethiopian music and performances before. These visiting artists from the Horn of Africa, while singing in a language that the Japanese teenagers never understood, appeared to have completely captivated the young audience's minds and hearts. Their movements and voices displayed an exquisite balance of vibrancy and stillness, light and darkness, courage and warmth, all unfolding on the stage filled with life. They were so foreign to the Japanese youth—yet somewhat so intimate.

The performances ended with resounding applause. A reflection time was set aside immediately afterwards, encouraging volunteers from the young audience to share their impressions using the open microphone. A student moved forward:

I must be completely honest. I came to the auditorium because our school organized this event for us. I had known nothing about Ethiopia before coming here, nor could I even point to Ethiopia on the world map. But having enjoyed your powerful music and dances, I now feel very close to Ethiopian people. I feel I have become a big fan of Ethiopia. Starting today, I will be following the news about your country closely. I would be happy whenever I hear good news about Ethiopia. I would feel sad whenever I hear sad news about Ethiopia.

Act Two: A Practitioner Workshop on Cross-Cultural Communication in Washington, DC

Two contested versions of conflict history unfolded on the floor in front of thirty-five workshop participants. On the right hand of the two parallel timelines, both extended from one end of the room to the other, lay several large sheets of paper, each recording a historical event that a few workshop participants from the United States government, all with extensive experience in diplomatic service, carefully selected. These chosen events, they said, represented their understanding of what the American public would see as the most decisive incidents that had led to the attacks on September 11, 2001 and to the major US actions that followed, with emphasis on Afghan-Pakistan-US relations. Their chronology read: 1978, Iranian hostage crisis and the fall of the Iranian ruler; 1979, Soviet invasion of Afghanistan; 1990–1991, First Gulf War in Iraq; 1988, US embassies bombed in Kenya and Tanzania; 2001, September 11; . . . 2003, US-led invasion of Iraq.

On our left was another timeline constructed by Pakistani participants, all of them with many years of professional background either as a journalist, government official, or NGO director. Their timeline described the Pakistani version of the history that had led to September 11 and beyond, again with emphasis on Afghan-Pakistan-US relations. While the US timeline was global in scope encompassing Iran, Iraq, Kenya, and Tanzania, the Pakistani version was decisively more local and more sharply focused on Afghan and Pakistani bilateral relations with the United States: 1954, Pakistan enters regional security alliances with the US; . . . 1979, Soviet intervention in Afghanistan; 1989, the US loses interest in the region with the Soviet withdrawal from Afghanistan; the mid-1990s, Osama bin Laden moves to Afghanistan and issues a religious decree against the US; 2001, September 11; 2004, US drone attacks start in Pakistan.

The sheets of paper recording these events were placed on the floor in two parallel timelines in such a way that a physical distance from one event to the next corresponded to the number of intervening years between them. Thirty-five workshop participants, including Americans, Pakistanis, and others from different parts of the world, formed a single line behind me as the facilitator standing at the beginning of the timelines. All of us then walked slowly and silently along the narrow path that

opened up between the two timelines, looking to the left and right as we walked. After the ceremonious walk, we formed a large circle surrounding the two timelines and reflected on this experience together.

The enactment of a walk-through history, as this method is commonly referred to among practitioners of peacebuilding, was intended to create a ritualistic space of sorts, inviting its participants to align their kinesthetic, sensory experience of walking to a joint exploration and discovery of contested worldviews and communal identities. Many of the participants were deeply engaged during the joint reflection, not only intellectually, but also emotionally. One American participant with many years of leadership experience in the US government went as far as apologizing to the Pakistani participants for what she saw as a decisively negative portrayal of the Islamic world mirrored in the US chronology. As she did so, some other American participants contested her interpretation. A Pakistani participant, on the other hand, reflected that their timeline, on the whole, illustrated their collective sense of having been betrayed repeatedly by the United States, as Washington had kept changing ways of leveraging its ties to Islamabad and Kabul in order to fulfill its ever-changing needs in the region.

A little over an hour of time prepared for the joint reflection was expectedly too short given the intensity of discussion that unfolded. Some of the participants kept standing along the timelines and talking even after the session was over.

• • •

These two forms of artistic encounters are qualitatively different in many ways. While the cultural exchange in Tokyo was made possible by the professional Ethiopian performers demonstrating their artistic skills to the young Japanese audience, the exercise of walk-through history was designed to create an opportunity for workshop participants to jointly create and experience the ritual. While the Ethiopian performances represented a centuries-old tradition in their home communities, the history walk was an artificial construct improvised by way of applying a technique used in the field of peacebuilding. Despite these and other apparent differences, both episodes illustrate how artistic experiences activate different senses that transcend logical, analytical thinking. They also demonstrate the capacity of artistic interactions to open up a humanizing space that invites authentic expression and engagement.

The artistic enactment of such humanizing encounters brings people together across cultures, worldviews, and communal identities, as demonstrated by the Ethiopian performers in Tokyo. It also invites the participants in these encounters to reflect both critically and imaginatively on their collective memories, identities, and worldviews, as illustrated by the symbolic walk through the American and Pakistani chronologies. Moreover, as this volume has cogently demonstrated, theatrical settings created by artists and participants alike have the capacity to break

silence, mainstream the voices of the voiceless, give permission to cross boundaries of political correctness, and give full expression to the moral imagination of divided communities in search of alternative ways of relating to each other.

These reflections on art and peacebuilding lead us to a final thought. To the extent that peacebuilding is a sustained, ever-evolving search for ways to discover, activate, and realize the full potential inherent in each individual and society, its ultimate goal is, I believe, one and the same as that of art. Art, in its most authentic sense, is not merely a means to build peace. Rather art, as a way of enacting the fullness of human potential, presents a far-reaching vision of peacebuilding and, as such, it is the end of peacebuilding in and of itself. *Acting Together* is a powerful contribution to establishing a rightful place that performing arts deserve to occupy both as a humanizing means and the ultimate end of peacebuilding in our time.

Tatsushi Arai
Associate Professor of Conflict Transformation,
School for International Training (SIT) Graduate Institute

Glossary

aesthetic experience: Pleasurable experience of perception brought about by the reciprocity between the qualities embedded in a form and the perceptual capacities of those who witness or behold that form. Aesthetic experiences generally integrate the senses, emotions, and spirit with intellect.

aesthetics: Critical engagement with art, culture, nature, and beauty.

archive: A body of material, usually collected and catalogued artifacts, that requires authorized access and is not easily available to assist communities in the construction of memory and meaning. It is clearly associated with structures of power.

artist-based art: Art, including performance, emerging from the impulses and creativity of artists and ensembles.

asymmetrical conflict: Conflict between parties whose relative power differs significantly. The group with relatively less power has less potential to resolve the conflict in ways that meet the needs and interests of its members.

carnival: A festival marked by merrymaking and processions in which community members wear masks and costumes. Participants behave "invertedly," that is they engage in behavior ordinarily deemed inappropriate in their society.

ceremony: An event of ritual significance, performed on special occasions. Ceremonies have performative or theatrical components such as dances, processions, or rites of passage, along with verbal pronouncements that explain or complete the event.

cipher: A group setting in freestyle hip-hop in which freestyle verses are often prepared on the spot by a rapper as other rappers in the cypher take their turn. Metaphors and similes are often used when freestyling in a cypher.

coexistence: Coexistence is the outcome of relationships across differences that are built on mutual trust, respect, and recognition, and is widely understood as related to social inclusion and integration.

colonization: Extension of a state's political and economic control over an area inhabited by a native population. Colonization requires the Indigenous population to be subdued and assimilated or converted, often forcibly, to the culture of the colonists.

community-based art: The creative expression that emerges from communities of people working together to improve their individual and collective circumstances. It is sometimes facilitated by professional artists trained in developing community expression through the arts.

conflict: A difference between two or more parties that impacts on them in significant ways. Conflict can be based on differences in values, power, or access to needed or desired resources. It may be easily observable or exist under the surface.

conflict analysis: The systematic study of the causes of, actors in, and dynamics of conflict. It aims at gaining a better understanding of the context of the conflict and the parties' roles in it.

conflict cycles: Stages through which conflicts typically move, which include: latent or hidden conflict, emergence or articulation of conflict, escalation, stalemate, de-escalation, resolution, peacebuilding, and reconciliation.

conflict resolution: A range of methods for addressing conflict that rely on faith in the rationality and fundamental goodwill of people. Processes of conflict resolution generally include negotiation, mediation, and diplomacy.

conflict transformation: Conflict transformation addresses human conflict through nonviolent approaches that increase mutual understanding and respect. Conflict transformation is flexible, both in structure and process, and views peace as a continuously evolving and developing quality of relationship, rather than a finite outcome.

creativity: A process involving the discovery of new ideas or concepts, or new associations of existing ideas or concepts, fueled by the process of either conscious or unconscious insight.

cultural work: The series of processes undertaken to support communities to recognize, celebrate, and develop their own expressive forms (such as folktales, folksongs, and foodways) based on the idea that knowledge is held collectively, expressed by groups, and that members of the group can turn to this knowledge as a source of power.

culture: The shared, often unspoken understandings in a group derived from individual and collective experience. These understandings are both learned and created by members of a group and include beliefs, values, attitudes, and norms.

embodiment: The giving of concrete form to an abstract concept. In peacebuilding performance it refers to the expression of concepts in and through the human body.

epistemic violence: Marginalization, oppression, or suppression of a people's or group's ways of knowing.

hip-hop: An artistic movement that includes elements of emceeing (rapping), DJing, writing (aerosol art), dance forms (breaking, up-rocking, popping, and locking), and vocal percussion (beatboxing).

Hip Hop Theatre: A performance that combines dialogue with hip-hop dance and music.

imagination: The capacity to form mental images and concepts of something that does not yet exist, and which then can be given shape in the world.

interdependence: The quality of being mutually responsible to others and recognizing that one person or group's well-being is contingent on the well-being of others.

liminal space: Space in which people experience the threshold between two different states of being. Symbolic and ritualistic communications are the primary modes of expression in liminal space, which is often used to mark social and cultural transitions.

mediation: A dispute resolution process guided by an impartial third party that aims to assist two or more disputing parties in reaching an agreement.

moral imagination: The capacity to imagine something based in the challenges of the real world, yet capable of giving birth to something that does not yet exist.

negative peace: The absence of war and other forms of large-scale violent human conflict.

nonviolence: A philosophy and strategy of social change that rejects the use of violence and offers an alternative to both armed struggle and passive acceptance of oppression. Nonviolence practitioners use diverse methods in their campaigns for social change, including civil disobedience, education and persuasion, and nonviolent direct action.

oppression: Repression of groups of people based on an unjust use of authority, mainly by governments or ruling powers, that impacts adversely on human rights, rule of law, Indigenous peoples, women, or minority groups.

paramilitary: A group of civilians organized in a military fashion, especially to operate in place of or to assist regular army troops.

peacebuilding: The set of initiatives by diverse actors in government and civil society that address the root causes of violence and protect civilians before, during, and after violent conflict. Peacebuilders use communication, negotiation, and mediation instead of violence to resolve conflicts.

performance studies: The formalized study of a wide range of performance, including theatre and ritual. Performance studies grew out of an interdisciplinary exchange between traditional theatre studies and anthropology, and now draws on numerous disciplines.

Playback Theatre: Theatre created through the collaboration between performers and audience in which an audience member tells a story drawn from his or her experience and then chooses actors to play the different roles in this story. Playback Theatre was originated by Jonathan Fox.

positive peace: A social condition in which exploitation is minimized or eliminated, and in which there is neither overt violence nor underlying structural violence.

presence: The quality of attention and receptivity a person brings to a performance, a community, or another person.

propaganda: The deliberate, systematic attempt to shape perceptions, manipulate cognitions, and influence behavior to achieve responses that further the desired intent of the propagandist. Often used by governments, political groups, and ruling powers to disempower or weaken another group.

reconciliation: A process that involves acknowledgment of the harm/injury each party has inflicted on the other; readiness to apologize and "let go" of the anger and bitterness caused by the conflict; commitment not to repeat the injury; redress of past grievances; compensation for the damage caused (to the extent possible); and the building of a new mutually enriching relationship.

repertoire: An embodied collection of performative work transmitted from generation to generation and from the performers to each other and to the public.

resistance: Unwillingness or refusal to obey a ruling power's demands or to succumb to its view of the limited agency and creativity of the people being ruled.

restorative justice: An approach to justice that focuses on the needs of victims and offenders rather than on abstract principles of law or punishment. It includes opportunities for victims to share their stories and hold the offenders accountable through some form of compensation/restoration, which may also include apologies.

retributive justice: A theory of justice generally based on a set of laws that considers criminal prosecution and punishment to be appropriate responses to crime.

ritual: A synchronization of many performative genres, often ordered by dramatic structure. All of the senses of participants and performers are engaged in transfor-

mative ways as participants are led into a "second reality" outside of everyday life in which they can embody different selves.

social imaginary: The set of values, institutions, laws, and symbols common to a particular social group and/or society.

social inclusion: A condition ensuring that marginalized people and groups have greater participation in the decision making that affects their lives, and allowing them to improve their living standards and overall well-being.

social power: The capacity to shape or control the behavior of others, either directly or indirectly.

state terror: Acts of violence committed by governments and quasi-governmental agencies and personnel against perceived enemies, both domestic and external.

story circle: A process based on deep communication and exchange in which members of the circle are invited to share their personal stories in an atmosphere of respect and focused listening.

street theatre: A form of performance held in outdoor public spaces in front of an audience formed from the people naturally found in that setting. One of the oldest forms of theatre, it is available to a wide range of people and its public nature often serves to draw attention to silenced histories, injustices, and contemporary conflicts.

structural violence: A form of violence in which social structures or institutions harm people by preventing them from meeting their basic needs.

Theatre of the Oppressed: Theatre of the Oppressed is based on a philosophy of non-violence that respects difference and works to change oppressive circumstances and achieve economic and social justice. The performative process is designed to restore dialogue among individuals or groups who are oppressed socially, politically, culturally, and to allow people to become empowered in their own lives.

theory of change: A blueprint for achieving large-scale, long-term goals. A theory of change identifies the conditions, pathways, and interventions necessary for an initiative's success. Theories of change may be clearly articulated or may be implicit within the actions and values of individuals or groups.

transformative justice: An approach that seeks to develop long-term, sustainable justice processes within civil society. Transformative justice involves identifying, understanding, and including various cultural approaches to justice besides the dominant Western worldview and justice system.

violence: Act of aggression against a person or group of people that results in observable injury and infliction of pain.

witnessing: The act of bearing witness to the experiences of others. In performance studies, witnessing describes the role that participants and audience members may take by reflecting on and sharing the stories they have heard in the performances in order to increase awareness of violence, injustice, and human rights violations.

worldview: A complex cognitive process that includes definitions of what is true, how reality is organized, what is valuable or important, and how people should act. Worldviews are lived activities that take place in the context of people's lives and are therefore emergent and dynamic systems. Peacebuilding includes learning how to manage, negotiate, and navigate multiple worldviews.

Notes

.................

Foreword

1. Translated by Roberto Gutiérrez Varea.
2. Erving Goffman, *The Goffman Reader*, ed. Charles Lemert and Ann Branaman (Malden, MA: Blackwell, 1997), 96–97.
3. "Person" in Spanish is *persona*. Identical to the Latin word for mask [translator's note].
4. Antonin Artaud, *The Theater and Its Double* (New York: Grove Press, 1958), 27–28.

Chapter 1

1. The Dutch portion of this chapter could not have come about without the cooperation of Marlies Hautvast and Jos Bours. They are the undisputed pioneers of community-based theatre in the Netherlands. Like no one else they are able to generate the trust of the people who end up acting in their plays. The trust these participants gave Jos and Marlies, they also extended to me: George Musch, Willem Meeuwsen, Kris Dwarka, Arjen Brouwer, Abdoelsamad Taky, Hainly Clemencia, Abdellah (Sidi) Hillali, Faris Kulgu, Alattin Erol, Sahir Sbaa, Bilal Sahin, Osman Kaya, Nasredin Hussein, and Mr. Laziz. Finally, I must thank Anita Schwab, the founder of Father Centre Adam. Without her, this project would never have happened.
2. I am deeply grateful to my close collaborator and friend, Kitche Magak. With integrity, innovation, and courage, he is pioneering new visions of education and community development for Africa and beyond. The story of *BrooKenya!* would not be told without the priceless contributions of Arena y Esteras, Angela Ahenda, Mitchell Bass, Theresa Brown, Mickie King, Alan Koppel, Frances Lozada, Kita Love, Carol Morrison, Caroline Ngesa, Jack Ogembo, Dennis Otieno Oluoch, Christine Ombaka, Felix Otieno, Felicia Reyes, Rosemary Salinger, Amy Samelson, Mitchell Shepherd, Wayne Starks, Linnaea Tillett, Ximena Warnaars, Donna Whiteman, and many others who gave of themselves so generously.
3. Eugene van Erven, *Radical People's Theatre* (Bloomington: Indiana University Press, 1988); *The Playful Revolution: Theatre and Liberation in Asia* (Bloomington: Indiana University Press, 1992); *Community Theatre: Global Perspectives* (London and New York: Routledge, 2001).

4. Eugene van Erven, transcript of video interview, The Hague, 2 June 2007.

5. van Erven, *Community Theatre*, 53–91.

6. "Livability and Safety Monitor," The Hague. Accessible at: www.denhaag.nl/smartsite.html?id =41960.

7. Anita Schwab, *Moedercentrum Staat als een Huis* (The Hague: Landelijk Centrum Opbouwwerk, 1999).

8. Jos Bours, *Community Theatre Methodiek* (Utrecht: Stut, 2007), 6.

9. Jos Bours, *Vadercentrum Adam* (The Hague: Vadercentrum Adam, 2007), 10–11.

10. Anita Schwab, interview with Eugene van Erven, The Hague, March 20, 2007.

11. Jos Bours, "In de Naam van de vaders" (unpublished play script, April 21, 2007), 38.

12. Marlies Hautvast, interview with van Erven, Utrecht, October 15, 2006.

13. Bours, "In de Naam van de vaders," 44–45.

14. Ibid., 12–13.

15. Eugene van Erven, video transcript of first script reading, November 7, 2006.

16. Bours, "In de Naam van de vaders," 26–29.

17. Ibid., 34.

18. Eugene van Erven, video transcript, June 2, 2007.

19. Marlies Hautvast, interview with Eugene van Erven, Utrecht, April 27, 2007.

20. Eugene van Erven, video transcript, June 2, 2007.

21. Bilal Sahin, interview with Eugene van Erven, The Hague, May 23, 2008.

22. Ibid.

23. Ibid., 113.

24. Eugene van Erven, *video clip 7*, November 7, 2006.

25. Due to the efforts of a great many people, including Kitche and his colleagues, the rates of infection dropped to a national average of 5.8 percent in 2006. Source: UNAIDS/WHO report, "Aids Epidemic Update, 2007." (Geneva, Switzerland: Joint United Nations Programme on HIV/AIDS and World Health Organization, March 2008), 14. Available at: data.unaids.org/pub /Report/2008/jc1526_epibriefs_ssafrica_en.pdf.

26. Kitche Magak, telephone communication with Kate Gardner, December 2003.

27. Community Theatre Internationale, "BrooKenya!" (unpublished script, Brooklyn, 2003).

28. Community Theatre Internationale, "BrooKenya!" (unpublished script, Kisumu, Kenya, 2004).

29. Community Theatre Internationale, "BrooKenya!" (Brooklyn).

30. Community Theatre Internationale, "BrooKenya!" (Kisumu).

31. Kitche Magak, e-mail correspondence with Kate Gardner, February 12, 2008.

32. Community Theatre Internationale, "BrooKenya!" (Kisumu).

33. Kitche Magak, statement presented at *BrooKenya! Live* (Kisumu, Kenya, and Brooklyn, November 20, 2004).

34. Quote by Oliver Wendell Holmes from John Paul Lederach, *The Moral Imagination: The Art and Soul of Building Peace* (Oxford, UK: Oxford University Press, 2005), 31.

35. Ibid., 34.

36. Z. D. Gurevitch, "The Power of Not Understanding: The Meeting of Conflicting Identities," *The Journal of Applied Behavioral Science* 25, no. 2 (1989): 161.

37. Ibid., 163.

38. Grant Kester, *Conversation Pieces: Community and Communication in Modern Art* (Berkeley: University of California Press, 2004), 109–10.

39. L. S. Vygotsky, *Mind in Society* (Cambridge, MA: Harvard University Press, 1978), 84–91.

40. S. Moran and V. John-Steiner, "Creativity in the Making: Vygotsky's Contemporary Contribution to the Dialectic of Development and Creativity," in *Creativity and Development*, ed. R. K. Sawyer, V. John-Steiner, S. Moran, R. J. Sternberg, D. H. Feldman, J. Nakamura et al. (New York: Oxford University Press, 2003), 78.

41. Eugene van Erven, video transcript, June 2, 2007.

42. Kester, *Conversation Pieces*, 122.

43. Ibid., 139.

44. Ibid., 10–11.

45. Anthony Jackson, "The Dialogic, the Aesthetic and the Daily Express: What Kinds of Conversations Do We Need to Weave with Our Audiences through the Arts?" (unpublished keynote lecture delivered at the Second Caribbean International Symposium in Arts Education, University of the West Indies, Trinidad, June 28, 2005), 1.

46. Rustom Bharucha, "What Kind of Community Art Research Do We Need?" 2007, www.cal-xl.nl/.

47. David Sloan Wilson, *Evolution for Everyone* (New York: Delacorte Press, 2007), 185.

48. Arvind Singhal et al., "Assessing Entertainment-Education By Handing Over the Tools of Knowledge Production to Co-Participants: Understanding Mingá Peru through Pencils, Markers and Cameras" (paper presented at the Ibero-American Conference for Entertainment Education and Social Change, Morelia, Mexico, 2005).

49. François Matarasso, *Use or Ornament? The Social Impact of Participation in the Arts* (Stroud, UK: Comedia, 1997). Available at: www.comedia.org.uk/pages/pdf/downloads/use_or_ornament.pdf.

50. François Matarasso, e-mail correspondence with Eugene van Erven, March 10, 2008.

51. Dalai Lama in Rick Ray's documentary, *10 Questions for the Dalai Lama*, 2006.

Chapter 2

1. I wish to thank all the people who so generously contributed their voices to the construction of this narrative, as well as Awam Amkpa and the wonderful NYU-in-Ghana administration. Huge credit due to: the NYU and University of Ghana students who worked so diligently in Buduburam and at CCS, especially HHTI members Wade Allain-Marcus, Utkarsh Ambudkar, Archie Ekong, Tristan Fuge, Eboni Hogan, Danielle Levanas, Brittany Manor, and Prentice Onayemi; Erin Threlfall, who assisted us; and Ismail Mahomed and Mary Jeffers for initiating the South Africa projects. Appreciation also very much due to Adam McKinney, Martha Diaz, Kathryn Ervin, Rickerby Hinds, and Rha Goddess for their ongoing support of this chapter and HHTI's work; and to Cynthia Cohen, Roberto Varea, and Polly Walker for their patient curating and visionary leadership.

2. To "spit" is to rhyme, rap, and/or speak text or poetry, improvised or otherwise.

3. Wole Soyinka, *Myth, Literature and the African World* (Cambridge, UK: Cambridge University, 1976), 40, 43.

4. Victor Turner, *From Ritual to Theatre* (New York: PAJ, 1982), 44.

5. These contributions have been assembled through e-mail and telephone conversations, requests for writing on the topic, and, in the case of Emile YX, an excerpt from previously published writing.

6. Nelson George, *Hip Hop America* (New York: Penguin, 1998), 14.

7. There are many excellent books on the history and practice of Hip Hop culture. Four indispensable texts are Nelson George's *Hip Hop America*; Jeff Chang's *Can't Stop, Won't Stop: A History of the Hip Hop Generation* (New York: St. Martin's Press, 2006); *Yes Yes Y'all: The Experience Music Project Oral History of Hip Hop's First Decade* (Cambridge, MA: De Capo Press, 2002), edited by Jim Fricke and Charlie Ahearn; and Tricia Rose's *Black Noise* (Middletown, CT: Wesleyan University Press, 1994). These texts, and many more, are taught at the university level, where there are hundreds of courses on Hip Hop in the US alone and multiple theses and dissertations already written and in process.

8. George, *Hip Hop America,* 18.

9. Michael Kimmelman, "In Marseille, Rap Helps Keep the Peace," *New York Times*, December 19, 2007.

10. Ishmael Beah, *A Long Way Gone* (New York: Sarah Crichton Books, 2007), 66–68.

11. Beah, *A Long Way Gone,* 169.

12. Human beatboxing is creating rhythms with the mouth, imitating drums and techno-production and, more recently, the sounds of DJing techniques such as scratching and backspinning.

13. Kris Parker (KRS-One), *Ruminations* (New York: Welcome Rain, 2003), 203.

14. Parker, *Ruminations,* 211.

15. Ibid., 198.

16. Clearly there are some commercially successful artists who attempt to infuse their work with a certain degree of conscious material, such as Jay-Z, Kanye West, and Lauryn Hill. See *Ruminations* and Byron Hurt's film *Hip Hop: Beyond Beats and Rhymes* (2006) for a more in-depth discussion of the balancing act between artistic freedom and financial success.

17. For example, activist Martha Diaz founded the Hip Hop Association (H2A) to combat deleterious stereotypes in film and the media and is a leading national proponent of Hip Hop Education. For more information see www.hiphopassociation.org.

18. In William Eric Perkins, *Droppin' Science: Critical Essays on Rap Music and Hip Hop Culture* (Philadelphia: Temple University Press, 1996), 214.

19. For a more complete discussion on the role of Puerto Rican youth in Hip Hop, see Juan Flores, *From Bomba to Hip Hop: Puerto Rican Culture and Latino Identity* (New York: Columbia University, 2000), and Raquel Z. Rivera, *New York Ricans from the Hip Hop Zone* (New York: Palgrave Macmillan, 2003).

20. This point indicates one of the mixed blessings of Hip Hop—the conflation of Hip Hop the culture and Hip Hop the product. While some of these allies made the skills of certain early DJs, aerosol artists, and Emcees viable commercially, this "cross-over" also resulted in a dilution and exploitation of the cultural production of Hip Hop, similar to the current situation of the record industry. Hip Hop has long struggled to balance the allure of the marketplace with the exigencies of revolution.

21. Parker, *Ruminations,* 181.

22. See Richard Majors and Janet Mancini Billson's seminal work *Cool Pose: The Dilemmas of Black Manhood in America* (New York: Touchstone, 1993).

23. *Adultism* is a term used in psychology and theories of oppression to describe the systematic oppression of young people.

24. Much of this material is covered in more depth in my introductory essay to *Say Word!: Voices from Hip Hop Theater* (Ann Arbor, MI, University of Michigan Press, 2011).

25. While it is often suggested to me that this is complicated sponsorship, which it can be, I want to relate that after numerous such residencies I have found the majority of Public Affairs officers

with whom I have worked to be truly committed to cultural exchange. The projects I have worked on have been strong on sharing and honest dialogue. The State Department also has programs that give non-US-based artists the opportunity to travel to the US and have similar experiences.

26. While *apartheid* is officially over in South Africa, much of the social structure that separated families and the society as a whole remains, especially in previously segregated townships and lower income areas. Therefore, there are areas that are still known as White, Black, Coloured, and Asian.

27. Martin Visagie, Nizaam Manuel, and Jasmine Arendse, "Rush Hour Sponsor Proposal" (unpublished fundraising document, Atlantis Township, South Africa: Rush Hour, 2006), 3.

28. Jeff Chang, *Can't Stop, Won't Stop: A History of the Hip Hop Generation* (New York: St. Martin's Press, 2006), 3.

29. This documentary by Eli Jacobs Fantauzzi focuses on prominent Hip Hop and Hiplife groups in Ghana. Several music videos, also shot by Fantauzzi, can be found on YouTube.

30. Reggie Rockstone, interview with the author. Legon, Ghana, April 2006.

31. The notion of "traditional" is of course a vexed one with the thousands of years of intercultural exchange and contact on the African continent. Highlife, now considered a fundamentally Ghanaian form of music, was the product of such a mixing—the result of local contact with European influences. For more information on Highlife, see the work of John Collins (specifically E.J. Collins, "Ghanaian Highlife," *African Arts* 10, no. 1 (1976), 62–68, 100.

32. Rockstone, interview with the author. Legon, Ghana, April 2006.

33. Korkor Amarteifio, e-mail correspondence with the author. New York, December 15, 2007.

34. Jenkins Macedo, e-mail correspondence with the author. New York, December 19, 2007.

35. Jenkins Macedo, e-mail correspondence with the author. New York, August 16, 2007.

36. Macedo, e-mail correspondence with the author. New York, December 19, 2007.

37. Macedo has since been relocated to the United States.

38. Sincere appreciation and acknowledgment are due to Gloria Cahill and Lisa Kail of the former Office of Community Service, now the Office of Civic Engagement, at NYU who assiduously supported several years of projects undertaken by students and faculty on the NYU-in-Ghana program. Neither of our service projects could have happened without their immediate and enthusiastic support.

39. Macedo, e-mail correspondence with the author. New York, August 16, 2007.

40. Macedo, e-mail correspondence with the author. New York, August 16, 2007. After our departure, Danielle Levanas, an NYU graduate who was one of my assistants in Ghana, founded an organization with other HHTI members in conjunction with refugee youth who had been repatriated to Liberia. L.Y.D.I.A. (Liberian Youth: Determination in Action) was named after a talented youth participant and leader whose school fees we collectively paid after we left Ghana. The organization is dedicated to "helping former refugee Liberian children and teens reintegrate into Liberian society through education scholarships and after-school arts programs." One of L.Y.D.I.A.'s projects is "Youth House," a center in Liberia for multiple arts and community building activities, including Hip Hop Theatre workshops and AIDS awareness groups. L.Y.D.I.A. is now an NGO and full leadership has been assumed by a local staff, including Alfred Kayee, one of the RESPECT Ghana volunteers who participated in our workshops.

41. Marcia Olivette, e-mail correspondence with the author. New York, August 8, 2007.

42. Emile Jansen, *My Hip Hop Is African and Proud* (Cape Town: Cape Flats Uprising, 2005), 6–7; reprinted with permission by the author.

43. This particular script calls for an all-male cast.

44. Emile Jansen, e-mail correspondence with the author. New York, March 29, 2008.

45. See Shaheen Ariefdien and Nazli Abrahams's excellent chapter in Jeff Chang, *Total Chaos* (New York: Basic Civitas, 2006), as well as Scott and Angelica Macklin's film *Masizakhe* (2008), for more information on the role of Hip Hop in reshaping the "new" South Africa.

46. Producer DJ Bionic (Bradley Williams), working with MC Tumi as writer and Jonzi D as director, was in the process of developing a Hip Hop musical called *Le Club*. *Le Club* tells the story of the origins of the South African Hip Hop scene in Johannesburg and includes some of the city's best-known performers—such as the Hymphatic thabs—as well as some of the original heads playing themselves. Both Bionic and thabs participated in the Market Hip Hop Theatre Lab, and Bionic helped to organize it.

47. Lucky Rathlhagane, "Sibikwa Hip Hop Theatre Workshop" (unpublished video footage, East Rand, South Africa, June 8).

48. Sibikwa Community Theatre, *Hip Hop Theatre Workshop* (East Rand, South Africa, 2006).

49. Sibikwa, *Hip Hop Theatre* (2006).

50. Daniel Banks, unpublished video documentation (Johannesburg, South Africa, June 2006).

51. Hip Hop Connected is an important event in the South African landscape of Hip Hop. It is a yearly Hip Hop "total performance" event that invites all the performance elements of Hip Hop onto one stage.

52. Monishia Schoeman, e-mail correspondence with the author. New York, December 24, 2007.

53. Cynthia E. Cohen, e-mail correspondence with the author. New York, October 23, 2007.

54. Siona O'Connell, e-mail correspondence with the author. New York, October 31, 2007.

Chapter 3

1. A huge thank you to the many young peacebuilders and artsworkers of Contact Inc., Street Arts, and Backbone Youth Arts who were so inspiring and willing to share their stories. In particular, thanks to Contact Inc.'s Peace Project participants Kaiya, Rebecca, Taisha, Gabrielle, and Jasmin who shared their photos of the Peace Project work in 2006 (which are reprinted here with the help of Queenie), and to former Backbone Youth Arts participant Roxanne Van Bael for sharing her reflections ten years after her Sk8 Grrl Space experience. The artistic directors of the arts companies involved have also been supportive colleagues and generous participants in opening their practice for critical engagement: Jane Jennison and Zoe Scrogings, formerly of Contact Inc.; Louise Hollingworth, formerly of Backbone Youth Arts; and Therese Nolan Brown, formerly of Street Arts. Some of the participant reflections printed here also appear in "Cultivating the Art of Safe Space," *Research in Drama Education* 13, no. 1 (2008): 5–21, and *The Peace Initiative*, a resource booklet published by Contact Inc. in 2009.

2. Henry A. Giroux, "Teenage Sexuality, Body Politics, and the Pedagogy of Display," in *Youth Culture: Identity in a Postmodern World*, ed. Jonathon S. Epstein (Malden: Blackwell, 1998), 38.

3. Paul Willis, *Moving Culture: An Enquiry into the Cultural Activities of Young People* (London: Calouste Gulbenkian Foundation, 1990), 14.

4. Pierre Bourdieu, *In Other Words: Essays Towards a Reflexive Sociology*, trans. Matthew Adamson (Stanford: Stanford University Press, 1990), 133.

5. Raimo Väyrynen, "From Conflict Resolution to Conflict Transformation: A Critical Review," in *The New Agenda for Peace Research*, ed. Ho-Won Jeong (Aldershot, UK: Ashgate, 1999), 150.

6. Väyrynen, "From Conflict Resolution to Conflict Transformation," 153–54.

7. Peace Initiative participants from phase one quoted in Contact Inc., unpublished report, 2003.

8. These organizations were Kyabra (a family support group), Sunnybank High School, Queensland Program of Assistance to Survivors of Torture and Trauma, Multicultural Development Association, Brisbane City Council, and Community Praxis Co-op.

9. Community Praxis Co-op Ltd and Contact Inc., "Peace, Conflict, Culture, Honour: A Report on The Peace Initiative" (June 2003), 7.

10. Contact Inc., unpublished report, 2003.

11. The "Third Place Policy" is a policy that continues to guide Contact Inc.'s approach to working with young people from diverse cultural backgrounds. Through youth arts projects, the policy aims to create spaces "where cultures can safely and meaningfully meet." For more information see www.contact.org.au/aboutus.

12. *Acting Together on the World Stage: Performance and the Creative Transformation of Conflict*, directed by Cynthia E. Cohen and Allison Lund (Waltham, MA: Peacebuilding and the Arts at the International Center for Ethics, Justice and Public Life, Brandeis University, 2011), DVD.

13. Jane Jennison, interview with the author. Fortitude Valley, August 4, 2004.

14. For a fuller exploration of the philosophy behind "facing the other," see Emmanuel Levinas, "Peace and Proximity," in *Emmanuel Levinas: Basic Philosophical Writings*, trans. Peter Atterton et al. and ed. Adriaan T. Peperzak, Simon Critchley, and Robert Bernasconi (Bloomington: Indiana University Press, 1996), 161–170.

15. Michael Bavly, "Second Track Diplomacy," last modified 1999, accessed March 5, 2007, www.shalam.org/SecondTrackDiplomacy.htm.

16. Community Praxis Co-op Ltd and Contact Inc., 7.

17. This observation and six of the accompanying images are also reproduced in "Cultivating the Art of Safe Space," *Research in Drama Education* 13, no. 1 (2008): 5–21.

18. Press release, Contact Inc., September 2006.

19. See Mary Ann Hunter, "Of Peacebuilding and Performance: Contact Inc.'s 'Third Space' of Intercultural Collaboration," *Australasian Drama Studies* 47 (2005): 140–58.

20. Contact Inc., unpublished report, 2003.

21. For an extended discussion of this project, see Mary Ann Hunter, "No Safety Gear: Skate Girl Space and the Regeneration of Australian Community-Based Performance," in *Performing Democracy: International Perspectives on Community-Based Performance*, ed. Tobin Nelhaus and Susan Haedicke (Ann Arbor: University of Michigan Press, 2001), 326–40.

22. See *Acting Together on the World Stage* DVD.

23. Ningi Connection (Ningi Youth Centre and Street Arts), *Zen-Che: A Tactical Arts Response*, artists Craig Walsh and Randall Wood (Street Arts, 1997), videocassette (VHS).

24. Shane Rowlands, "Media to Move the Margins," *Real Time Online*, 22 (1997), accessed January 12, 1998, www.realtimearts.net.

25. For an extended discussion on the codes of masculinity and race in this performance, see Mary Ann Hunter, "Performing Youth: A Tactical Arts Response," *Ariel: A Review of International English Literature* 32, no. 4 (2001): 229–43.

26. John Paul Lederach, *The Moral Imagination: The Art and Soul of Building Peace* (Oxford: Oxford University Press, 2005), 5.

Chapter 4

1. With thanks to my fellow pioneers of Playback Theatre, in particular Jonathan Fox and Judy Swallow; to the members of Hudson River Playback Theatre; to the children who engage in Playback Theatre to address bullying; to Hjalmar-Jorge Joffre-Eichhorn for his sup-

port in including the description of his work in Afghanistan; to Bev Hosking, Jenny Hutt, Ben Rivers, and Armand Volkas for permission to include accounts of their work; and to the tireless and visionary editors of this anthology, Roberto Gutiérrez Varea, Cynthia E. Cohen, and Polly O. Walker.

2. The name Playback Theatre is capitalized by some writers, including myself. Others use lower case unless referring to the name of an ensemble. In this chapter I've preserved the usage of each quoted writer.

3. Jonathan Fox is the founder of Playback Theatre and the author of *Acts of Service: Tradition, Commitment, Spontaneity in the Nonscripted Theatre* (New Paltz, NY: Tusitala Publishing, 1994).

4. Psychodrama is a group psychotherapy method created by J. L. Moreno in the 1930s in which an individual (the "protagonist") reenacts a problematic experience from his or her life with other group members taking roles. A therapist-director guides the process.

5. Playback Theatre's history is described in my book *Improvising Real Life: Personal Story in Playback Theatre* (New Paltz, NY: Tusitala Publishing, 1993).

6. Robert Wright, *The Evolution of God* (New York: Little, Brown and Company, 2009).

7. Robert Wright, "Why We Think They Hate Us: Moral Imagination and the Possibility of Peace," June 8, 2009, www.cato-unbound.org, 1.

8. Bev Hosking is a Playback Theatre practitioner and trainer from New Zealand. Jenny Hutt is a New Zealand/Australian writer and former PT practitioner.

9. Christian Penny is a theatre artist and trainer in New Zealand. He and Bev Hosking codirect the Playback Theatre Summer School in Wellington, New Zealand.

10. Jonathan Fox, "A Ritual For Our Time," in *Gathering Voices*, 119. Accessible at: www.playback theatre.org/wp-content/uploads/2010/04/Ritual-.pdf.

11. Accessible at: www.brandeis.edu/ethics/peacebuildingarts/library/artists/index.html#hutt.

12. I wrote about the trance in Playback at more length in "What is 'Good' Playback Theatre?" in *Gathering Voices: Essays on Playback Theatre,* ed. Jonathan Fox and Heinrich Dauber (New Paltz, NY: Tusitala Publishing, 1999). Accessible at: www.playbacktheatre.org/wp-content /uploads/2010/04/What-is-Good-PT.pdf.

13. Folma Hoesch, "The Red Thread: Storytelling as a Healing Process," in *Gathering Voices*. Accessible at: www.playbacktheatre.org/wp-content/uploads/2010/04/Red-Thread.pdf.

14. The Conductor role is parallel and in some respects similar to the Joker in Boal's Forum Theatre.

15. Jonathan Fox addresses this and related points at more length in "Playback Theatre in Burundi: Can Theatre Transcend the Gap?" in *The Applied Theatre Handbook*, ed. Sheila Preston and Tim Prentki (London: Routledge, 2008), 241-247.

16. Robert Graves, *Goodbye to All That* (New York: Anchor Books, 1929; 1957).

17. Ibid., 38.

18. "Schools Battle Suicide Surge, Anti-Gay Bullying," *CBS News*, October 11, 2010, www.cbsnews.com.

19. Cyberbullying, "the use of information and communication technologies to support deliberate, repeated, and hostile behavior by an individual or group, it is intended to harm others," notoriously contributed to several deaths by suicide in the US in 2010: www.nytimes.com/2010 /10/03/weekinreview/03schwartz.html. For more information on cyberbulling see: www. cyberbullying.org.

20. Susan M. Swearer and Beth Doll, "Bullying in Schools: An Ecological Framework," in *Bullying Behavior: Current Issues, Research, and Interventions,* ed. Robert A. Geffner, Marti Loring, and Corinna Young (Binghamton, NY: Haworth Press, 2001), 19.

21. Sally-Ann Ohene, Marjorie Ireland, Clea McNeely, and Iris Wagman Borowsky, "Parental Expectations, Physical Punishment, and Violence among Adolescents Who Score Positive on a Psychosocial Screening Test in Primary Care," *Pediatrics* 117 (2006): 441-447.

22. Kevin Cullen, "The Untouchable Mean Girls," *The Boston Globe,* January 24, 2010, www.boston.com.

23. Janet Strayer and William Roberts, "Children's Empathy and Role Taking: Child and Parental Factors, and Relations to Prosocial Behavior," *Journal of Applied Developmental Psychology* 10 (1989): 227-239.

24. Dan Olweus, "Familial and Temperamental Determinants of Aggressive Behavior in Adolescent Boys: A Causal Analysis," *Developmental Psychology* 16 (1980): 644-660.

25. July 22, 2010, www.nytimes.com/2010/07/23/opinion/23engel.html.

26. Linda R. Jeffrey, DeMond Miller, and Margaret Linn, "Middle School Bullying as a Context for the Development of Passive Observers to the Victimization of Others," in *Bullying Behavior,* 154.

27. Dan Olweus, *Bullying At School* (Carlton, Australia: Blackwell Publishing, 1993).

28. Hudson River Playback Theatre began developing NMB in 1999 and so far has worked with over 25,000 children. Other PT companies in the US and Canada have also adopted this approach.

29. www.clemson.edu/olweus.

30. www.pbis.org.

31. Jo Salas, "Using Theater to Address Bullying," *Educational Leadership* (2005): 78-82.

32. Maxine Greene, *Releasing the Imagination: Essays on Education, the Arts, and Social Change* (San Francisco: Jossey-Bass, 1995), 30.

33. "In their stories… they witnessed themselves, and thus knew who they were, serving as subject and object at once." Barbara Myerhoff, *Number Our Days* (New York: Simon & Schuster, 1978), 33.

34. Judith Herman, *Trauma and Recovery: The Aftermath of Violence—from Domestic Abuse to Political Terror* (New York: Basic Books, 1992).

35. Paulo Freire, *Education for Critical Consciousness* (New York: Seabury Press, 1973).

36. Robert N. Bellah, Richard Madsen, William M. Sullivan, Ann Swidler, and Steven M. Tipton, *Habits of the Heart: Individualism and Commitment in American Life* (New York: Harper & Row, 1985).

37. Hjalmar-Jorge Joffre-Eichhorn, "Tears into Energy: Theatre and Transitional Justice in Afghanistan" (unpublished draft, 2010).

38. Hjalmar-Jorge Joffre-Eichhorn, e-mail correspondence with the author, May 24, 2009.

39. The International Center for Transitional Justice website defines transitional justice as "a response to systematic or massive violations of human rights. It seeks recognition for victims and to promote possibilities for peace, reconciliation and democracy. Transitional justice is not a special form of justice but justice adapted to societies transforming themselves after a period of pervasive human rights abuse." For more information see: ictj.org/.

40. Aunohita Mojumdar, "War Crimes Amnesty Adds to Afghan Women's Grief," *Women's eNews,* March 26, 2010, www.womensenews.org.

41. Hjalmar-Jorge Joffre-Eichhorn, *Tears into Energy/Das Theater der Unterdrückten in Afghanistan* (Hannover, Germany: Ibidem Verlag, 2011).

42. Hjalmar-Jorge Joffre-Eichhorn, e-mail correspondence with the author, March 17, 2011.

43. Argentinian writer Ricardo Piglia speaking at a seminar at the University of the Mothers of the Plaza de Mayo. Maria Elena Garavelli, "Tales Rescued from Oblivion: The Construction of Collective Memory," *Interplay* (December 2001): 1.

44. Joffre-Eichhorn, "Tears into Energy," 35-36.
45. Joffre-Eichhorn, "Tears into Energy," 32.
46. Ibid., 33-35.
47. Ibid., 30.
48. I am completing this chapter during the immediate and tragic aftermath of the earthquakes in Japan and New Zealand in 2011. In both countries local Playback companies are already offering their communities the chance to tell their stories.
49. Armand Volkas is a drama therapist, the founder of the Center for the Living Arts in San Francisco, and the founder/director of Living Arts Playback Theatre Ensemble. Ben Rivers is a drama therapist and Playback Theatre practitioner.
50. The performance filmed for the training DVD *Performing Playback Theatre* (www.playback centre.org) included a teller who needed firm persuasion to come to the teller's chair—and then told a trauma story, quite unexpected in that context.
51. Fox, "Playback Theatre in Burundi," 243.
52. Herman, *Trauma and Recovery*, 221.
53. Jenny Hutt and Bev Hosking, "Playback Theatre: A Creative Resource for Reconciliation," www .brandeis.edu/ethics/peacebuildingarts/pdfs/peacebuildingarts/Bev_Jenny_final_ALDEdit.pdf (Waltham, MA: International Center for Ethics, Justice, and Public Life, Brandeis University, 2004), 13-14.
54. This project is described in Jo Salas, "Immigrant Stories in the Hudson Valley," in *Telling Stories to Change the World,* ed. Rickie Solinger, Madeline Fox, and Kayhan Irani (New York: Routledge, 2008), 109-118.
55. Training on all aspects of Playback Theatre practice is available through the Centre for Playback Theatre and its international affiliates: www.playbackcentre.org. The three-year diploma training encompasses entry through advanced levels, culminating in a three-week Leadership course.

Chapter 5

1. I would like to acknowledge the support of my wife, Bertha O'Neal, who is always there when I need her, and the dozens of others who worked so hard to make Free Southern Theatre and Junebug Productions, which made the experience this essay is based on possible. The conversations that resulted in this piece included Cynthia E. Cohen, Polly O. Walker, Roberto Gutiérrez Varea, Catherine Michna, Lesley Yalen, and others too numerous to mention.
2. These are a collection of sayings that I have heard over the years and collected in my journal.
3. John O'Neal, *Don't Start Me to Talking or I'll Tell You Everything I Know: Sayings from the Life and Writings of Junebug Jabbo Jones.* Available from johoneal@junebugproductions.org.
4. William Shakespeare, *Hamlet*, Act I, Scene 3.
5. If you think it worth your time and energy, shoot me an e-mail to let me know how you do or don't find these stories helpful (johoneal@junebugproductions.org). It will help me to do better the next time.
6. "Race" is a social construct that refers only to an agreed-upon description that changes according to the needs of the given circumstance.
7. I know of only two of Ted's plays that have received viable commercial productions, *Our Lan'* and *A Great White Fog*. Ted produced and directed *A Great White Fog* in Chicago with support from the WPA Theater Project during the late 1930s before he moved to New York where for a

time he shared an apartment with Langston Hughes in Harlem. I saw a brilliant production of the play at the Guthrie Theater in or about 1994 under the direction of Lou Bellamy, founder and director of the Penumbra Theatre in St. Paul, which earlier introduced August Wilson to the world as a playwright. In 1975, the Free Southern Theater presented another of Ted's plays, *Candle in the Wind*, about the murder of a reconstruction era congressman from Mississippi when we were able to have Ted back for a second term as Writer-in-Residence. Ted's entire catalogue of plays is available in the Hatch-Billops part of the Schomberg Collection, which is part of the New York Public Library in Harlem.

8. This is based on my vivid recollection of a presentation that Ted made to the FST staff during his first residency with us.

9. As distinct from the *thousands* of killings of unknown persons who preceded *and* followed these and other notable figures to their deaths at the hands of murderous thugs who remain and most likely will always be unaddressed by any court of justice.

10. "Ain't We Got Fun?" by Gus Kahn and Raymond B. Egan, music by Richard Whiting, Jerome H. Remick and Co., New York, 1921.

11. Adapted from Genevieve Fabre, "The Free Southern Theater, 1963–1979," *Black American Literature Forum* 17, no. 2 (Summer 1983): 55–59.

12. There are many resources to engage with performance in the classroom. My personal favorite is the Viola Spolin's classic *Improvisation for Theater* (Evanston, IL: Northwestern University Press, 1999).

13. R. W. Kates, C. E. Colten, S. Laska, and S. P. Leatherman, "Reconstruction of New Orleans after Hurricane Katrina: A Research Perspective," *Proc Natl Acad Sci USA* 103, no. 40 (October 3, 2006): 14653–14660, accessed April 3, 2011, www.ncbi.nlm.nih.gov/pmc/articles/PMC1595407/.

14. Reilly Morse, *Environmental Justice through the Eye of Hurricane Katrina* (Washington, DC: Joint Center for Political and Economic Studies, 2008), accessed April 3, 2011, www.jointcenter.org/hpi/sites/all/files/EnvironmentalJustice.pdf.

15. Charlie Cobb was a field secretary, one of the first for SNCC, who went on to become a notable journalist. His bibliography includes *Radical Equations: Civil Rights from Mississippi to the Algebra Project*, with Bob Moses (Boston: Beacon, 2001); *No Easy Victories: African Liberation and American Activists over a Half Century, 1950–2000*, ed. William Minter, Gail Hovey, and Charles Cobb, Jr. (Trenton, NJ: Africa World, 2008); and *On the Road to Freedom: A Guided Tour of the Civil Rights Trail* (Chapel Hill, NC: Algonquin, 2008).

16. Excerpt from the first artistic vision statement written for the FST by Gilbert Moses and John O'Neal in 1963 for *Freedomways*, the Quarterly Journal of the Freedom Movement and available in the Archives of the Free Southern Theater, Junebug Productions and John O'Neal at the Amistad Center at Tulane University.

17. Junebug Productions, Inc., accessed April 3, 2011, www.junebugproductions.blogspot.com/.

18. "The Junebug Cycle: *Don't Start Me to Talking Or I'll Tell You Everything I Know: Sayings from the Life and Writings of Junebug Jabbo Jones*," accessed April 3, 2011, www.holdenarts.org/junebugcycle.htm.

19. Junebug Productions, Inc., *Don't Start Me to Talking or I'll Tell You Everything I Know: Sayings from the Life and Writings of Junebug Jabbo Jones*, accessed April 3, 2011, junebugproductions.blogspot.com/2008/03/performance-at-new-orleans-contemporary.html.

20. From the lyrics to "Blessed Are Those Who Struggle" by The Last Poets.

Chapter 6

1. For assistance with this chapter and the next, I feel oceans full of gratitude: for Polly and Roberto, who have allowed their words and ideas to weave together with my own; to the other *Acting Together* contributors and advisors for insights shared at gatherings and in drafts of writing; to Lesley Yalen, Catherine Michna, Allison Lund, Katie Bacon, and Stefania De Petris who proposed important editorial changes; to Jonathan Fox and Jo Salas who pushed me to think more boldly about the relationships between the moral imagination and the permeable membrane. Ideas about aesthetics, art, culture, peacebuilding and social transformation that frame these chapters have been nourished by Farhat Agbaria, Dee Aker, Hizkias Assefa, Jessica Berns, Scott Edmiston, Mari Fitzduff, Lyn Haas, Barbara Houston, John Paul Lederach, Adrienne Rich, Gay Rosenblum-Kumar, Jane and Hubert Sapp, Dan Terris, James Thompson, Wen-ti Tsen, and teachers, students and other colleagues too numerous to mention. I have also been supported to work on these chapters by my sister Susan Snyder, in her home in Norwalk, Connecticut; at Papalani, a retreat in Hana, on the island of Maui; on Stradbrooke Island off the coast of Brisbane, Australia, where Polly and I were visited by whales, dolphins, eagles, a kangaroo and two rainbows—all at one moment; and by Ann, in our home in New Hampshire.

2. Adrienne Rich, "Permeable Membrane," in *A Human Eye* (New York: W. W. Norton, 2010), 99.

3. Mary B. Anderson and Lara Olson, *Confronting War: Critical Lessons for Peace Practitioners* (Cambridge, MA: Collaborative for Development Action, Inc., 2003), 10.

4. As we recall from the Introduction in volume I, the moral imagination is cultivated through four disciplines: the inclination to construct spaces for creativity; the willingness to take risks in the direction of trust and vulnerability; the recognition of the interdependence that characterizes relationships among people and communities; and the curiosity about the paradoxical nature of things that seem at first to be opposed.

5. Gregory Bateson, *Steps to an Ecology of Mind* (New York: Ballantine, 1972), 146.

6. Augusto Boal, *Theatre of the Oppressed*, trans. Charles A. McBridge and Maria-Odilia Leal McBridge (New York: Theatre Communications Group, 1985), 126.

7. Elaine Scarry, *The Body in Pain: The Making and Unmaking of the World* (New York: Oxford University Press, 1985), 108–109.

8. For example, in the afterword to volume I, Devanand Ramiah describes the effects on local Sri Lankan theatre initiatives of the donor community's efforts to "professionalize" their work.

9. Several of the case studies in this volume illustrate that despotic regimes have targeted artists (in Cambodia, Argentina, Uganda) and extremist groups (in Sri Lanka, Serbia, Palestine).

10. See, for instance, James Thompson's "Incidents of Cutting and Chopping," in *Performance Affects: Applied Theatre and the End of Effect* (Houndmills, UK: Palgrave MacMillan), 15–42.

11. Our definition of "collaborative" hinges on the work of those who engage in what Grant Kester refers to as "the ethics of collaborative exchange" as a guiding principle. These collaborations take place among the ensemble directly involved in the creative process and also, importantly, between the production team and the community. In this regard, it is important that the permeable membrane be porous in both directions: inspiration and sources from the community enter into the creative space, and meaning inspired by the work is constructed by the community as well.

12. The social imaginary refers to the set of values, institutions, laws, and symbols common to a particular social group and the corresponding society.

13. The importance of the collaborative nature of meaning construction in peacebuilding performance is highlighted by contrasting it with the imposition of meaning in performances of the "theater of oppression," which over centuries has included both rituals and actual plays, like *The Moors and the Christians*, the first Western play ever performed in the Americas, which demonstrated to the native people the power of the Spanish crown. Catholic passion plays, religious ceremonies, military parades, public executions, and elaborate torture practices are intended clearly as "performances of oppression," with predetermined meanings imposed by those with power on those who witness and engage with the productions.

14. Richard Schechner, *Performance Studies: An Introduction* (New York: Routledge, 2002), 28.

15. HIJOS is the Spanish acronym for "sons and daughters (of the disappeared) for identity and justice and against forgetting and silence."

16. Schechner, *Performance Studies*, 28.

17. Diana Taylor, *The Archive and the Repertoire: Performing Cultural Memory in the Americas* (Durham, NC: Duke University Press, 2003).

18. Vamik D. Volkan, "Transgenerational Transmissions and Chosen Traumas: An Element of Large-Group Identity," *Group Analysis* 34 (2000): 79–97.

19. Martha Minow, *Between Vengeance and Forgiveness: Facing History after Genocide and Mass Violence* (Boston: Beacon Press, 1998).

20. The ritual at the site of the Myall Creek massacre in Australia, described by Polly O. Walker in the first volume of this anthology, poignantly illustrates that retributive justice itself is rarely sufficient to heal relationships and to free people from the traps associated with victim/perpetrator identities.

21. The impact of these time-limited workshops was extended also by Daniel Banks' careful attention to cultivating local leadership among participants.

Chapter 7

1. In addition to the production of the two volumes of this anthology, the Acting Together anthology also includes the development of a related documentary, toolkit and website, and conversations with many colleagues engaged in peacebuilding and in performance.

2. All too often, the safety of the people who have dedicated their lives to engaging their communities with these stories has been jeopardized by their commitments. The creativity with which they confront the threats from governments and other armed forces and the constraints of censors is a source of inspiration. Resources for artists at risk of human rights abuses can be found through freedimensional.org.

Introduction to Section III

1. Many additional resources, including eighteen short videos and additional print documents can be found on *Acting Together on the World Stage: Tools for Continuing the Conversation,* the DVD of the *Acting Together* documentary. A description of the contents and instructions for ordering can be found at www.actingtogether.org.

2. The Acting Together website (www.actingtogether.org) includes updated versions of these recommendations and action steps for students, educators, artists, and peacebuilding practitioners. Please visit the site and let us know how we can strengthen these recommendations, based on your own responses and experiences.

Chapter 8

1. John O'Neal, "Story Circle Process Discussion Paper," *Race Matters*, www.racematters.org /storycircleprocess.htm.

Chapter 9

1. John Paul Lederach, *The Moral Imagination: The Art and Soul of Building Peace* (Cambridge, UK: Oxford University Press, 2005).

Bibliography

Anderson, Mary, and Lara Olson, with assistance from Kristin Doughty. *Confronting War: Critical Lessons for Peace Practitioners*. Cambridge, MA: Collaborative for Development Action, Inc., 2003.

Arai, Tatsushi. *Creativity and Conflict Resolution: Alternative Pathways to Peace*. Abingdon, UK: Routledge, 2009.

Artaud, Antonin. *Theater and Its Double*. New York: Grove Press, 1958.

Avruch, Kevin. "Part I: Culture." In *Culture and Conflict Resolution*, 6–17. Washington, DC: U.S. Institute of Peace Press, 1998.

Banks, Daniel. *Say Word! Voices from Hip Hop Theater*. Ann Arbor: University of Michigan Press, 2011.

Barash, David P., and Charles P. Webel. *Peace and Conflict Studies*. 2nd ed. Thousand Oaks, CA: Sage Publications, 2009.

Bateson, Gregory. *Steps to an Ecology of Mind*. New York: Ballantine, 1972.

Bavly, Michael. "Second Track Diplomacy." Last modified 1999. Accessed March 5, 2007. www.shalam.org/SecondTrackDiplomacy.htm.

Beah, Ishmael. *A Long Way Gone*. New York: Sarah Crichton Books, 2007.

Bellah, Robert N., Richard Madsen, William M. Sullivan, Ann Swidler, and Steven M. Tipton. *Habits of the Heart: Individualism and Commitment in American Life*. New York: Harper & Row, 1985.

Berns, Jessica, with Mari Fitzduff. "What is Coexistence and Why a Complimentary Approach?" Working Paper, Coexistence International, Brandeis University, Waltham, MA, 2007.

Bharucha, Rustom. "What Kind of Community Art Research Do We Need?" 2007. www.cal-xl.nl/.

Boal, Augusto. *Theatre of the Oppressed*, translated by Charles A. McBridge and Maria-Odilia Leal McBridge. New York: Theatre Communications Group, 1985 [1979].

Bourdieu, Pierre. *In Other Words: Essays Towards a Reflexive Sociology*, translated by Matthew Adamson. Stanford: Stanford University Press, 1990.

Bours, Jos. *Community Theatre Methodiek*. Utrecht: Stut, 2007.

Bours, Jos. *Vadercentrum Adam*. The Hague: Vadercentrum Adam, 2007.

Chang, Jeff. *Can't Stop, Won't Stop: A History of the Hip-Hop Generation*. New York: St. Martin's Press, 2006.

Chang, Jeff. *Total Chaos*. New York: Basic Civitas, 2006.

Cleveland, William. *Art and Upheaval: Artists on the World's Frontlines*. Oakland, CA: New Village Press, 2008.

Cobb, Charlie. *On the Road to Freedom: A Guided Tour of the Civil Rights Trail*. Chapel Hill, NC: Algonquin, 2008.

Cobb, Charlie, and Bob Moses. *Radical Equations: Civil Rights from Mississippi to the Algebra Project*. Boston: Beacon, 2001.

Cohen, Cynthia E., Roberto Gutiérrez Varea, and Polly O. Walker, eds. *Acting Together: Performance and the Creative Transformation of Conflict. Volume I: Resistance and Reconciliation in Regions of Violence*. Oakland, CA: New Village Press, 2011.

Cohen, Cynthia E. "Creative Approaches to Reconciliation." In *The Psychology of Resolving Global Conflicts: From War to Peace*, edited by Mari Fitzduff and Chris E. Stout. Westport, CT: Greenwood Publishing Group Inc., 2005. Available at: www.brandeis.edu/ethics/pdfs/publications/Creative_Approaches.pdf.

Cohen, Cynthia E. *Working with Integrity: A Guidebook for Peacebuilders Asking Ethical Questions*. Waltham, MA: International Center for Ethics, Justice, and Public Life, Brandeis University, 2001. Available at: www.brandeis.edu/ethics/peacebuildingarts/library/authors/index.html.

Cohen, Cynthia E., ed. *Recasting Reconciliation through Culture and the Arts*. Waltham, MA: International Center for Ethics, Justice, and Public Life, Brandeis University, 2005. Available at: www.brandeis.edu/ethics/peacebuildingarts/recasting/index.html.

Collins, John. "Ghanaian Highlife." *African Arts* 10, no. 1 (1976): 62–68, 100.

Cullen, Kevin. "The Untouchable Mean Girls." *The Boston Globe*. January 24, 2010. www.boston.com.

Dambach, Chic. "What is Peacebuilding." Alliance for Peacebuilding. Accessed October 25, 2010. www.allianceforpeacebuilding.org/?page=aboutpeacebuilding.

Docherty, Jayne. *Learning Lessons from Waco: When the Parties Bring Their Gods to the Negotiation Table*. Syracuse, NY: Syracuse University Press, 2001.

Driver, Tom F. *Magic of Ritual: Our Need for Liberating Rites that Transform Our Lives and Our Communities*. New York: Harper San Francisco, 1991.

Fabre, Genevieve. "The Free Southern Theater, 1963–1979." *Black American Literature Forum* 17, no. 2 (1983): 55–59.

Fisher, Simon, Deana Ibrahim, Jawed Ludin, Richard Smith, Steve Williams, and Sue Williams. *Working with Conflict: Skills and Strategies for Action*. New York: Palgrave, 2003.

Flores, Juan. *From Bomba to Hip-Hop: Puerto Rican Culture and Latino Identity*. New York: Columbia University, 2000.

Fox, Jonathan. *Acts of Service: Tradition, Commitment, Spontaneity in the Nonscripted Theatre*. New Paltz, NY: Tusitala Publishing, 1994.

Fox, Jonathan. "A Ritual for Our Time." In *Gathering Voices: Essays on Playback Theatre*, edited by Jonathan Fox and Heinrich Dauber. New Paltz, NY: Tusitala Publishing, 1999.

Fox, Jonathan. "Playback Theatre in Burundi: Can Theatre Transcend the Gap?" In *The Applied Theatre Handbook*, edited by Sheila Preston and Tim Prentki. London: Routledge, 2008.

Freire, Paulo. *Education for Critical Consciousness*. New York: Seabury Press, 1973.

Fricke, Jim, and Charlie Ahearn, eds. *Yes Yes Y'all: The Experience Music Project Oral History of Hip-Hop's First Decade*. Cambridge, MA: De Capo Press, 2002.

Galtung, Johan. "Cultural Violence." *Journal of Peace Research* 27, no. 3 (August, 1990): 291–305.

Garavelli, Maria Elena. "Tales Rescued from Oblivion: The Construction of Collective Memory." *Interplay* (December 2001).

George, Nelson. *Hip Hop America*. New York: Penguin, 1998.

Giroux, Henry A. "Teenage Sexuality, Body Politics, and the Pedagogy of Display." In *Youth Culture: Identity in a Postmodern World*, edited by Jonathan S. Epstein. Malden, MA: Blackwell, 1998.

Goffman, Erving. *The Goffman Reader*. Edited by Charles Lemert and Ann Branaman. Malden, MA: Blackwell, 1997.

Goldbard, Arlene. *New Creative Community: The Art of Cultural Development*. Oakland, CA: New Village Press, 2006.

Graves, Robert. *Goodbye to All That*. New York: Anchor Books, 1957.

Greene, Maxine. *Releasing the Imagination: Essays on Education, the Arts, and Social Change*. San Francisco: Jossey-Bass, 1995.

Gurevitch, Zali D. "The Power of Not Understanding: The Meeting of Conflicting Identities." *The Journal of Applied Behavioral Science* 25, no. 2 (1989): 161–173.

Herman, Judith. *Trauma and Recovery: The Aftermath of Violence—From Domestic Abuse to Political Terror*. New York: Basic Books, 1992.

Hoesch, Folma. "The Red Thread: Storytelling as a Healing Process." In *Gathering Voices: Essays on Playback Theatre*, edited by Jonathan Fox and Heinrich Dauber. New Paltz, NY: Tusitala Publishing, 1999.

Holmes, Robert. "General Introduction." In *Nonviolence in Theory and Practice*. Belmont, CA: Wadsworth Publishing Company, 1990.

Hutt, Jenny, and Bev Hosking. "Playback Theatre: A Creative Resource for Reconciliation." Waltham, MA: International Center for Ethics, Justice, and Public Life, Brandeis University, 2004. Available at: www.brandeis.edu/ethics/peacebuildingarts/pdfs/peacebuildingarts/Bev_Jenny_final_ALDEdit.pdf.

Hunter, Mary Ann. "No Safety Gear: Skate Girl Space and the Regeneration of Australian Community-Based Performance." In *Performing Democracy: International*

Perspectives on Community-Based Performance, edited by Tobin Nelhaus and Susan Haedicke, 326–40. Ann Arbor: University of Michigan Press, 2001.

Hunter, Mary Ann. "Performing Youth: A Tactical Arts Response." *Ariel: A Review of International English Literature* 32, no. 4 (2001): 229–43.

Hunter, Mary Ann. "Of Peacebuilding and Performance: Contact Inc.'s 'Third Space' of Intercultural Collaboration." *Australasian Drama Studies* 47 (2005): 140–58.

Hunter, Mary Ann. "Cultivating the Art of Safe Space." *Research in Drama Education* 13, no. 1 (2008): 5–21.

Hunter, Mary Ann. *The Peace Initiative*. Brisbane, Australia: Contact Inc. Excerpts in Arabic, Spanish, and French available at: www.contact.org.au/read-peace -initiative-09.

Jansen, Emile. *My Hip Hop Is African and Proud*. Cape Town: Cape Flats Uprising, 2005.

Jeffrey, Linda R., DeMond Miller, and Margaret Linn. "Middle School Bullying as a Context for the Development of Passive Observers to the Victimization of Others." In *Bullying Behavior: Current Issues, Research, and Interventions,* edited by Robert A. Geffner, Marti Loring, and Corinna Young. Binghamton, NY: Haworth Press, 2001.

Joffre-Eichhorn, Hjalmar-Jorge. "Tears into Energy: Theatre and Transitional Justice in Afghanistan." Unpublished draft, 2010.

Joffre-Eichhorn, Hjalmar-Jorge. *Tears into Energy/Das Theater der Unterdrücken in Afghanistan*. Hannover, Germany: Ibidem Verlag, 2011.

Jowett, Garth, and Victoria O'Donnell. *Propaganda and Persuasion*. 4th ed. Thousand Oaks, CA: Sage Publications, 2006.

Kates, Robert W., Craig E. Colten, Shirley Laska, and Steven P. Leatherman. "Reconstruction of New Orleans after Hurricane Katrina: A Research Perspective." *Proceedings of the National Academy of Sciences* 103, no. 40 (October 3, 2006): 14653–660.

Kahn, Gus, and Raymond B. Egan. "Ain't We Got Fun?" Music by Richard Whiting. Jerome H. Remick and Co., New York, 1921.

Kester, Grant. *Conversation Pieces: Community and Communication in Modern Art*. Berkeley: University of California Press, 2004.

Kimmelman, Michael. "In Marseille, Rap Helps Keep the Peace." *New York Times*, December 19, 2007.

Knight, Keith, and Mat Schwarzman. *Beginner's Guide to Community-Based Arts*. Oakland, CA: New Village Press, 2006.

Lambourne, Wendy. "Transitional Justice and Peacebuilding after Mass Violence." *International Journal of Transitional Justice* 4, no. 2 (2010): 28–48.

LeBaron, Michelle. "Culture and Conflict." In *Beyond Intractability*, edited by Guy Burgess and Heidi Burgess. Boulder, CO: University of Colorado, Boulder—Conflict Research Consortium, 2003. Accessed December 1, 2010. www.beyondintractability.org/essay /culture_conflict.

LeBaron, Michelle, and Vanashri Pillay. "Conflict, Culture, and Images of Change." In *Conflict Across Cultures: A Unique Experience of Bridging Differences*, 11–24. Boston: Intercultural Press, 2006.

Lederach, John Paul. *Building Peace: Sustainable Reconciliation in Divided Societies*. Washington, DC: United States Institute of Peace, 1997.

Lederach, John Paul. *The Moral Imagination: The Art and Soul of Building Peace.* Cambridge, UK: Oxford University Press, 2005.

Lederach, John Paul. "Conflict Transformation." Beyond Intractability. Accessed October 1, 2010. www.beyondintractability.org/essay/transformation/?nid=1223.

Levinas, Emmanuel. "Peace and Proximity." In *Emmanuel Levinas: Basic Philosophical Writings,* edited by Adriaan T. Peperzak, Simon Critchley, and Robert Bernasconi, 161–170. Translated by Peter Atterton et al. Bloomington: Indiana University Press, 1996.

Majors, Richard, and Janet Mancini Billson. *Cool Pose: The Dilemmas of Black Manhood in America.* New York: Touchstone, 1993.

Mojumdar, Aunohita. "War Crimes Amnesty Adds to Afghan Women's Grief." *Women's eNews.* March 26, 2010. www.womensenews.org.

Martin, Gus. *Understanding Terrorism: Challenges, Perspectives, and Issues.* Thousand Oaks, CA: Sage Publications, 2006.

Matarasso, François. *Use or Ornament? The Social Impact of Participation in the Arts.* Stroud, UK: Comedia, 1997.

Midgley, Mary. *Can't We Make Moral Judgements?* New York: Palgrave MacMillan, 1993.

Minow, Martha. *Between Vengeance and Forgiveness: Facing History after Genocide and Mass Violence.* Boston: Beacon Press, 1998.

Minter, William, Gail Hovey, and Charles Cobb, Jr., eds. *No Easy Victories: African Liberation and American Activists over a Half Century, 1950–2000.* Trenton, NJ: Africa World, 2008.

Moran, Seana, and Vera John-Steiner. "Creativity in the Making: Vygotsky's Contemporary Contribution to the Dialectic of Development and Creativity." In *Creativity and Development,* edited by R. Keith Sawyer, Vera John-Steiner, Seana Moran, Robert J. Sternberg, David Henry Feldman, Jeanne Nakamura, and Mihaly Csikszentmihalyi, 61–90. New York: Oxford University Press, 2003.

Morse, Reilly. *Environmental Justice through the Eye of Hurricane Katrina.* Washington, DC: Joint Center for Political and Economic Studies, 2008.

Myerhoff, Barbara. *Number Our Days.* New York: Simon & Schuster, 1978.

Ohene, Sally-Ann, Marjorie Ireland, Clea McNeely, and Iris Wagman Borowsky. "Parental Expectations, Physical Punishment, and Violence among Adolescents Who Score Positive on a Psychosocial Screening Test in Primary Care." *Pediatrics* 117, no. 2 (2006): 441–47.

Olweus, Dan. *Bullying At School.* Carlton, Australia: Blackwell Publishing, 1993.

Olweus, Dan. "Familial and Temperamental Determinants of Aggressive Behavior in Adolescent Boys: A Causal Analysis." *Developmental Psychology* 16 (1980): 644–60.

Parker, Kris (KRS-One). *Ruminations.* New York: Welcome Rain, 2003.

Perkins, William Eric. *Droppin' Science: Critical Essays on Rap Music and Hip Hop Culture.* Philadelphia: Temple University Press, 1996.

Prentki, Tim, and Sheila Preston. *The Applied Theatre Reader.* New York: Routledge, 2009.

Rich, Adrienne. "Permeable Membrane." In *A Human Eye: Essays on Art in Society, 1997-2008,* 96–99. New York: W. W. Norton, 2010.

Rivera, Raquel Z. *New York Ricans from the Hip Hop Zone.* New York: Palgrave Macmillan, 2003.

Rose, Tricia. *Black Noise*. Middletown, CT: Wesleyan University Press, 1994.

Rowlands, Shane. "Media to Move the Margins." *Real Time Online* 22 (1997). Accessed January 12, 1998. www.realtimearts.net.

Salas, Jo. "Immigrant Stories in the Hudson Valley." In *Telling Stories to Change the World,* edited by Rickie Solinger, Madeline Fox, and Kayhan Irani. New York: Routledge, 2008.

Salas, Jo. *Improvising Real Life: Personal Story in Playback Theatre*. New Paltz, NY: Tusitala Publishing, 1993.

Salas, Jo. "What is 'Good' Playback Theatre?" In *Gathering Voices: Essays on Playback Theatre,* edited by Jonathan Fox and Heinrich Dauber. New Paltz, NY: Tusitala Publishing, 1999.

Salas, Jo. "Using Theater to Address Bullying." *Educational Leadership* (2005): 78-82.

Scarry, Elaine. *The Body in Pain: The Making and Unmaking of the World*. New York: Oxford University Press, 1985.

Schechner, Richard. *Performance Studies: An Introduction*. New York: Routledge, 2002.

Schirch, Lisa. *Ritual and Symbol in Peacebuilding*. Bloomfield, CT: Kumarian Press, 2007.

Schwab, Anita. *Moedercentrum Staat als een Huis*. The Hague: Landelijk Centrum Opbouwwerk, 1999.

Sharp, Gene. *The Politics of Nonviolent Action, Part One: Power and Struggle*. Boston: Porter Sargent Publishers, 1973.

Soyinka, Wole. *Myth, Literature and the African World*. Cambridge, UK: Cambridge University Press, 1976.

Spolin, Viola. *Improvisation for Theater*. Evanston, IL: Northwestern University Press, 1999.

Strayer, Janet, and William Roberts, "Children's Empathy and Role Taking: Child and Parental Factors, and Relations to Prosocial Behavior." *Journal of Applied Developmental Psychology* 10 (1989): 227–239.

Swearer, Susan M., and Beth Doll. "Bullying in Schools: An Ecological Framework." In *Bullying Behavior: Current Issues, Research, and Interventions,* edited by Robert A. Geffner, Marti Loring, and Corinna Young. Binghamton, NY: Haworth Press, 2001.

Taylor, Diana. *The Archive and the Repertoire: Performing Cultural Memory in the Americas*. Durham, NC: Duke University Press, 2003.

Thiong'o, Ngugi Wa. *Decolonising the Mind*. London: James Curry/Heinemann, 1981.

Thompson, James. "Incidents of Cutting and Chopping." In *Performance Affects: Applied Theatre and the End of Effect*. New York: Palgrave MacMillan, 2009.

Thompson, James, Jenny Hughes, and Michael Balfour. *Performance in Place of War*. New York: Seagull Books, 2009.

Turner, Victor. *The Ritual Process: Structure and Anti-Structure*. Ithaca, NY: Cornell University Press, 1977.

Turner, Victor. *From Ritual to Theatre: The Human Seriousness of Play*. New York: Performing Arts Journal Publications, 1982.

UNAIDS/WHO. "Aids Epidemic Update, 2007." Geneva, Switzerland: Joint United Nations Programme on HIV/AIDS and World Health Organization, March 2008. Available at: data.unaids.org/pub/Report/2008/jc1526_epibriefs_ssafrica_en.pdf.

van Erven, Eugene. *Radical People's Theatre.* Bloomington: Indiana University Press, 1988.

van Erven, Eugene. *The Playful Revolution: Theatre and Liberation in Asia.* Indianapolis: Indiana University Press, 1992.

van Erven, Eugene. *Community Theatre: Global Perspectives.* New York: Routledge, 2000.

Väyrynen, Raimo. "From Conflict Resolution to Conflict Transformation: A Critical Review." In *The New Agenda for Peace Research*, edited by Ho-Won Jeong, 135–60. Aldershot, UK: Ashgate, 1999.

Visagie, Martin, Nizaam Manuel, and Jasmine Arendse. "Rush Hour Sponsor Proposal." Unpublished fundraising document. Atlantis Township, South Africa: Rush Hour, 2006.

Volkan, Vamik D. "Transgenerational Transmissions and Chosen Traumas: An Element of Large-Group Identity." *Group Analysis* 34 (2000): 79–97.

Vygotsky, Lev Semenovich. *Mind in Society.* Cambridge, MA: Harvard University Press, 1978.

Willis, Paul. *Moving Culture: An Enquiry into the Cultural Activities of Young People.* London: Calouste Gulbenkian Foundation, 1990.

Wilson, David Sloan. *Evolution for Everyone.* New York: Delacorte Press, 2007.

Wright, Robert. *The Evolution of God.* New York: Little, Brown and Company, 2009.

Wright, Robert. "Why We Think They Hate Us: Moral Imagination and the Possibility of Peace." June 8, 2009. www.cato-unbound.org.

Additional Resources

Websites

Acting Together on the World Stage: Performance and the Creative Transformation of Conflict. www.actingtogether.org.

Alliance for Peacebuilding. www.allianceforpeacebuilding.org/.

Arts in the One World. hwww.brown.edu/Departments/Theatre_Speech_Dance/about/oneworld.html.

Beyond Intractability: A Free Knowledge Base on More Constructive Approaches to Destructive Conflict. www.beyondintractability.org/.

Centre for Playback Theatre. www.playbackcentre.org/.

Coexistence International. www.heller.brandeis.edu/academic/ma-coex/resources/Ci/index.html.

The Common Ground Film Series at the United Nations. www.sfcg.org/programmes/filmfestival/united_nations.html.

Community Art Lab. www.vredevanutrecht2013.nl/En/Programme/Community-Arts-Lab.aspx.

Contact Inc. (Brisbane, Australia). www.contact.org.au/.

DNAWORKS: Dialogue and Healing through the Arts. www.dnaworks.org/.

freeDimensional. www.freedimensional.org/.

Hemispheric Institute of Performance and Politics. www.hemisphericinstitute.org/hemi/.

Hip Hop Associations (H2A). www.hiphopassociation.org.

Hip Hop History: Universal Zulu Nation. www.zulunation.com/hip_hop_history_2.htm.

International Center for Transitional Justice. www.ictj.org/.

International Theatre Institute. www.iti-worldwide.org/.

Magdalena Project: International Network for Women in Contemporary Theatre. www.themagdalenaproject.org/.

New Village Press. www.newvillagepress.net/.

Peace and Collaborative Development Network. www.internationalpeaceandconflict.org/.

Peacebuilding and the Arts. www.brandeis.edu/ethics/peacebuildingarts/index.html.

Reimagining Community, Art, and Social Transformation. www.recastinc.org/.

Seagull Foundation for the Arts. www.seagullindia.com/sfa/sfahome.html.

Search for Common Ground. www.sfcg.org/.

Story Circles – Junebug Productions. www.junebugproductions.org/.

Theatre Communications Group. www.tcg.org/.

Theatre of the Oppressed. www.theatreoftheoppressed.org/.

Theatre Without Borders. www.theatrewithoutborders.com/.

Transcend International: A Peace Development Environment Network. www.transcend.org/.

UNESCO (United Nations Educational, Scientific and Cultural Organization). www.unesco.org/.

United States Institute of Peace. www.usip.org/.

Films

Avni, Ronit, director, and Julia Bacha, codirector. *Encounter Point*. DVD. Just Vision, 2006. www.justvision.org/.

Bacha, Julia, director. *Budrus*. DVD. Just Vision, 2009. www.justvision.org/.

Cohen, Cynthia E., and Allison Lund, directors. *Acting Together on the World Stage: Performance and the Creative Transformation of Conflict*. DVD. Waltham, MA: Peace Building and the Arts at the International Center for Ethics, Justice and Public Life, Brandeis University, 2011.

Fine, Sean, and Andrea Nix Fine, directors. *War Dance*. DVD. Fine Films, 2007. www.wardancethemovie.com/.

Hurt, Byron. *Hip-Hop: Beyond Beats and Rhymes*. DVD. God Bless the Child Productions, Inc., 2006.

Jacobs-Fantauzzi, Eli, director. *Homegrown: Hiplife in Ghana*. DVD. 2008.

Macklin, Scott, and Angelica Macklin, directors. *Masizakhe: Building Each Other*. DVD. Open Hand Reel, 2008.

Mitchell, Rodney, director. *Two Rivers*. DVD. Greenleaf Street Productions, 2008. www.tworiversfilm.com/.

Ningi Connection (Ningi Youth Centre and Street Arts). *Zen-Che: A Tactical Arts Response*. Artists Craig Walsh and Randall Wood. VHS. Street Arts, 1997.

Ray, Rick. *10 Questions for the Dalai Lama*. DVD. Monterey Media, 2006.

Reticker, Gini, director. *Pray the Devil Back to Hell*. DVD. Fork Films, 2008. www.praythedevilbacktohell.com.

Credits

.........................

Chapter 1 Eugene van Erven and Kate Gardner, *Performing Cross-Cultural Conversations*

Community Theatre Internationale, excerpts from *BrooKenya!* (unpublished script). Reprinted by permission.

Chapter 4 Jo Salas, *Stories in the Moment*

Jenny Hutt and Bev Hosking excerpt from Playback Theatre: A Creative Resource for Reconciliation. Reprinted with permission of the Program in Peacebuilding and the Arts, Brandeis University.

Index

.................